Reimagining Liberation

THE NEW BLACK STUDIES SERIES

Edited by Darlene Clark Hine
and Dwight A. McBride

*A list of books in the series appears
at the end of this book.*

Reimagining Liberation

How Black Women Transformed
Citizenship in the French Empire

ANNETTE K. JOSEPH-GABRIEL

UNIVERSITY OF
ILLINOIS PRESS
Urbana, Chicago, and Springfield

Publication of this book was supported by funding
from the University of Michigan Office of Research
and the College of Literature, Science, and the Arts.

Portions of chapter 1 previously appeared as "Beyond
the Great Camouflage: Haiti in Suzanne Césaire's
Politics and Poetics of Liberation" in *Small Axe* Vol.
20 No. 2, July 2016, pp. 1–13. Portions of chapter
6 previously appeared as "Feminist Networks and
Diasporic Practices: Eslanda Robeson's Travels in
Africa" in *To Turn the Whole World Over: Black Women
and Internationalism,* ed. Keisha N. Blain and Tiffany
M. Gill (University of Illinois Press, 2019).

Library of Congress Cataloging-in-Publication Data
Names: Joseph-Gabriel, Annette K., author.
Title: Reimagining liberation : how Black women
 transformed citizenship in the French empire /
 Annette K. Joseph-Gabriel.
Description: Urbana : University of Illinois Press,
 [2020] | Series: The new Black studies series | Includes
 bibliographical references and index.
Identifiers: LCCN 2019025426 (print) | LCCN 2019025427
 (ebook) | ISBN 9780252042935 (cloth) |
 ISBN 9780252084751 (paperback) | ISBN 9780252051791
 (ebook)
Subjects: LCSH: Women, Black—French-speaking
 countrie—Biography. | Women, Black—Political
 activity—French-speaking countries—History—20th
 century. | Anti-imperialist movements—French-
 speaking countries—History—20th century.
Classification: LCC HQ1163 .J67 2020 (print) | LCC HQ1163
 (ebook) | DDC 305.48/8960944—dc23
LC record available at https://lccn.loc.gov/2019025426
LC ebook record available at https://lccn.loc.
 gov/2019025427

For Laura
and Jeannette

Contents

Acknowledgments

I am grateful for the incredible support I received while writing this book. I owe an immense debt of gratitude to Tracy Sharpley-Whiting for her guidance and mentorship at all stages of this project and beyond. I am grateful to Stéphane Robolin, in whose courses this journey began and who has remained a generous mentor over the years. Many other teachers along the way taught me to ask necessary questions and to seek answers both within and beyond the genres and disciplines that are most readily legible to the academy. To these teachers—Robert Barsky, Edan Dekel, Trica Keaton, Vera Kutzinski, Paul Miller, Kenda Mutongi, Tiffany Patterson, Kashia Pieprzak, Neil Roberts, Virginia Scott, Evie Shockley, and Shanti Singham—I am most grateful.

Archival "discoveries" are often thanks to archivists' deep knowledge of their collections. For showing me the way, I extend sincere thanks to the archivists at the Archives départementales de la Martinique, the Archives nationales d'outre-mer, the Bibliothèque national de France, the Bibliothèque littéraire Jacques Doucet, the Fondation Charles de Gaulle, the Archives du Sénat, the Archives départementales des Bouches-du-Rhône in Aix-en-Provence and Marseille, and the Moorland-Spingarn Research Center. Support from the Carrie Chapman Catt Prize for Research on Women and Politics was invaluable for visiting some of these archives.

In preparing this work, the feedback I received from anonymous reviewers helped to shape my thinking. I am especially grateful to anonymous Reviewer C, whose thorough reading and comments showed me more clearly the black feminist shape of this work. I extend my sincere thanks to Dawn Durante for believing in this book from the start and for being such a wonderful editor.

The support I received from colleagues has been invaluable. Thank you, Keisha Blain and Ashley Farmer, for daily writing check-ins that kept my butt in the seat and for your scholarship on black women that has served as a model for my work. Thank you to Jarrod Hayes for reading the manuscript (twice!) and to Rob Watson for valuable feedback on early versions of chapters. Petal Samuel and Kathleen DeGuzman, I am so grateful for your insightful comments on countless drafts and for blowing me away every day with your brilliance as Caribbeanists and your kindness and generosity as friends. I will always cherish the newbie crew: Adi, David, Desiree, Julie, Kadian, Kevin, and Stephanie. Your scholarship and activism remain a guiding light. Thank you to my RLL colleagues at the University of Michigan, Ann Arbor, whose welcome, friendship, and support I truly appreciate.

Thank you, Yemisi Cookey and Michelle Wilson, for your friendship and reminders to be human. I am so grateful to the Pecome family and to Manette Joseph-Gabriel for making Martinique my second home. I thank my grandparents Agnes, Laura, and Jonathan for the work they did in creating a better, more just world. To my father, Andy; my mother, Jeannette; and my brothers, Andy Jr. and Jean, thank you for immeasurable sacrifices, for making fifteen years away easier to bear and for bridging the distance with love and laughs. Steeve, my friend, my love, my archive slayer, my travel partner, the calm to my chaos, thank you will never be enough. This, like everything, is for you. May the rest of this journey hold nothing but light and happiness for you.

Reimagining Liberation

Prologue

I became a French citizen in 2017 as I was writing this book. There was no pomp and circumstance, no singing of the Marseillaise in a tearful ceremony attended by joyful relatives eager to welcome me into the folds of France. None of my relatives are French. The plain white envelope that arrived in the mail from the French consulate contained a red, white, and blue folder bearing the image of Marianne swinging the tricolor, an image taken from Eugène Delacroix's famous nineteenth-century painting *Liberty Leading the People*. Inside the folder, the form letter bearing François Hollande's signature announced my "attachment to the long history of a France that, over centuries, has welcomed women and men who have recognized themselves in its values: liberty, equality, fraternity, secularism." The well-known tripartite motto of liberty, equality, fraternity that began as the rallying cry of the French Revolution sported a new addition in this repackaging of national values for an age when secularism was no longer brandished in the face of the Catholic clergy with as much conviction as in the revolutionary era, and when Islam now constituted a key site of contestation over who could really be French. The rest of the folder's contents illuminated the government's view on the necessary ingredients for becoming a good citizen: the official scores of the mandatory language exam proved that I knew enough French to be French. Glossy A4 sheets printed with the words to the Marseillaise (finally!), the constitution of the French Fifth Republic, and the 1789 Declaration of the Rights of Man and of the Citizen were testaments to the specific elements of French history that I could now apparently claim as mine. This last document would be a useful point of departure for my analysis of citizenship in this book.

Of the plethora of administrative documents that came with my acquisition of French citizenship, two in particular stood out as emblematic of the comfort and discomfiture that this new status brought. The first was a brochure informing me that if I had not responded to the consulate's initial offer regarding the Gallicization of my name, it was not too late to do so. Anyone who has been through a French administrative process will be struck, as I was, by the rarity of second chances. An entire dossier could be unceremoniously thrown out or, at best, returned to the applicant over a typo. To offer a second chance at modifying the spelling of my name, then, is to underscore a need to render legible to the French state those names, identities, and selves deemed illegible.

The second document was a French consulate registration card issued in Chicago as proof that I had now been placed under consulate protection. This was a year when unstable leaders in the United States and North Korea goaded each other with barbs about their physical appearances, mental capacities, and nuclear arsenals. The consulate's language of protection, dubious as its efficacy may be, provided an illusion of safer alternatives to a grim reality. This was, however, also the year that the French government fired the high-profile feminist, antiracist activist Rokhaya Diallo from the National Digital Council over her use of the term "state racism" to publicly contest institutionalized racism in France. The promises of rights and protections, the administrative reminders to re-baptize myself for legibility, and the realities of black women's ongoing and unfulfilled demands for equality in France all come together in the terms on which I engage with citizenship in this book.

Citizenship, as my French naturalization folder attests, is the individual's relationship to the state. It unfolds in the legal arena of constitutions and laws, rights and duties. The linguistic and visual images in the folder show that citizenship also unfolds in the social, cultural, and political spheres of community building, identity formation, and belonging. It is concrete and abstract. What follows in this book is an examination of the different ways that the concrete and abstract came together and pulled apart as black women demanded full citizenship in the mid-twentieth century, at a particularly pivotal period in French history. In the texts that form the core of this project's archive, we find a different set of ingredients for good citizenship. We hear a remix of the Marseillaise that calls on Guadeloupeans to make their political voice heard by voting for Eugénie Éboué-Tell to become the first black woman deputy in the French National Assembly. We see the tricolor in the hands of Aoua Kéita, a community organizer in rural Mali, as she stitches the letters "RDA" onto the French flag to represent the Rassemblement Démocratique Africain, a West Africa–wide anticolonial political party. These different texts

go beyond simply showing that black women too can be French citizens. They prod us instead to rethink the relationship between race, gender, belonging, and political agency. They show us again and again that to demand full citizenship as a black woman is to unmake and remake the French Republic. It is to redefine the very nature of civic participation and national identity in a country that both sees itself as white and claims to be color-blind. It is also to imagine citizenship beyond the borders of imperial France and to reclaim multiple forms of belonging that take into account the varied spaces that black women have historically claimed and continue to claim as theirs.

Introduction

In August 1944, as General Philippe Leclerc marched into Paris to liberate the city from German occupation, Andrée Blouin marched into the mayor's office in Bangui, a French territory in Central Africa, to obtain a quinine card for the malaria treatment that would save her two-year-old son, René. Quinine cards were for Europeans only, and the mayor let the distraught woman know this in no uncertain terms. As the daughter of an African mother and a European father, Blouin was classified by colonial law as "*métisse*" or "mixed race," a status that extended to her son. Colonial guards dragged her out of the office as she screamed, "I am a French citizen, the same as you, and so is my son. . . . Yours is an accursed race! Cursed authors of a murderous law!"[1] In her autobiography, Blouin maintains that the events of World War II and her son's death in a seemingly far-flung outpost of the French empire in Africa were inextricably linked: "I have been asked 'Why would white people be so cruel to a child who was three-fourths white?' My answer is: this was deepest Equatorial Africa and the war was on."[2] The institutionalized racism that viewed people in the colonies as dispensable bodies on the battlefields of Europe was also at work in the "murderous law" that reserved antimalaria treatment for white Europeans only.

René's preventable death from malaria galvanized Blouin into political action. She first fought the quinine law and obtained a reform, making the antimalaria treatment more accessible. From there her activism became more explicitly anticolonial and took on a regional and then international scale. She worked as an adviser to Sekou Touré and Kwame Nkrumah, the first presidents of Guinea and Ghana, respectively, and eventually became chief of protocol in the cabinet of Congolese prime minister Patrice Lumumba. Blouin's ex-

periences of exclusion and discrimination as an African woman in colonized territory propelled her to advocate for a more expansive form of citizenship beyond France's exclusionary, race-based, tiered citizenship policies. After losing her son, it became even more urgent to work toward a decolonized world.

Blouin was not the only woman whose experiences of loss and trauma during World War II informed her anticolonial activism. In the mid-twentieth century, African, Antillean, Guyanese, and African American women generated a body of writing that highlighted the pernicious effects of colonial oppression against the backdrop of violence and death wrought by a world war. The women in this study were injured by German torpedoes, incarcerated in concentration camps, censored by governments, stripped of their passports, and condemned to death by the state. They risked their lives and lost what liberty they had. In the process, they articulated different ways of contesting the intertwined, institutionalized oppressions they faced as black women in the French empire and worked toward dismantling colonial power structures.

Black women living in or traveling through the francophone world imagined political configurations that were varied and often shifting. For Martinican writers Suzanne Césaire and Paulette Nardal, this dismantling would take the form of departmentalization for overseas France. For the Guyanese-born senator Eugénie Éboué-Tell and her colleague from Oubangui-Chari (present-day Central African Republic), Jane Vialle, the end of colonialism meant incorporating the former colonies into a more democratic French Union. For Andrée Blouin, Malian deputy Aoua Kéita, and American anthropologist and activist Eslanda Robeson, only national sovereignty would do. Despite their differences, they shared a common desire for women's emancipation in the post-colony. Above all, they were convinced that decolonization could not be attained without women's political representation and meaningful participation in public life.

Black women in the francophone world were political protagonists in the struggle against colonialism; their activism went hand in hand with literary production.[3] They produced texts across a range of genres that articulated their visions for a future free from colonial domination and chronicled their roles in working toward this future. Because a protagonist is the primary character in a work of literature, the term "political protagonist" is useful for highlighting the centrality of black women's roles in the intertwined domains of anticolonial politics and literary production. It also offers a wider scope of engagement that allows us to account for francophone women's writings not only within but also beyond the private spaces of intimacy and familial relationships in which scholarly analyses have usually located such work. Black women realized their anticolonial visions—with varying degrees of success—in several

spheres, including intellectual production, grassroots organizing, state policy, and transnational networks. Reading them as political protagonists therefore illuminates the multiple terrains on which they battled colonialism.

Reimagining Liberation: How Black Women Transformed Citizenship in the French Empire is the story of seven women who made significant contributions to decolonization in the mid-twentieth century, contributions that have largely been overlooked or underestimated in retrospective analyses. The story, told from the double perspective of the literary history and politics of this period, begins with Suzanne Césaire's arrival in Martinique from Paris aboard the SS *Bretagne* in 1939 with war looming on the horizon. It ends with the U.S. government's restitution of Eslanda Robeson's passport in 1958 after nearly a decade of restricting her international mobility. Between these bookends, Paulette Nardal boards the SS *Bretagne* on its ill-fated return journey to Europe; Eugénie Éboué-Tell and Jane Vialle crisscross the Atlantic as their senatorial duties take them to France, the United States, and the Caribbean; Andrée Blouin is expelled from the Belgian Congo as Lumumba's government comes under siege and arrives in Rome with a sensitive political document hidden in her chignon; and Aoua Kéita travels to Leipzig to represent the interests of Malian women as workers at the International Trade Union congress. *Reimagining Liberation*, then, is also about black women's geographies of resistance, about mobility and intersections, and about transatlantic movement as exile, as homecoming, as survival, and even as liberation.

In this book I argue that the women studied here used the language of citizenship to claim their belonging to multiple cultural and political communities at once; France, Africa, the Caribbean, the African diaspora, the Global South. In so doing, they expanded the possibilities of belonging beyond the borders of the nation-state to imagine Pan-African and Pan-Caribbean citizenships that were informed by their experiences as black women in the French empire. Black women in the French-speaking world, though relatively marginalized in the intellectual history of anticolonial thought, were active contributors to the political movements that reached their zenith in the aftermath of World War II. Eliding their voices therefore provides only a partial view of how colonized people envisioned liberation at a pivotal historical moment in postwar France writ large.

In order to situate black women's leading roles in this larger story of anticolonial thought, it is important to understand how World War II altered France's discourse on national identity and changed the terms of its relationship with the colonies. The French colonies played a crucial role in the metropole's liberation from wartime occupation. In a now historic speech delivered via BBC radio broadcast on June 18, 1940, Charles de Gaulle declared that

despite German occupation, France was not yet defeated. The metropole could count on its vast empire for its liberation.[4] Once de Gaulle made it clear that a defeated France could rise only with the aid of its subjects, colonial relations would never be the same again. The colonized subjects whom France had supposedly set out to civilize entered the war to save a crumbling Europe from itself. As Paris fell to Vichy, the pro–Nazi collaborationist regime, the Guyanese Félix Éboué made history by becoming the first French administrator to publicly support de Gaulle. Éboué organized troops throughout West and Central Africa to join the war effort. Radio Brazzaville became the voice of La France Libre. Of this period, Robeson writes, "For the first time in colonial history, a Colony took over from the Mother country and became the leader—morally, legally, militarily, economically and practically."[5] In the immediate postwar period, colonized populations heightened their contestation of French oppression, often invoking the immense sacrifices that the colonies had made for the metropole during the war.[6]

The changing discourse on colonial relations had important political and legal repercussions. The new postwar constitution that established the French Fourth Republic in 1946 also redefined the relationship between metropole and colonies by giving rise to the French Union. This unequal federation included France's *vieilles colonies* (old colonies) of Martinique, Guadeloupe, French Guyana, and Réunion as overseas departments. The newer colonies in Africa were now categorized as overseas territories of France. In short, the new constitution abolished the colonial status and recognized overseas populations as French citizens, at least on paper. Governing power, however, remained centralized in the metropole, and the lived reality of what it meant to be a subject-citizen soon fell short of the lofty constitutional promises. Voting rights were unevenly applied, leaving out large segments of people in Africa. The Hexagon was likewise selective in extending social security benefits in the Antilles, particularly to women. Many in overseas France soon realized that they remained on the margins of this supposedly new, egalitarian France. The French Union established after World War II was in many ways the old French empire under a new name.

As France was negotiating the terms of its relationship with its colonies, it was also involved in redefining the role of women as citizens in the metropole. Notably, in 1944 French women won the right to vote and hold public office. After over a century of organizing by supporters of women's suffrage and a series of parliamentary debates, French women gained the vote, not through a democratic process but via a decree signed by de Gaulle. For some, the decree signaled de Gaulle's need to legitimize his precarious provisional government in wartime and distinguish it from the Vichy regime by positioning himself

as "the representative of the sovereign people."[7] For others, it showed the power that women wielded as a demographic viewed by political parties as both numerically significant and malleable.[8] With the constitutional recognition of citizenship in overseas France and women's suffrage in the Hexagon, women in the colonies were now uniquely situated at the intersection of these two monumental shifts in the political landscape. In this moment of fluidity and change, black women in the French empire saw an opportunity to demand political representation and unsettle such foundations of colonialism as the notion of a French civilizing mission, the erasure of the histories and civilizations of the colonized, and the physical and psychic violence enacted by colonial domination. In imagining multiple citizenships that would both refigure their relationship to the French state and reach beyond the state to create and sustain transnational cultural and political communities, they also demanded a more complete reckoning with and recognition of the complex nature of belonging.

Decolonial Citizenship

The Declaration of the Rights of Man and of the Citizen, a charter passed by the National Assembly in 1789 during the French Revolution, continues to be read as a founding text of both human rights and citizenship. This document contributes to the invention of Man, which Sylvia Wynter cautions us to understand as different from human.[9] According to Wynter, Man is a deliberate Western bourgeois creation, a definition of the human that is limited and exclusionary along lines of class, gender, ethnicity, race, nationality, and sexuality. More specifically, Man is European, heterosexual, white, and male, initially understood to be Christian but later, in the Enlightenment period, redefined as rational. The construction of Man is deeply entangled with the history of colonial conquest, because Man came to be defined in opposition to the colonized "Other," the nonwhite, non-Christian, and, later, supposedly irrational savages. The narrowly defined, exclusionary parameters of Man are not the only pernicious elements of this historically constructed identity. Wynter explains that it is the overrepresentation of Man "as if it were the human itself" that enacts "the Coloniality of Being/Power/Truth/Freedom."[10] In other words, when Man stands in for human, it pushes all "Others" to the margins, to the limits of humanness or even outside of humanity. Historically, this conflation of Man and human was used to legitimize "African enslavement, Latin American conquest, and Asian subjugation."[11]

I return to Wynter's evocation of coloniality shortly, in my discussion of what constitutes the coloniality of power and therefore decolonial citizenship

as a refusal of coloniality. For now, it is important to note that the Declaration of the Rights of Man and of the Citizen as a social contract, outlined a new relationship between Western bourgeois Man and the state, one that redefined Man's status from subject of a divinely ordained monarchy to citizen. As Étienne Balibar argues, this expression of the rights of "man *as citizen*" equated humanity with civic participation such that those considered to be outside the category of Man could not access citizenship, and, conversely, one's humanity became inseparable from one's status as citizen.[12] This fusion of Man and citizen, what Wynter describes as "the new humanist and ratiocentric conception of Man$_2$ (i.e., as homo politicus or the political subject of the state)," lays the groundwork for the othering of those excluded from the category of citizen.[13] As Balibar argues, "Those who have been excluded from citizenship (and there are always old or new categories that are) are represented, and so to speak 'produced,' by all sorts of disciplinary or institutional mechanisms as imperfect human beings, as 'abnormals' or monsters on the margins of humanity."[14]

If, in a book about black women's political participation and visions of belonging, I begin with a masculinist, Eurocentric definition of citizenship, it is precisely because of the concept's profoundly Western roots in the ancient Greek concept *politeia*. Politeia describes the relationship between the political community, or *polis*, and the people who participate in that community.[15] It defines the conditions of an individual's place within the collective body, conditions that, in certain ancient Greek city-states, included factors such as birthplace and status as slave or free. These conditions laid the groundwork for the exclusionary elements in notions of belonging that have been transmitted over time under the name of citizenship. As Balibar explains in describing the Aristotelian notion of citizenship, "Reciprocity can only exist, for Aristotle and his contemporaries, between those who are equal by *nature*. This means that at the core of the political there is a mechanism for discrimination on the basis of anthropological difference: gender difference, age difference, the difference between manual and intellectual capacities, specifically insofar as it justifies the institution of slavery."[16] The inequalities in experiences of citizenship, then, do not stem only from its selective application. They were already built into the concept at its origins as it defined not only one's relationship to the state but also the very possibility of being human.

Wynter's evocation of the Coloniality of Being/Power/Truth/Freedom suggests that the narrow definition of Man-as-citizen is one of the many manifestations of what Anibal Quijano has termed "the coloniality of power."[17] This term defines colonial power as rooted in a racial and labor hierarchy that is in turn premised on the supposed superiority of Western modes of thinking,

knowing, and being. The notion of the superiority of European civilization was central to the colonial project of appropriating land, exploiting labor, and delegitimizing and erasing the civilizations of the colonized. As Aimé Césaire shows in *Discours sur le colonialisme*, colonial conquest was not only the work of "the adventurer and the pirate, the wholesale grocer and the ship owner, the gold digger and the merchant."[18] It was also carried out by the politician and the philosopher. At the center of coloniality is the privileging of Eurocentric thought and ways of being.[19] Historically, citizenship has not been the only mode of understanding collective identity and belonging. Walter Mignolo writes, "What is universal is the human drive to build communities grounded on memories and experiences that constitute the house, the dwelling place of different people."[20] Citizenship is not universal. Imposing it as the only way to organize political communities is a colonial act, one that silences and denies the existence of the many other notions of belonging articulated in non-European civilizations.[21] Over time, different groups subjected to the coloniality of power "became painfully aware of the ways in which modern political forms, such as nation-states and citizenship, were connected to a prior history of colonialism rooted in race."[22]

Black women too were aware of the profoundly colonial nature of citizenship as it was defined and practiced in the context of imperial conquest. In response, they challenged the colonial project on all its terms, peeling back the sheer veneer of the metropole's rhetoric of a civilizing mission in order to lay bare the reality of colonialism as a system of economic exploitation, racist and sexist violence, and the negation of non-European epistemologies. Their overlooked contributions to anticolonial movements, and their application of their decolonial thought to practices of belonging and autonomous governing is what I term "decolonial citizenship." Concretely, decolonial citizenship does two things. First, it contests the colonial foundations of citizenship and the elements of coloniality that shape this notion of belonging. These elements include the disavowal of non-European epistemologies, the conflation of racial and national identity, and the hierarchical model of belonging based on the state's demarcation of good citizens and undesirables. Given that, as Wynter asserts, any attempt to upend the coloniality of power will have to unsettle the overrepresentation of Man as human, decolonial citizenship is invested in this unsettling. It refuses the colonial label of "Other" on the margins or outside of humanity and, in the words of the Negritude poet, articulates "its belief in its humanity."[23] Second, it aims to untether citizenship from the narrow confines of the nation-state as the only political community imaginable and advocates a shift toward plural forms of belonging. This does not mean disavowing citizenship entirely but rather resituating it within a broader con-

stellation of notions of belonging such that it becomes one of many possible models.[24] Decolonial citizenship is not about inclusion, moving a token few marginalized people from the periphery to the core of the imperial nation-state. It is remaking, redefining the very terms on which collective identity and belonging can be imagined.

In the French Antilles, this remaking occurs in the shift in Suzanne Césaire's geographic and political focus from Martinique's colonial relationship with France to the possibility of building a new Caribbean civilization. In articulating decolonial citizenship, Césaire also models the necessity of decolonizing knowledge and embracing multiple epistemologies rather than reifying the canon of white male thinkers. Thus, her vision of a Pan-Caribbean civilization places Caribbean religious and cultural practices, language, and philosophies alongside Frobenian theory and surrealism to imagine liberation from colonialism. In the African context, decolonial citizenship as remaking occurs through Andrée Blouin's unsettling of the putatively neat mapping of racial identity onto national identity. As Ramon Grosfoguel has argued, "The construction of national identity is entangled with racial categories."[25] As she reflects on her place in African liberation movements, Blouin's seemingly ambiguous and shifting racial identification refuses the racialization of Frenchness as white and of Pan-Africanism as reducible to narrowly defined notions of blackness. Decolonial citizenship, as it emerges across the writings of black women in the French empire, emphasizes the plurality of epistemologies, identities, forms of belonging, and political configurations as central to anticolonial movements.

My earlier evocation of Aimé Césaire's astute analysis of the philosophical underpinnings of colonial power and exploitation in *Discours sur le colonialisme*, placed alongside the decolonial praxis of Suzanne Césaire and Andrée Blouin, reflects this study's larger project of situating black women as integral to the genealogy of thinkers and practitioners in liberation movements in the African diaspora rather than as cordoned off into a separate and parallel lineage. Before it came to be the rallying cry of opposition to colonial domination, *Discours sur le colonialisme* began as an essay titled "L'Impossible contact" (The Impossible Contact) written at the request of the conservative journal *Chemins du Monde* for their special issue titled "Fin de l'ère coloniale?" (The End of the Colonial Era?).[26] The journal's editors assumed that Aimé Césaire's role as sponsor and fierce advocate of the law of assimilation, later baptized as the law of departmentalization, made him an ideal candidate to pen an essay that would be sympathetic to colonial ideas of assimilation. They did not receive such an essay. What they did receive was a scathing denunciation of the barbarity of European civilization and an unequivocal declaration that

Nazism was nothing but Europe's colonial chickens come home to roost. Césaire's contribution sat uneasily alongside essays that extolled the supposed virtues of France's civilizing mission and others that recognized the destruction of the cultures of colonized communities but attributed that destruction to the overzealous methods of well-intentioned colonizers. The editorial that preceded the contributions hastened to assure readers that Césaire's overly critical essay was tempered by many other fine contributions that highlighted the glorious legacy of "great Colonists of whom we can be proud."[27]

Césaire's handwritten draft of "L'Impossible contact" is a fascinating document on which canceled words, curved arrows, and marginal comments show the inner workings of his thought process as he penned this magisterial treatise.[28] That it was written on May 6, 1948, much closer to the end of World War II than the 1955 date of the final version's publication under the Présence Africaine imprint, underscores the urgency of his reflections on Nazism as white supremacy turned onto Europe itself. This earlier date of authorship, on the centennial of the abolition of slavery in the French Antilles, also suggests that Césaire was undoubtedly thinking about white supremacy's deep roots as he wrote. Beyond its content, however, it is the paratext of "L'Impossible contact" that bears a stunning twist of vital importance to any discussion of decolonization: when Césaire sat down to write his condemnation of Europe's imperial machine let loose on the world, he reached for blank sheets of paper that carried the French National Assembly's letterhead. The birth of the text that would become *Discourse on Colonialism*, on official French parliamentary stationery, is today a visual reminder of the tensions between Césaire's radical writings and his investment in the French state as a deputy who, in the early years of his political career, pursued departmentalization for the Antilles rather than a clean break from the metropole. It is a reminder of his place writing and speaking from within the very spaces and political institutions that he critiqued in his work.

The African, Antillean, and Guyanese women examined in this study were not immune to these tensions as black French thinkers whose ideas were both shaped by and articulated in opposition to colonial France. I make the deliberate choice, therefore, to explore what I term their decolonial citizenship rather than to claim that they were *decolonizing* citizenship. Decolonization posits a total rupture with extant systems of colonial oppression, a "delinking from the rules of the game."[29] The methods of anticolonial resistance that the women in this book employed did not always indicate a complete divestment from structures of power and established spaces of political influence. Nardal's progressive gender politics did little to challenge class divides in Martinique. Éboué-Tell's and Vialle's firm belief in the rhetoric of French republicanism

left little room for imagining liberation beyond refiguring the balance of power in the French Union. Blouin's racial politics betray a lingering investment in the very colonial racial hierarchy she challenged. My goal in this work is neither to reconcile these tensions and defend these authors nor to bemoan a perceived failure on their part to articulate an acceptably radical politics. Instead, I aim to examine the range of visions that black women put forward in response to colonialism and to highlight the crucial elements of decolonial thought that motivated their work. As their stories unfold in this book, different women walk on and off the stage of each chapter, supporting one point of view or expressing their dissatisfaction with another. Their political views were as diverse as the contexts within which they were formed. They also chose a variety of genres to articulate their political visions, from essays that laid out manifestos for a Caribbean renaissance or a Global South anti-imperialist movement to autobiographies that explored the possibilities and limits of national belonging for African women in the early years of independence. The variations and contradictions within and across their writings show the wide-ranging terms on which black women challenged colonialism.

Indeed, the seven women of *Reimagining Liberation* are neither the beginning nor the end of the story of black women's intellectual and political work in the French-speaking world. Even in the small slice of history that is the focus here, several other women who make brief appearances in these pages were political protagonists in their own right, working in collaboration with the women of this study or in opposition to them when they occupied different sides of the political aisle. Nardal, for example, found an outspoken critic in Jane Léro, founder of the feminist organization Union des femmes de Martinique. Similarly, the battle for the parliamentary seat for Guadeloupe's first electoral district pitted Éboué-Tell against the even more politically radical Gerty Archimède, who eventually won the seat, but not before lobbing accusations of electoral fraud at her opponent.[30] Annette Mbaye d'Erneville in Senegal and M'Ballia Camara and Jeanne-Martin Cissé in Guinea were leaders in a generation of African activists who challenged colonialism and patriarchy through their work in a slew of domains, including literature, labor movements, and international politics. Some, such as Cissé, went on to occupy positions of power in international organizations such as the United Nations. Others, such as Camara, lost their lives for their activism. In acknowledging the centrality of their roles to the discourse on race, power, and belonging in the twentieth century, I suspect that many of these women would reject any claims of their "exemplary representativity."[31] To borrow from Natalie Melas's work on sites of enunciation in postcolonial comparative contexts, these

women do not stand *for* the world but rather stand *in* the world as witnesses to black women's theories and practices of citizenship.

Visibility and Archival Traces

To retrace black women's contributions to the discourse on citizenship and political identities in the francophone world is invariably to grapple with their contemporary legacies. It means thinking through visibility and invisibility as central to the project of excavating private lives in public archives. One of the primary challenges in undertaking this kind of work is the dearth of materials, not because women did not write in this period, as some commentators have suggested, but because too many of their works are lost, as in the case of Suzanne Césaire's play *Youma* or Vialle's short stories published in Algeria during World War II. In some cases, family members closely guard their legacies, wary of how their ancestors may be represented. The family members contacted for this study were forthcoming to varying degrees. Eve Blouin generously shared her personal testimony of her mother's work and life but was not able to grant access to Blouin's papers. Suzanne Césaire's son, Marc, gave his consent to view his mother's letters, but any discussion of citing their contents had to be routed through his Paris-based attorneys. The ensuing negotiations and ultimately prohibitive cost of permissions have shaped the possibilities for representing Césaire's voice and archive in this book. The gaps and silences, willful or otherwise, ask that we be attentive to the terms of archival visibility.

Unearthing documents, images, and testimony as part of the research process involves navigating the intensely political waters of archival access. One such space where this access means quite literally wandering the labyrinthine halls of power is the French Senate archives located in the Palais du Luxembourg in Paris. Entry requires making one's way past armed guards, through a metal detector, and then past several receptionists with the requisite forms and two pieces of government-issued identification. The reading room itself is small. A few paintings in somber shades hang discreetly on the walls, but one bright, colorful artwork is prominently displayed opposite the doorway and is the first thing one sees on walking into the room. It is a painting of Jane Vialle. According to the archivist I met there, her colleague had found the painting in the building's basement and thought it would be amusing ("marrant") to display it in the reading room in anticipation of my visit.[32] Vialle is highly visible in the archives. However, with no identifying information on the artist or his or her subject, the display of her image also renders

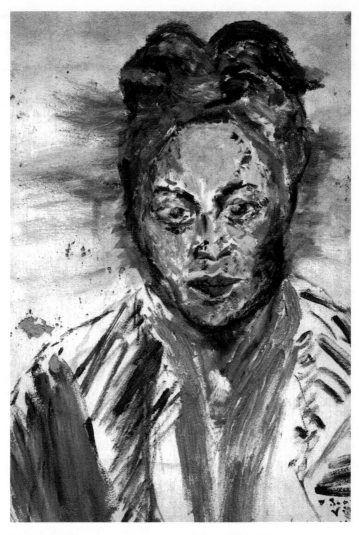

Portrait of Jane Vialle. Courtesy Archives du Sénat, Paris.

her invisible, her presence acknowledged only as a potential source of curious amusement to the viewer.

For those who know where and how to look, Vialle's portrait is a reminder that the arc of French political history includes the people that France sought to remake in its image, sword in hand.[33] The plush Palais du Luxembourg is not only the seventeenth-century residence of the Queen Regent Marie de Medicis and the current seat of the Senate. It is also the space from which

women like Vialle and Éboué-Tell challenged the hubris of the French colonial project and asserted African and Antillean women's humanity and right to citizenship. Vialle's portrait shows the invisibilizing tendencies of forms of commemoration that remain muted testimonies to black women's roles and presence in public spaces. Today the Résidence Jane Vialle hostel in Marseille, with no accessible historical documentation or commemorative plaque on the simple white building, is the only remaining trace of the fact that only a few years after her internment in a concentration camp, Vialle managed to purchase several buildings in France's largest cities to house female students from the colonies who were struggling to live on inadequate and often de-layed government stipends. Likewise, Éboué-Tell is now largely forgotten in contemporary scholarship on French colonial politics and her name is a street sign among many in the Parisian suburb of Asnières. The form of com-memoration, in making her name more visible, also leaves her contributions to the discursive framing of black, French, Afro-diasporic identities unspoken. In considering black women's roles in shaping decolonial citizenship in the francophone world, the fact that many of these political protagonists are today relegated to the margins of history, even when seemingly immortalized by cultural and historical artifacts, suggests that there may be other ways to remember.

By centering women's roles in contesting colonialism and redefining citi-zenship in the francophone world, this study enters into a multidisciplinary conversation about French imperial politics, transnational black feminism, and Afro-diasporic literature. Recent scholarly works on decolonial thought and black transnationalism that engage with the francophone world have reinforced two strands of thought. The first is that Paris is the central node in the intellectual geography of the French-speaking world.[34] And while it is true, as Brent Edwards, Imaobong Umoren, and others have noted, that the European capitals of London and Paris were "critical contact zones" for black internationalist movements, that critical contact happened elsewhere too.[35] This intellectual geography that locates Paris as the privileged site of black literary and cultural production also continues to relegate sites such as French Guyana, Mali, and the Central African Republic to the margins of scholarly engagement. The reality that black women created networks that spanned a variety of spaces contests this marginalization and suggests the need for a shift in scope from the wheel-and-spokes approach that places Paris as the center of transnational engagement to an approach that situates the metropole's capital in a larger constellation of sites of anti-imperial movements.

Michelle Stephens writes in "Re-imagining the Shape and Borders of Black Political Space" that "transnational approaches are producing a transformation

in the politics of identity, moving us beyond postmodern and postcolonial paradigms of margin/center subjectivities to a reframing of Gloria Anzaldúa's notion of border mentalities."[36] Stephens makes a case for the importance of border mentalities "in describing not just settlements but also movements across borders—identity formations that occur in the act of migration between two or more places, across the seas as much as between the homelands of modernity."[37] This border mentality is at the core of my analysis of Suzanne Césaire's writings in chapter 1, where I attribute the shift in her thinking from a Martinican focus toward a broader Caribbean consciousness, to the specific and pivotal moment when she boarded a Pan American Airways flight from Fort-de-France to Port-au-Prince. Similarly, my reading in chapter 2 of Nardal's character Elisa, a Martinican woman caught between home and exile in Paris, and in chapter 4 of Blouin's hybrid narrative that speaks of racial identity formation from a space between the genres of biography, autobiography, and historical fiction, highlights the productive possibilities that border mentalities held for black women whose work emphasized as much the trajectory as the destination, inscribed a broader geography of transnational engagement, and displaced the colonial metropole as the privileged site of identity formation and intellectual work.

The second prevailing strand of thought is that the genealogy of ideas in the francophone tradition is composed of a long line of male thinkers from Toussaint Louverture to Edouard Glissant. Aimé Césaire, Léopold Senghor, and Frantz Fanon loom large in this tradition. Aimé in particular stands as both the inheritor of Louverture's political vision and the progenitor of a new generation of thinkers. Suzanne Césaire and Maryse Condé make the occasional appearance, with the former once startlingly designated a "negritude father."[38] Representative texts in this intellectual history include crucial and pioneering works in the field such as Nick Nesbitt's *Caribbean Critique: Antillean Critical Theory from Toussaint to Glissant*; Gary Wilder's *Freedom Time: Negritude, Decolonization, and the Future of the World*; and the volumes *Toussaint to Tupac: The Black International since the Age of Revolution* and *Post/Colonialism and the Pursuit of Freedom in the Black Atlantic*. These works shed important new light on the political imagination of black thinkers in the twentieth century. Nesbitt and Wilder especially put forward new ways to read these thinkers' works as evidence of an anticolonial project that sought to remake France by redefining the very idea of the French nation. They present a shift in the long-standing critique of departmentalization as assimilation and acquiescence, as the ultimate capitulation to colonial domination, and nudge us toward a more nuanced understanding of the liberatory possibilities that this status held, especially in the moment when it

was first defined. Certainly, no one text can be expected to cover the breadth of African diasporic intellectual history. The fact remains however that many of the French-speaking African and Antillean women who made important contributions to this intellectual history continue to hover on the periphery of scholarly vision. Brent Edwards's *The Practice of Diaspora: Literature, Translation, and the Rise of Black Internationalism* provides an astute and informative analysis of the Nardal sisters' contributions to black internationalism in the interwar years. And yet one can argue, as some scholars have, that there is a difference between reading black women in supporting roles as participants in revolutionary processes spearheaded by black men and situating them as political protagonists whose ideas galvanized visions of what a decolonized world could look like.[39]

Even as Aimé Césaire penned *Discourse on Colonialism* and Frantz Fanon wrote *The Wretched of the Earth*, two texts that are heralded today as foundational works of decolonization, theirs were not the only voices in the francophone tradition advocating for new modes of being that disrupted colonial ideologies. Black women played crucial roles in this enterprise, and the centrality of their roles has been the subject of a growing number of works. Jennifer Anne Boittin's *Colonial Metropolis: The Urban Grounds of Anti-Imperialism and Feminism in Interwar Paris*; T. Denean Sharpley-Whiting's *Negritude Women*; and Jennifer Wilks's *Race, Gender, and Comparative Black Modernism: Suzanne Lacascade, Marita Bonner, Suzanne Césaire, Dorothy West* have all situated francophone women writers as key contributors to global intellectual movements. Lorelle Semley's *To Be Free and French: Citizenship in France's Atlantic Empire* takes a more sweeping historical view of the debates on French citizenship from Haiti in the time of revolution, to slave revolt in Martinique's St. Pierre, to the work of black intellectuals in interwar Paris and politicians in the French Union. These studies have challenged the male-centered genealogy of intellectual production in the French empire and expanded our understanding of citizenship, resistance, and liberation through their careful attention to race and gender in these processes.[40] They also generate new questions that inform the present study. Given black women's undeniably crucial roles in contesting limited representations of people of African descent, how did they combine their theories of contestation with practices of resistance? How did these praxes in turn reshape their thinking about community, belonging, identity, and civic participation across national, imperial, and linguistic borders?

Taking up these questions requires centering black women as political protagonists, as both the primary actors and chroniclers of their own organizing and intellectual production. The black feminist concerns of voice, recognition, and intersectionality that permeate both their writings and my analysis of their

work reject the idea of black feminism as a primarily U.S.-centric enterprise. Nardal's and Vialle's woman-centered journals, for example, provided a textual space for Antillean and African women to engage in a public conversation about voting rights in the former French colonies and share collective visions for women's enfranchisement and advancement in the postwar economy. Thus, they anticipated Aoua Thiam's *La Parole aux négresses*, a 1978 publication that challenged the exclusion of African women's voices from debates about social and political issues and is today cited as an early text of African feminism. Likewise, Blouin's and Kéita's autobiographies emphasize how constructions of racial and class identities shape African women's experiences of colonial violence and thereby stand as early examples of Kimberlé Crenshaw's theory of intersectionality—that is, the interlocking nature of racial, gendered, and class oppressions. In each of these examples, black women's expression reverberates beyond national, regional, and even linguistic boundaries. From Robeson's travel writings throughout Central Africa to Éboué-Tell's network that spanned Africa, the Caribbean, Europe, and the United States, this study brings together black women whose writings allow us to engage with the transnational nature and global scope of black feminisms.

Reimagining Liberation draws on an archive whose range of genres also shifts our understanding of francophone women's writings as focused on interiority and contained uniquely within the domestic sphere. More contemporary writers, including Mariama Bâ, Aminata Sow Fall, Simone Schwarz-Bart, and Gisèle Pineau, have explored the raced and gendered foundations of colonial rule and the continued legacy of these intersecting oppressions through the novel as primary form. Recent scholarly analyses of these novels have questioned the ongoing assumption that francophone women's writings in the twentieth century were apolitical, "concerned only with domestic issues and certainly not part of the national narrative."[41] These scholarly works argue that women writing after the formal end of colonialism articulated their ideas on nationalism through home and family as allegory. They grappled with the idea of the nation from within the home or the garden as micro-spaces that symbolize a larger political entity.

The present study builds on but also departs from the emphasis on the domestic by focusing on women as key participants and leaders in the domain of public politics. I do not discount domestic space as the location from which women have undertaken political action and continue to do so. For many of the women studied here, silence on domestic issues was not a way to minimize the importance of that space but instead a strategy of self-preservation to protect themselves and their families. Their works demand that in addition to focusing on the politics of domesticity in the postcolonial

context, we account for the public activism of the colonized women who came before—women for whom nationalism could be both an inclusive discourse and an exclusionary act, women who situated their engagement with imperialism not only in the home or garden but also in the arena of public political action. For the women in this book, the boundary between public and private was porous at best. Sometimes they made use of that porosity to challenge the ways that private and public were used as social categories to impose limits on who could be considered a citizen. This study therefore reads across a variety of genres, including essays, autobiographies, intimate journal entries, and personal correspondence to friends and family. These texts not only provide much-needed contextual information about the public lives of women who remain comparatively under-studied but also reveal the complex relationship between their private desires and public utterances and broaden the scope of what we recognize as "women's writings" in the francophone world.

Public Works, Private Lives

Blurring the lines between private experiences and public narratives was not always advantageous for black women in the French empire. Sometimes, as private lives spilled out into public discourse, women in the colonies found themselves flattened into symbols of transatlantic agreement or discord in the collective imaginary. One such flattening occurs in the much-mediatized marriage between Léopold Senghor and Ginette Éboué. In September 1946, at least eleven newspapers in metropolitan France ran press releases announcing the forthcoming Senghor-Éboué union. The announcements highlighted Senghor's position as a Senegalese deputy involved in drafting the new French constitution. They also outlined Ginette's family history as the daughter of the illustrious and recently departed national hero, Félix Éboué, and the current deputy representing Guadeloupe, Eugénie Éboué-Tell. Headlines such as "An Idyllic French Union" and "Union in the Union" accompanied a photograph of Senghor and a smiling Ginette standing in front of the Palais Bourbon.[42] The seat of the French National Assembly as the backdrop for the Senghor-Éboué union framed their marriage as a metaphor for African and Antillean political unity and the successful formation of the French Union. In 1958 the French press again turned their attention to Senghor and Ginette, casting their divorce as a new symbol, this time of the French Union's dissolution that same year. One magazine chose a wedding photograph of Senghor in a tuxedo and Ginette in a white gown to illustrate its coverage of the split between Charles de Gaulle and the Mouvement Républicain Populaire (MRP) party that had initially supported de Gaulle's return to the French presidency in 1958.[43]

The Senghor-Éboué symbol persisted not only in French political rhetoric but also in scholarship about the francophone world.[44] Daniel Delas, for example, describes the divorce as "the failure of the hoped-for dialogue between Antilleans and Africans, a dream that today remains an invisible thread."[45] In her biography of Léopold Senghor, Janet Vaillant writes that Senghor often found himself on the receiving end of racial epithets from Antillean women in general and Éboué-Tell in particular. If Ginette functions in these narratives as a symbol of rupture, her mother is largely understood to be the agent that actively severed the much-hoped-for link between Africa and the Antilles. There is a geographic collapsing of the Antilles and French Guyana in this discourse, one that erases the South American territory by subsuming it under the rhetorical umbrella of the Antilles. Ginette and her mother thus come to symbolize the Antillean woman who is the broken link between African and Antillean political unification. In the Senghor-Éboué story of the perfect political marriage gone wrong, intimate relationships come to stand in for the Negritudian project of fashioning a transatlantic black identity.[46] The gendered implications of Senghor's and Ginette Éboué's marriage as political metaphor are even more troubling when juxtaposed with the story of the harmonious meeting between Africa, the Antilles, and French Guyana embodied by Senghor, Césaire, and Léon Gontran Damas, the three poets often described as the founding fathers of Negritude. In this version of history, African, Antillean, and Guyanese men negotiate their political and poetic differences to unite around the idea of a shared racial identity. Guyanese women, misidentified as Antillean, function uniquely as a divisive element, unable to see beyond the colonial legacy of perceived Antillean superiority and African inferiority that Frantz Fanon so expertly deconstructs in his 1955 essay "Antillais et Africains."[47]

I engage with Senghor's and Ginette's marital drama here because the negotiation between private lives and public politics sheds useful light on the notions of race, gender, and place in public life that shaped narratives about black women as no more than metaphors for political intrigue and determined the terms on which their identity constructions were read. All the women in this study contested the reduction of women to their perceived symbolic roles, and they did so by navigating the porous boundaries between their private lives and public activism in their writings. Their approaches were varied. For Suzanne Césaire, letters sent to friends and family served as private documents in which she could express her radical anticolonial politics despite Vichy censorship of the journal *Tropiques*. Yet these intimate textual spaces were also always under the threat of being violated by the prying eyes of government officials on the lookout for evidence of dissidence. Aoua Kéita,

in contrast, maintained a strict silence on her private life in her autobiography, viewing those details as a distraction from the political narrative she sought to transmit. For Jane Vialle, family affairs, such as paternal recognition of métis children, were very much also matters of public legal debate. Andrée Blouin's personal tragedies as a mother directly motivated her political activism. Eslanda Robeson imagined a more harmonious relationship between the two domains when she argued that women's experiences with domestic work, such as raising children and managing household budgets, made them uniquely qualified to take charge of national and international affairs. In reflecting on the deep imbrication of private and public in ideas about place and belonging, black women made important theoretical interventions on identity and citizenship in the francophone world.

Liberatory Narratives

Reimagining Liberation begins with Suzanne Césaire, whose writings on political and cultural citizenship in relation to both France and the Caribbean are some of the most forceful articulations of antifascism and anti-imperialism in the French Antilles during World War II. Although scholars to date have focused exclusively on Césaire's published essays in order to situate her as a contributor to the Negritude and surrealist movements, I draw on untapped archival sources, including her private letters, unpublished writings, and photographs of her, to explore her thoughts on Antillean political identities in the upheaval of a world war. Chapter 1, "Suzanne Césaire: Liberation beyond the Great Camouflage," situates Césaire's articulations of citizenship in the context of her engagement with Haiti specifically and the Caribbean archipelago more broadly. Her writings from Port-au-Prince during her stay there with her husband as members of a French cultural delegation reveal a shift in her analytical focus from the legacy of French colonialism in Martinique to the possibilities for a Pan-Caribbean belonging expressed through political practices and artistic creation. The five formative months that she spent in Haiti in 1944 reveal the island to be, for Césaire, a site of political imagination and a generative space for forging a Caribbean identity.

The chapter ends with a close reading of Suzanne's interpretation of Aimé's canonical poem *Cahier d'un retour au pays natal* and its vision for black diasporic resistance and creativity. Her correspondence functions as the space from which she speaks of her continuing engagement with the literary and political debates of her time, long after her public writings for *Tropiques*. From Martinique to the Caribbean to the African diaspora, Césaire's evolving work retains her unshakable faith in artistic creation as the foundation for imagin-

ing new political communities and configurations of belonging beyond the oppression of colonial domination.

Analyzing Césaire's strident denunciation of colonialism and her hopes for Caribbean self-expression in wartime also provides useful context for examining Nardal's postwar writings. Chapter 2, "Paulette Nardal: Martinican Women as Political Protagonists in the Overseas Department," situates the conversation that Césaire began on citizenship in Martinique in the context of the island's newly acquired departmental status. Nardal sharpens her compatriot's focus on a new Caribbean identity by exploring more explicitly women's roles in shaping this identity. Her definition of citizenship for Martinicans is anchored in plurality rather than belonging to a single nation-state. Her writings, addressed specifically to Martinican women as the newest citizens of France, placed Antillean women at the center of a careful negotiation of a plural, composite French-Antillean citizenship. She believed that Martinican women were uniquely positioned to challenge the metropole's exclusionary forms of citizenship and urged them to do so through their political engagement and cultural production. Ultimately for Nardal, women would be the catalysts for Martinique's political transformation from a colony to a decolonized space where French citizenship could coexist with, rather than erase, the specificities of the island's Caribbean heritage and where citizens' recourse to legal protections would counter the hegemonic power of the white Creole elite.

As with Césaire, I broaden the scope of existing scholarship on Nardal by reading beyond a select few published stories and essays. Nardal's writings during the interwar years in Paris have increasingly been the subject of studies on Negritude and black internationalism. Those texts, however, form only a small subset of her oeuvre written over nearly four decades from two continents. This chapter's analysis of Nardalian thought beyond Negritude traces the arc of her engagement with Martinique's political identity across some of her lesser-known works, including articles in Parisian newspapers in the interwar years, her contributions to a government-commissioned tourist guidebook, her 1946 report on colonial feminism, and her editorials for the journal *La femme dans la cité* published after the war. The diversity of genres allowed Nardal to engage with different audiences on both sides of the Atlantic as she sought to strike a delicate balance between Antillean cultural belonging and French political identity in the early years of departmentalization in Martinique.

Nardal's journal, *La femme dans la cité*, emphasized the crucial role of Antillean women in postwar rebuilding. As one of the few sites to preserve black women's testimonies of their wartime experiences, her journal also serves as a reminder that the story of African and Antillean women in the

world wars remains to be told. Éboué-Tell's and Vialle's work in the French Resistance provides one possible beginning of this story by shedding light on the effects that World War II had on black French women's articulations of citizenship in the postwar period. At the peak of their careers, Éboué-Tell and Vialle were prominent voices in a transatlantic conversation on race, gender, and citizenship at a time when France was reinventing itself as a nation and attempting to redefine what it meant to be French. Memories of the country's resistance to and collaboration with Nazi occupation were still fresh in collective memory when the Constituent National Assembly ratified the new constitution in 1946. Éboué-Tell, a deputy at the time, was involved in drafting this constitution that reconfigured the French empire as the French Union, a federation that included metropolitan France and its overseas territories in Africa, Indochina, and the Atlantic and Indian Oceans. Éboué-Tell and Vialle were voted into the French Senate to represent Guadeloupe and Oubangui-Chari, respectively, in this historic moment when Africans and Antilleans were now situated somewhere between subjects and citizens. Harnessing the powerful and often seductive rhetoric of French republican ideals, both senators put forward legislation to increase economic and educational opportunities for Antillean and African women. They also actively sought to build feminist networks throughout the African diaspora as an expression of a more expansive notion of belonging beyond the French empire.

Chapter 3, "Eugénie Éboué-Tell and Jane Vialle: Refiguring Power in the French Union," functions as a bridge between the first two chapters on imagining possibilities for liberation located in the gray area of departmentalization for the Antilles, and the next two on African women's demands for independence. I do not assume an inherent interconnectedness between francophone Africa and the Antilles based solely on the fact of their colonization by France. Instead, I examine the ways in which Éboué-Tell's and Vialle's work in the French Senate in the 1940s and 1950s deliberately connected the anticolonial activism of women in the Antilles and French Equatorial Africa (AEF) and extended this activism beyond the borders of imperial France to include the United States. Éboué-Tell and Vialle forged transnational black feminist networks and thus claimed multiple communities and political affiliations across imperial and nation-state borders. This chapter examines their ideas expressed in a variety of forms through speeches, interviews, essays, and campaign posters to show how both women's experiences as part of the French Resistance—Éboué-Tell as a member of the women's volunteer corps in Brazzaville and Vialle as a clandestine agent and then prisoner in a concentration camp in France—informed their anticolonial politics. Éboué-Tell, a Guyanese woman living in Central Africa, and Vialle, a métisse African

traveling between metropolitan France and AEF, outlined a new, expanded geography of Afro-diasporic feminist and transnational resistance.

As daughters of African mothers and French fathers, Vialle and Blouin navigated the fraught racial politics of anticolonial movements. Both women claimed métisse as a racial and gendered identity. They also saw it as a political affiliation, arguing that the social realities imposed upon them by the racializing logics of French colonialism necessitated a particular set of political strategies for liberation. In her autobiography, Blouin describes the lived reality of métisse African women who navigated an ever shifting, politically charged space, particularly in the context of decolonization struggles. She shows that defining community and political alliances for African women who identified or were categorized by the colonial government as métisse required negotiating identities vis-à-vis multiple colonial spaces, which for Blouin included France, Belgium, and their respective Congos. Chapter 4, "Andrée Blouin: Métissage and African Liberation in *My Country, Africa: Autobiography of the Black Pasionaria*," examines Blouin's work advocating for modes of citizenship that account for the shades and nuances that often fall through the cracks of anticolonial discourse on black/white, African/European identities. Blouin's grappling with her place at the intersection of multiple racial, cultural, and political locations shaped her vision for a more capacious Pan-African citizenship in the early years of independence. Through a close reading of the paratextual interventions of Jean MacKellar—an American woman who transcribed her interviews with Blouin in order to produce *My Country, Africa*—and Henri Lopes's novel *Le lys et le flamboyant*, which is loosely based on Blouin's life, I read Blouin's expressions of identity through the textual *métissage* at work in her contested autobiography. This textual hybridity that challenges the boundaries between biography and autobiography, mirrors Blouin's own navigation of her *double appartenance* (double belonging) as a métisse invested in the project of decolonization in Africa.

As author and subject of *Femme d'Afrique: La vie d'Aoua Kéita racontée par elle-même*, Aoua Kéita is the political protagonist par excellence. She is both the subject of a historic narrative—the first autobiography published in French by an African woman—and a central figure in the anticolonial struggle of French Sudan. Kéita was a community organizer in colonial French Sudan, the first female deputy in the National Assembly of newly independent Mali, and laureate of the prestigious Grand prix littéraire d'Afrique noire, whose recipients include Senghor, Mariama Bâ, Veronique Tadjo, and Alain Mabanckou. Unlike all the other women studied thus far who engaged with citizenship from the perspectives of educated urban elites, Kéita gave voice to nonliterate women in areas such as rural Mali that are as overlooked in

scholarship now as they were neglected by imperial France then. Her writings contest this erasure by identifying rural women as a formidable force in the struggle for decolonial citizenship in French Sudan.

Chapter 5, "Aoua Kéita: Rural Women and the Anticolonial Movement in *Femme d'Afrique: La vie d'Aoua Kéita racontée par elle-même*," expands the narrative on black women's feminist networks to include collective resistance and community formation by women in rural areas. Reading Kéita's autobiography alongside Ousmane Sembène's novel *Les bouts de bois de Dieu* and his film *Emitaï* centers rural women's roles in anticolonial struggle in West Africa and their strategies of collective resistance that hinged primarily on transgressive mobility. Through marches, protests, and occupying space—actions that were often accompanied by a range of speech acts, including singing and ululating—women in rural communities worked to reverse colonial dispossession of land and the disenfranchisement of black women. This chapter engages primarily with Kéita's autobiography as a literary and historical source on the politics of women's self-representation and public activism in the years preceding independence. It also draws on Sembène's creative works whose fictionalized representations of the mass political action led by women in French West Africa enlarge the field of possibility for imagining and representing women's contestation of colonial exploitation. Kéita's and Sembène's works present alternative historical accounts that bear witness to the centrality of African women's roles in liberation movements.

Eslanda Cardozo Goode Robeson is the link that brings these interconnected stories even closer together. In her journalistic and anthropological work in the United States, Central Africa, and Europe, Robeson encountered nearly all the women whose works are examined here. She interviewed Nardal in Paris in 1932 and Vialle in Oubangui-Chari in 1946. She also exchanged letters with Éboué-Tell in the 1940s. Indeed, many of these women were directly or indirectly connected. Vialle and Blouin knew each other.[48] Kéita and Blouin were both participants in the historic 1957 congress of the Rassemblement Démocratique Africain (RDA) party, which brought hundreds of West and Central African delegates together to strategize toward independence.

Robeson's presence in the story that this study seeks to tell is not simply occasioned by her connections to women like Nardal and Éboué-Tell. Her extensive travels presented new possibilities for black women to further expand their work toward decolonial citizenship beyond the francophone context. Her reflections during these travels also have much to contribute to current scholarly debates on the definition of the Global South. What interests me most, therefore, about Robeson's work is her engagement with notions of solidarity as she sought to articulate a citizenship of the Global South that

was rooted in resistance to imperialism. Chapter 6, "Eslanda Robeson: Transnational Black Feminism in the Global South," focuses on Robeson's travel journals chronicling her journeys through Southern Africa in 1936 and AEF in 1946. In these texts, she imagines a Global South project that displaces subjection to imperial rule as the imagined connection among the people of Africa, Asia, and the Americas. Instead, she describes the Global South as defined by varied forms of concerted acts of resistance against imperialism and highlights women's roles in leading or carrying out these acts of resistance. Robeson's work is important because it decenters white supremacy and patriarchy even while engaging with these oppressive forces. Her pursuit of a transnational citizenship that would unify the world's marginalized allows this study to examine black women's discursive shaping of the Global South.

The women whose voices are highlighted in this work wrote at a specific moment when the world was reeling from a second world war, anticolonial organizing was at its peak, and the possibilities for imagining a new, more equal decolonized world included the possibility of reconfiguring not only the world of the colonized but also that of the colonizer. With the dissolution of the French Union and the wave of independence that swept across the African continent, the possibilities for self-determination also changed. In the conclusion to this work, I consider writings by a subsequent generation of writers and their visions for women's political organizing and intellectual production. Specifically, *AWA: La revue de la femme noire*, a woman-centered journal that circulated in West Africa in the 1960s and '70s under the editorial leadership of Annette Mbaye d'Erneville, offers a site for examining black women's formation of transnational feminist networks after independence. *Reimagining Liberation* puts black women's writings in a renewed engagement with global black identities as a basis for understanding expressions of belonging and solidarity across national and linguistic borders. These women's lives and experiences bear testimony to the fact that as imperialism spanned continents so too did feminist networks and modes of resistance.

1. Suzanne Césaire

Liberation beyond the Great Camouflage

Once again in Haiti, during the summer mornings of '44,
the presence of the Antilles, more than perceptible, from
places which, like Kenscoff, the view over the mountains is
unbearably beautiful. And now total insight.
—Suzanne Césaire, "The Great Camouflage"

When Suzanne and Aimé Césaire arrived in Port-au-Prince in May 1944, they were greeted with much enthusiasm and fanfare. In the coming months, they would find themselves immersed in the world of the Haitian intelligentsia as they both taught French literature at the Université d'État d'Haïti, each one's course offerings complementing the other's. Perhaps more surprisingly, they were also immersed in Haiti's political milieu. In their official capacities as cultural ambassadors of the French government to Haiti, the Césaires were guests of honor at receptions held at elegantly appointed venues such as the Palais National, where, with some degree of discomfort, they rubbed shoulders with Haitian ministers of state and foreign ambassadors. Their participation in the now historic International Congress of Philosophy, held in Port-au-Prince in 1944 and attended by philosophers and government officials from Haiti, France, the United States, and the United Kingdom, testifies to the intermingling of intellectual exchange and political hobnobbing that characterized the Césaires' government-contracted work on the island.

Although often relegated to a passing reference in the story of Aimé's intellectual engagement with Haiti, Suzanne was also an official member of the delegation that traveled from Fort-de-France to Port-au-Prince. Telegrams and memos between French intellectuals, such as Henri Seyrig, and government representatives, including Georges Louis Ponton, governor of Martinique, and Milon de Peillon, ambassador of the French provisional government to Haiti, testify to the flurry of administrative activity that would provide Suzanne with time away from her job as a teacher in Martinique and allow her to work on

a temporary government contract as part of the French cultural mission to Haiti.[1] The Césaires' mandate, as Seyrig envisioned it, was to strengthen the Haitian intelligentsia's cultural ties to France.[2] Ponton expressed the hope that Suzanne could be assigned to teach courses at women's institutions.[3] Suzanne was therefore understood to be integral to this project of reasserting France's presence in Haiti, a project that Seyrig framed in the ostensibly benign language of cultural connections and that included Haitian women students as a specific target audience. Yet, while the travel expenses of both Césaires were financed by Martinique's colonial budget, Aimé was remunerated for his work but Suzanne was not. She noted in her report to Ponton that despite her working in an official capacity as an envoy of the French provisional government, only Aimé received a stipend, one calculated to cover the expenses of a single man. The couple was obliged to borrow money from friends to sustain themselves.[4]

Suzanne's and Aimé's accounts of their collaboration in Haiti differ in crucial ways. In July 1944, when Aimé wrote to the governor of Martinique to update him on his work in Haiti, he noted that he was giving weekly public talks and teaching modern French literature at the university.[5] He then modified his statement by inserting between the opening lines of his letter the addendum that he was doing so with his wife. In this account, Suzanne, identified not by name but by her relation to Aimé, is scripted after the fact. She is suspended quite literally between the lines, held in parentheses, and inserted into the narrative with the aid of a long, curved arrow drawn in Aimé's hand to indicate her place at his side. In contrast, in her rendering Suzanne informed the governor of the collaborative nature of her work with Aimé, particularly as she was also teaching French courses at the university.[6] Given the circumstances and material conditions of their time in Haiti, what is most striking about Aimé's and Suzanne's respective accounting of their work is the terms on which Suzanne is written into and eventually out of this narrative on intellectual and cultural exchange in the French-speaking Caribbean. In juxtaposing the Césaires' respective reports on their activities in Haiti, the omissions and insertions in the archive illustrate how Suzanne is at once present, an integral part of France's reach into Haiti, and absent, noted as a parenthetical afterthought or erased through a refusal of compensation despite the terms of her government-issued contract and her repeated reminders to Martinique's governor for fair remuneration.

Similarly, in contemporary Caribbean literary and political history, Suzanne is at once present in a growing number of scholarly works that examine her intellectual contributions to Negritude, surrealism, and modernism and absent through the systematic erasure and sidelining of her thought in the decades

preceding the more recent attention to her work.[7] Her report to Ponton, unpublished and thus far not analyzed in any scholarship about Suzanne, does more than establish her as Aimé's collaborator. It also attests to a body of writing that is far more extensive than her seven published essays in *Tropiques* that have been the subject of contemporary scholarly engagements with her work. Suzanne's unpublished writings, primarily correspondence, are a crucial part of her corpus of texts. Her letters were a combination of literary analyses, political commentary, and personal news about her health or her children's grades, signed Suzanne Césaire, Suzy Césaire, or, to her closest friends, simply Suzy. Their rich and revelatory contents are a reminder of the importance of engaging with the totality of a thinker's work, not just the genres that are privileged by academic discourse. What would it mean, then, to take into account Suzanne Césaire's report to Ponton about American standardized testing in Haiti, and how does reading such a text alongside the more recognizable genres of poetry and essays allow us to rethink our intellectual genealogy of writers engaging with imperialism in the Caribbean?

Although Césaire has become increasingly prominent in scholarship on the Caribbean and the African diaspora, she remains an elusive figure, as evidenced by the inconsistencies in the biographical information found in scholarship about her. Notably, renderings of her maiden name as Roussy and Roussi, birth dates that range from 1913 to 1915, birth locations in Trois-Ilets and Rivière Salée, and workplaces that oscillate between the prestigious Lycée Schœlcher and the markedly different vocational Lycée Bellevue, all paint a hazy picture of Césaire's life. The Césaires' marriage certificate allows us to clarify these inconsistencies and serves as the basis for the biographical information presented here.[8] Jeanne Aimée Marie Suzanne Roussi was born in Trois-Ilets, Martinique, on August 11, 1915. According to Michel Leiris, she spent her childhood in Rivière Salée, in a household where the differences between her chores and the more demeaning tasks assigned to the child of a poorer relative living with her family highlighted for the young Suzanne the demarcations in the island's socioeconomic hierarchy.[9]

In the 1930s Suzanne studied philosophy in France, where she met and married Aimé Césaire in the summer of 1937. Like her contemporaries, Suzanne had to navigate the racial tensions that marked everyday life in the metropole as a woman from a colony. White acquaintances who were otherwise perfectly pleasant drew her irritation when they invariably marveled that she spoke French with "the purest accent from Île-de-France!"[10] A vendor she knew inscribed her in his client records as "la mulâtre."[11] This odd combination of the feminine article and the masculine form of the noun at once misgendered her and fixed her to a racialized category. In 1939, with war looming on the

horizon, the Césaires returned to Martinique, where they cofounded the journal *Tropiques* with René Ménil, Lucie Thésée, and Aristide Maugée. After *Tropiques*, Césaire moved to Paris, where she taught French literature at the Collège technique Estienne. She worked with her students to contribute to the school's renowned annual journal, *Les Cahiers d'Estienne*, in 1949.[12]

Throughout her life, Césaire remained a visionary and, in her writing, articulated an awareness of the complexity of Caribbean identity that was far ahead of her time. Sharpley-Whiting describes Césaire's "liberatory poetics" as the poet's ability to represent not just the beauty of the Martinican landscape but also "the island's history, pain, and exploitation."[13] Maryse Condé has shown that Césaire was more interested in the Antilles as a space for the convergence of complex, multicultural influences and less in a return to an idealized African past as proposed by other Negritude writers.[14] This Caribbean focus situates her as an important precursor to other Antillean theorists such as Edouard Glissant and the creolists Jean Bernabé, Patrick Chamoiseau, and Raphaël Confiant.

Until her death in 1966, Césaire suffered from decades of ill health, a situation that often limited her and Aimé's possibilities for travel and employment. Notably, Aimé turned down Seyrig's offer to take a position as a cultural attaché in Algeria and informed him that Suzanne was suffering from a malfunctioning pneumothorax.[15] A pneumothorax is a collapsed lung, a condition that one suffers rather than a part of the body that can malfunction. Aimé's confounding description is therefore in fact revealing of the overwhelming nature of Suzanne's illness, captured here in his muddled articulation of a diagnosis. The Césaires' financial situation was further complicated by the tenuous nature of Suzanne's employment, which did not offer the same benefits and protections as those accorded to civil servants on a permanent contract.[16] These details of Suzanne's life underline the great risk she took in producing work that was as politically charged as it was poetically engaged. Her vocal essays in *Tropiques* and her bold letter to the chief of information services in Martinique, Lieutenant de Vaisseau Bayle, on his censorship of the journal, were dangerous acts whose consequences could quickly become a matter of life and death when taken in light of her ill health.

In writing Suzanne Césaire not as a parenthetical insertion whose story is contained between the lines of her more illustrious husband's narrative but rather as a political protagonist whose work challenges colonial discourses of racial discrimination and political subjugation, I focus here on her politics and poetics of liberation. These terms describe her desire to dismantle the foundations of colonial thinking and her imaginative construction of a new

Caribbean civilization beyond colonial domination. I define her politics of liberation in the context of World War II as her focus on freedom from the oppressive policies of Vichy occupation and her dissident thinking and scathing attacks on fascism and racism, camouflaged as reviews of literary and ethnological studies to escape censorship. Her poetics emphasizes Caribbean art forms free from restrictive stylistic rules and, consequently, able to articulate and represent the realities of the Antilles beyond the stereotypical images of an idyllic tropical paradise. Reflections on cultural belonging, intellectual affiliations, and political attachments run through her writings and illuminate her vision of decolonial citizenship and Antillean belonging that recognizes the Caribbean archipelago as a confluence of epistemologies.

My examination of Césaire's political engagement goes beyond her published essays in the Martinican journal *Tropiques* to include the untapped archive of her private letters.[17] Césaire's rich, personal correspondence with French intellectuals, including Seyrig, André Breton, and Yassu Gauclère, served as a more secure space in which to articulate her desire for a Caribbean cultural renaissance than the highly scrutinized pages of *Tropiques* would allow in the years of Vichy censorship. Césaire's writing before, during, and after her time in Haiti reveals the island's tremendous influence in shifting her focus from the colonial relationship between Martinique and France to the Caribbean archipelago as a generative space within which an Antillean cultural and political renaissance could take place.

Before Haiti: Literary and Political Liberation in Martinique

The Vichy regime brought significant political changes to Martinique. The collaborationist government that ruled France from 1940 to 1943 appointed colonial officials who were sympathetic to the draconian laws of Philippe Pétain's National Revolution. As vieilles colonies, Martinique and Guadeloupe had a long history of political engagement and representation in France, dating back to the 1848 abolition of slavery. Under Admiral Georges Robert, Vichy's high commissioner to the French Antilles, these limited freedoms disappeared. Robert revoked universal male suffrage and replaced black mayors with white Creole businessmen. He also implemented new measures increasing surveillance and curtailing movement. Arbitrary detention and deportation awaited dissenters. For many, the new political climate, with its attendant racial, social, and cultural oppression, bore a startling resemblance to slavery.[18] Any form of dissenting public expression was therefore a subversive political act.

It was into this setting of political repression that *Tropiques* was born, and it was in this context of truncated freedoms that Suzanne Césaire would hone her skills of literary evasion—that is, the publication of subversive essays camouflaged as ethnographic studies. Much has been said about Césaire's fiery open letter to Lieutenant Bayle in response to his censorship and ultimate ban of the journal. Yet open condemnation of political and artistic repression was not Césaire's only strategy of resistance. During her stay in Haiti in 1944, she wrote to Léonie Henriette (Yassu) Gauclère in Algiers.[19] Recalling the unbearable atmosphere of repression in wartime Martinique, she described the period as one that necessitated various forms of flight and escape.[20] "Le grand camouflage" is therefore apt both as the title of her final essay and as a description of her entire body of work. At a time when political evasion meant a steady stream of Martinican dissidents to Dominica and then on to New York to join de Gaulle's Free French Forces, Césaire employed literary evasion—that is, the skillful deployment of images that allowed her to publicly express her politics and poetics of liberation.[21]

For Césaire, liberating Martinique required addressing cultural assimilation, the result of centuries-old racist colonial policies. In her essay "Malaise d'une civilisation" she cites eighteenth-century ordinances that sought to stifle upward class mobility for enslaved and free people of color by regulating dress and access to nonagricultural work. Césaire argues that by barring enslaved people's entry into the middle and upper classes, the colonial status quo ultimately made freedom synonymous with assimilation into these classes: "One will understand that from that point forward the fundamental goal of the colored man became assimilation. And with overwhelming force, a disastrous confusion takes place in his mind: *liberation means assimilation.*"[22] Equating freedom with assimilation results in acute alienation, particularly among middle-class Martinicans, a profound schism in "the collective self of the Martinican people."[23] In art this alienation manifests itself in the dearth of poetry that truly captures a Martinican collective consciousness. For Césaire, whereas folklore is a repository of rich images that convey the beauty and suffering of Martinique, literature produced by the bourgeoisie remains shackled to rigid French rules of style.

To repair this schism, Césaire argues, it is important to fully understand and embrace Martinican cultural identity. She reveals, in her letter to Gauclère from Haiti, that she read German ethnologist Leo Frobenius's *Histoire de la civilisation africaine* as Aimé wrote *Cahier d'un retour au pays natal* and, like her husband, sought to apply Frobenian thought to the sociocultural realities of 1940s Martinique.[24] In "Malaise" therefore, she uses Frobenius to answer the central question: "Qu'est-ce que le Martiniquais fondamentalement, intime-

ment, inaltérablement?" ("What is the Martinican fundamentally, intimately, unilaterally?").[25] Césaire's question is striking because it affirms the possibility of a Martinican identity that is not subsumed under the banner of imperial France, a possibility she describes as "of decisive importance for the future of this country."[26] Such a proto-nationalist project of collective self-definition would become controversial after departmentalization, a few short years after the publication of this essay. Césaire goes on to define the Martinican as "un homme-plante" ("a plant human"),[27] described as one who does not seek to dominate nature but rather allows himself to be possessed, moved along by the force of life.[28] The Martinican as *homme-plante* rejects the urge to conquer and dominate and refuses the violent, destructive impulse that fuels the war machine of the 1940s. Césaire's use of plant imagery to define Martinican identity reflects what Anny Dominique Curtius describes as her "ecopolitical awareness," which both centers nature and interweaves it with political issues such as colonial history and injustice.[29] Césaire drew on Frobenian theory to craft a definition of Martinican identity because she believed that World War II necessitated that the tiny Caribbean island take its place on the global stage: "Il est maintenant urgent d'oser se connaître soi-même, d'oser s'avouer ce qu'on est, d'oser se demander ce qu'on veut être. Ici aussi, des hommes naissent, vivent et meurent. Ici aussi, se joue le drame entier" ("It is now vital to dare to know oneself, to dare to confess to oneself what one is, to dare to ask oneself what one wants to be. Here, also, people are born, live, and die. Here also, the entire drama is played out").[30] Here, Césaire emphasizes Martinican agency in this project of self-definition by buttressing her use of the reflexive pronoun "se" with the self-referential "soi-même." She also locates this autonomy in the "ici" (here) and "maintenant" (now) of Martinique and thereby identifies the island as the source of its own narrative of origins.

Camouflaged by the seemingly benign summary of Frobenius's ethnographic works was a call to autonomous and therefore dissident thinking that flew in the face of the demands for unquestioning obedience issued by Vichy France's head of state Philippe Pétain. Pétain addressed his first radio broadcast specifically to the French colonies on September 19, 1940, and reiterated his demand for submission in a November 19, 1942, broadcast: "I remain your guide. You have only one duty: to obey. You have only one government: that which I have given the power to govern. You have only one fatherland: that which I embody—France."[31] In Martinique, Vichy high commissioner Georges Robert's obsession with surveillance, censorship, and suppressing mobility meant this was a dangerous time for Martinicans to embark on a project of self-definition. Embedded therefore in Césaire's urgent call is both a poetics of liberation—to free Martinique's cultural and artistic expression from the limitations of as-

similation—and a political project of recognizing that Martinique too, despite its small size and seeming global insignificance, was an arena in which the conflict between fascism and freedom was to play out.

Césaire viewed surrealism as the tool that would allow for this collective self-determination through poetic expression. The Césaires' encounter with André Breton in Martinique in 1941 was a source of inspiration for them. In a joint letter to the Bretons, they describe this meeting as of vital importance in their lives and emphasize the liberation that came from reading André's work in the repressive atmosphere of the Vichy regime.[32] Engaging with Breton's work in occupied Martinique allowed the Césaires to imagine what political and aesthetic liberation would look like. In their letter to the Bretons, the Césaires also state that the third issue of *Tropiques*, published that year, was organized around Suzanne's essay "André Breton, poète. . . ." This seemingly small detail is important because it emphasizes the centrality of Suzanne's thought to the *Tropiques* project. Suzanne argues in this essay that Breton's surrealism is concerned not only with art but with all aspects of human existence. She situates Breton as "the originator of the most extraordinary revolution that ever was, since it also involves not just art, but our life in all its entirety."[33] For Suzanne, surrealism was not solely a literary aesthetic; it was also a politically engaged movement that condemned imperialism worldwide.[34] It was the vehicle through which she articulated what Jennifer Wilks aptly describes as Césaire's "poetic militancy," an engagement with surrealist poetics "as a tool for Caribbean cultural revitalization."[35] Wilks's emphasis on regeneration is particularly compelling given Césaire's emphasis on surrealism's impact on the totality of Antillean life. It is through surrealism that Césaire expresses the possibility of life, of rebuilding a Caribbean civilization after the erasure enacted by colonial policies of assimilation and the violence and death prevalent in wartime.

Beyond the pages of *Tropiques*, Césaire continued to engage with surrealism as an avid reader of *VVV*, the surrealist journal edited by Breton and other French writers in exile in New York. Aimé Césaire and Wifredo Lam contributed poems and illustrations, respectively, to each issue. *VVV* stated as one of its goals, victory "over all that is opposed to the emancipation of the spirit, of which the first indispensable condition is the liberation of man."[36] In a 1943 essay for *VVV*, Breton argues, "From one war to the other, one may say that it is the impassioned quest for liberty that has constantly motivated surrealist action."[37] He goes on to describe surrealism's rejection of both Pétain's repressive laws and the stylistic and linguistic rules governing French literary production.

Although Césaire did not write for *VVV*, she read the essays and poetry by Breton, René Etiemble, Pierre Mabille, and Roger Caillois as creative resistance. She viewed their work using poetic expression to revive social and political freedoms through art in a period of historical crisis as clairvoyant. For Césaire, a poet is a prophet of sorts, one who is able to see patterns in world political events and articulate those patterns through poetry. We now know that Césaire taught nineteenth-century French literature, including the work of Arthur Rimbaud. In her epistolary exchange with Gauclère, she emphasizes the poet's clairvoyance in terms that recall Rimbaud's *Lettres du voyant*. As Rimbaud writes, "Il faut être voyant, se faire voyant. Le Poète se fait voyant par un long, immense et raisonné dérèglement de tous les sens" ("One must be a seer, must make oneself a seer. The Poet makes him/herself a seer by the long, immense, rational derangement of the senses").[38] Like the surrealists, Césaire embraces Rimbaud's *dérèglement*, the rejection of restrictive rules of logic, as the only way to apprehend reality. Like the surrealists, she recasts the *voyant* as an explicitly political figure, one who through this dérèglement is able to access knowledge not available to others in order to perceive the political reality of the world around him/her.

Returning to her Rimbaldian roots, Césaire proposes designating the community of French writers in exile as seers whose poetic clairvoyance provides the needed clarity to see and imagine new political futures.[39] She finds in their articulation of surrealism the possibility for political and artistic liberation in the Antilles. Yet Césaire is also attentive to the power dynamic at work when a subset is charged with representing, in art and in politics, the whole. She confides in Gauclère that she proposes the term "communion of seers" to sidestep appellations such as "the best" or "the greats."[40] Césaire rejects the top-down model of political and artistic representation and advocates instead a collective, communal deployment of surrealism to counter wartime oppression.

Césaire's engagement with Frobenian theory and surrealism as part of her liberatory vision for Antillean literature and politics has drawn criticism from various quarters.[41] Marie-Agnès Sourieau reads Césaire's exploration of Ethiopian and Hamitic civilizations as a reductive binary that reinforces the colonial stereotypes of "the passiveness of the colonized inevitably conquered by the Western/Hamitic civilization."[42] Yet Césaire's essay on Frobenius is not simply an uncritical replication of the German ethnologist's work. Instead, she harnesses Frobenius's ideas to debunk the myth of humanity's linear progression from barbarity to civilization, a myth that reverberated in the supposed justifications for colonialism that placed Europeans at the civilization end of

the spectrum and their colonial subjects as evidence of pre-civilization barbarity. Applying Frobenian thought to her contemporary reality of World War II, Césaire dismantles this myth by pointing to the barbarity of European violence and destruction in wartime.[43] Her writing therefore disrupts not only the assumptions of European superiority and African inferiority but also the notion of the "perfectibility of humankind" that, as Alice Conklin has argued, undergirded the French civilizing mission.[44]

Sourieau's critique that Césaire maintains the dyadic relationship between the Martinican as Ethiopian/homme-plante and the European as Hamitic/homme-animal is certainly valid. The totality of Césaire's work, however, speaks to her own movement beyond binaries and toward a more expansive reading of Caribbean civilization. Her invocation of the "women of four races and dozens of bloodlines,"[45] her analysis of the historical significance of African civilizations such as the Gao empire,[46] her engagement with European theorists, and her examination of métissage in the Antilles as a legacy of slavery's violence,[47] when taken together, weave a complex image of Caribbean civilization as a composite whole situated at the meeting point of different histories, racial identities, and intellectual traditions.

Nowhere is the disruptive nature and generative power of the tapestry of Caribbean civilization more evident than in Césaire's writings from Haiti. Widening her scope from the colonial relationship between Martinique and France to a panoramic view of European and American imperialism in the Antilles, Césaire situates her Caribbean renaissance within the geographic phenomenon and conceptual framework of the archipelago. Her archipelagic politics, a term to which I will return, does not travel the well-worn path of Haiti as a symbolic stand-in for Africa in the Caribbean. Instead, it imagines Haiti, Martinique, Puerto Rico, and the rest of the Caribbean as interconnected spaces that are also the site of a new Caribbean civilization. Examining the ways that her time in Haiti activates this archipelagic vision is valuable because it shifts the very terms on which we may read Martinique and Haiti together in the context of decolonial citizenship. Although the two islands are often considered separately because of the marked differences in their histories, Césaire's work shows that the difference in relation to France that characterizes these histories does not preclude other political and cultural affiliations that, rather than remaining tethered to the metropole/colony relationship, reach across the Caribbean to imagine new forms of belonging.

In Haiti: Caribbean Cultural Citizenship at the Crossroads

On May 16, 1944, Suzanne and Aimé Césaire boarded a Pan American Airways flight that took them from Fort-de-France to Port-au-Prince.[48] This journey most likely inspired Suzanne to later write the following words in her final published essay, "Le grand camouflage," as a meditation on both the stagnation and death that characterized her contemporary wartime moment and the possibilities for seeing new life hidden beneath the seemingly impenetrable realities of terror and repression: "Once again the sea of clouds is no longer virginal since the Pan American Airways System planes have been flying through. If there is a harvest maturing, now is the time to try to glimpse it, but in the prohibited military zones, the windows are closed. . . . Our islands seen from above, take on their true dimension as seashells."[49] Césaire evokes her travel aboard the Pan American Airways clipper as she widens her intellectual vision from Martinique to this panoramic view of the Caribbean archipelago seen from the sky. She attempts to pierce through the opaque blanket of military occupation that smothers the islands to catch a glimpse of the vitality that her writings have always underscored.

The expanded vision from vitalism in Martinique to the Caribbean archipelago that the rest of "Le grand camouflage" expresses occurred during her time in Haiti, where her work brought her into direct contact with both the legacy of French colonialism and the ongoing reality of American imperialism in the Caribbean. Sharpening her discourse on liberation in this context therefore necessitated a broader view of the Caribbean as a fragmented whole, as islands connected not only by a shared history and contemporary reality of imperialism but also by the possibility of articulating a viable Caribbean civilization that would counter imperialism's erasure and domination. Juxtaposing Césaire's official report on her work as an envoy of the French government to Haiti with her private letters and her *Tropiques* essays reveals her understanding of this Caribbean civilization as a complex nexus of geographies and intellectual traditions. This interweaving, however, was not without its tensions. In other words, the seams remain visible.

In navigating the tensions between their political vision for the Antilles and the cultural mission for which they had been recruited by the colonial French government, the Césaires claimed an intellectual tradition rooted in histories of revolt and revolution on both sides of the Atlantic. Aimé's public talks, held in Port-au-Prince and Cap Haïtien at increasingly larger venues due to his popularity, were literary analyses of the works of Rimbaud, Charles Baudelaire, and Stéphane Mallarmé, analyses that emphasized the subversive

poetics of these writers. As one Haitian newspaper reported, "Aimé Césaire does not dispute that Mallarmé is a poet and a great poet. He is, above all, revolutionary, at least in the realm of poetry and syntax, because, at a time when positive philosophy reigned, Mallarmé was able to turn his back on Reason and fall frantically into the Unreal, the Dream. All of Mallarmé's poetry is a creation."[50] Aimé lauded Mallarmé's "refusal, his hatred of common sense, of the real that imprisons man to the point of annihilating him."[51] His courses and talks on French literature therefore emphasized a refusal of dominant stylistic rules and schools of thought and explored the subversive power of creating new poetic forms.

Like Suzanne, Aimé espoused an intertwined politics and poetics of liberation. His captivating ninety-minute talks sparked intense debates about Haiti's political climate among the audiences crammed into lecture halls and spilling out into the streets. The newspaper *Le Soir* hinted at the political implications of the reception of his talks: "Minds are agitated. There is a question mark. Consciousnesses have been awakened."[52] Reflecting decades later on the "Césaire effect" in Haiti, René Depestre credits Aimé's lectures with laying important groundwork for the subsequent talks that Breton delivered in 1945 on Baudelaire, Mallarmé, Rimbaud, Guillaume Apollinaire, and surrealist writers and painters, talks that sparked the student-led movement that would successfully overthrow Haitian president Elie Lescot barely a year after the Césaires' departure.[53]

Suzanne was an active collaborator in this project of reclaiming a literary tradition of subversion, refusal, and creation in Haiti. Teaching courses on French literary methods such as the *explication de texte* to an audience of teachers, journalists, and senators, her work dovetailed with Aimé's in her focus on writers such as Blaise Pascal, Jean Racine, Baudelaire, and Rimbaud.[54] Although little trace remains of the content of Suzanne's courses, it is possible to draw a line of continuity from her scathing letter in response to Bayle's interdiction of *Tropiques* in 1943 to her choice of authors for her courses in Port-au-Prince a year later. In her eloquent refusal of the Vichy regime's silencing of *Tropiques*, Césaire situates the journal in a long tradition of protest and revolution in the Atlantic world and cites a transatlantic constellation of thinkers including Racine, Rimbaud, Toussaint Louverture, Claude McKay, and Langston Hughes as the forebearers of this tradition.[55] Her prescient essay "1943: Le surréalisme et nous" ("1943: Surrealism and Us") articulates the potential for revolutionary change that comes from drawing on a range of subversive sources. In this essay, Césaire warns of a forthcoming revolution led by "le plus déshérité de tous les peuples" ("the most deprived of all people") in terms that foreshadow Fanon's evocation of the wretched of

the earth.[56] She expresses her hope that in this revolutionary era, "it will be time finally to transcend the sordid contemporary antinomies: Whites-Blacks, Europeans-Africans, civilized-savage."[57] Her anti-imperial stance in Haiti, as in Martinique, imagined new futures beyond colonial binaries by harnessing the "transformative political possibilities" of several intellectual traditions.[58]

Not all the tensions raised by Césaire's dual position as an advocate for anti-imperialism and a representative of the colonial French government in Haiti could be thus reconciled. Notably, her report to Ponton emphasizing the importance of a French-based pedagogical model in Haiti rather than Creole language instruction sits uneasily alongside her valorization of Haitian Creole as a vehicle for theorizing a Caribbean ontology. Likewise, her critique of the minister of education, Maurice Dartigue, and his U.S.-backed educational reforms in Haiti was penned on the heels of state dinners and receptions organized for the Césaires, Dartigue, and other political elites.[59] The tensions between Césaire's role in a state-sponsored project to reclaim French cultural dominance in the face of encroaching American influence and her own reflections on Haiti's place in imagining a Caribbean civilization point to a more complex narrative of mobility and cultural citizenship in the Antilles, one that troubles the reading of the Césaires in Haiti as solely representatives of a Negritudian philosophy of Afro-diasporic identity and black solidarity.

In analyzing her vision for Haitian self-determination, I draw at length from Suzanne's little-known, unpublished report on Haiti.[60] This crucial but untapped archival source provides contextual information on the nature of her work in Port-au-Prince and its political implications in the immediate postwar period. It also allows us to account for the heretofore elusive shift in her writing style and geographic focus between her early essays for *Tropiques* and her final publication in 1945. Her earlier call for Martinican self-definition in *Tropiques* echoes throughout her articulations of a similar vision for Haiti and will reverberate again in her expressions of a Caribbean ontology a year later in "Le grand camouflage." In her writings from Port-au-Prince, Césaire reflects on the place of language and education in achieving Haitian autonomy from American imperialism.

In her report to Ponton, Césaire reflected on the political imperative behind her seventeenth-to-twentieth-century French literature courses at the Université d'État d'Haïti. She emphasized the importance of these courses in reinforcing the Haitian elite's relationship to French culture. Repurposing the language of the colonial administrators who had sponsored her trip, Césaire ascribed this urgency to the dwindling prestige of the French educational system in the face of the pro-American educational policies pushed by the Haitian minister of education. If, in her letter to Gauclère, Césaire outlined

her pedagogical emphasis on French methods of textual analysis such as the explication de texte in the courses she taught in Haiti, it is because, as she wrote to Ponton, the American system of standardized testing was rapidly becoming the state's preferred form of assessing student knowledge. In a prescient analysis that echoed the concerns of other observers, such as Eugénie Éboué-Tell and Claudia Jones, about the United States' designs on the Caribbean and that preceded Aimé's and Fanon's warnings about U.S.–American imperialism, Césaire explained to Ponton the "Americanization" of Haiti as she saw it unfold in the education system. She pointed out the politically strategic nature of ostensibly well-meaning gestures such as state-sponsored scholarships and teacher training programs that the United States bestowed on young Haitians who went on to occupy administrative positions upon their return to Haiti, replicating at home the models of education they had encountered in the States.

On first read, Césaire's report strikes a very different tone when compared to her earlier works. The generic conventions of an official report are evident in the pragmatic language about education policy, standardized testing, and the political machinations of seemingly benign cultural organizations. This document takes on the real, concrete manifestations of the more abstract ontological questions raised in her early *Tropiques* essays. Ultimately it engages with the same questions about power and Caribbean identity that had been at the heart of her essays thus far. Césaire deftly weaves together language, culture, intellectual production, and economic and political futures in her examination of what it means to teach nineteenth-century French literature in Haiti. Writing more than two decades after the ostensible end of the U.S. occupation of Haiti, Césaire shows the tenacious hold of American imperialism on the island. She reveals language instruction to be a crucial tool in maintaining a vice-like grip on Haitian culture, politics, and the economy and proposes education reform as a means to resist this hold. It is significant that in her report to Ponton, her description of English as a mandatory language in the school curriculum ends with the observation that American-sponsored and -educated Haitian elites return to take up positions of power in the education sector. Césaire suggests here that the United States' scholarship program was a deliberate effort to institutionalize the English language and U.S.–American pedagogical methods, a strategy aimed at consolidating the United States' cultural and political presence on the island. It is striking, however, that in response to this increasing Anglicization, Césaire advocated for French-language instruction over the use of Haitian Creole in schools. She advised Ponton that the Haitian government's efforts at creating courses taught in Creole ran the risk of "nationalizing" the language, which she de-

scribed as a patois. This nationalization, she argued, ran counter to the goal of advancing French interests. Césaire's rejection of a mass Creole adult literacy program reveals the tensions between her previously articulated political views and her role as a cultural emissary of the French government. Although she describes Creole literacy as detrimental to French interests, her emphasis on nationalization also suggests a concern about the potential for government co-opting of Creole for destructive ends.

Césaire does not elaborate on the potential drawbacks of nationalism in her report. However, her compatriot Frantz Fanon would later pen a scathing indictment of nationalism gone awry in newly independent African countries. In *The Wretched of the Earth*, Fanon critiques the role of the bourgeoisie in furthering neocolonialism through their pursuit of nationalism via racial and linguistic substitution. He argues that a simple takeover of colonial economic and political institutions by bourgeois nationalists, rather than dismantling those institutions and placing the talents of the bourgeoisie in the service of the masses, results in a weakened and ultimately destructive form of nationalism. The result is "a crude, empty, fragile shell," a far cry from what a national consciousness should be: "the coordinated crystallization of the people's innermost aspirations . . . , the most tangible, immediate product of popular mobilization."[61] Fanon's analysis of nationalism in the immediate aftermath of African independence in the mid-twentieth century is at a geographic and temporal remove from Haiti and its acquisition of sovereignty in 1804. Yet, as Laurent Dubois shows in his comprehensive study *Haiti: The Aftershocks of History*, the legacy of colonialism has persisted in the economic and political structures on the island from independence to our contemporary moment, due in part to the political class's perpetuation of colonial labor systems and racial hierarchies, often upheld by nationalist rhetoric. During Césaire's time in Haiti, there was little to suggest that the specific government-supported program of Creole language instruction she observed was that Fanonian expression of the people's collective will and aspirations. Indeed, as she affirms later in her report, the program relied on the Laubach model of literacy education, a pedagogical method initiated by Dr. Frank C. Laubach, rooted in an American missionary tradition, and often deployed as a stepping-stone to the instruction of English as a second language. Her text suggests, therefore, that the role of Creole literacy programs, as envisioned by the American-backed Haitian government, was to camouflage the institutionalization of the United States' imperial reach in Haiti.

If Césaire was keenly aware of the entanglement of culture and politics, she remains silent about her own role in this entangled process. The same objective of surreptitiously advancing political interests through cultural interven-

tion was also the underlying motive for the French colonial administration's selection of the Césaires as cultural emissaries to Haiti. As Seyrig argued in his letter to Ponton, the most effective French response to the economic and political ties between Haiti and the United States would be to strengthen the island's cultural connection to France as a gateway to political and economic ties since direct intervention would immediately raise the specter of colonialism.[62] Seyrig went on to argue that Aimé's popularity in Haiti made him the perfect candidate for promoting French interests, all the while avoiding Haitian suspicion of French colonial incursion. For Seyrig, as for the United States, language and culture were the arenas in which the battle for political and economic dominance in Haiti would be fought. It is troubling, therefore, that Suzanne's work in Haiti is inscribed within this narrative of colonial contest. It is even more troubling that her response to what she describes as the "Americanization" of Haiti was to advocate for the propagation of a French linguistic and intellectual tradition, particularly given the history of French colonization of the island.

Certainly there are unsettling aspects of Césaire's writings about Haiti. Notably, her description of Creole as a patois that was merely a step along the path to French suggests a subordination of Creole to French.[63] To argue, however, that Césaire discounts the role and place of Creole in articulating Caribbean identity would be to limit her intellectual engagement with Haiti to a formal report written to the governor of Martinique. Here too her private letters serve as that privileged space within which she voiced observations and analyses that allow us to further nuance her public texts. Writing to Gauclère from Port-au-Prince, Césaire hearkens back to her use of Frobenian theory to define the Martinican as homme-plante but expands her focus now to encompass a broader definition of Caribbean identity. Language and landscape in Haiti provide her with the tools for this expanded analysis. In this letter she expresses her dismay at her "stillborn" community and in the same breath recounts with much enthusiasm her discovery of the Haitian Creole expression *laissé grainin*, which she translated as "let it seed, let it bear fruit."[64] Césaire's description of Antillean society as stillborn reminds us of her critiques in *Tropiques* of assimilation as a manifestation of slavery's legacy and a stifling of creativity and expression in Martinique. Yet we also hear a tinge of hope as she finds in this Creole expression a plant metaphor that will allow her, in "Le grand camouflage," to articulate a more nuanced identity rooted in the Caribbean archipelago as a viable space within which this identity can originate and thrive. Césaire's use of Creole is significant because it comes at a time when Martinican writers relied heavily on the French language as the vehicle for imagining a global black identity. In *laissé grainin*, Césaire reads

Frobenius through the lens of a popular Creole expression in Haiti in order to articulate a more nuanced Caribbean ontology.

Haiti had a direct impact on the marked changes in Césaire's writing after World War II. She in turn left a distinct mark on the island through work that provided Haitian students and intellectuals with some of the tools they ultimately employed to overthrow the U.S.-backed government.[65] On her return to Martinique, Césaire would continue to hone her incisive critiques of global imperialism and her vision for Caribbean self-determination located at the intersection of political resistance and poetic creation.

After Haiti: Seeing the Caribbean Archipelago

There is a clear distinction in both scope and style between Césaire's first six essays published between 1941 and 1943 and her essay "Le grand camouflage," which appeared in the final issue of *Tropiques* in 1945. Whereas her earlier work is characterized by a laser-sharp focus on the legacy of French colonialism in Martinique, her last published essay takes a broader view of the Caribbean. As Wilks notes, "After the pointed critique of exoticist literature in her earlier essays, the lyricism of 'Le grand camouflage' is stunning."[66] This essay is more Caribbean in outlook, as Césaire grapples with the possibility of authentic art forms to express—indeed, to call into being—a decolonized society free from the stranglehold of racism and fascism. She is at her most poetic and arguably at her most political in "Le grand camouflage." She focuses on the geography of the Caribbean in terms that contain the germ of what Michelle Stephens would later articulate as an archipelagic approach to Caribbean studies. For Stephens, this approach "would begin to understand the ways the unit of the 'island,' as a political and discursive construct, is actually not a part of an archipelago but rather its very antithesis. It is the archipelago, as opposed to the island, that offers a vision of bridged spaces rather than closed territorial boundaries."[67] In "Le grand camouflage" Césaire reads the Caribbean as interconnected space rather than a series of discrete islands. Blurring both spatial and temporal boundaries, her authorial voice situates itself throughout the Caribbean.

"Le grand camouflage" is best characterized in Césaire's own words as "le grand jeu de cache-cache" ("the great game of hide-and-seek"), a text that almost playfully weaves between veiling and revealing the geography, history, and social reality of race relations in the Antilles.[68] Césaire deftly juggles the images of lucidity and what Keith Walker, in his introduction to the English translation of her collected works, describes as "the work it takes not to see."[69] It is in this essay that Césaire finally fully takes on the role of the seer, that

quality of the poet as voyant that she had previously admired only in others. The shift from her identification of French poets as seers to her own inhabiting of that role in her engagement with the Caribbean archipelago requires a further nuancing of the definition of a seer. As Carole Boyce Davies writes, "In Caribbean context, *seeing* refers to having high-level vision, the ability to see and read, that is, interpret beyond the given, into the past, in the present, and into the future."[70] Seeing is a political act because it refigures the terms of one's engagement with the Caribbean. It refuses the superficial, imperialist encounter with a Caribbean filtered through the lens of the tourist guidebook, Césaire's hated "guide bleu," and engages the seer in a critical engagement with the nuanced, intertwined, and ongoing processes of destruction and regeneration at work in forging a Caribbean civilization.

In the progression of her narrative, Césaire reveals herself as seer in three movements, focusing on sight as the principal sense for apprehending or misapprehending the Caribbean. First, she sees the blinding beauty of the Caribbean: "Il y a sous mes yeux la jolie place de Pétionville, plantée de pins et d'hibiscus. Il y a mon île, la Martinique et son frais collier de nuages soufflés par la Pelée" ("There is before my eyes, the pretty square in Pétionville, planted with pines and hibiscus. There is my island, Martinique, and its fresh necklace of clouds buffeted by Mount Pélé").[71] In this first movement, to behold only the Caribbean's beauty is to be but a passive onlooker. Notice here that Césaire does not employ verbs relating to sight such as *voir* (to see) or *regarder* (to look) as she will later in the essay. The onlooker is not the active subject. Rather it is the space of the Caribbean archipelago that controls what is to be seen. In the second movement, she sees the exploitation and degradation wrought by colonialism in the Caribbean: "Mon regard par-delà ces formes et ces couleurs parfaites, surprend, sur le très beau visage antillais, ses tourments intérieurs" ("My gaze, over and beyond these shapes and these perfect colors, catches, upon the very beautiful Antillean face, its inner torments").[72] In this moment she becomes the seer whose desire to apprehend the Caribbean in its totality propels her to uncover what lies beyond the great camouflage. Seeing is an active process of engagement with the space. Césaire is the subject who does the work of seeing the pain of colonial exploitation and erasure camouflaged by the images of the Caribbean as an idyllic tropical paradise. Finally, she goes on to reveal camouflage as resistance in her poignant closing lines: "Si mes Antilles sont si belles, c'est qu'alors le grand jeu de cache-cache a réussi, c'est qu'il fait certes trop beau, ce jour-là, pour y voir" ("If my Antilles are so beautiful, it is because the great game of hide-and-seek has succeeded; it is then because, on that day, the weather is most certainly too blindingly

bright and beautiful to see clearly therein").[73] The seer and the space remain entangled in the dynamic interplay between camouflage and discovery.

Césaire recognized also the difficulty of the seer's role. Writing from Haiti, she expressed an urgent desire to possess a lucid, clear-eyed view of the world around her. Turning away from myth as a means of apprehending her world, she also forcefully denounced any trace of bovarism that might cloud her vision.[74] In her specific phrasing, she stated in rapid succession that she was lucid and wanted to be lucid. In that pause between being and wanting to be lies Césaire's reflection on the temporality of lucidity, of poetic engagement as continuous, ongoing. Her expression of lucidity as a repudiation of bovarism is striking for two reasons. First, as a scholar of seventeenth-to-nineteenth-century French literature, it places her in conversation with Gustave Flaubert's examination of his protagonist's alienation and illusory vision of herself in the eponymous novel *Madame Bovary*. Here, Césaire refuses the potential characterization of the seer as possessing a vision of self that is removed from and out of touch with the realities of the Caribbean space. The seer, for Césaire, retains that poetic lucidity that allowed surrealist poets to imagine worlds beyond the grim realities of World War II and that made surrealism, in the wartime period, "the tightrope of [Antillean] hope."[75]

The fact that Césaire wrote her rejection of bovarism from Haiti also places her in conversation with the Haitian ethnographer Jean Price-Mars, who identified a "collective bovarism" in Haiti, defined as the tendency of "a society to see itself as other than what it is."[76] In his 1928 collection of essays, *Ainsi parla l'oncle*, Price-Mars dates this collective alienation to the founding moment of Haitian independence in 1804 and argues that the republic formed after the Haitian Revolution remained tethered to a French colonial models of sociopolitical organization and definition of self. Price-Mars summarizes the resulting alienation as learning to be "des Français colorés" ("colored French") and unlearning what it means "à être des Haïtiens tout court" ("to simply be Haitians").[77] Price-Mars and Césaire, both writing from Pétionville nearly two decades apart, outline a project for decolonial citizenship that would be expressed through artistic creation. Both thinkers identify folklore as that authentic expression of an Antillean being that would counter the alienation wrought by colonial erasure, cultural substitution, and political domination.

The poet's role in this process, Césaire maintained, was to call into being an imagined Caribbean civilization through art, culture, and politics. While in Haiti, she shared her hope that the vital life force of a cosmic fire would recreate viable art forms that permeate all aspects of Antillean culture.[78] This

life force, Césaire believed, would unify Antillean modes of being and expression across art, clothing, and other forms of self-representation. Drawing on both René Ménil's articulation of a new Antillean myth and Victor Schœlcher's political writings, Césaire argued that it was the very political destiny of the Antilles that was at stake in her vision for poetic creation. Here too she draws on a range of intellectual traditions, including the work of French abolitionist Schœlcher, whose vision for the Antilles included, "along with freedom and dignity, the title of citizen."[79] Césaire's vision for Antillean cultural expression counters the violence and death that proliferates Antillean history—from colonial conquest and slavery to a destructive world war—with vitality and creation. Her Caribbean renaissance therefore comprises citizenship as both artistic and political transformation, and Haiti is at the heart of this vitalist vision.

Césaire's clearest expression of this renaissance comes in the opening paragraph of "Le grand camouflage":

> Il y a les plus hauts plateaux d'Haïti, où un cheval meurt, foudroyé par l'orage séculairement meurtrier de Hinche. Près de lui son maître contemple le pays qu'il croyait solide et large. Il ne sait pas encore qu'il participe à l'absence d'équilibre des îles. Mais cet accès de démence terrestre lui éclaire le cœur: il se met à penser aux autres Caraïbes, à leurs volcans, à leurs tremblements de terre, à leurs ouragans.

> There are the highest plateaus of Haiti, where a horse dies, lightning-struck by the age-old killer storm at Hinche. Next to it, his master contemplates the land he believed sound and expansive. He does not yet know that he is participating in the island's absence of equilibrium. But this sudden access to terrestrial madness illuminates his heart: he begins to think about the other Caribbean islands, their volcanoes, their earthquakes, their hurricanes.[80]

Césaire's turn to Greek mythology here is striking. The highest plateaus of Hinche in central Haiti are reminiscent of Mount Parnassus, home of the muses, and here in the Caribbean a vantage point from which the Haitian man as seer, and therefore as poet, contemplates the land. For Césaire, the politics of imagining a Pan-Caribbean identity in the immediate postwar moment remain intricately bound up in the poetics of this identity. The Haitian man accesses poetic inspiration atop the mountain in order to see not just his island but also the Caribbean as a whole. Carole Boyce Davies notes that "the claiming of Caribbean Space captures ontologically ways of being in the world. It assumes movement as it makes and remakes the critical elements of Caribbean geography: landscape and seascape, sky and sun, but also music, food, and style."[81] The panoramic vision of the Haitian man is

one that reclaims the Caribbean and imagines new ways of being. Further, Césaire's engagement with the mountains is significant on an island whose name means "land of mountains," because it identifies Haiti as a space in which the poet is uniquely positioned to envision and articulate a broader, archipelagic reality. Césaire's writing moves away from the colonial boundaries that separate the Anglophone, francophone, and hispanophone Caribbean, as well as the historical separation of Haiti as an independent republic set apart from the then-colonies of Martinique and Guadeloupe, to imagine an archipelago of interconnected spaces, histories, and experiences.

Césaire's private letters again provide the key to identifying Haiti's role in her understanding of what this new Caribbean civilization could look like. In a curious move in her letter to Gauclère, she declares on one page her desire to see a myth of a newly defined Antillean come to fruition and on another page that she does not dream of creating a new myth.[82] Rather than read these moments as contradictory, we may understand Césaire as engaged in a dual process of myth-making and demythologizing. She draws on Greek mythology to articulate a new myth of origins for the Caribbean. Yet this narrative does not center on mythical gods and demigods but rather on the everyday man. Pegasus, Césaire's horse on the mountaintop, is dead, and it is the peasant, whom Césaire describes as leaning against a *mapou* tree with his toes rooted in the earth, as well as the "women of four races and dozens of bloodlines," who embody the rhizomatic nature of a composite Caribbean identity.

As is the case in her earlier writings, Césaire articulates here also notions of identity that are decades ahead of her time. Ménil, cofounder of *Tropiques* and author of the concept that Césaire describes in her letter as "the myth of the new Antillean," will argue in a 1980 essay titled "Mythologies Antillaises" (Antillean Mythologies) that Caribbean literature is invested in creating narratives of singular heroic figures such as Toussaint Louverture and Louis Delgrès as a response to colonial attempts at erasing Antillean history. Ménil calls for new narratives on Caribbean identity that are not simply reversals of colonial representations but that instead create new stories of Caribbean subjectivities by accounting for the past, all the while engaging productively with present social and economic realities. For Ménil, this future of Antillean self-expression lies in what he calls "un ailleurs non-mythologique" (a non-mythological elsewhere), a textual space unique for its total rupture with the French colonial myth that Martinique and Guadeloupe are but Caribbean extensions of the metropole.[83] Ménil's non-mythological elsewhere is neither a divestment from mythology as a site of political imagination nor an attempt to produce counter-myths of singular heroes that reverse colonial representations of the Antilles. It is a space in which the seemingly opposed

acts of myth-making and demythologizing allow artists, writers, and activists to imagine and articulate new Antillean identities.

Forty years before the publication of Ménil's essay, Césaire already models this myth of the new Antillean. She illustrates how to move away from reactionary counter-myths by emphasizing micro-narratives of multiplicity through the image of "women of four races and dozens of bloodlines," the Haitian peasant on the mountaintop contemplating the plurality of the Caribbean archipelago, as well as the Martinican peasant with his toes rooted in the mud, spreading out in multiple directions. The Caribbean is the locus of this myth that is not a myth. The multiple continent-straddling roots of Césaire's Martinican peasant are particularly noteworthy because he is a symbol of hybridity rather than the singular essentialist representation that emerges in the work of her contemporaries, such as in Jacques Roumain's *Les gouverneurs de la rosée*. It is further significant that the mapou, or silk-cotton, tree against which the Martinican peasant leans occupies a central place in religions in the circum-Caribbean region, including vodou and myal.[84] Césaire moves away from her earlier assertion of Caribbean civilization as stillborn to envision the archipelago as fertile grounds for generating a viable civilization characterized by systems of belief and nuanced racial and cultural identities.

In his long poem *Cahier d'un retour au pays natal*, Aimé Césaire famously described Haiti as the birthplace of Negritude, as the origins of a global black identity rooted in a shared African past. For Suzanne Césaire, Haiti is the birthplace of a Caribbean civilization that bears seed in the present. The Caribbean itself is the site of its own myth of origin. It is neither a space that is swallowed up by the foundational myths of France as expressed in policies of assimilation, nor is it solely grappling with its beginnings in the terms of displacement, deracination, and fracture that will come to characterize Caribbean intellectual traditions from Antillanité to Créolité and beyond. "Le grand camouflage" articulates this vision of the Antilles as a generative space through *laissé grainin* as a viable framework for conceptualizing the revitalization of a Caribbean civilization.

Césaire Reads Césaire: Global Black Identities in *Cahier d'un retour au pays natal*

On a blustery winter day toward the end of February 1962, Suzanne placed a phone call from her home at 1–3 avenue de la Porte Briançon in the 15th arrondissement of Paris to Aimé in Fort-de-France. Among other things, she had hoped to talk about *Cahier d'un retour au pays natal*. Aimé's German translator, Janheinz Jahn, urgently needed clarification on certain stanzas

of the poem on the eve of publication of its German translation, *Zuruck ins Land der Geburt*. However, fearing that an exchange of letters between Berlin and Fort-de-France would delay publication, Jahn contacted Suzanne in Paris for her reading of *Cahier*. She provided him with an initial analysis but preferred to defer to Aimé for further clarification. Unfortunately, the telephone connection between Paris and Fort-de-France was so poor that day that the Césaires were unable to carry on much of a conversation. In relaying this difficulty back to Jahn, she collapsed two phenomena: difficulty hearing and an inability to speak.[85] Suzanne's description of words spoken and lost over a bad connection reflects some of the silencing mechanisms that would render her, for a time, relatively voiceless in Antillean literary history in the years to come.

Likewise, over the poor connection of history (lost texts, archival gaps, the silence of family members desirous of keeping the memories of their loved ones private), one finds the oft-repeated assertion, based on her publications alone, that Suzanne no longer spoke after *Tropiques*. Daniel Maximin, for example, consigns her to "silence absolu" ("absolute silence") after 1945 because her only public writing after *Tropiques* was subsequently lost.[86] Was this absolute silence really the case? What did Suzanne do after *Tropiques*? Did she retreat from public life as many scholars have stated, more often "doing the dishes than holding a pen"?[87] Perhaps more importantly, in the light of this impossible telephone conversation with Aimé, what would it mean to try to restore communication between Suzanne as writer and ourselves as readers of those lost words? How might we shift from the assumption of her silence post-*Tropiques* to a critical engagement with the auditory difficulties that accompany attempts to hear voices that are muffled in the archives?

The technical difficulties of finding Suzanne are due primarily to the fact that there are no Suzanne Césaire archives. Both Eugénie Éboué-Tell and Eslanda Robeson, the other two women featured in this study who worked in the shadow of their famous husbands' legacies, have archival dossiers of their own, albeit contained within the larger, more comprehensive collections dedicated to their husbands. There is no Suzanne Césaire sub-folder. Uncovering her words and her presence means looking for Suzanne in the interstices of Aimé's archive. It means being attuned to moments when she might appear, in the background of a photograph or mentioned by an acquaintance in a letter to Aimé. These fragments tell a different story from that of "absolute silence" after 1945. They reveal Suzanne to be an active and vocal political collaborator who played an important role in her husband's political career. Suzanne's call for Antillean self-definition in *Tropiques*' inaugural issue, the opening salvo in the journal's contestation of Vichy oppression, closed with a quote from

Aimé's *Cahier*: "It is time to gird one's loins like a valiant man."[88] Although the phone call between the Césaires was cut short, this intertextuality in their work highlights their long-term engagement with each other's ideas and points the way toward new avenues for hearing Suzanne after *Tropiques*.

I began this chapter with the assertion that Suzanne Césaire's contemporary legacy is one of both absence and presence. In addition to the relatively small body of scholarly analyses of her work, writers and artists have also sought to fill the archival gaps and silences with fictional renderings of her life. Maximin and Ronnie Scharfman, for example, have each sought to make an imagined Césaire speak in order to situate her as a central figure in the Negritude movement specifically and in Antillean literary history more broadly.[89] However, Césaire was not as silent in the conversation on global black identities in the twentieth century as the need for these fictional renderings would suggest. Photographs of Césaire attest to her visibility, her presence in the spaces of political and literary discourse in Martinique and Haiti in the pivotal years during and after World War II. Her private letters remained a privileged, often intimate space in which she reflected on her engagement with the political developments and defining texts of her time. In remembering her, then, I do not seek to recreate a fictional Césaire, necessary as such a gesture may be for recuperating her memory and legacy. Rather, I turn once again to her epistolary exchanges as texts from which Suzanne continued to speak after *Tropiques*.

One conversation in particular allows us to hear her voice as it reaches beyond the Martinican journal's pages and echoes in contemporary Caribbean literature: her critical reading of Aimé's *Cahier*. Published for the first time in French in 1939, *Cahier* has long been regarded as one of the pioneering works of Negritude, for its affirmation of a diasporic consciousness forged through a shared history of colonial oppression. Among the poem's many translations, the German version stands out because Aimé worked particularly closely with his German translator, Jahn. We also find in this version nearly invisible traces of Suzanne. In his letter to Suzanne about the text, Jahn notes that he had difficulty interpreting the following stanza from *Cahier*: "Alors voilà le grand défi et l'impulsion / satanique et l'insolente / dérive nostalgique de lunes rousses, / de feux verts, de fièvres jaunes!"[90] His question specifically concerned the use of "dérive" (drift). Was it modifying only "lunes rousses" or also "feux verts, fièvres jaunes," he asked.[91] Jahn also wanted to know if the poet's evocation of "a great challenge" and a "satanic impulse" meant that the natural images of moons, fires, and fevers had been displaced. His question points to an interpretation of *Cahier* that prevails in contemporary commentary on the French text. Notably, the image of moons, fires, and fevers moving out of their designated places suggests the poet's destabilization

of a natural order. Negritude scholar Lilyan Kesteloot marshals this stanza as evidence that the poet rejects Christianity and Westernization—symbolic of global imperialism—by transforming himself into a sorcerer able to command nature.[92] Kesteloot's reading most likely arises from her interpretation of "feux verts" as "green fires," an interpretation that also prevails in English translations of the text. Consequently, in this reading, moons, fires, and fevers represent the elements of nature that the poet commands and destabilizes in order to signal his opposition to the West. *Cahier*, as read by Jahn, Kesteloot, and other Negritude scholars, is primarily a text of destabilization, the poet's refusal of global imperialism through an affirmation of the humanity of people of African descent, the colonized, and the downtrodden.

In a stunning interpretation, Suzanne provides a close reading of the stanza that focuses less on the organic imagery and more on the poet's use of color. Unlike prevailing scholarly analyses and attendant translations that have read "feux verts" as "green fires," Suzanne reads the poet's words here as "green lights."[93] Moving away from Jahn's emphasis on "moons," "fires," and "fevers" as symbols of a natural order, she highlights instead the colors "russet," "green," and "yellow." The image of the traffic light therefore emerges from Suzanne's close reading, and she interprets its implicit presence in the stanza as symbolizing an implosion of European civilization occurring at the crossroads of large cities.[94] These spaces of intersection are also sites at which multiple cultural influences coincide to create new Afro-diasporic art forms. Concretizing her analysis of these abstract ideas for Jahn, Césaire identified two complementary strategies of this anti-imperial resistance. The "great challenge, the satanic impulse" that had so baffled Jahn in the stanza, was, Suzanne explained, the result of black cultural and political movements. Black people, she said, either literally fight oppression through anticolonial wars, or their creative force subverts European culture to create new forms of expression.[95] She highlighted the popular dance the twist as an example of this new form of expression. In a surprising evocation of the twist as, in today's parlance, a viral dance propagated by young people in big cities, Césaire reads the frenzied movements of the twist as invention and recreation of African dance forms by urban youth rather than as inauthentic mimicry. Her assertion to Jahn that this subversive creativity corrupts European knowledge carries clear echoes of her call for Caribbean literature that cannibalizes.

In this reading of *Cahier*, Suzanne expands her earlier vision for a new Antillean civilization that draws on multiple cultural influences to imagine an Afro-diasporic civilization forged at the crossroads. In the connection she establishes here between anticolonial resistance through armed struggle and diasporic creation through dance, Césaire presents an even more radical

vision of black liberation than that which is conveyed in extant scholarly readings of this stanza as uniquely a refusal of Westernization. We see here Césaire's joint politics and poetics of liberation at work once again. Moving from her engagement with Martinique to her vision for the Caribbean and now to her focus on the African diaspora, Césaire continues to locate the possibilities of a resistive imagination at sites of multiple, intersecting cultural, political, and intellectual traditions. Her interpretation in turn changes the terms on which we may read *Cahier*. For Césaire, the poet's act of refusal is not inscribed within a binary relationship of the black poet's proximity to nature in opposition to Western Christianity. It is instead an act of cultural and artistic creation that emphasizes resistance through subversive acts that engage with European and African thought and culture at the crossroads of multiple influences. In short, resistance for Césaire is always a creative act.

Suzanne's voice, unheard or, rather, unacknowledged, speaks on in the German translation of *Cahier*, which, unlike the English versions, explicitly carries her reading of creative resistance through the image of the traffic light in its rendering of the stanza as "der roten Monde / der grünen Lichter und des gelben Fiebers."[96] In preparing his 1993 annotated edition of *Cahier*, Abiola Irele not only worked from the 1956 French edition but also took into account Jahn's German translation, a decision he supports with the assertion that "[Aimé] Césaire is known to have worked closely with Jahn in the preparation of this edition, so that its deviation from the 1956 Paris edition can be considered to have met with his approval."[97] The reading of "green traffic lights" that Irele reproduces in his commentary is actually the work of Suzanne's hand, guiding the reader toward a new understanding of Aimé's project of situating Afro-diasporic creativity at the crossroads of global movements of artistic and political resistance.[98]

In addition to leaving her mark on *Cahier*, Suzanne also coauthored letters with her husband. The Césaires' epistolary exchanges with the Bretons, for example, juxtapose the different poetic styles of both writers. Suzanne's carefully formed cursive script sharing the page with Aimé's abrupt, telegram-style phrases, scrawled in what seems to be an impatient hand, attests to the collaboration between the Césaires as coproducers of texts that were at once intellectual reflections on the impact of surrealism in the Caribbean and personal discussions of their fears and uncertainties about the future.

After World War II, Suzanne turned her attention back to local politics in Martinique and to the island's political relationship with France. Aimé was not yet a member of the Communist Party when he agreed to run on the party's ticket for the mayoral election that would mark his entry into public politics in 1945. The Archives départementales in Martinique tells this story

of his political debut as one of intrigue starring male protagonists including Louis Adrassé, the member of the Communist Party who first proposed Aimé's candidature; Georges Gratiant, who opposed it; and Victor Sévère, the incumbent mayor of Fort-de-France whose retreat from the political scene cleared the way for Aimé's victory.[99] As usual, this political genealogy elides Suzanne, who was the conduit for communication between Aimé and the Martinican communists. Suzanne was the one who informed Aimé of the proposition to include him on the Communist Party's list of mayoral candidates. She was also the person Aimé charged with reporting back to the communists his decision to run on their party's ticket.[100] Thus began his political career. In one striking photograph that bears witness to Suzanne's continued presence during Aimé's electoral campaign that year, we see her, the only woman, standing among a group of men who would go on to become Martinique's literary and political elites.[101] The picture captures members of the Communist Party in a flurry of activity, presumably working to ensure Aimé's success. His brother-in-law, Aristide Maugée, is sitting next to a group of men who are in earnest conversation. Pierre Aliker is standing near Aimé looking into the distance. Upright in front of a microphone, Aimé has taken the time to pose with his right hand in his suit pocket and a somewhat tense smile on his face. He is the only person looking at the camera. Suzanne is the only person looking at him. She leans intently over the shoulders of the men clustered behind Aimé, her mouth open in mid-speech. The photograph preserves evidence of Suzanne's presence at political meetings, even as her words at those gatherings are lost to us today.

I have often been asked what Suzanne thought about Martinique's somewhat controversial status as an overseas department of France. This is difficult to ascertain. However, it is clear that in the early years she believed that this new status would afford Martinique greater representation in the metropole in order to address some of the critical problems facing the island. She followed closely Aimé's work in the Constituent National Assembly and on the commission for overseas territories and was impatient to see what this representation would bring to Martinique.[102] At the same time, she was critical of the metropole's lukewarm commitment to its new overseas departments. She noted as much in a letter to Adrassé. Like Aimé, who wrote the first draft of *Discours sur le colonialisme* on National Assembly stationery, Suzanne too reached for French parliamentary letterhead as she penned her critique of deputies in the metropole who dismissed as trivial what Césaire quite literally underscored as "vital" issues for the island.[103] Césaire noted that right-wing newspapers, which she saw as imperial mouthpieces, were waging a racist campaign designed to thwart political enfranchisement for the colonies. In a

stunning declaration from someone who herself had suffered state censorship, she argued for state censure of these newspapers, thus weighing in on the long and ongoing debate about freedom of speech and hate speech. It is not surprising that Suzanne would see already in the early days of departmentalization the promises and pitfalls of Martinique's new status. The poetic lucidity that she so ardently desired during her *Tropiques* days made her a prescient observer of French and Antillean politics. An acquaintance once wrote to Aimé describing Suzanne's "marvelous lucidity" and hypothesizing that she would surely disagree with what was at the time Aimé's rumored decision in 1955 not to stand for reelection on the Communist Party's ticket.[104]

Suzanne was a close collaborator in joint textual production and political activism with Aimé. The urgency of her writings and their continued relevance today attest to the fact that her imagined project of artistic regeneration and political freedom remains unrealized. Césaire never pursued an active political career and suffered decades of serious health problems. If the letters and essays analyzed here provide insight into her ardent desire for Martinique's liberation during the war years, they also raise new questions that for now remain unanswered. What role did she envision for literary production in a postwar Martinique integrated into the French Republic?[105] Often the only woman or one of a handful of women at gatherings of the literary giants and prominent politicians of her time, how did she theorize women's place and role in public life?[106] Where Césaire's pen leaves off, her compatriot Paulette Nardal's picks up. Nardal's journal *La femme dans la cité*, published on the heels of *Tropiques* between 1945 and 1951, actively engages with the role that Martinican women would play in the rebuilding efforts of postwar France through their political activism in the new overseas departments. Nardal's work allows us to follow the thread of thought found in Césaire's essays on Caribbean identity forged through political and cultural work that is both global in scale and local in outlook.

2. Paulette Nardal

Martinican Women as Political Protagonists in the Overseas Department

The Martinican woman has entered the City of Men.
—Paulette Nardal, *La femme dans la cité*

When Suzanne Césaire stepped off the SS *Bretagne* onto Martinican soil in September 1939, she had no idea that the ocean liner's return voyage to France would be its last.[1] Nor could she know that her compatriot and fellow writer Paulette Nardal would be aboard the vessel during its harrowing last days as one of the first casualties of World War II. Nardal had spent the last two months in Martinique working on a tourist film at the request of the minister of the colonies, Georges Mandel.[2] Fully expecting her stay on the island to be temporary, she had left her Paris apartment in the care of the building's concierge. She was still in Martinique when the war began. Determined to return to her work in Paris, Nardal secured passage aboard a banana carrier and arrived at the quay at Fort-de-France an hour before the scheduled departure only to learn that the carrier had already left.[3] Telegrams dispatched to Martinique were warning of German submarine attacks. The captain had thought it prudent not to linger. Nardal must have been relieved to find space on the next departing ship, the SS *Bretagne*.

On October 13, a month after her departure from Martinique, and with the ocean liner a day away from the English coast, Nardal's relief turned to horror. The liner was torpedoed by the German submarine U-45. She would later recall the German guns hammering away at the section of the *Bretagne* where the lifeboats reserved for women and children were stored. Nardal had to act quickly. Three times she tried to grasp a knotted cord and attempt the daring maneuver of climbing down the side of the ship into one of the lifeboats.

Three times she failed. Nardal lay on a *chaise longue* and resolved to go down with the boat until a fellow passenger persuaded her to jump. She did, and landed knees-first in a lifeboat. She lifted herself onto a bench and spent an agonizing four hours waiting for a rescue ship. Her injuries were so extensive that during the first days of her nearly yearlong recuperation at City Hospital in Plymouth, as German Luftwaffe bombs rained down on the city, medical personnel were reluctant to send the telegram that Nardal had composed to her family, because they were convinced that she would not survive.[4]

As with the enigmatic Césaire and her work in Haiti, much of what we know about Nardal's ordeal comes from her own reporting, particularly her letters to the colonial administration requesting compensation and disability benefits. Like Césaire, Nardal too wrote a report to Martinique's governor, Georges Louis Ponton, requesting that her labor in the service of the colonial government and the resulting financial losses she incurred be recognized and compensated. Despite their government-contracted work, both women had had to borrow money to survive. Their reports are crucial, if neglected, documents that provide more than simply the biographical details with which to flesh out relatively scanty portraits of their lives. They also highlight the difficult choices that Martinican women made as colonial subjects writing themselves as citizens. Both women critiqued the colonial accounting practices that failed to see the whole person and that were unable to account for the personhood of Antillean women. At the same time, their efforts to make themselves legible to the colonial administration highlights their awareness that France's recognition of the value of their labor depended very much on their ability to represent themselves as deserving citizens working and acting in the interests of France.

Just as Césaire simultaneously disavowed Haitian Creole in her report to Ponton and revealed in her private letters that a plant metaphor in Creole provided a linguistic and conceptual basis for her understanding of Antillean identity, Nardal rewrote her intellectual genealogy for Ponton in ways that seemed to run counter to the actual content of her works. Paulette Nardal, a pioneer of the Negritude movement who highlighted the work of black women as important intellectuals, cultural producers, and political actors, is virtually unrecognizable in this report to Ponton. She expunges from her bibliography her numerous articles about racial identity and racism and remains silent on the journal *La revue du monde noir*, which she founded in Paris some years before. She elides her more radical writings, such as the now canonical essay on the intersections of racial and gendered discrimination, "Eveil de la conscience de race" ("The Awakening of Racial Consciousness"). She emphasizes instead the tourist film on which she was working before the

attack, as well as her tourist guidebook, a significantly under-studied text that I will analyze in this chapter as a crucial component of Nardal's articulation of citizenship. Nardal rewrites herself for Ponton, transforming herself from a perceptive critic of interlocking racial and gendered oppression in France into a writer who had "always served the colonial cause with all the dedication with which [she is] capable and which is inspired by [her] attachment to France."[5]

It took two years for Nardal's request to Ponton for disability benefits due to her war injuries to wend its way through the interminable French bureaucratic process. Ponton died, and his immediate successor, Georges Parisot, took charge of the dossier. As the war raged on and letters and telegrams shuttled back and forth between the governor's office in Fort-de-France and the Colonial Commission in Algiers, Nardal waited for news at her home at 85 rue Schœlcher and subsisted on the support of her seventy-nine-year-old father and her own meager earnings from teaching English classes. Much like Suzanne Césaire, whose temporary status on the rolls of the French Ministry of National Education made her ineligible for certain much-needed forms of health insurance coverage, Nardal remained outside of the legal provisions for disability benefits, because although she taught English, she was not employed by the state to do so. The final blow came in 1945 in a telegram from Algiers. Nardal was not eligible for compensation because there was no legislation that recognized civilian casualties in colonies that had not suffered direct damage ("dommages directs") in the war.[6] Her claim to indemnity as a war victim had been denied and with it all the economic scarcity, racial discrimination, and political repression that Martinique had faced during the war. Distance from the metropole meant erasure of the very real losses that the island and its people had suffered, coded here in the language of a supposed absence of "direct damage."[7]

I begin this chapter on Paulette Nardal with a discussion of her wartime act of self-inscription because that act was very much about claiming French citizenship by refusing to fall between the cracks of legal frameworks that defined her as ineligible for state support. Contemporary narratives about her life after Paris retain the image of a fiery Nardal teaching English to Martinican dissidents preparing to join the Resistance in Dominica, or of the joyful Nardal who directed the choir La Joie de Chanter. Coupled with these images, as her report to Ponton attests, are the material realities of financial hardship and physical pain and the French colonial administration's refusal to recognize those realities. Nardal's life in Martinique during the war was a difficult one, and those difficulties informed her continued navigation of French citizenship after World War II.

Nardal's interwar writings on race consciousness in Paris and her later works on women's political engagement in Martinique after World War II are often treated as separate, unrelated parts of her broader oeuvre. Reading across her texts from Paris to Fort-de-France, however, shows the continuity in her engagement with intersectionality and citizenship over time. Far from being an anomaly, her under-studied texts, such as her tourist guidebook, her report on colonial feminism, and her editorials about Martinican women and the electoral process in the journal *La femme dans la cité*, are better understood as the culmination of her desire, first articulated in her Parisian texts, for marginalized people to reimagine social relations and political structures on terms different from the limited and discriminatory ones instituted by colonialism. Facing intersecting oppressions as black women colonized subjects, Martinican women's contributions to political life signaled, for Nardal, the advent of a more egalitarian postwar France.

In this expanded reading of Nardalian thought beyond Negritude, I argue that the examinations of race and gender in Nardal's writings from and about Martinique have as their underlying focus the possibility of a French-Antillean citizenship. As this chapter shows, French-Antillean citizenship strategically locates civic participation within the sphere of French politics and situates Antillean cultural identity apart from France. It enacts what Ramon Grosfoguel calls in his analysis of Puerto Rico a double location, "a simultaneous interior/exterior cultural and political location" that Nardal mobilizes against colonial discrimination by the metropole and exploitation by white Creole elites in Martinique.[8] For Nardal, in this hyphenated French-Antillean citizenship lies both the refusal of cultural assimilation as a condition of French citizenship and the leveraging of civil rights and legal protections afforded by political attachment to France in order to disrupt the colonial racial and economic hierarchy on the island. In that crucial moment at the dawn of departmentalization, when Martinicans obtained the status of French citizens, Nardal put forward a model of belonging that emphasized the multiple cultural and political communities that would comprise Antillean citizenship.

Born on October 12, 1896, in François, Martinique, Paulette Nardal moved to Paris in 1920 to study English literature at the Sorbonne. Her publications in journals like *La Depêche africaine* and *La revue du monde noir*, which she cofounded with Léo Sajous in 1931, explored a collective black diasporic but also French identity. Nardal and her sisters Jane and Andrée opened their salon in the Parisian suburb Clamart in the early 1930s to students and artists from Africa, the Antilles, and the United States and thus presided over a space for diasporic exchange, debate, and literary creation. After nearly two decades living and working in France, Nardal returned to settle permanently

in Martinique under the traumatic circumstances of World War II. In 1944 she founded the Rassemblement féminin, the Martinican branch of the moderate, Catholic French women's organization the Union féminine civique et sociale. She also served as editor of the Rassemblement féminin's organ *La femme dans la cité*, published monthly between 1945 and 1951.[9]

Though her writings span several decades and different genres, Nardal consistently sought to define a nuanced model of political belonging for Martinicans that would recognize the island's intertwined history with metropolitan France as well as its Caribbean cultural heritage. Like Suzanne Césaire, she was wary of artistic representation of Antilleans as exotic Others to feed colonial fantasies of the *outre-mer* and of political representation that was based on policies of assimilation. She sought to strike a balance between recognizing Martinique as politically French and culturally Antillean, a project that puts her in conversation with other Martinican intellectuals, such as the Césaires and Ménil, who also pursued a similar balancing act in their work. In the debates that took place both in the French National Assembly and in the pages of *La femme dans la cité*, citizenship emerges as the application in the former colonies of legal protections and rights already in place in the metropole. Nardal's extension of a traditional, exclusionary definition of citizenship to colonized spaces ultimately disrupted the very definition of citizenship itself by reconfiguring it in terms of plurality and flexibility in order to recognize the Antilles as a confluence of multiple histories, geographies, and cultures.

Writing Home in Exile

During the interwar years, Nardal wrote about home and exile as a way to engage with the complexity of navigating French-Antillean belonging. In her writings for audiences in the Hexagon, she conveyed the conflicting experiences of belonging and alienation for Antilleans in Paris who straddled the boundary between colonial subjects and citizens. Where Suzanne Césaire exposed the inability of literary assimilation at home to capture Antillean culture and reality, Nardal revealed the impossibility of cultural assimilation for Antilleans abroad. For both women, assimilation was a destructive myth that erased Antillean history and cultural production and espoused narrow and exclusionary notions of Frenchness. Nardal's short story "En exil" ("In Exile"), for example, examines the obstacles to assimilation and the constant negotiation of home in exile through the experiences of an Antillean woman in Paris. Published in the December 15, 1929, edition of the journal *La Dépêche africaine*, "En exil" presents a moving tableau of the intersections of race, class, and gendered oppressions through the protagonist Elisa, an elderly Martinican

woman employed as a domestic worker in France. Elisa is a solitary figure hovering, wraithlike, on the margins of Parisian society. As she makes the daily trek from her home to her workplace, the Parisians she encounters either misrecognize her or fail to see her altogether. She dreams of the home she left behind in Martinique and is ultimately rescued from wasting away in a hostile country by her son, who has made his fortune in the leather trade and who announces his imminent arrival in Paris to take her home. In this story, Elisa's experience of alienation in the metropole as an elderly working-class Antillean woman highlights the Nardalian brand of intersectionality avant la lettre that would later become the focus of *La femme dans la cité*.

"En exil" follows Elisa as she travels to and from work, navigating a city that is revealed to be hostile and alienating. Nardal stages encounters between Elisa and Parisians at key sites that evoke the imperial history of France. Thus, as Elisa walks along rue des Écoles, she is mockingly apostrophized as "la belle blonde!" by a group of students presumably from one of the many prestigious educational institutions, such as the Sorbonne, that give the street its name. Her map of this city that she cannot claim also includes her cleaning job at the dingy apartment located on rue Cuvier, a street named after the famed French naturalist Jacques Cuvier, who examined the body of Saartje Baartman, a South African woman who was exhibited nude in Europe for the consumption of curious white audiences. Cuvier's examination of Baartman's body after her death provided the foundation for his "master text on black female sexuality for Europe's scientific community."[10] Rue des Écoles and rue Cuvier serve as spatial markers of France's imperial history, delineating the hallowed halls of higher learning to which Elisa will never have access as an elderly working-class woman from the colonies and the racist narratives that place her in a long line of black women, including Baartman, whose bodies become subject to the white European gaze. These sites also stand in opposition to Elisa's nostalgic memories of towns like Saint-Marie in Martinique, thereby highlighting the juxtaposition of colony and metropole, home and exile.

Nardal defines the experience of exile in this story as the impossibility for a black woman to belong in a France that continues to subject her to an imperial gaze that marks her as Other. The resulting alienation leaves Elisa voiceless throughout the narrative. Unlike Nardal's better-known short story "Guignol Ouolof," which employs direct speech to convey the protagonists' views on race and place in the metropole, "En exil" highlights Elisa's silence through the marked absence of the protagonist's direct speech. The narrative therefore recognizes the impossibility for women like Elisa to successfully speak of their presence and examines this negation and erasure through Elisa's interior monologue. If Nardal makes the reader privy to the innermost

thoughts and desires of this elderly woman reminiscing about the Antilles as she trudges through Paris on a cold, gray winter's day, it is to show the dissonance between that interior voice that does indeed speak and the Parisians for whom her speech remains inaudible.

Nardal is careful to show that Elisa's lack of voice does not arise from her inability to speak—for she does in fact articulate her Antillean identity through dress—but rather from her interlocutors' inability to decode her speech. For example, on the bus, Elisa's madras head tie marks her as foreign and exotic: "It was especially her calendered madras, so oddly knotted, that drew glances. People didn't seem to suspect that that might bother her."[11] The spectators on the bus whose stares confine Elisa to the role of object of fascination ignore her discomfort as they center their own curiosity. As with her encounter with the students on rue des Écoles, the location of this failed interaction on the bus is again crucial. For Fanon and Aimé Césaire, public transportation, symbolic both as an arena for public interaction and as a means of mobility through contested space, functions as a key site of racial misrecognition and displacement. In *Peau noire, masques blancs*, Fanon describes the alienation brought on by the empty seats next to him on the train. The white passengers' refusal to sit next to him, coupled with the exclamation "Look, a Negro!," fixes his identity to his skin color and marks him as Other, as out of place.[12] In *Cahier*, Césaire's narrator describes his encounter on the tram with "a nigger who was comical and ugly, and behind me women were looking at him and giggling."[13] Here we see the supposedly comical black passenger from the concerted perspective of the narrator and the women behind him. In each of these narratives, the gaze of the relatively privileged white viewer, "neither neutral nor benign," is determined by the history of uneven power relations between colonizer and colonized.[14]

Nardal is a precursor in this literary history of Antillean thinkers theorizing race and recognition in spaces of public transit. Her black woman–centered lens allows us to examine the role of gender in this process of Othering. Where Césaire's and Fanon's black men, both trembling from the vulnerability of their exposure, are perceived as violent and menacing, Elisa, like Baartman, is viewed as curious and exotic, an object to be consumed. The madras head tie that draws stares on the bus, also known as *une coiffe* or *une tête*, is a cultural object in the Antilles that conveys messages about a woman's marital status. The style and number of knots in a head tie indicates whether a woman is married, single, looking for a partner, or some combination of these. However, in exile the head tie as a speech act is rendered unintelligible. Elisa's madras conveys no meaning for the Parisians on the bus beyond her difference as a curious, exotic presence in their midst. The scrutiny to which Elisa is subjected

in public space ultimately erases her identity by misrecognizing her. In *Sister Citizen: Shame, Stereotypes, and Black Women in America*, Melissa Harris-Perry argues that this misrecognition of black women who are viewed through a distorted racialized lens has direct political implications: "As members of a stigmatized group, African American women lack opportunities for accurate, affirming recognition of the self and yet must contend with hypervisibility imposed by their lower social status. As a group, they have neither the hiding place of private property nor a reasonable expectation of being properly recognized in the public sphere. This situation undermines the intersecting needs for privacy and recognition that underlie the democratic social contract."[15] Harris-Perry's observations of the American context resonate with Elisa's exposure to mockery on the street and gawking on the bus. Because Elisa's communication with Parisians as potential interlocutors is curtailed by the colonial history that overdetermines their interactions, her experience raises questions about who can be a citizen and on what terms.

Nardal applies her intersectional lens to representing Elisa's perceived alterity by examining the effects of class on the experience of exile. As an elderly black woman in France, Elisa works as a maid, one of the few forms of employment readily available for a woman in her position.[16] She is alone, old, and poor, with no access to opportunities for upward social mobility. As a working-class woman with limited possibilities for leisure, she is also unable to cultivate a community to counter the effects of her isolation: "This life—which left no room for contented idling, for happy and animated conversation in the evening with her roommate and her other friends, exiled like her—just seemed too painful."[17] Nardal's portrayal of Elisa is far from the sometimes romanticized depictions of cosmopolitan blacks in Paris, sipping tea in bilingual salons and rubbing shoulders with international artists and intellectuals. Here we are far from Josephine Baker's stardom at the Folies Bergère. As Edward Said reminds us, "Paris may be a capital famous for cosmopolitan exiles, but it is also a city where unknown men and women have spent years of miserable loneliness."[18] By naming Elisa and exploring her innermost thoughts, Nardal counters the anonymity of Antillean women who are multiply Othered in the metropole.

Nardal's narrative of alienation in exile ultimately grapples with colonialism's disfiguring of the very idea of home. Faced with the "mirage" of Paris as a second home, Elisa finds refuge in her memories of Sainte-Marie, Martinique. She hears the drums that accompany *laguia* dance battles and affirms that "it's the whole soul of old Africa, which passes into this Antillean tomtom."[19] She also hears the call-and-response incantations in Martinican folklore, which she describes as "African tales adapted to the Antillean soul."[20] Jacqueline Couti reads Elisa's nostalgia as Nardal's replication of "metropolitan negrophilia,"

an attempt to recast an idealized, "pure black Martinican soul" as a foil for a cold, hostile France.[21] This interpretation elides to some degree the operative word "adapted," which highlights less an imagined purity of origins and more the process of creation and invention of Antillean cultural production that Nardal's compatriot Suzanne Césaire also examined in her writings. My reading of this moment is more in line with that of Claire Oberon Garcia, who sees Elisa's relationships to Paris and Martinique as representative of Nardal's engagement with the interlocking nature of racial, gendered, and class oppression wrought by colonialism.[22]

To this reading of intersectionality, I offer an added dimension by examining "En exil" as one of Nardal's early attempts to interrogate the terms on which black working-class Martinican women could claim French citizenship. What Nardal casts here as the metropole's rejection of the black woman colonial subject will resurface in *La femme dans la cité*'s call to Martinican women to no longer be the silenced Elisas of the world but rather to see in their acquisition of the vote a new way to "speak back" to the Hexagon. Certainly Nardal's middle-class identity tinges much of her representations of the struggles of working-class Martinicans with a degree of condescension. As I show in my later discussion of her engagement with the Communist Party, for example, her class bias is present even when she attempts to expose the failures of capitalism in the French colonies. For now, however, I want to highlight what I see to be the most salient element in "En exil" for understanding the ideas of French-Antillean citizenship that Nardal would later develop in her postwar writings: the relationship between home and exile.

As Brent Edwards so persuasively notes, "The condition of migration is exilic for the colonial subject."[23] Multiple forms of uprooting and loss are therefore at work in shaping Elisa's experience of exile as a Martinican woman in Paris. Said contends that "exile is predicated on the existence of, love for, and bond with, one's native place; what is true of all exile is not that home and love of home are lost, but that loss is inherent in the very existence of both."[24] Elisa dreams of home in exile, but it is a home that is constructed through language that mourns yet another loss, that of Africa as imagined origins, an Africa that Elisa now yearns to rediscover through cultural production such as Antillean folklore and dance. Nardal's protagonist grapples with the implications of what Stuart Hall describes as being "twice diasporized," uprooted from Africa through the triangular trade and economically displaced from Martinique as an immigrant in France.[25] In "En exil," Martinique as a home that is firmly rooted in its African cultural heritage exists only in reverie. France as metropole continues to interrupt this hoped-for engagement with an imagined homeland, for it is in the middle of this reverie that the bus

driver's shout "Rue de Rennes!" violently jolts Elisa back to her sterile life in Paris: "That shout, the brutal lights of the storefronts, have shredded the veils of her reverie."[26] For Elisa, home is caught somewhere between Africa and France, a mythical past and a brutal present separated by a thin veil whose rending symbolizes the impossibility of several layers of return.

Ultimately, however, Elisa does not disappear Martinique in her quest to recover a mythical Africa. She repeatedly characterizes the folktales, drums, and dances as Antillean, recognizing both their origins and the process of creation by which these cultural artifacts become uniquely Caribbean. For example, the madras *tête calandée* headscarf she wears as she dreams of home during her bus ride is made from the technique of calendering, which consists of painting the lighter parts of the madras with a mixture of chrome yellow and gum arabic in order to make the otherwise dull fabric more lustrous.[27] Nardal mobilizes the symbol of a fabric that originated in India and became incorporated into Antillean modes of dress in order to emphasize the island's history and culture beyond the sphere of its relationship with France and Africa. If "En exil" is very much invested in Martinique as absence, as a site where home and exile overlap, Elisa's madras head tie nevertheless contains the germ of Martinique's cultural presence. It signals Nardal's move beyond the poles of Africa and France to locate the island as the confluence of several histories and traditions that give rise to a distinct culture of its own. This turn to cultural products that symbolize an Antillean identity that is neither displaced from France nor routed through a lost African homeland is amplified in Nardal's subsequent writings and will ultimately be central in her articulation of French-Antillean citizenship on her return to Martinique.

This amplification is perhaps most evident in a series of essays about Antillean women that Nardal wrote for the Parisian newspaper *Le Soir*, shortly after the publication of "En exil." Nardal's serialized profiles of different groups of Antillean women appeared in 1930 in four installments: "Femmes de couleur: L'Antillaise" (Women of Color: The Antillean Woman); "L'Antillaise: Marchandes des rues" (The Antillean Woman: Street Vendors); "L'Antillaise: Bourgeoise créole" (The Antillean Woman: The Creole Bourgeoisie); and "L'Antillaise: Étudiante à Paris" (The Antillean Woman: The Student in Paris). Where "En exil" emphasizes the erasure of black women in France, "Femmes de couleur" proposes an alternative model of belonging, one that recognizes the multiplicity of Antillean women's identities across race and class. This series is another rewriting of home in exile. Aimed at a Parisian audience, the four short articles seek to write Antillean women out of colonial discourse and into a body of literature that recognizes their cultural, intellectual, and economic contributions. In her introduction to the series, Nardal warns her

readers that they will not find in her profiles the familiar stereotypes of Antillean women as sexually available island belles. It is noteworthy therefore that the four essays often appeared on the same page as *Le Soir*'s coverage of the imminent 1931 Paris Colonial Exposition and therefore functioned as direct counter-representations to the degrading images of colonized people exhibited for public visual consumption in Europe. Nardal's representation of women focused instead on their vibrant cultural and economic presence in the Antilles, an image that was as much a reversal of the stereotype of the lazy Antillean as it was a subtle indictment of the colonial economy that necessitated back-breaking work for little pay.

In "Marchandes des rues," Nardal uses movement to great effect as she shows how Antillean women navigate colonial space as economic actors. She follows street vendors as they crisscross Fort-de-France balancing heavy loads on their heads and calling out to potential customers from dawn until well into the night. She takes her readers to some of the poorest communes of the city, La Levée and Terres-Sainville. Yet in reversing the exotic representations of the island, in seeking to show readers beneath the great camouflage, she does not turn urban poverty into a spectacle. She represents the working-class Antillean woman in the street, in the city, in public space as a proud income earner: "She crosses Fort-de-France now, her step proud, her gaze keen."[28] Nardal's romanticized description emphasizes Antillean women's visibility on their own terms, moving through and occupying public spaces without apology. Yet it also elides the fragile nature of this agency. Carolle Charles's characterization of Haitian women as *machann ak machandiz* (sellers and commodities), aptly captures the duality of working-class Antillean women's tenuous relationship to power. Charles argues that "Haitian women have been in a subordinate position in all fields of gendered, racialized, and classist relations of power within Haitian society, yet at the same time they have been able to act as agents defining and negotiating these same relations of power."[29] Similarly, Nardal's street vendors labor in the spaces between the formal sector of state-recognized work and therefore navigate their simultaneous mobility through public spaces and the disenfranchisement that comes with the absence of state recognition.

The stories recounted by my mother-in-law, Manette, about her experiences as a *marchande de rue* in Martinique in the 1970s and '80s show that for some Antillean women, this liminal space remained the only viable option for sustenance despite France's recognition of Martinique as an overseas department and the implementation of new labor laws that accompanied departmental status. For fifteen years, Manette left her house at the crack of dawn with her cooler of sandwiches and made her way from Plateau Fofo in

Schœlcher to downtown Fort-de-France. She sold her food to civil servants at the social security offices, the prefecture, and the social welfare office (La Caisse d'allocations familliales). She became such a fixture that she often arrived with employees' sandwiches already labeled by name according to their preferences that she had come to know so well. Manette was a visible and well-known presence in government administrative offices. Yet as a marchande in the informal sector, her labor was not officially recognized or sanctioned by the state. This absence of recognition today directly impacts her ability to access the full benefits of French citizenship, particularly because her social security benefits are now pegged at a rate lower than that of a minimum-wage earner.

Nardal's picturesque depiction of street vendors does not acknowledge that the economic autonomy that this work may sometimes provide Antillean women rarely translates into political representation, concerns that she will only later come to articulate in her editorials for La femme dans la cité. For now, her women straddle the machann ak machandiz binary, at once producing and sustaining Antillean culture through the local cuisine they make and sell and embodying that very culture to be consumed: they "represent the preservation of that which is purely indigenous about Antillean life."[30] This statement of Antillean cultural belonging affirms the existence of a civilization that is not routed through metropolitan France but is rooted in the Caribbean and manifested in the local economy.

If Nardal sought to counter the colonial rhetoric of assimilation by valorizing the presence and contributions of black women both in the Antilles and in hexagonal France through her essays, her most delicate balancing act between these two spaces came in her 1931 tourist guidebook. The volume was commissioned by the French Geographical Society as part of the 1931 Paris Colonial Exposition.[31] It was divided into three sections. The first section, on Martinique—complete with maps and photographs—was written by Nardal. The other two sections were on Guadeloupe and French Guyana, and Saint Pierre and Miquelon, respectively. Nardal's work on this publication has flown under the radar of existing scholarship, because its genre poses particular challenges. Specifically, the wariness of exoticization and Othering that Nardal expresses in her introductory article to her "Antillaise" series sits uneasily alongside her production of a tourist guidebook, the dreaded "guide bleu" that Suzanne Césaire so roundly condemned in the pages of Tropiques. Yet, read alongside her earlier works, this guidebook is not entirely an outlier in the corpus of Nardal's writings. It is another project of rewriting home in order to imagine new possibilities for French-Antillean identities beyond the paradigm of assimilation.

Throughout the guidebook, Nardal seeks to situate Martinique as both a part of and apart from France. She presents the island as just the right combination of familiarity and difference for would-be French tourists:

> Le touriste . . . pourra constater que la Martinique est une petite France, une France lointaine. Les usages ne diffèrent pas essentiellement des usages français. La vie, là-bas, n'est qu'une adaptation de la vie européenne aux nécessités du climat tropical. Il ne rompra pas toute attache avec la métropole, ou, s'il est étranger, avec sa patrie, car, tous les soirs, le bulletin du câble le mettra au courant des évènements mondiaux de la nuit précédente et de la journée. S'il a laissé de la famille au loin, le câble, la T.S.F., les courriers et les cargos le relieront à ceux qui lui sont chers.[32]

> The tourist . . . will realize that Martinique is a little France, a faraway France. The customs are not essentially different from French customs. Life there is but an adaptation of European life to the necessities of a tropical climate. He [the tourist] will not break all attachment with the metropole, or, if he is a foreigner, with his home country, since every night the cable bulletin will keep him updated on world events of that day and the night before. If he has left family far away, the cable, wireless telegraphy, the mail and cargoes will connect him to all that is dear to him.

On first read, Nardal's Martinique is a tropical replica of France, akin to Hall's description of the island as "a bewildering place . . . more French than Paris, just darker."[33] It is noteworthy, however, that Nardal presents Martinique as more than simply a remote outpost of France. She argues that the tourist will find continuity between France and Martinique and will remain firmly connected to global affairs via the technological advances in communication that link the island to the rest of the world. Her archipelagic view resonates with Suzanne Césaire's. Like Césaire, she asserts that Martinique exists in relation to a world that goes beyond the narrow confines of the colony/metropole relationship. This assertion is important in the context of a tourist guidebook intended primarily for a French audience. Nardal suggests that Martinique is neither a pristine paradise to which the tourist can escape from the rest of the world nor simply a replica of France in the Antilles. Rather, in the rest of the text, she offers a complex definition of Martinique as part of a larger French polity, a territory with its own unique history and culture rooted in the Caribbean archipelago, and a space that opens out onto the rest of the world.

Indeed, what is most fascinating about Nardal's text is not what it says but what it does. Contrary to what one might expect of a typical tourist guidebook, Nardal's includes much more than a list of hotels and landmarks. She situates the tourist experience within a larger presentation of the island

itself—its history, political status, and topographic features. Drawing on extensive historical and anthropological sources such as the works of Moreau de St. Mery and Léo Sajous, Nardal devotes a significant portion of her text to the history of Martinique. Rather than begin with the arrival of the first French *colons*, she describes the culture and political organization of the Arawaks and Caribs, the island's original inhabitants. She describes, for example, the Carib practice of incorporating Arawak women into their social units after conquering and killing Arawak men. Nardal's text pushes back against the European imperial language of "discovery." In this reframing of history, Martinique's existence does not begin with its "discovery" by France but with the rich history and culture of the Arawaks and Caribs. Throughout the book Nardal paints an extensive picture of linguistic and culinary practices from these early inhabitants that persist in contemporary Martinican culture. For a 1931 publication, Nardal's tourist guidebook, which was also available to Martinican readers at the central library, the Bibliothèque Schœlcher in Fort-de-France, contained more information on Martinican cultural and natural history than textbooks found in colonial Antillean classrooms at the time. Thus, despite saying that Martinique is but a "petite France," Nardal's text shows the opposite by presenting the island as a distinctly Caribbean space with its own history that is both intertwined with France's through the fact of colonization and distinct because of its Caribbean heritage.

The thematic concerns of Nardal's publications in Paris during the interwar years, from her short stories and essays to her guidebook, certainly informed her editorials in *La femme dans la cité* in postwar Martinique. She remained concerned with Antillean women's work and representation in the public sphere but now placed this discussion in the context of departmentalization. Nardal believed that the new political status would empower the Elisas and marchandes des rues in Martinique to be heard not only in the pages of Parisian newspapers and journals but also at the voting booth. She recognized that with women's suffrage in France in 1944 and French citizenship in the Antilles in 1946, Antillean women were now uniquely placed to shift the discourse on race, gender, and belonging both in France and in the Caribbean. As the world turned its focus to the postwar rebuilding effort, Nardal would urge Martinican women to harness their newly acquired political leverage, through the vote, to reverse the economic, political, and social effects of centuries of colonization in Martinique. Her exhortations to women to actively participate in the life of the city echo Suzanne Césaire's affirmation of Martinique as a key player in global affairs, as more than a forgotten speck on the face of the sea.

Women in the City of Men

In her editorials for *La femme dans la cité*, Nardal identified Martinican women as central actors in a particularly pivotal moment in France's history. Women acquired the vote at a crucial juncture when the French population had to decide whether France would return to the Third Republic or usher in the Fourth Republic with new elected representatives.[34] The stakes were high, and for Nardal, Martinican women were to be political protagonists in this new chapter of history. She articulated this urgency in her October 1946 editorial "En face de l'histoire" ("Facing History"), in which she asks, "Is it true that tens of thousands of women refuse to go drop a ballot in the ballot box on election day, refuse to 'remake the world,' to create History?"[35] In imagining possibilities for Martinican women to make history by exercising their rights as citizens of France in the Caribbean, Nardal would draw on some of the strategies she proposed in her earlier Parisian writings on striking a balance between French citizenship and Antillean belonging. To this end, she presented a two-pronged approach in *La femme dans la cité*: a project of collectively defining Antillean political identity and women's active participation in representing this identity on the political and cultural scene in Martinique and beyond.

Nardal explained this dual approach in her editorial "Les femmes martiniquaises et la politique" ("Martinican Women and Politics"), written four months after departmentalization was voted into law. In this editorial she argues that "Martinique should draw attention to itself through the importance of female participation in decisive elections. We must present the true face of Martinique, this time, to France and to the world."[36] By defining their political interests, Antillean women would continue the collective project of self-definition that Suzanne Césaire emphasized in wartime. Notably, Nardal uses the formulation "the true face of Martinique" to emphasize the need to read beyond what Césaire described as the great camouflage of the beautiful landscape and supposedly insouciant inhabitants and to recognize the social, political, and cultural effects of colonial exploitation in the Antilles.

Discovering the true face of Martinique was a collective, reflexive process for Nardal: "In order to better clarify our choice, we thus have the duty to inform ourselves about social questions and involve ourselves in deep reflection based on knowledge of ourselves and observations of reality."[37] Nardal argues here that women's political participation goes beyond the single act of casting a vote. It also involves a collective self-consciousness, cultivated by empirical knowledge of the political, social, and economic realities on the island. Nardal provides a woman-centered response to Suzanne Césaire's

wartime call to know oneself amid repression and upheaval. Where Césaire imagined a project of collective self-definition that would lead to a cultural revolution in Martinique, Nardal envisions a social revolution that would lead to political representation that reflects the interests and collective will of Antillean women.

Nardal's social revolution was as much about political realities in Martinique as it was about the need to represent this political engagement in France and to the rest of the world. As she writes to readers of *La femme dans la cité*, "La loyauté, l'esprit de conciliation, la concorde sont indispensables non seulement à la reconstruction de notre grande patrie, la France, mais encore à la vie, à l'avenir de notre petit pays. Les luttes politiques aux Antilles ne constituent plus un sport, un dérivatif à l'ennui que crée l'absence de distractions, de joies plus nobles. L'enjeu en est maintenant terriblement sérieux" ("Loyalty, the spirit of conciliation, harmony is not only indispensable to the reconstruction of our great fatherland, France, even to the life, to the future of our little country. Political struggles in the Antilles no longer constitute a sport, derived from boredom bred by the absence of distractions, of joys more noble. The stakes at the moment are terribly high").[38] Nardal's juxtaposition of "notre grande patrie" and "notre petit pays" echo her 1931 description in the tourist guidebook of Martinique as "une petite France, une France lointaine." The articulation of the island's national identity as both French and Antillean performs the dual function of affirming a Martinican identity and rejecting the status of colonial subject by also claiming full French citizenship.

The upheaval of World War II contributed to the new possibilities for women's increased participation in public life. Several contributors to *La femme dans la cité* evoked recent memories of war to stress Martinican women's roles in postwar rebuilding efforts. One writer penned the following lines for the journal: "It is women who make and unmake homes / It is women who make and unmake families / It is women who must make the Nation and must never allow it to be unmade."[39] This framing situates Martinican women's political engagement on a larger national and even global scale by emphasizing their role in reconstructing the war-ravaged nation. It seeks to strike the balance that Nardal pursued in her tourist guidebook by refusing the assimilationist desire to erase the history and agency of Antillean actors and to misrecognize them as incidental to the unfolding of French history and the construction of its multifaceted national identity. Unlike the colonial administrator who denied Nardal's request for state assistance following her war injuries on the grounds that Martinique was not directly impacted by the war, *La femme dans la cité* posits a different historical narrative in which Martinique in general

and Martinican women more specifically are political protagonists whose civic participation radiates from the home to the nation.

Women's civic participation, or what Nardal called their "entry into the city," came with a distinct set of challenges. Nardal described the high costs of women's leadership in the public sphere as follows: "Furthermore, those among us who, in 1948, courageously entered the fight soliciting and obtaining the seats of municipal advisors, declare themselves disgusted by the experience. . . . Facing blaring ignorance, astounding credulity, or perfidious sectarianism of certain milieus demands a rare courage, a hardened temperament, relentless health."[40] The work of Guadeloupean deputy Gerty Archimède illustrates the monumental obstacles that women faced as they contributed to the debate on departmentalization and the practical applications of French citizenship in the Antilles.

Archimède was elected to the National Assembly at the same time as Aimé Césaire, and both deputies were at the forefront of the struggle for equal citizenship throughout the transition from colony to department. In a speech to the assembly, Archimède gave voice to Antillean women's concerns, particularly the intersecting racial and class discrimination that continued to deprive them of the social assistance and benefits that women in the metropole received: "For the past two years, women in our departments have wished to benefit from the subsidies granted to French mothers, and they do not understand the discrimination that it seems the government would like to institute."[41] Two years later, decrying France's continued inaction, Césaire intervened in the assembly's proceedings, echoing Archimède's argument. In his lengthy speech, Césaire condemned the colonial practices of discrimination, violence, and cultural erasure that continued to characterize the Hexagon's treatment of the Antilles despite the new departmental status. He argued that the overseas departments could not lay claim to full citizenship status when Antillean women were systematically denied the ability to feed their children: "For we cannot accept that a Martinican woman, a Guadeloupean woman, continues to receive, as is currently the case, 18 or 20 francs per day per child, regardless of the number of children . . . 18 or 20 francs per day for a child to whom you generously offer equality before death but refuse equality before the law and before life!"[42] Archimède and Césaire both skillfully mobilized the republican language of equality onto which France now held even more dearly after the suspension of those republican values during the occupation.[43] Their positions resonated with contributors to *La femme dans la cité*, who affirmed their solidarity with their elected representatives' struggles on their behalf.[44] Archimède herself confirmed these resonances between her politi-

cal advocacy and *La femme dans la cité's* objectives in a short essay titled "Le Rassemblement féminin vu de la Guadeloupe" (The Rassemblement Féminin Seen from Guadeloupe.)[45]

Archimède's experiences also illustrate the forms of sexism that sought to undermine women's work in the political sphere. In 1959 when she lost her seat as representative of Basse-Terre, members of the opposing party paraded through her street, carrying an effigy with disproportionately large breasts and a large posterior. On another occasion, a group of opponents attacked her while she was delivering a speech at a conference and attempted to strip her naked.[46] Both attacks indicate more than just differences in political ideology; they enact a specifically gendered form of violence that is rooted in misrecognition as a strategy of erasure. Their aim was to reduce Archimède to the stereotypical image of the black woman as hypersexualized object.

In engaging with these questions about Martinican women's place in political life, Nardal envisaged *La femme dans la cité* to be a space for interracial dialogue. When the simmering racial tensions in the new overseas department exploded into an outcry because metropolitan government workers were paid higher salaries than their Martinican counterparts in the same sector, Nardal dedicated several pages of her journal's July 1951 issue to a public conversation about racism. In her editorial, she asserts that this "humiliating inequality" had aggravated the racial malaise already present on the island.[47] She also saluted efforts by elected officials to propose a law to address the clearly racialized income disparity. In an effort to place Martinican women's concerns in conversation with the perspectives of women from the metropole, Nardal invited the reflections of "a metropolitan friend."[48] The one-page article, titled "Racisme" in large bold letters, was signed by "H. D."[49] Evidence from previous issues of the journal suggests that H. D. was in fact Hélène Durand, the wife of a French civil servant who had been living in Martinique for about a year and contributed actively both to the journal and to the Rassemblement féminin. That Durand would sign her full name to all of her essays but this one attests to the fraught and controversial nature of discussions around race and equality in Martinique as an overseas department. Her intervention also attests to Nardal's project of creating a textual space in which women could participate in the ongoing negotiation of French citizenship and its promises of equality in Martinique.

These conversations in the pages of *La femme dans la cité* were not limited to the realm of women's social engagement in Martinique. They soon became important considerations for the colonial administration as it sought to gauge political sentiment among Martinican women in the lead-up to

departmentalization. In 1945 the governor, Georges Parisot, began making inquiries with various branches of the colonial administration, including the information, medical, and education services, to find out the state of affairs concerning what he termed "le féminisme colonial" ("colonial feminism").[50] Were Martinican women registering to vote? What was their turnout at the polls? Had any women been elected to public office? The responses he received were the equivalent of a clueless shrug. The head of the information service, for example, declared in his cable to Parisot that he had the honor of informing the governor that he possessed absolutely no information whatsoever about feminism in Martinique. He continued: "It seems to me that the only person able to provide some information on this question is Mademoiselle Nardal, director of the journal 'La Femme dans la cité.'"[51]

Thus, two months after the colonial administration in Algiers pronounced Nardal ineligible for compensation for her war injuries, her name once again crossed the governor of Martinique's desk, this time as an expert on feminist issues and movements on the island. Barely a year after its inauguration, *La femme dans la cité* had established Nardal as the leading voice in women's issues in Martinique. Ascertaining the applicability of feminism as a descriptor to Nardal's work remains a matter of scholarly debate. Sharpley-Whiting argues that determining whether Nardal and her contemporaries "were feminists in the American sense of the word is necessarily fraught with cultural complications for *féminisme* in the France and Martinique of 1920–1950, and even today, does not readily translate with the same 'engaged' nuances."[52] Imaobong Umoren has described Nardal as drawing on "relational feminism to assert the importance of women."[53] What we can say for certain is that Nardal engaged with the term by maintaining Parisot's language of "féminisme colonial" as the title of the report she prepared in response to his request.

Like her tourist guidebook, Nardal's "Féminisme colonial" is a woefully under-studied text, garnering little more than a passing mention in scholarship about her work.[54] Yet this text is crucial for understanding Nardal's politics, because, unlike her newspaper and journal articles that sought to spark or contribute to conversations about race, gender, and class in the French empire, this report's specific goal was to influence public policy.[55] The form of the text resembles Nardal's "Femmes de couleur" series and therefore establishes the report not as an anomaly in her oeuvre but rather a continuation of her engagement with intersecting oppressions in Martinique and the Hexagon. Like her "Femmes de couleur" series, this text is divided into profiles of different groups of Martinican women. It attempts to account for the heterogeneous attitudes to political engagement among women of color and enumerates the

challenges faced by women in different social categories, including spouses, mothers, and "femmes abandonnées" ("abandoned women").[56] It also critiques white Creole women's emphasis on charity as the only mode of engagement with social ills.

The report is in many ways emblematic of Nardal's socially conservative views. Its astute reading of social and economic inequality in Martinique is interspersed with condescending, elitist claims about the ignorance and apathy of Martinican women and the supposed "African atavism" of Martinican men who placed their wives at the bottom of the social hierarchy.[57] Nardal also took aim at her political opponents in the report, calling out the Communist Party here as elsewhere for what she viewed as their promotion of racial animus. In a thinly veiled reference to the Union des femmes de la Martinique, another woman-centered organization, founded by Jane Léro on the heels of Nardal's Rassemblement féminin in 1945, she criticized an unnamed women's group on the far left, claiming that the group made its social assistance programs contingent on adherence to a political party (the Communist Party) that in her view promoted violence.

What is most interesting about this report for the present analysis of Nardal's engagement with citizenship are the recommendations it makes to the governor of Martinique for improving the quality of life and economic prospects of women on the island. Nardal went above and beyond Parisot's request for a summary of women's activities to propose specific policies that would alleviate what she saw to be the problems facing women on the island. In this way she asserted Martinican women's rights to state protection and assistance as French citizens. She asked the administration to determine a minimum level of child support payments and to make welfare payments directly to mothers. She also requested France extend its family welfare and maternity leave laws to Martinique and suggested the creation of educational programs to train women as social workers. Ever the social conservative, Nardal proposed the creation of "une vraie police de mœurs" ("a true morality police") and echoed the proposition put forward by the Catholic organization the Union féminine civique et sociale in the metropole to disenfranchise sex workers by taking away their electoral cards.[58] She closed with a section titled "Conclusion et opinion personnelle," which called for religious instruction in schools and civic education for Martinican girls: "It would be important to prepare girls in school for their future roles as spouses, mothers, and citizens by including civic instruction in the school curriculum and making it a subject whose study would be sanctioned by prizes and other rewards."[59]

From education to welfare to legal protections, Nardal argued for the extension of the same rights that covered women in the metropole to the

colony. At the time of her report, Martinique was not yet an overseas department, but for Nardal in the postwar period this was a new day. Martinican women could no longer continue to fall between the cracks of French legal and political discourse on equality in the way that she had when her wartime appeal for disability benefits was denied. With each recommendation in her report, she referred Parisot to the corresponding issue of *La femme dans la cité* and thus to the voices of Martinican women weighing in on these issues and asserting their place in public life and their rights as French citizens in the journal's pages. Nardal's vision for redressing economic inequality in this 1946 report is very different from the one she put forward a decade earlier in an article published in the French newspaper *Je suis partout*.[60] Adding her voice to those of sugarcane workers who had gone on strike to protest the governor's arbitrary decree of a 20 percent decrease in wages, Nardal roundly condemned the failures of capitalism in Martinique and traced the roots of the problem back to the sugar economy instituted during slavery. Yet, despite her perceptive analysis of the structural nature of inequality and the poor living conditions for working-class Martinicans, her only proposed solution was to appeal to the Christian sensibilities of the white planter class and entreat them to pay their workers fair wages. Nardal's recommendations in her "Féminisme colonial" report are therefore significant. Martinicans could not depend on the goodwill of the white planter class to improve their lot. They would have to turn to France, she believed, not cap in hand as colonial subjects but as citizens whose state-recognized rights would provide respite from the crushing power of the local white elites.

Labor Movements in the New Overseas Department

It has been my primary contention in this chapter that Nardal's writings about race and gender during her Paris years laid the foundation for her vision of Martinican women as political protagonists of departmentalization, and that this vision was undergirded by notions of a double Martinican cultural and French political location that would alleviate inequality on the island all the while refusing cultural erasure by assimilation. Nowhere was Nardal's hope for equality more evident than in her responses to the explosive labor movements that marked the early years of departmentalization. In her responses to these events, Nardal applied an intersectional framework, honed through her profiles of working-class women such as Elisa living in economic exile in Paris, to her analysis of the persistent racism that denied working-class Martinicans the status of full citizens. In her October 1948 editorial for *La femme dans la*

cité, she felt compelled to weigh in on the explosive events of the previous month, a violent strike that led to the murder of Guy de Fabrique, the white Creole administrator of the Habitation Leyritz in Basse-Pointe, a commune in the north of Martinique.[61]

On September 6, 1948, Fabrique received a report that sugarcane workers on strike at the Habitation Leyritz had threatened to kill their overseer, his brother Gaston. He arrived at Leyritz brandishing a revolver and accompanied by gendarmes. During the heated exchange with the laborers, Fabrique is believed to have fired his revolver, narrowly missing one of them. Unnamed workers in turn hacked his revolver-wielding hand with a machete. They pursued the fleeing Fabrique into the cane fields and killed him with thirty-six machete blows. His neck was subsequently broken with a crowbar.[62] The arrest of sixteen agricultural workers and the trial that followed in Bordeaux in 1951 became known as the *Affaire des 16 de Basse-Pointe*. The legal proceedings reverberated throughout hexagonal and overseas France. For many observers, it was a trial not of the sixteen accused but of colonialism itself. The team of defense lawyers, which included Archimède, highlighted the questionable role that state police had played, and the many irregularities in the subsequent legal proceedings, including induced testimonies and disappeared evidence. Martinique's first prefect, Pierre Trouillé, was called to the stand and in his testimony described himself as the governor of the island, a telling use of colonial terminology that revealed his vision of Martinique as still a colony administered by a governor rather than a department headed by a prefect.[63]

Yet, as extraordinary as Fabrique's murder was for the intensity of the violence, the ensuing media frenzy, and the enduring silence of the surviving members of the sixteen accused to this day, the events at the Habitation Leyritz were not the first time a strike had gone so violently awry in Martinique. Six months before the Basse-Pointe affair, Martinique had been rocked by murders in the neighboring commune of Carbet. Workers on strike at the Habitation Lajus were lured into an ambush by their béké boss under the guise of paying their overdue salaries.[64] Unbeknownst to the workers, their boss had invited, housed, and fed a group of law enforcement officials who now awaited the workers' arrival. They opened fire on the cane workers, killing two of them and wounding several more. Newspapers carried the story in Martinique. In France, Aimé Césaire made urgent calls for the National Assembly to repeal Trouillé for his complicity and role in the affair. Césaire declared that "a veritable atmosphere of terror reigns on this peaceful island."[65] He would later describe the Basse-Pointe sixteen as victims of colonial violence who struck out in counterviolence of their own.[66] As Aaron Freundschuh notes, "Sensational crimes play a role in reordering colonial relations."[67] Both

Césaire's calls for the sacking of the prefect and Archimède's leveraging of the French judicial system in her work on the Basse-Pointe sixteen's defense team were loud calls to France to make good on its promises of full citizenship in the Antilles and to protect Martinicans from the considerable power of the descendants of slaveholders on the island.

Read in this context of explosive and deadly race and class relations in Martinique that had clear roots in the bloody history of the island's sugar economy, Nardal's editorial on the Affaire des 16 de Basse-Pointe took a markedly conservative stance. Claiming to speak for all Martinican women and in solidarity with Fabrique's wife, she chastised the Leyritz workers for acting as "des brutes sanguinaires" ("bloodthirsty brutes") misled by false political propaganda aimed at stirring up racial and class divides.[68] Yet even as she criticized the workers, she also recognized the appalling living conditions endured by the laborers who she argued made up a large portion of the island's population and declared that the exploitative labor conditions of the colonial era, what she called "l'exploitation d'antan" were no longer tenable in Martinique's new political configuration as an overseas department.[69] For Nardal, as for Aimé Césaire, the promises of departmentalization, including the application of French law in place of the colonial penal system, would provide legal recourse for Martinique's working poor and end the pattern of unpunished killings of laborers by state police apparently at the behest of wealthy white Creoles. Both Césaire and Nardal framed Martinique's belonging to the French nation as a path to justice in the face of historical inequalities. France's former colonial subjects could theoretically use the legal rights and protections afforded them as citizens to counter béké colonial practices such as economic exploitation and police brutality.

To be sure, the limitations of this project are certainly clearer today than they were in the mid-twentieth century. Agricultural workers continue to bear the brunt of departmentalization's failures, as evidenced by the ongoing chlordecone scandal.[70] In 2007, Louis Boutrin and Raphaël Confiant published *Chronique d'un empoisonnement annoncé* (Chronicle of a Poisoning Foretold), in which they charged that Guadeloupe's and Martinique's soil and water had been poisoned by the pesticide chlordecone, used on banana plantations. France had permitted the continued use of a toxic pesticide in the Antilles over two decades after its interdiction in the Hexagon. The report sent a shockwave throughout the islands. A flurry of medical tests and studies by government bodies, journalists, and independent organizations revealed the potential links between the contamination and the startling statistic that Martinique today with its population of only about four hundred thousand people, has the highest rate of prostate cancer in the world. For many, that

France continued to authorize the use of a toxic substance in the Antilles long after it had taken steps to protect residents in the Hexagon speaks of the continued devaluing of Antilleans' claims to French citizenship. As banana workers reveal higher rates of breast and prostate cancer, they also express what they view as the state's refusal to satisfactorily address a dire situation.

The tense and sometimes deadly struggles for equal treatment in the overseas departments plays out as much in the chlordecone scandal today—particularly as it is felt by the agricultural workers who were in closest contact with the pesticide—as it did when Nardal weighed in on the trial of sugarcane workers in 1948. As Aimé Césaire would acknowledge in coming years, this strategy of using French citizenship as a means of anticolonial resistance would be a constant battle, one that Martinicans would not always win.[71] At the time of *La femme dans la cité*'s circulation, however, this citizenship remained a viable tool for disenfranchised Martinicans to voice their dissatisfaction with inequalities and to seek redress.

Nardal shared this utopian view of the promises of French citizenship in an interview with the *Chicago Defender* in 1946 while in the United States as a United Nations area specialist for the French West Indies: "Since the war [Nardal] said, the French franc lost much of its value and the great losses had left many of her people very poor. Their spirits have been elevated, however, due to the fact that in January they will become for the first time an official department of the French."[72] Nardal once again embodies the seeming contradictions of Martinique's political position. On one hand, she articulates the hope that Martinique's status as a French department would better the island's economic fortunes. On the other hand, her stated objective at the UN—"to impart information about her country on questions of economic and social significance on non-self-governing territories"—shows that Nardal remained keenly attuned to the particularities of Antillean social and political reality and sought to advocate for specifically Antillean interests on an international stage.[73] Finally, that the headline to this newspaper article describes the fifty-year-old Nardal as "Martinique Girl Given High Post with UN Body" reminds us once again of the obstacles to recognition and equal treatment that characterized black women's inclusion in political discourse.

Nardal's continued focus on intersecting forms of oppression, present already in her Parisian writings of the 1930s, persisted throughout her work in Martinique. In an October 1945 editorial in *La femme dans la cité*, she encouraged Martinican women to form coalitions across political party affiliations as well as racial and class differences.[74] Nardal herself formed an array of alliances in pursuing what she described as "the just demands of women."[75] These connections included French and American feminist and religious

groups as well as radical socialists and communist activists with whom the Rassemblement féminin stood in solidarity against fascism.[76] Nardal was not alone in recognizing the importance of forging transatlantic feminist alliances. The collaboration between two senators, Eugénie Éboué-Tell and Jane Vialle, whose networks spanned Central Africa, metropolitan France, the Antilles, French Guyana, and the United States, was emblematic of the transnational nature of black women's engagement with citizenship.

3. Eugénie Éboué-Tell and Jane Vialle

Refiguring Power in the French Union

Few words express more ideas, activities and differences than the word "colonial." And yet in both French and English, it has been used very carelessly and most of the time without discrimination, as if men had failed to see that it concerned the very existence of hundreds of millions of human beings.
—Eugénie Éboué-Tell, "French End Colonial Era"

The task set before us is long, it will stretch across multiple generations, but I repeat, there will be no true and profound evolution without the evolution of women.
—Jane Vialle, AFUF Editorial, May–June 1948

Eugénie Éboué-Tell's and Jane Vialle's elections to the French Senate after World War II came at a time when France was reinventing itself as a nation. Resistance to and collaboration with Nazi occupation during the war were foremost in collective French memory and played a crucial role in shaping the postwar discourse on national identity. The place of French women in this new nation in formation was at the fore of these conversations, because women's contributions to the war effort presented new possibilities to occupy social and political positions to which they previously had limited access. In a December 1944 article, *Horizons*, a weekly magazine published in Marseille, joined the conversation on citizenship and patriotism in wartime by tracing the history of women's military service back to eighteenth-century France. To drive home its point that they had been a crucial force in the French Resistance, the magazine featured photographs of women in army uniforms, marching in unison with guns slung over their shoulders. The accompanying

LES FEMMES-SOLDATS
EXISTENT DEPUIS LONGTEMPS

Beaucoup d'Anglaises connaissent la vie du soldat...

IL y a quelques jours une compagnie féminine F. F. I. a défilé à Londres, où le peuple britannique lui a réservé un accueil chaleureux.

Les femmes-soldats existent depuis longtemps. La France, la première, a donné ce spectacle au monde, des familles entières s'enrôlant pour aller au combat, en 1792, et repousser les armées étrangères.

C'étaient de bonnes bourgeoises, d'actives ménagères, qui pensaient défendre le pays comme on défend la maison, ou bien des jeunes filles à l'âme ardente, que les dangers de la Patrie avaient désolé.

On vit des jeunes filles du monde hausser leurs pieds délicats d'épais sabots, blesser leurs mains blanches au maniement des armes, manger des pommes de terre crues, sommeiller au bivouac, sur la « dure », au milieu des soldats.

Un an plus tard, en 1793, les femmes qui combattaient aux armées ayant été congédiées, beaucoup, pour tromper leurs camarades, s'habillèrent en soldats et s'enrôlèrent de nouveau sous des noms d'hommes.

Plusieurs de ces femmes-soldats furent décorées de la Légion d'honneur pour leur bravoure. L'une d'elles, Jeanne-Marie Barrière, ex-chasseur d'infanterie légère, originaire des Hautes-Pyrénées, sollicita de Napoléon la Croix d'honneur et l'obtint sans peine. Elle lui écrivait notamment :

Mes papiers, qui sont dans vos bureaux, Monseigneur, vous attesteront la vérité des actes de bravoure ci-après relatés, que je me flatte d'avoir produits, et qui furent consignés dans le recueil des traits héroïques.

Le 23 juillet 1793, étant tirailleuse; je fus enveloppée par l'ennemi, désarmée, et faite prisonnière. J'arrachai le fusil de l'un d'eux, après avoir tué son camarade avec cette arme, je le fis prisonnier. Ce fait se passa entre les deux armées, et au milieu d'une grêle de balles.

Le 5 août suivant, je reçus une balle dans la cuisse droite. Je l'en arrachai, je la mis dans mon fusil, et je la renvoyai à l'ennemi. A la vue de ma blessure, mes chefs me sommèrent de me retirer pour me faire panser. Je m'y refusai.

A la prise de Tolosa, en Espagne, j'étais tirailleur. J'entrai un des premiers dans la ville. Un officier me surprit et me terrassa d'un coup de sabre sur l'épaule, et son cheval me passa sur le corps. Sans perdre mon sang-froid ordinaire je me levai et, d'un coup de carabine, je lui fis mordre la poussière...

La Croix des braves et une pension récompensèrent Jeanne-Marie Barrière dont le courage — sinon les exploits — a été égalé par plus d'une de nos femmes-soldats F.F.I.

MAX LEVASSEUR.

...et quelques Françaises d'Afrique la connaissent aussi

FALA
accepterait-il, lui, des chats dans la MAISON BLANCHE ?

DES chats royaux ont-ils le droit de pénétrer dans la « Maison Blanche » à Washington ?

Deux petits chats mignons, Jane et Belinda, nés dans le palais du roi d'Angleterre, ont été offerts au président Roosevelt comme compagnons de son chien Fala. C'était une sorte de « prêt et bail » réciproque.

Mais un secrétaire de la « Maison Blanche » a décommandé ce royal cadeau au président, en arguant que Fala n'aime pas les chats. Cependant, ce n'est pas la vraie raison.

En réalité, c'est une vieille superstition qu'un chat dans la « Maison Blanche » porte malchance au président occupant. Depuis Mc Kinley qui fut assassiné, plus aucun président n'a eu un chat dans sa demeure officielle.

« Oui, mais... Roosevelt a déjà passé outre tant de traditions établies — entre autres en se faisant élire pour la quatrième fois — qu'il pourrait aussi en finir avec cette vieille superstition que les chats portent la « poisse » à la « Maison Blanche ».

Mais, peut-être Fala aime-t-il les chats, surtout quand ils viennent de Buckingham-Palace ?

13

Women soldiers in *Horizons* magazine. Courtesy Bibliothèque nationale de France.

captions cast a wide geographic net and extolled the patriotic wartime service of English and French women: "Many English women know army life . . . And some French women from Africa know it also."[1]

These photographs are striking because they foreground women in the public discourse on French history in the making. The smiling faces of many of the soldiers as they march triumphantly through the streets craft a celebratory narrative of heroic women erupting victoriously onto the scene of public life through their military service. The photographs are striking too for their conspicuous erasure of black women from this narrative. Despite the gesture to "quelques Françaises d'Afrique" ("some French women from Africa"), the accompanying images suggest that this designation refers only to white French women living in Africa. In this article, written less than two years before the ratification of the *loi Lamine Guèye* in May 1946, which granted French citizenship, at least on paper, to all of France's colonial subjects, a photograph of "quelques Françaises d'Afrique" could conceivably refer to white women only.

As decorated members of the French Resistance and, later, elected representatives to France's highest governing bodies, Éboué-Tell and Vialle disrupted this exclusionary narrative. Through their participation in the Resistance and in their writings about their wartime experiences, they challenged notions of black women in the French empire as silent and invisible. Their subsequent work in the Senate allows us to examine the nature of feminist anticolonial practices that emerged from domains such as public politics that were and continue to be marked as masculine. A close reading of their anticolonial visions across a series of interviews, essays, and legislative texts brings into sharper focus the contours of a transnational feminism that was both constituted by and positioned against the established power of colonial rule. In their work, Éboué-Tell and Vialle articulated their feminist politics in the context of a transnational network of black women's resistance that connected Central Africa to the Antilles, French Guyana, the United States, and hexagonal France.

Éboué-Tell and Vialle were two of the most prominent voices in the conversation on race, gender, and citizenship on both sides of the Atlantic. Their stories are a testament to the political ties that connected disparate parts of the French empire in a shared claim to citizenship in and equality with metropolitan France. Éboué-Tell, a woman from French Guyana who spent over two decades living in French Equatorial Africa (AEF), would come to represent Guadeloupe in the National Assembly in Paris. Vialle's arrest and trial in Marseille would provide one of the few documented cases of an African woman interned in a concentration camp in Europe during the war. Their

articles and speeches are particularly valuable because they allow us to examine black feminist anticolonial discourse within the context of the peculiar and short-lived polity that was the French Union. Both women disrupted the dominant view of black women's place on the margins of political action through their wartime service in the French Resistance. Then, drawing on this wartime service, they worked to reverse the discourse on France's "gift" of civilization to the colonies. They reformulated the idea of the colonial debt as the metropole's indebtedness to the colonies for its liberation from Nazi occupation. This reversal provided a platform for both women to demand France's recognition of its former colonial subjects, particularly women, as full citizens. Harnessing the powerful and seductive language of French republicanism, Éboué-Tell and Vialle articulated a new model of political identity rooted in the recognition of the fundamental rights of Africans and Antilleans in general and black French women in particular. Citizenship for Éboué-Tell and Vialle, as this chapter shows, was premised on a transfer of power from the metropole to overseas France through increased political representation and control over local economies.

Eugénie Tell was born in Cayenne, French Guyana, on November 23, 1891, to Joséphine and Herménégilde Tell. Her father would later become director of the prison that made France's South American colony an infamous penitentiary. Eugénie married Félix Éboué, also Guyanese, in 1922 and moved to Oubangui-Chari, where her husband worked in the colonial administration. Félix already had two sons, Henri and Robert, from previous unions with African women whose only official presence in the archives today is the inscription "mère inconnue" (mother unknown) on their sons' birth certificates.[2] Eugénie and Félix had two children, a son, Charles, and a daughter, Ginette, whose marriage to Léopold Senghor came to symbolize for a time an Afro-Antillean political alliance in the French Union. In 1932 the couple spent two years in Martinique, where Félix worked as secretary general until his transfer to French Sudan for the next two years.[3] From there they moved to Guadeloupe. Félix's tenure as governor there between 1936 and 1938 left such a mark on the island that after his death, in 1944, members of Guadeloupe's Socialist Party asked Eugénie to run for elections as their parliamentary representative. As governor of Chad from 1938, Félix made history in August 1940 as the first French administrator to publicly reject Vichy rule and rally much-needed troops and resources for Charles de Gaulle's nascent Free French Forces.

The Éboués publicly supported de Gaulle at a time when it was neither popular nor safe to do so. After Félix's declaration of allegiance to the French Resistance, the Vichy government in France condemned him to death in

absentia and confiscated the Éboué family home in Asnières, a suburb of Paris. While the youngest Éboué son, Charles, was training in Britain and Canada to join the air force, Eugénie and her husband spent a nerve-racking year desperately seeking news about their older children, Henri, Robert, and Ginette, who were at the mercy of Vichy retaliation in Europe. A Vichy official reportedly tried to dissuade Félix from supporting de Gaulle in a menacing radiogram that said simply, "What can little French Africa do? Think of your children!"[4] The two young men, as Eugénie and Félix later found out, had been held in a German prisoner-of-war camp from June 1940. After eighteen months, Robert escaped. Henri was later released with the help of the camp's French doctor and a set of falsified x-rays that showed him to be ill with tuberculosis.[5] Ginette was no longer allowed to continue at the Legion of Honor School but had gained admission to a different school in occupied France. The three children were eventually smuggled out of Europe on British passports.[6]

In a January 1943 press release slated for the Sunday newspapers, the U.S. Office of War Information reported that the three Éboué children had been reunited with their parents in Brazzaville after being "held as virtual hostages in France since the turbulent months following the Armistice of June 1940—the period when the whole French colonial empire hung in the balance."[7] Félix's choice of Free France over Vichy rule placed both his family and France's African colonies under new scrutiny on an international stage. It also marked a turning point in the war by bolstering the resources of a defeated France. On his death in Cairo, in 1944, French newspapers printed a special black-bordered edition of mourning.[8] Félix Éboué was the first black man to be interred in the Pantheon, one of the highest honors France confers on its departed national heroes.

Though lesser known, Éboué-Tell was just as ardent a Gaullist as her husband. She was one of a handful of people in the governor's inner circle privy to the clandestine organizing of troops throughout Africa in the early days of the French Resistance movement. She joined the Corps des volontaires de l'Afrique française combattante (Women's Army Auxiliary Corps) and served at the Brazzaville military hospital as a nurse between 1941 and 1944. Her wartime service and later political work earned her at least twenty-six medals of recognition in France, Ivory Coast, and other countries. Her citations include three of France's highest honors: a Médaille de la Résistance (1945), a Croix de Guerre avec Palme (1939–1945), and a Chevalier de la légion d'honneur (1946). Despite this recognition, her legacy is nowhere near as prominent as her husband's. Not only has Éboué-Tell been marginalized in contemporary

scholarship, but her work has been actively minimized as well. A biography of Félix, for example, has this to say about her:

> In the meantime Madame Eboué enjoyed shopping for clothes that she could wear at the receptions and dinners. In spite of the fact that the world economic depression had struck France, the designers still had enough spirit to argue about hemlines, skirt lengths and hair styles. But Madame Eboué's taste in clothing was conservative and, in any case, she, like her husband, had become a little stout. She did not thus try the new dresses with the wasteline [*sic*] at the hip, a Patou innovation, or the Victorian bustle that one courier tried to bring back, or even the "Eugénie" hat which, in spite of its name, had little appeal.[9]

Éboué-Tell plays an ornamental role in this narrative. She manages to remain blissfully unaware of world events and is shielded from the effects of the Great Depression despite the resulting hardship that was also felt in the colonies. Draped in a flurry of lace and taffeta, her only noteworthy contribution is to lend her name to an unpopular hat.

There is, of course, more to her story than this. After the war and Félix's death, Eugénie ran for a seat in the Constituent National Assembly on the Socialist Party's ticket. She represented Guadeloupe in the assembly from 1945 to 1946 and worked alongside fellow deputies Césaire, Senghor, and others in drafting the constitution of the French Fourth Republic. In this role, Éboué-Tell pushed for and obtained an amendment to the constitutional article that allowed inhabitants of overseas France who did not have a French *statut civil* to keep their personal status under local law. The statut civil, also known as an *état civil*, designates the state's recognition of a person's place within a family, community, and nation. This recognition is recorded on documents such as a birth or marriage certificate. In the colonial period, there were many obstacles that could make acquiring such documentation impossible for those in the colonies, including barriers of language and literacy as well as limited access to administrative centers. The statut civil therefore presented a potential loophole that would allow colonial administrators to deny citizenship rights to those who could not obtain the necessary paperwork. Éboué-Tell's amendment specified that the absence of a French statut civil "can under no circumstance constitute a motive to refuse or limit the rights and freedoms that accompany the status of French citizenship."[10] Her amendment draws a crucial distinction between symbolic citizenship on paper, encapsulated in the documentary evidence of a statut civil, and citizenship in practice, the acquisition of legal rights and protections enshrined not in the bureaucratic

processes of administrative paperwork but in the very fact of one's being in and belonging to a larger, reimagined France.

After her brief tenure in the Constituent National Assembly, Éboué-Tell was elected to the Senate in 1946, where she continued the work she began as a deputy, advocating for equal rights for France's overseas subjects-turned-citizens in concrete terms that went beyond symbolic gestures of citizenship in name only. She lost her Senate seat in 1952 but was elected that year as vice president of the French Union. On the dissolution of the union, she became councilwoman for Asnières in 1958, where she remained politically active until her death in 1972. While in the Senate, Éboué-Tell faced much opposition to her efforts to pass legislation in favor of women in the French Union. She found an ally in Jane Vialle, a senator representing Oubangui-Chari. Together they worked on resolutions to apply French paternity law to overseas territories and to protect Malagasy politicians from political retaliation. They also served together on the Commission de la France d'outre-mer (Commission on Overseas France). Éboué-Tell later penned an article titled "Les rôles des femmes" (Women's Roles) for the Guadeloupean newspaper *La Raison*, in which she cited Vialle as an example of an African woman holding her own in a Senate dominated by men.[11]

Jane Vialle was born in Ouesso in the Republic of the Congo, on August 27, 1906, to a French man and an African woman. Like the African mothers of Félix Éboué's older sons, Vialle's mother is also virtually erased from the archive. Her name, rendered as Tchiloumba,[12] Tchilambou,[13] and Tchilombou,[14] and Eslanda Robeson's brief annotation in her travel journal that Jane was living with her mother in Brazzaville in 1946 are the only textual traces of her life.[15] Jane's father, Michel Vialle, was the director of the concessionary company Compagnie des sultanats du Haut Oubangui, which oversaw the exploitative extraction of ivory and rubber from the Central African colony. He hired Éboué's brother-in-law, Félix Gratien, but soon came into conflict with Éboué when the administrator ordered Vialle's trading company to stop underpaying African merchants for their ivory.[16] Vialle later moved to France with his seven-year-old daughter, where she received her *baccalauréat* from the Lycée Jules-Ferry in Paris.

Jane Vialle resurfaces in the archives in 1940 when she moved from Paris to Marseille at the start of the war. She worked for various journals, drawing comic strips and writing short stories.[17] She was also a clandestine agent for Jean Gemähling, head of information services for the Provence-Côte d'Azur regional branch of Combat, one of the three major Resistance movements in the south of France. She was arrested in January 1943 at her home in Marseille, along with Gemähling, who used the premises as an office. Both

were charged with treason ("atteinte à la sureté extérieure de l'Etat").[18] She was interned from January to April 1943 in the Brens women's concentration camp and then transferred to the Beaumettes women's prison in Marseille until December. The historical accounts differ on what happened next. The transcripts of her trial indicate that she was released from prison for lack of evidence that she knowingly participated in the Resistance. This declaration is noteworthy because it relies to an extent on the trope of the hapless woman with an insufficient capacity to discern the context and consequences of her own actions. A competing narrative, however, appears in the text of her post-humous 1953 Citation à l'Ordre de la Nation, which states that Vialle escaped from prison, a coup whose details remain shrouded in mystery. Her wartime actions also earned her, like Éboué-Tell, a Médaille de la Résistance in 1945.

After the war, Vialle moved from the arena of underground resistance to the realm of public politics. In 1945 she undertook "a 9,000-mile speaking tour through Senegal, Ivory Coast, Ubangui Chari and Chad," addressing critical issues surrounding "the educational and economic needs of the African people."[19] By the next year she had founded her own political party, the short-lived Association pour l'évolution de l'Afrique Noire (APEAN), as well as a women's organization, the Association des femmes de l'Union française (AFUF), which had its own journal.[20] She also won a seat in the French Senate as an independent candidate. In her capacity as secretary general of the AFUF, she worked closely with Michelle Auriol, who was then the first lady of France and president of the association, and Thérèse Monnerville, vice president of the AFUF and wife of the president of the French Senate, Gaston Monnerville. The Guyanese-born Monnerville was a crucial ally for Vialle and Éboué-Tell in the Senate because the office he held made him one of the most powerful politicians in the French Fourth Republic. He would have by law succeeded de Gaulle as interim president of France when the former resigned from office in April 1969. Had Monnerville sought reelection at the end of his Senate presidency in 1968, only a few months before de Gaulle's resignation, he would have been the first black president of France. In addition to her ties to some of France's most prominent black politicians, Vialle was also active on the international stage. She was a member of the United Nations Ad Hoc Committee on Slavery between 1949 and 1951 and was charged with documenting the existence of forms of slavery in Africa at the time. She lost her Senate seat at the same time as Éboué-Tell in 1952 and died in a plane crash a year later.

Scholarly analyses of Éboué-Tell's and Vialle's contributions to the discursive framing of citizenship in the French empire are today few and far between.[21] Yet at the height of their political activity, they were two of the most power-

ful black women in the world. Éboué-Tell, for example, was not only the wife of the man who one newspaper headline trumpeted as "the Negro who defeated Hitler."[22] She was also a major player in French and Afro-diasporic politics in the 1940s and '50s. She was featured in the eighth edition of the encyclopedic collection *Who's Who in France* and was one of the rare politicians whose interventions in the divided National Assembly and Senate often drew thunderous applause across party lines. A particularly heated parliamentary debate in December 1945, for example, brought outre-mer deputies together to advocate for economic reforms and sustained government investment in the development of overseas France. Raymond Vergès and Aimé Césaire spoke in succession about the ills of the colonial banking system in Réunion and the sugar economy in Martinique, respectively. Éboué-Tell followed with her own lengthy intervention, in which she took a broader view of overseas territories as a whole and argued for a range of reforms across several sectors, including education, infrastructure, and health care. She buttressed her demands for a living wage for Antillean laborers with the forceful declaration: "Plus de salaire de misère!" ("No more poverty wages!").[23] Her speech was interrupted thirteen times by applause throughout the chamber, punctuated with deputies' affirming cries of "Très bien! Très bien!" and met with a standing ovation.[24]

Across the Atlantic, Éboué-Tell also had an active presence in the United States. The *Baltimore Afro-American* reported that by 1958 she had made 138 trips to the States. During her travels, she was often met by a crowd of journalists who were eager to hear her analysis of race relations both in the United States and in the French Union.[25] The Guianese clarinetist Rudolph Dunbar introduced Éboué-Tell to the NAACP's executive secretary, Walter White, in 1945.[26] A year later, during one of her many brief stops in New York City on her travels between Paris and Basse-Terre, White scrambled to organize a dinner with NAACP leaders in Éboué-Tell's honor and hoped to host it at one of the three luxurious hotels near Grand Central Terminal: the Biltmore, the Roosevelt, or the Commodore.[27] Over the years, Éboué-Tell maintained epistolary exchanges with White—who had met and interviewed Félix in Cairo about a month before his death—and hosted Ralph Bunche in Paris in 1952 before she herself jetted off to Brazzaville for the city's bicentennial festival.[28] The *Amsterdam News* concluded that Éboué-Tell was "one of the busiest women in the world,"[29] and the *Pittsburgh Courier* announced to its American readers that she held "the most advanced political position occupied by any Negro in the so-called Occidental world today."[30]

Jane Vialle also had a significant political presence on both sides of the Atlantic. Barely a year into her tenure in the Senate, she managed to secure funds to buy two hostels, including a fifty-room building in Paris, to house

outre-mer students who struggled with inadequate government accommodations and the often delayed disbursement of their meager scholarships.[31] She was the NAACP's guest of honor in January 1951 and later that year was invited to speak at Wellesley and Hunter Colleges, where she stressed that women's increased access to education was crucial for democracy in Africa.[32] Vialle was also featured in a Negro History Week kit, the only woman in a lineup of prominent black internationalist figures including Carter G. Woodson, W.E.B. Du Bois, Emperor Haile Selassie, and Félix Éboué. The thirty-two-page pamphlet was intended "for school and group use during Negro history week" and sought to "emphasize the struggles of Negroes at home and abroad to achieve first class citizenship."[33] In addition to recognizing Vialle's political contributions, the publication, as a project of collective memory, also placed these contributions in the context of twentieth-century black transnational politics.

Although both women espoused progressive political ideas for their time, their works do not appear particularly radical today, especially when read alongside demands for national sovereignty by more revolutionary thinkers. As political elites, Éboué-Tell and Vialle believed in France's republican promises. As women from the colonies who constantly straddled the line between colonial subject and citizen, they were also engaged in a project of reimagining the political future of Africa and the Antilles free from colonial rule. My goal in this reading of their works is neither to lament this seemingly paradoxical position of outsiders within the corridors of power nor to craft a celebratory narrative of elite black women overcoming the contradictions of their social and political positions in order to espouse a singular, unified, and acceptably radical politics. Instead, I am interested in examining the range of black women's responses to colonialism and the different methods and political models they envisioned in their practice of anticolonial resistance. Both Éboué-Tell and Vialle were invested in imagining new forms of French citizenship in opposition to colonialism and crafted a political narrative that aimed to stretch, reshape, and ultimately refigure Frenchness. Rather than demand the inclusion of the colonized into the existing, exclusionary body of colonial France, they sought to remake France in its own idealized republican image. This remaking—an act of creation, as Suzanne Césaire imagined it—was necessarily transnational in nature, as it located itself at the distinct but porous boundaries of hexagonal and overseas France. It was also feminist, because its architects placed black women at the center of their demands for a redistribution of political and economic power in the transition from colonial subjects to citizens.

Éboué-Tell and Vialle questioned the racial classifications that France wielded in the service of colonial conquest and put forward legislation for

increased access to education and changes to the colonial economy that would give Africans and Antilleans, particularly women, power and control over their own lives and labor. To demand such a foundational shift in the ethos and organization of the French empire was also to demand a fundamental transformation in the colonial relationship between the metropole and overseas France. For Éboué-Tell and Vialle, this transformation was not simply a question of colonial reform—giving concessions to different groups in the colonies in order to maintain the colonial imbalance of power. Both women were involved in a decolonial project that may today appear contradictory, for while it was deeply invested in dismantling colonial power, it was not predicated on a complete rupture from France. They both viewed the French Union as that alternative model of political belonging that would refigure the colonial model of France's unilateral authority over its colonies as a political relationship among equals. Yet both women were aware of the tensions in their positions as ardent believers in French republicanism and staunch opponents of French colonialism. They continued to face and resist racism and the marginalization of women in this new polity that was ostensibly to be a more just and equal French Union, wielding France's tripartite motto of liberty, equality, fraternity in their struggle for decolonial citizenship.

Black Women in the French Resistance

Éboué-Tell and Vialle drew heavily on their wartime experiences in defining their anticolonial politics. The role of France's colonial subjects in the world wars has been explored in some important and much-needed scholarly inquiries.[34] Notably, scholarship on the *tirailleurs sénégalais*, troops drawn from African colonies, raises important questions about racism in the French army as well as the impact that World War II had on veterans who went on to further anticolonial demands through protests and labor strikes on their return to the colonies.[35] A new study also provides an essential historical account of the role of women in the French army during the world wars.[36] However, like the *Horizons* article and photograph described in the opening of this chapter, this account establishes a military genealogy that begins with Joan of Arc and ends with women in World War II, a genealogy in which "all the women are white."[37] The story of African and Antillean women in the world wars remains to be told. Éboué-Tell's and Vialle's contributions to the French Resistance provide a useful beginning to this story, one that reveals the impact of World War II on black French women's articulations of citizenship in the postwar period.

As a candidate for one of Guadeloupe's two seats in the Constituent National Assembly in 1945, Éboué-Tell based her electoral campaign on her wartime contributions to France and the colonies. In a speech addressed to voters in Guadeloupe, she cast herself as a political protagonist, as both a central actor in and a chronicler of the story of France's liberation. The first third of this thirty-page handwritten address reads like an epic narrative about Africa's role in World War II. Éboué-Tell provides a day-to-day breakdown of the clandestine organizing of troops between de Gaulle's landmark June 18 BBC radio broadcast and the deployment of African soldiers in August. In her speech we hear de Gaulle's voice rallying France and its colonies to repudiate Vichy occupation and join the Free French Forces, and we witness, from Éboué-Tell's point of view, the impact of this voice on France's subjects in Chad, who responded with a resounding "Oui!" She recounts: "When, on the 18th of June, a deep voice, melancholic despite its firmness, cried out from London 'France has lost a battle, but France has not lost the war, she still has an *intact* empire,' . . . such a shiver ran through us that one might say for most of us the way had been opened."[38] Éboué-Tell establishes this moment as the crucial opening salvo in an epic narrative that sees battalions of African soldiers marching "from success to success" from Chad to the heart of Germany to liberate France.[39]

In recuperating the immediate past memory of war, Éboué-Tell crafts a new account of the French Resistance that centers African and Antillean actors. It is interesting to note that despite her use of quotation marks to demarcate de Gaulle's speech within her own, Éboué-Tell misremembers his words. She quotes here a combination of de Gaulle's second radio broadcast on June 22, in which he turns to France's vast empire for help to liberate the metropole, and the catchy expression "La France a perdu une bataille, mais la France n'a pas perdu la guerre" ("France has lost a battle, but France has not lost the war") that headlined the posters plastered around London after the radio broadcast. Éboué-Tell's conflation of multiple declarations reveals her deliberate production of world history that seeks to capture both the personal story of her family's participation in the Resistance and the collective memory of overseas France's service to the metropole.

As she outlines her own central role in this epic, Éboué-Tell assures Guadeloupean voters that she and her husband often thought of "this emerald island, the beautiful Guadeloupe, feeling that your hearts were beating in unison with ours."[40] Éboué-Tell traces a line of continuity from her family's military service in AEF in 1940 to her electoral promise in 1945 to obtain more equitable remuneration for exploited Guadeloupean cane workers: "It

is this Resistance that you followed, and which became *France Combattante* that I evoke today in order to stand before you and ask for your votes."[41] Her deft maneuvering between past and present, Africa and the Antilles, was strategic. As a Guyanese woman who had spent most of the past decade in AEF, she needed to establish her credibility as a politician who could represent Guadeloupe and advocate for the rights and benefits due the island's inhabitants as French citizens.[42] She articulates through her narrative a transatlantic connection that emphasizes a shared politics of liberation and links AEF and Guadeloupe through their wartime resistance.

Éboué-Tell's transatlantic solidarity was multidirectional. In a parliamentary speech in favor of establishing local governing assemblies in French West and Equatorial Africa, respectively, she emphasized the crucial role that African soldiers played in liberating France, military service that the metropole now hoped to conveniently forget in the face of demands for increased political autonomy in the colonies: "Il faut bien que chacun se pénètre du fait que ces noirs qui ont souffert, ces noirs qui ont donné leur sang pour que la France vive . . . doivent recevoir aujourd'hui la juste récompense qu'ils ont toujours espérée" ("It is necessary for each one to understand and accept the fact that these blacks who have suffered, these blacks who have given their blood for France to live . . . must receive the fair compensation for which they have hoped for so long").[43] Her use of the verb "se pénétrer" is particularly noteworthy. It is a term that may be addressed to a particularly skeptical or stubborn interlocutor. It means to internalize or to become profoundly convinced of something. Although the debate at hand was not directly about colonial veterans, Éboué-Tell insists here on the centrality of France's recognition of colonial troops to the broader question of establishing more democratic frameworks for political participation and local government. Citizenship, she believed, would symbolize France's recognition of the humanity of those who gave their lives to liberate the Hexagon, of those Africans who occupied the footnotes of French history as expendable on the battlefields of Europe. As Éboué-Tell argued in the National Assembly in 1946, the debate on citizenship was "a serious question for the destiny of our overseas territories."[44] It was, without hyperbole, a matter of life and death, because it would determine access to adequate health care, formal education, and employment and would, above all, abolish the brutal colonial penal system, the hated *indigénat*.

In this same speech, Éboué-Tell went on to buttress her call for recognition of African veterans with a clear statement of transatlantic solidarity that is worth quoting in full for its unequivocal black transnational politics: "I do not feel removed from them simply because I now belong to a department. My heart is as close to them now as I was yesterday, at a time when our na-

tive country was but an overseas territory. It is for this reason that I ask the government and the entire assembly to consider that it is high time that we give satisfaction to the brothers of our race, to my brothers at the very least, in short, to our brothers."[45] Éboué-Tell grounds her expression of solidarity with the French African territories in a common history of French colonization in Africa and French Guyana and in a shared racial identity that echoes some of the more politicized articulations of Negritude. As she reminds her fellow parliamentarians, this larger project of transforming France from an empire to a union was ongoing, and the gradual acquisition of equal rights gained thus far was due to the continued and unified efforts of those still colonized by France.

Éboué-Tell's retelling of the story of France's liberation provided her with a platform from which to advocate for outre-mer women's inclusion in determining the political destiny of the French Union. Throughout her time as a deputy and, later, as a senator, she argued that women's contributions to the army and the wartime economy had prepared them to take up positions of authority in politics and in the workforce. She declared in her 1945 electoral campaign speech in Guadeloupe, "For the first time, women have been called upon in France to enjoy the same electoral rights as men; if there are some women who ascend the steps of the Palais Bourbon, they must, by their work, carriage, and dignity, show that they have long been ready to take up these duties."[46] Here, in the specific context of overseas France, Éboué-Tell argues that women have long been ready to participate actively and meaningfully in government. Like Nardal, who presents the image of Martinican women entering the city as a metaphor for their visibility in public life, Éboué-Tell uses the image of women ascending the steps of the Palais Bourbon, the seat of the National Assembly, in order to emphasize this visibility. Her emphasis on the history of women's readiness and capability to fulfill these roles suggests that women's political work had been rendered invisible and that their new status as citizens, voters, and political actors would now counter that invisibility.

Throughout her political career, Éboué-Tell continued to build on this idea of women's wartime service in order to garner support for feminist legislation. In 1947 she presented before the Senate a proposed law that would increase state financial assistance to single mothers.[47] This project was the result of her collaboration with Gilberte Brossolette, the first woman vice president of the Senate and wife of the decorated Resistance hero Pierre Brossolette. Gilberte Brossolette was a clandestine courier during the war, relaying information between London and Paris in the service of the Free French Forces. The Gestapo arrested her husband in 1944 and subsequently tortured and

killed him. Like the Éboués, the Brossolettes earned France's highest military honors for their work, including the Legion d'honneur and the Medaille de la Résistance. Éboué-Tell's collaboration with senators like Vialle and Brossolette speaks to a specific feminist politics rooted in women's wartime resistance. In her speeches, Éboué-Tell established a continuity of women's contributions to the ideal of freedom, beginning with their wartime activities and extending into their political engagement in the immediate postwar moment. Their participation in the Resistance became a platform from which to demand full recognition as citizens of France and to advocate for women's increased access to politics, education, employment, and state protection.

In addition to evoking her own contributions to the Resistance in order to advocate for women's political representation, Eugénie also used the popularity of the Éboué name in French collective memory to lend more credence to her projects in the public eye. She was a savvy politician who knew well the prevailing suspicion of and hostility to black women in positions of power that Paulette Nardal so eloquently described in the pages of *La femme dans la cité* and that women like Gerty Archimède experienced firsthand. Ascending the steps of the Palais Bourbon would not be easy. Consequently, she strategically represented herself as the inheritor of her husband's political legacy by invoking Félix's name throughout her electoral campaign and in her interventions as deputy and senator. For example, in her speech advocating for France to recognize the citizenship rights of Africans in the French Union by allowing for the creation of local governing bodies, Éboué-Tell used the weight of her husband's legacy to support her arguments: "If the man whose name I bear were here in this auditorium in my stead today, given his experiences with his African brothers, he would affirm that it is not possible today for France to renege on her commitment. . . . It is a voice from beyond the grave that calls out over mine to tell you to consider and respond to their aspirations."[48] With this image of Félix speaking beyond the grave through her, Eugénie aligns herself with her husband's politics in order to lend legitimacy to her demands in the eyes of her fellow deputies. Her strategy was successful, and her speech was interrupted multiple times by applause across the aisles of an otherwise divided National Assembly.

Unlike Suzanne Césaire, who was quickly eclipsed by her husband's literary and political reputation, Éboué-Tell merged her political identity with the public memory of her husband in order to gain recognition and to counter the erasure of her voice and presence. It is important to note, however, that this was a political strategy, not an indication of a lack of her own vision independent of her husband's legacy. One journalist accurately summarized Eugénie's political positioning when he stated in a newspaper profile that

"she considers herself as the executor of her husband's political, economic, and social ideals, but has developed original conceptions of her own. She is striving for the same goal both Éboués have been aiming at since their early age: the emancipation of the colored peoples and especially of the African Negroes."[49] Eugénie couched her work as a shared project begun with her husband, and she benefited from the popularity of his legacy in France and in Guadeloupe to advance her vision of a transformation of the French empire into a democratic union. Yet she also continued to negotiate (in)visibility throughout her career. She remained visible as long as Félix was remembered and celebrated. By the 1970s, however, his prominence in French collective memory faded and, consequently, so did hers.[50]

Jane Vialle's role in the Resistance and her subsequent recuperation of this narrative in her political work was significantly different from Éboué-Tell's, because the effectiveness of her contributions to the war effort depended largely on her silence and invisibility. Vialle's work as a clandestine agent required markedly different strategies of resistance that would later inform her postwar feminist politics. Notably, her use of silence and invisibility to camouflage her activities are examples of *sousveillance*, what Stephen Mann describes as the strategies of "undersight" by which those with relatively less power observe and collect information on those in positions of greater power. Mann posits sousveillance as diametrically opposed to surveillance, because it involves individuals' use of "panoptic technologies to help them observe those in authority."[51] Sousveillance is an act of *détournement*, "the tactic of appropriating tools of social controllers and resituating these tools in a disorienting manner."[52] Sousveillance is ultimately about a reversal of the power of sight in a political economy that trades in information. While Mann's analysis of this phenomenon focuses on the use of modern technologies such as video cameras and other recording devices, the concept of sousveillance can be applied to historical acts of reverse surveillance, such as Vialle's work as a clandestine agent during the war.[53]

Vialle's principal strategy of sousveillance was indecipherability. As secretary to Jean Gemähling, head of information services for the Resistance movement throughout the Provence-Côte d'Azur region, Vialle handled large amounts of sensitive information, expertly categorized and coded in language that Vichy police could not decipher. Among the documents found at her home when she was arrested, coded entries like "GERVAIS, 12 rue Jean de Tourne" sent the police on searches from Lyon to Toulouse to Poligny with no results.[54] In addition to the names and addresses that Vichy police found in Vialle's possession, they discovered falsified identification cards, maps, and reports on the movement of German troops and the operations of Vichy police as well

as documents detailing the formation of de Gaulle's provisional government. During her arrest, interrogation, and trial, Vialle admitted only to possessing a falsified identification card under the name El Bidaoui. Her undersight of the Vichy government—that is, her knowledge of its operations acquired while camouflaged as El Bidaoui—is an important reversal of the surveilling gaze and would later provide a platform for her to articulate another kind of reversal in postwar France, this time of racist patriarchal power as she advocated for the social, political, and economic mobility of African women.

During her interrogation and trial, Vialle sought to maintain her indecipherability through silence and denial. While the other members of Combat who were arrested with her gave lengthy explanations of their activities when interrogated, Vialle responded to most of the questions with a terse "Je désir m'expliquer en présence d'un avocat" ("I wish to respond in the presence of a lawyer").[55] Vialle's insistence on her right to legal counsel in the extraordinary times of suspended rights during Vichy rule was already a claim to the citizenship that was denied those categorized as racial Others in Nazi-occupied France. She went on to deny all knowledge of clandestine activities. She attributed the compromising documents found in her possession to one Philippe, a mysterious and most likely fictive tenant in her home, and the equally untraceable Madame Citron. When her interrogators asked her to explain why she had not burned the documents as she claimed she had been asked to do, Vialle responded simply, "Je ne me l'explique pas, mais je maintiens ma déclaration" ("I do not explain it, but I stand by my declaration").[56] Throughout the court proceedings, Vialle used silence to counter Vichy's language of criminality. To be invisible and silent, usually understood as signs of subalternity, became a crucial means of resisting the Vichy regime.

After World War II, Vialle evoked memories of her arrest and incarceration to argue for an end to the silencing of those deemed as subversive in the postwar period. For Vialle, the strategies of silence and evasion were to be replaced by open dialogue and public debate in the hopeful period of rebuilding. Consequently, she encouraged women of the French Union to use the AFUF's journal as an avenue for public expression and advocacy. In describing the AFUF's founding ethos, she writes, "Everywhere we could feel women's ardent desire to continue in broad daylight the actions they had begun clandestinely."[57] She traced the genealogy of the organization back to secret meetings she held with the other "femmes résistantes" who now formed part of the AFUF's directorship: "The women who experienced the torture of prisons, the horror of concentration camps, the life of the hunted, and who, for many years, trembled in fear for their parents, their friends, their

work colleagues, wanted to bring together all the women of overseas France in the spirit of fraternity, to work toward the same goal: to allow all women to establish honorable and happy homes in a peaceful atmosphere."[58] Vialle's vision for women's activism was deeply anchored in the history of their roles in the Resistance movement. Like Éboué-Tell, Vialle establishes continuity between metropolitan and outre-mer women's contributions to the war effort and their postwar organizing in order to situate her transnational feminist politics in a history of women's resistance. By emphasizing outre-mer women's wartime service to France, both Éboué-Tell and Vialle couched their demands for feminist economic policies and political representation not as adversarial to France but as a continued manifestation of their commitment to rebuilding both hexagonal and overseas France.

Forging Transnational Feminisms

The transnational nature of Éboué-Tell's and Vialle's feminist work allowed them to expand the possibilities for anticolonial resistance by challenging national borders and linguistic boundaries. Éboué-Tell maintained a steady track record of woman-centered political action that reached beyond France. She was a member of the International Alliance of Women, headquartered on Cromer Street in London. In 1945, as she traveled to Paris to take up her position as deputy in the National Assembly, she made a short stop in New York City, where she addressed American journalists. She affirmed that in helping to write the new French constitution, she would "speak for women and colonial peoples."[59] A few years later, in a New Year's address to her Guadeloupean constituents, Éboué-Tell reported on a recent trip to Belgium and on her meetings with Belgian feminists.[60] She believed that women worldwide were engaged in a similar struggle and that "nothing separates us."[61] She also expressed her desire to see all Guadeloupean women actively involved in bringing about "the emancipation of the feminine masses."[62] In her capacity as vice president of the French Union, Éboué-Tell also turned her feminist focus to AEF, where, she argued, women had a key role to play in the economic development and political life of the French federation.[63] Paulette Nardal's journal, *La femme dans la cité*, reported in 1946 that Éboué-Tell had founded a women's organization in Paris known as Les Femmes de l'Union française, which took a keen interest in Caribbean women's contributions to the historic West Indian Conference held in St. Thomas that year.[64] From Guadeloupe to Belgium to New York to AEF, Éboué-Tell wove together a geography of activism that envisioned political representation for black women on an international scale.

Vialle's feminist organizing also identified the transnational scope of outre-mer women's concerns. The AFUF's manifesto began, "We call upon all women of the French Union, the West Indies, North Africa, Black Africa, Madagascar, Indo-China, and all the overseas territories, who for six long years were separated from the metropolis and who suffered from the racist methods of the Vichy regime, to unite."[65] The fact that the only known record today of this manifesto is preserved among Eslanda Robeson's papers at the Moorland-Spingarn Research Center in Washington, D.C., attests to the international circuit of feminist ideas to which Vialle contributed. Vialle worked toward creating a feminist network that would advocate for the interests of women throughout overseas France. In addition to its headquarters in France, the AFUF also had active branches in several territories in French West and Equatorial Africa. Like Éboué-Tell, Vialle was primarily concerned with the possibility of upward social and economic mobility for women throughout the French Union. The AFUF focused its resources on providing housing, counseling, and health care for female students from the French territories studying in the metropole. Vialle took her action even further by advocating not only for girls to study in the Hexagon but also for the French government to provide comparable higher education facilities in the overseas territories.

By collaborating with women who were highly placed in French politics, including France's first lady, Michelle Auriol, and Gaston Monnerville's wife, Thérèse Monnerville, Vialle conceived of the AFUF as a strategic alliance. She sought to gather a critical mass of women from all corners of the French empire, advocating for their political interests on an even larger scale than what Paulette Nardal envisioned when she created the Rassemblement féminin in Martinique. Vialle rejected all attempts to label the AFUF a charity. She insisted that it was a social movement whose goal was to contribute to the intellectual uplift of women.[66] To this end, she encouraged epistolary exchanges as one way of articulating feminist solidarity in the French Union.[67] She strongly believed, and said so on multiple occasions, that there could be no "true and profound evolution without the evolution of women."[68] This belief also informed her work in the Senate and resurfaced in her arguments against a proposed law that would strip African women of their right to vote.[69]

Throughout her contributions to Senate debates, Vialle remained a prominent voice in highlighting the intersectional nature of discrimination and marginalization in the French Union. She cited multiple examples of this intersectionality and continued to engage her colleagues in public debates on the subject. Her examples include the case of a doctor who could not find work in Madagascar despite her skills: "She is a woman, she is a doctor, she is Malagasy. For more than a year she has requested to return to her country to

care for sick children there; there is no position for her in Madagascar, because she is Malagasy, because she is a doctor, because she is a pediatrician."[70] Vialle dismissed her colleagues' argument that the woman was denied a job because she was possibly a communist and insisted that the constitutive nature of racial and gendered discrimination kept her exiled from Madagascar.

Neither Vialle nor Éboué-Tell were radical to the point of imagining a political future for the overseas territories outside of the French Union. Instead, they worked within the union and through international women's organizations to counter outre-mer women's second-class citizenship on a global scale. Through this work, they sought to redefine the very understanding of womanhood and women's roles as political protagonists, both in the unfolding history of postwar France and the francophone world and on a global scale.

French Citizenship in a Transnational Context

The transnational conversations to which Éboué-Tell and Vialle contributed, however, did not always end on a harmonious note with declarations of a unified political vision. Indeed, few of the thinkers who have posited French citizenship rather than national sovereignty as part of their anticolonial thought have been spared the label of assimilationist from critics who argue that attempting to dismantle colonial power from within was a naïve goal that would yield at best modest reforms and concessions from France.[71] Like her contemporaries, Éboué-Tell faced criticism regarding her claims to Frenchness, and she attempted to respond to them using the language that characterized the thought of many elite black French politicians and intellectuals. During a press conference in New York City in 1945, a group of African American journalists accosted Éboué-Tell in a heated exchange over independence versus federation for French African colonies. One journalist noted the following about the perceived conflict between national and racial identification in Éboué-Tell's political thought: "To Madame Eboue's reiterated assertion that the Africans in the French colonial area feel closely identified with France, there was a question by the reporter on whether the African feels closer to the background of European France than he does to his own traditional African background. The visitor answered that there was no question of going away from the native tradition, that the attitude was one of identification with whatever is consistent in modern life that France might have to offer."[72] For the journalists who queried Éboué-Tell, to claim French citizenship was to disavow blackness and usurp Frenchness—understood as a white European identity. It was to assert that one was French *first*, above and beyond any other identities.

The tensions in these diasporic conversations were largely due to Éboué-Tell's self-positioning as a black woman claiming French citizenship, a position that black journalists in the United States saw as assimilationist and a betrayal of the goal of independence. As the *Chicago Defender* relates in its coverage of Éboué-Tell's sparring with American journalists, "Someone asked her if she favored her husband's view of 'Africa for the Africans.' She said she did, but this did not exclude European policies from having a part in determining African conditions. The tenor of madame's replies to most questioning revealed that she is profoundly French in her orientation and outlook."[73] This profound Frenchness was again on display when Éboué-Tell responded to a query from Eslanda Robeson, who was also in the audience. Robeson asked whether the constitution that Éboué-Tell was drafting with her fellow deputies contained the possibility for African independence. Éboué-Tell responded that "the colonial population was not interested in secession."[74] Her Frenchness was expressed also in her repeated affirmations of loyalty to France and her constant deflection of questions that invoked Southeast Asian independence movements, questions that sought to frame flag sovereignty as the single and only viable path to political autonomy and equality for all disenfranchised people globally. For Éboué-Tell, some elements of the struggle for equality in the French empire—itself a very heterogeneous polity—were applicable in a global context, and other elements were not. Ultimately, Éboué-Tell's turn to French citizenship as a viable path toward fashioning a more democratic political relationship between France and its colonies alienated her from the African American journalists who had come to hear her speak. One newspaper decried the "outspoken pro-imperialistic stand of the only Negro woman elected to the French Assembly."[75]

Éboué-Tell's use of an interpreter at the press conference allowed her to translate, linguistically, her vision for black liberation through French citizenship. However, the idea itself did not travel well across the Atlantic. Throughout the press conference, as reporters pushed a pro-independence line of questioning and Éboué-Tell maintained her stance on citizenship within a larger French federation, her audience concluded that she simply did not understand the questions she was being asked. In their newspaper coverage after the event, several journalists reported that "she did not fully grasp this line of questioning,"[76] "she did not grasp the point,"[77] and "she did not understand what they were driving at. . . . Apparently, there were quite a few things the good Mme. did not comprehend."[78] The specific wording in these descriptions by different journalists is crucial. It is not that Éboué-Tell does not understand the questions. It is that she does not understand *the point* of the questions, the responses she is expected to give, and the role she

is expected to play in a black transnational conversation that seeks to connect black liberation struggles worldwide with the thread of independence. For the group of black journalists who had gone to extra lengths to seek out France's first black woman deputy even though the French embassy in New York had made no provisions for a press conference, Éboué-Tell's reclamation of French citizenship was baffling and disappointing because it did not fit into their framework of transnational black solidarity. The sometimes discordant nature of these diasporic conversations underscores Brent Edwards's astute observation about the importance of "attending to the ways that discourses of internationalism *travel*, the ways they are translated, disseminated, reformulated, and debated in transnational contexts marked by difference."[79] Far from signaling a failure of black political imaginations, these differences are productive in highlighting the complexity of claiming black French citizenship in a transnational context.

Éboué-Tell protested that there was room to imagine citizenship beyond a binary, to envision a composite black French identity rather than additive and opposing identities where one always superseded the other, and to claim a more expansive definition of Frenchness that would ultimately disrupt the notion that only white Europeans in the Hexagon could lay claim to France. This is not to argue that her vision of a French-African identity, put forward during her tense press conference in New York, necessarily resonated with all Africans. As we will see in the case of Aoua Kéita, French citizenship soon became untenable for some Africans who called for new political structures beyond formal ties to France. Nor is it to suggest that African and Antillean political aspirations were identical and can be grouped under a conveniently homogenous umbrella of black Frenchness. Rather, for Éboué-Tell, it was imperative that the French Union and its promise of citizenship be understood as a fundamental recognition of the humanity, cultures, and civilizations of the formerly colonized—a recognition that each one could wield as she wished against colonial exploitation and that would exist in harmony with, rather than negate, claims to other cultural and political communities.

Thus in 1946, as she prepared to attend the West Indian Conference that would bring delegates from across the Caribbean together in the U.S. Virgin Islands to discuss political and economic cooperation, Éboué-Tell wrote a lengthy article that reads like an attempt to clear the air on the disastrous and widely covered 1945 press conference in New York. The article carried the rather bold title "French End Colonial Era, Grant West Indies Citizenship: We Resent Being Called Dependent" and was published in English. Éboué-Tell chose three of the most established black newspapers in the United States at the time to print it—the *Pittsburgh Courier*, the *Baltimore Afro-American*,

and the *Amsterdam News*—showing that her reflections on race were as much about the United States as they were about the Antilles and France. The article is best described as Éboué-Tell's idealized vision of a decolonized France, couched as a reality that had already come to pass. Her definition of decolonization unfolds in several steps.

First, it is a humanistic vision of self-determination that is understood not in the impersonal terms of political units and administrative bureaucracy but as the possibility for communities to develop free from coercion, violence, and exploitation. As she writes in her opening lines, the realities of colonialism "concerned the very existence of hundreds of millions of human beings."[80] Éboué-Tell defines the terms of her engagement with colonialism, its effects, and its abolition by centering people's lived experiences and the possibilities for their emancipation and development. Development, Walter Rodney argues, "implies increased skill and capacity, greater freedom, creativity, self-discipline, responsibility, and material well-being."[81] This definition underwrites much of Éboué-Tell's articulation of the place of Africa and the Antilles in the new, expanded France she imagines. The basis of French citizenship, she argues, is a fundamental respect for "the original sources from which all those people derived their varied customs, beliefs and aspirations, and their age-old attitudes towards the great problems which confront every man in all his fields of activity as a member of social, political, religious, and other collectivities."[82] She situates France and the overseas territories in Africa, the Americas, Indochina, and the Pacific and Indian Oceans in a constellation of equal epistemologies:

> If humanity forms a whole and if all men are interdependent, the many ways in which . . . they express those inner tendencies that produce different philosophies and customs do not set up obstacles between them but, on the contrary, constitute inexhaustible riches, the diversity of which enables men to follow different paths, compare their ideas, and hasten their progress. In other words, and in plain language, a threat hangs over humanity; the curse of uniformity.[83]

Uniformity, in this narrative, would be the imposition of a singular and narrowly defined French identity on all of France's diverse colonial subjects. Such a project of colonial assimilation, Éboué-Tell notes, enacts cultural violence and erasure, a "curse" that threatens humanity's very existence and stifles what Aimé Césaire describes in *Discours sur le colonialisme* as productive contact among civilizations.

The second element of her definition of decolonization is its temporality. Decolonization is an ongoing process, one that demands fundamental

changes that will dismantle empire in favor of a more egalitarian community. Éboué-Tell situates the origin of these changes in the French Revolution and identifies the newly elected parliament of 1945 as an inheritor of that legacy: "In 1789, the representatives of the Nation had proclaimed the fraternity of blood and spirit which united all those living on French soil; the members of the present Constituent Assembly, which comprises sixty representatives from overseas France, have faithfully followed that tradition by wiping out the last differences that still existed between Frenchmen of various races."[84] There is a supposed spectrum of historical progress implied in her temporalizing here. The year 1789 represents the ideological revolution—one that in reality was carried out not only by the masses in the metropole but also the enslaved in overseas French territories such as Saint-Domingue—that enshrined equality as a foundational ethos of the French Republic. The 1945 parliament, with its representatives from overseas France, is carrying forward the republican ideals birthed with the French Revolution. Per Éboué-Tell's timeline, it is only with the inclusion of the colonized as equal citizens that France can finally realize its own national identity as a republic.

There is no doubt that in this article Éboué-Tell significantly downplays imperial France's ravaging of its colonies. Her assertion that the colonial era had ended with the election of overseas representatives to the Constituent National Assembly further ignores the reality of continued French exploitation and racism in the colonies. Indeed, her claim that all forms of racism had been eliminated in the French army with the integration of black troops in the nineteenth century contradicts Félix's accounts of the racist treatment suffered by Henri and Robert in the French army during World War II and his demands for "a minimum of equity and justice" for his sons.[85] What, then, accounts for her seeming disregard of continued French colonial violence in this article?

It is important to attend here to questions of audience in order to fully grasp the anticolonial undercurrents of Éboué-Tell's citizenship claims and idealized image of French history and politics. As she informed her American readers in this article, Éboué-Tell was preparing to attend the West Indian Conference in St. Thomas in her official capacity as chief of French commissioners and chairman of the delegation from Martinique, Guadeloupe, and French Guyana. The key to deciphering the apparent contradictions in her article comes in a separate report after the conference, where she writes candidly about fears of American imperial expansion in the Caribbean:

Les Américains laissent voir leur volonté bien arrêtée d'orienter la Conférence vers des questions politiques. . . . L'attitude des Commissaires [amé-

ricains] comme des délégués a clairement montré la volonté des États-Unis à pousser les territoires intéressés vers l'autonomie, puis vers une fédération. Cette position parait d'ailleurs absolument conforme aux intérêts des États-Unis. Il est bien certain qu'une fédération antillaise, politiquement, financièrement et économiquement coupée des métropoles actuelles tomberait, par la force des choses, dans l'orbite des États-Unis, qui auraient alors le contrôle complet des investissements des capitaux et, en conséquence, celui du commerce extérieur des pays intéressés.[86]

The Americans have made clear their decisive interest in orienting the conference toward political questions. . . . The attitude of the [American] commissioners as well as delegates has clearly shown the United States' desire to push the territories concerned toward autonomy and then a federation. This position appears to be absolutely in line with the United States' interests. It is certain that a Caribbean federation, politically, financially, and economically cut off from the current metropoles, will fall, according to the order of things, into the orbit of the United States, which would then have complete control of the investment of capital and, consequently, of the external trade of these countries.

The image of Éboué-Tell that emerges in this analysis is markedly different from the one presented in Éboué's biography, of a woman whose knowledge of foreign affairs was limited to her preoccupation with Victorian bustles, hemlines, and hairstyles. Her concerns echo those of other black women contemporaries, including Claudia Jones, whose analysis of America's financial interests in the Anglophone islands, and Suzanne Césaire, whose observations of American overreach in the education system in Haiti, made them both wary of the United States' imperialist motives in the Caribbean.[87] After the West Indian Conference, Éboué-Tell made a political calculation that self-determination was not necessarily synonymous with independence, particularly if flag sovereignty left Caribbean islands open to American economic domination and the attendant political interference. Although the larger size of African territories and the possibility for the continent to unite into a formidable force would make Africa a more difficult target for American imperial designs than the smaller Caribbean islands, Éboué-Tell still chose to cast her lot with France, with the hope of attaining equal rights and representation for Africans and Antilleans within the geopolitical limits of a French federation.

As the heated debates on what it meant to be black and French continued on both sides of the Atlantic, Vialle too weighed in with a specific focus on cultural assimilation. In her 1948 editorial in the AFUF journal, she put forward the question at the heart of the discussion: "Should we aim for assimilation? This is the eternal polemic that opposes the partisans of free advancement

in the ancestral setting and those who favor the interpenetration of people and races."[88] Vialle offers her readers two possible responses to the question. The first imagines civilizations evolving separately, and the second imagines them developing in close contact with one another. The latter would result in each exchanging values, traits, and practices with the others. Vialle's editorial joins a body of writings by francophone intellectuals who sought to imagine possibilities of belonging that refigured the imbalance of power in the French empire. In *Discours sur le colonialisme*, Aimé Césaire argues that productive exchange among civilizations is necessary, desirable, and even possible.[89] However, colonization was not the productive meeting of civilizations suggested by colonial propaganda. Rather, it was accompanied by physical and psychic violence as well as economic exploitation. Colonization precludes the kind of exchange necessary for the evolution and survival of civilizations.

Vialle's editorial, written around the same time as the first iteration of Césaire's *Discours*, published as the essay "L'Impossible contact," undertakes the same project of proposing a more equitable, symbiotic form of contact as an alternative to the colonial model of assimilation: "In our times, we cannot pretend to have a pure civilization, so I lean toward this international advancement that makes man a citizen of the world without at the same time taking away the originality of his homeland."[90] Vialle's formulation challenges France's so-called civilizing mission that postulates the superiority of French culture and civilization to be spread by all means throughout the empire. She imagines instead contact that is mutually beneficial because it is not premised on notions of relative superiority and inferiority.[91] Vialle extended the debate on the possibilities for productive encounter further than Aimé and her other contemporaries did by envisioning women as active agents in this encounter. She argued that women of the French Union would both preserve traditional practices and lead their countries in fusing these practices with the knowledge they acquire from their French education: "They are the ones, with their heart, their courage, their womanly intuition, who will knead the dough from which tomorrow's men will be made."[92] Within her framework of productive contact of civilizations, outre-mer women were to be the creative, formative force preparing a new generation of men who would in turn ensure the future of the French Union.

In rejecting colonial notions of assimilation, Vialle also critiqued the formation of *évolués*, a class of people envisioned by the colonial administration to be useful allies in the colonial enterprise by virtue of their French education and their adoption of French cultural practices such as language and religion. In 1949 Vialle presided over a colloquium organized by a cultural association just outside of Paris. She followed her talk with an editorial in the AFUF

journal on her response to the event's theme: "Are Outre-mer elites prepared to respond to their people's call?"[93] Vialle begins her response by reiterating her belief that without women there could be no formation of the elite: "Women play a primordial role in the formation of these elites, and if, in the past years their education has been neglected, since the liberation there has been a larger understanding of the role of women in the people's advancement."[94] Here she advances an intergenerational framework for women's roles in public life. In this framework, older women undertake the crucial roles of advisers and teachers. Younger women and girls, particularly those educated in France, are equally important as members of this elite, returning to Africa to serve as skilled workers steeped in and respectful of the traditions and cultures of their countries.

Yet even as she extolled the benefits of a French education, Vialle also questioned the unequal access to power and upward socioeconomic mobility inherent in the formation of a colonial elite. She took to task évolués in particular, a move whose irony may not have been lost on her readers given that Vialle, as a French-educated African métisse, would be considered the évolué par excellence. However, she was quick to distance herself from this term. In her editorial, she distinguishes between an elite that would soon make itself obsolete by contributing to the uplift of all in the French Union and évolués who primarily served colonial interests. She argues for "true civilization— that is, the civilization of the masses, that of a people through knowledge of themselves . . . Once the African comes to know himself, the word 'évolué' will be buried."[95] Civilization of the masses as Valle defines it is antithetical to the French colonial project of creating a small, selective cadre of Africans to help in propagating the myth of French cultural superiority. Vialle's civilization is not a superficial adoption or mimicry of French culture but rather a deep, profound knowledge of oneself as African. Her call for a collective self-awareness echoes Suzanne Césaire's assertion in Martinique of the urgency to know oneself. Like Césaire, Vialle sought to shift the power of self-definition and agency from France as civilizing agent to Africans as determiners of their own place in the constellation of cultures and civilizations that made up the French Union. She disrupts the narrative that accompanied colonial conquest: the narrative of France benevolently bestowing its civilization on its subjects.

Refiguring the Colonial Family

What, then, were the stakes of interrupting the French colonial discourse of a civilizing mission in favor of a new narrative on cultural and political equality? In her study of colonial relations between France and Réunion,

Françoise Vergès describes the relationship between France and its overseas territories as a colonial family romance, an unequal power relationship in which France's subjects, conceived of as children, remain perpetually indebted to the *mère-patrie* for its colonial *don* (gift). Vergès argues that "the debt was constituted by the ideals of the French Revolution, of the French republic. In territories where feudalism, barbarism, or backwardness reigned, maternal France had brought Enlightenment and progress. She would save her children and elevate them toward full humanness."[96] The don, as a gift that is undeserved yet bestowed, highlights the impossibility of political autonomy for those populations figured as perpetual children trapped by a debt that will always be too great to be repaid. Vergès's formulation of colonialism as the construction of a filial relationship based on perpetual debt emphasizes the foundational element of dependence on which colonial power is built and consolidated. Maintaining the myth of the colonial family also hinges upon the mère-patrie's withholding of recognition of her subject-children's humanity. For the colonizer to recognize the full humanity of the colonized would be to acknowledge the illegitimacy of colonial conquest and rule.

The colonial family romance is a useful framework within which to read Éboué-Tell's and Vialle's anticolonial resistance, because both women sought to reconfigure the relationship between metropolitan and outre-mer France as one between equals. Their goal, fundamentally, was to obtain the colonizer's recognition of the humanity of the colonized. This demand for recognition is perhaps one of the most fraught moments in their work, the moment when the tensions present in their dual positions as supporters of the French Republic and critics of French colonialism are most visible. To maintain the discourse on filiation as the point of departure for challenging colonialism, as Éboué-Tell and Vialle did, is to perpetuate dependence even as one seeks emancipation. Thus, as both women dedicated their work to reversing the image of the colonized as a perpetually indebted child by highlighting the political, economic, and cultural contributions of overseas France, they accepted the colonizer's initial terms of the family romance by couching these contributions as a political coming of age. In other words, they did not question the initial don but argued for the mère-patrie's recognition of the political maturity of the colonies as children who have come of age, have paid their debt, and can now control their own affairs. These tensions in Éboué-Tell's and Vialle's political discourse are unsettling. They also contain the germ of the strand of anticolonial thought that was based on the belief that France's recognition of its colonial subjects through citizenship and political autonomy would delegitimize the colonial enterprise and make the French Union an alternative model of political identity grounded in French republican ideals.

In Éboué-Tell's retelling of AEF's role in the Resistance, her emphasis on overseas France liberating the metropole was a particularly powerful strategy, because it reversed the colonial discourse of the colonized subject's eternal indebtedness to a benevolent metropole. In her alternative account, the overseas populations step into the role of liberator, saving Vichy France from itself. In a sense, Éboué-Tell espouses a politics of liberation that is a reversal of Suzanne Césaire's. Where Césaire argues for an aesthetic liberation of the Martinican imagination from French imperialism, Éboué-Tell argues that it was metropolitan France that needed liberation, a feat it could not achieve without vital contributions from the colonies. This don of liberation, bestowed by the colonized onto a beleaguered metropole, meant that outre-mer populations deserved the same rights and state protections enjoyed by French citizens in the metropole specifically because they had risked and even lost their lives safeguarding those rights for France.

Éboué-Tell's reversal of the colonial don was also an attempt to refigure the colonial family by representing the colonized not as unrecognized children but as legitimate intellectual heirs of French republican ideology. An heir, in the language of the colonial family romance, is a child who has come of age and inherits the parent's legacy. As Jacques Derrida notes, "One can recognize an authentic heir in the one who conserves and reproduces, but also in the one who respects the *logic* of the legacy even to the point of turning it on occasion against those who claim to be its guardians, to the point of revealing, against the usurpers, what has never been seen in the inheritance: to the point of giving birth, by the unheard-of *act* of a reflection, to what had never seen the light of day."[97] This inheritance, as Derrida describes it, is anything but an uncritical acceptance. During her electoral campaign for the 1945 National Assembly elections, Éboué-Tell repurposed republican language in order to situate herself within the parameters of French political discourse. Her campaign poster illustrates the complexity of this inheritance.

The poster's portrait orientation creates a visual effect that draws the viewer's eye vertically from top to bottom. This strategy establishes a line of continuity in a narrative that begins with the French Revolution and ends with World War II. The alternating distribution of text-image-text-image-text reinforces this continuity by placing French republican iconography in conversation with the 1945 National Assembly elections. Notably, the French tricolor flies over this invitation to all citizens ("Citoyennes et Citoyens") of Guadeloupe's first district to vote for Madame E. Éboué-Tell. Even more striking is the large photo of Éboué-Tell looking into the distance, which is positioned underneath a drawing of another woman leading the charge with her sword pointing forward, an image that is most likely intended to recall the figure of

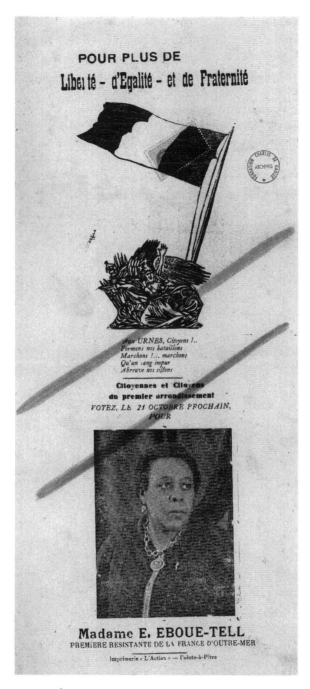

Eugénie Éboué-Tell's campaign poster. Courtesy Fondation Charles de Gaulle.

Marianne in Eugène Delacroix's painting *La Liberté guidant le peuple* (*Liberty Leading the People*). As the viewer's eyes travel up and down the poster between history and the present, between republican iconography and Éboué-Tell's portrait, Eugénie becomes the feminine embodiment of liberty, a black Marianne whose election to one of the highest offices of the land would symbolize the pinnacle of France's recognition of all its citizens and serve as proof of the republic's genuine adherence to its tripartite motto. Éboué-Tell as black Marianne disrupts the whitewashed image of a French Republic represented by the bust of a white woman that graces official government documents and is omnipresent in town halls and law courts across France today. Her repurposing of Marianne, a symbol that remains contentious in contemporary France over its (in)ability to adequately represent the country's citizens, engages with how the construction of national identity is raced and gendered.[98]

Yet Éboué-Tell's was not an uncritical adoption of French republicanism. She presents a curious definition of liberty, not as that absolute state of being whereby one is free or not but as a sliding scale on which France can move back and forth in accomplishing the goals of the Revolution. Electing the first black woman deputy would be, Éboué-Tell announces, a move in the right direction toward "more liberty, equality, fraternity." She also quotes the refrain of the French national anthem, the Marseillaise, but reformulates the text in a way that crafts a new, possibly more inclusive narrative of French citizenship. "Aux armes citoyens" ("To arms, citizens") becomes "Aux URNES, citoyens!" ("To the BALLOTS, citizens!"). "Formez vos bataillons" ("Form your battalions") is in turn rendered as "Formons nos bataillons" ("Let us form our battalions"). Éboué-Tell's modification of the lyrics suggests a new revolution under way, one that would take place not on the barricades but in the voting booths. The shift from the plural second-person pronoun "your" to the collective first person "our" suggests that Éboué-Tell and her Guadeloupean constituents form the new battalion of France's most downtrodden, who will fight for citizenship rights and the overthrow of tyranny. As with her epic retelling of the events of World War II, Éboué-Tell again casts herself as a political protagonist in this reimagining of French history that is also a narrative about a more hopeful egalitarian future.

Once elected, Éboué-Tell's rhetoric on citizenship did not remain on the symbolic order of republican promises and love for the mère-patrie. Rather, this language proved to be an important political tool for engaging the French government in a dialogue on what outre-mer French citizenship would look like on the ground. In a particularly heated parliamentary debate on budget allocations, outre-mer deputies took their metropolitan colleagues to task over France's colonial economic policy. Césaire, Éboué-Tell, and Monnerville

followed one another in rapid succession in a National Assembly debate and demanded that the metropole redefine the terms of its relationship with its overseas territories. Monnerville aptly sums up Césaire's and Éboué-Tell's arguments in his own demands for a more equitable distribution of wealth in the colonies:

> Je voudrais donc savoir exactement quelle est sa politique coloniale, c'est-à-dire celle du nouveau Gouvernement. Votre politique est-elle une politique d'investissements dans les colonies, c'est-à-dire de reconstruction, dont les territoires d'outre-mer ont tant besoin? Où est-ce encore la vieille politique de prestige qui consiste à faire des dépenses somptuaires, spectaculaires, au lieu de ce que nous appelons, nous, "la politique du puits"—je pense à l'Afrique—c'est à dire la politique dont tout à l'heure Mme Éboué-Tell a tracé les grandes lignes, qui consiste d'abord à penser à l'élément de la colonisation ou des territoires d'outre-mer: l'homme, à sauvegarder la santé de l'être humain, de façon à lui permettre de produire à la fois pour lui, pour le territoire dont il est originaire, et pour la métropole?[99]

> I would therefore like to know what exactly the new government's colonial policy is. Is your politics one of investment in the colonies—that is, the reconstruction that the overseas territories so badly need? Or is it still the old politics of prestige that consists of sumptuous, spectacular spending instead of what we call "the politics of the well"—I am thinking of Africa—I mean the politics that Madame Éboué-Tell outlined previously, which consists first and foremost of thinking about the human element in colonization or in the overseas territories: man, to safeguard human health in such a way as to allow him to produce at once for himself, for the territory that is his homeland, and for the metropole?

Monnerville posits two kinds of economic models for France in the colonies. In the first, France's so-called civilizing mission is manifested in the construction of sumptuous bridges and railway lines in a predatory system that exploits the labor and natural resources of the colonies while proclaiming the benevolence of supposed French assistance. Elsewhere in his speech Monnerville is adamant that this exploitation occurs as much in Africa as in the Antilles and his native French Guyana. The second and presumably more desirable economic model is defined by Éboué-Tell. She proposes placing the human at the center of France's economic policies. This means first moving away from the vision of the colonized as devoid of subjectivity, as subaltern, as thing, and recognizing his or her humanity. For Césaire, Éboué-Tell, and Monnerville, citizenship would reconfigure the colonial system of economic exploitation and thingification primarily by recognizing the humanity of the formerly colonized.

For African and Antillean politicians in the French Union, this recognition would in turn translate into concrete changes such as improved education and health care; a local, semiautonomous governing body; social security and workers' benefits; and development of infrastructure and resources that would allow the colonies to produce first for themselves and then for the metropole. This redefinition of the colonial relationship was an important precursor to the different anticolonial visions—that is, independence and departmentalization—that were ultimately realized in Africa and the Antilles, respectively. Certainly, neither independence nor departmentalization has brought about this utopian state of equitable and harmonious exchange between France and its former colonies. Just as the supporters of the French Revolution grew disillusioned because of the economic inequalities that persisted in France even after the overthrow of the monarchy, so too did African and Antillean politicians and intellectuals grow disillusioned with French republicanism. Racial discrimination in the French Union remained a reality that sat uneasily alongside the promise of liberty, equality, fraternity. Yet the fact that outre-mer deputies continued to hold France accountable for upholding its tripartite motto abroad attests to the lasting attraction of French republicanism as a path to decolonization.

Vialle's notions of a citizenship that would be guaranteed by France's republican foundations were also firmly inscribed in the language of the colonial family, perhaps even more so than Éboué-Tell's. She was particularly invested in obtaining paternal recognition for métis children in order to counter their abandonment, which had become the practice among white men in the colonies. Consequently, she fought a four-year battle in the Senate to extend France's paternity law to the overseas territories. The law would allow métis children to conduct a paternity search, and fathers could be legally mandated to recognize and provide for their children. As Owen White and Emmanuelle Saada have shown in their respective studies on métissage in twentieth-century overseas France, the French administration viewed the métis as déclassé—that is, one who did not fit into any of the social categories that made up the colonial hierarchy.[100] In a period where racial essentialism held much currency, to be déclassé was understood to mean occupying a liminal position between aspirations of social mobility that stemmed from having French blood and the inability to attain that mobility due to the influence of African blood. The colonial administration's response to the supposed problem of métis who they claimed were ever discontent with their in-betweenness was to sequester them in so-called orphanages. This confinement in orphanages which where institutions of physical and psychic colonial violence, was the situation that Vialle sought

to address with her law. She drew on her own experience as a métisse as well as empirical evidence provided by branches of the Association des métis in Bangui, Chad, and Cameroon in arguing for paternal recognition of métis children—both symbolic and financial—in order to eliminate the state's claim to the children. Her law therefore shifted the discourse from the essentializing colonial language of race as biological fact and emphasized instead the social and political implications of racial segregation in French colonies.

Vialle argued that extending French paternity law to the rest of the French Union would set in motion a process of recognition for a hitherto mis-recognized segment of the population. She explained in the Senate, as her acquaintance Andrée Blouin would decades later in her autobiography, that the state-run orphanages served to only deepen colonial racial complexes for métis children and their families: "What kind of education do they give them in these institutions?" she asked.[101] Vialle responded to her own question: "In general, they are made into children filled with complexes, children who are not conscious of their personality, who do not know where to turn, who despise the black milieu and envy the white milieu. When they have to re-immerse themselves into social life, they do not know what attitude to adopt, because on one side they are rejected, and on the other they are not accepted."[102] Here, Vialle echoes the language of liminality that characterized French colonial discourse on déclassés. However, she does not subscribe to the essentialist ideas that métis occupied a liminal position because of their supposedly mixed blood. Rather, she attributes their socially in-between status to a colonial racial hierarchy that denied them legal recognition beyond their limited status as wards of the state. Further, the colonial education they receive in the orphanage precludes any possibility of self-recognition. Vialle's language in her Senate speech captures this negation through her use of multiple negatives. She argues that paternal recognition of métis children would be a desirable alternative to the colonial administration's project of erasing their identities and subjecting them to a colonial education far out of sight behind the walls of the orphanages. For Vialle, the possibility for métis children to have legal recourse to obtaining this recognition—legal recourse already available in the metropole—would be an affirmation of their identities as French citizens and their belonging in their home communities.

True to her postwar feminist politics, Vialle's refiguring of the colonial family is part of her retelling of the story of World War II in which African women are protagonists. She proposes a different reading of colonial history from Éboué-Tell's epic narrative of brave soldiers fighting for liberty. Vialle argues in the Senate that in French territories such as Chad—a hub of the Resistance due to Félix Éboué's work there—the number of métis children

increased dramatically "après le passage de la glorieuse colonne LECLERC" ("after the passage of the glorious Leclerc regiment").[103] Vialle's ironic use of "glorieuse" contrasts with Éboué-Tell's tone in invoking the march of African soldiers from Chad to the battlefields of Europe. Vialle paints here the less than glorious picture of white French soldiers who, while undertaking the noble task of liberating their mère-patrie, also abdicated their responsibility as fathers. She argues that this abdication was also about a fundamental disregard for African women: "We have seen too often in the overseas territories, women taken on by Europeans as 'housekeepers' and then abandoned, along with their métis children, once they give birth. . . . It is therefore important, for the dignity of the métis children and the respect owed to the mother, that a paternity search be made possible."[104] As Vialle argues, and as Blouin later attests in her autobiography, African women in the colonial family were objects of sexual desire, denied agency, and rejected as viable spouses and mothers. Vialle names African housekeepers with the specific term "ménagères" to show the conflation of African women's sexuality and labor in the colonial economy. To be a "ménagère" was to occupy the dual position of domestic help and sexual object. Through her narrative, Vialle dissociates the image of French soldiers marching through Africa from the discourse on resistance and liberation and deploys it instead as a symbol of colonial sexual violence and conquest. In this context, her proposed law must be understood as an anticolonial gesture, because it refuses the very basis on which colonial power is founded. In seeking to obtain recognition from *père* and patrie on behalf of African mothers and their métis children, her proposed law holds at its core the same demand for the recognition of the humanity of the colonized that Éboué-Tell, Césaire, Monnerville, and other black French politicians also articulate.

Vialle's attempt to reconstitute the broken colonial family, to bring together white French father, black African mother, and métis child in a relation of mutual recognition, was ultimately about reimagining a new family romance. While her law does not dismantle the family structure, a severe limitation that meant these demands for recognition would always be framed in the restrictive terms of the colonial family, it does seek to reconfigure the distribution of power by demanding that laws that were in effect in France be made applicable throughout the French Union if said union was to be truly a federation of equals. For Vialle, her proposed paternity law was ultimately about laying the groundwork for a postcolonial future in which republican principles held true for all French citizens regardless of race or gender: "One of the bases of this union is the respect that individuals must have for one another, the respect that must be manifested not only toward men but also toward women."[105]

Vialle was cautiously optimistic, however, about French citizenship and its ability to bring about this imagined decolonial future. When her fellow senator André Carles tried to appropriate her paternity law as a symbol of the metropole's triumph over all racial prejudice against outre-mer populations, Vialle sounded a note of caution. Carles, in his capacity as rapporteur for the commission on justice and civil legislation, declared victoriously in the Senate, "We have shown once again, through this modest proposed law, as we have done many times before in this assembly, that this French Union is truly a reality, that all the sons of metropolitan and overseas France are now treated on an absolutely equal footing."[106] For Vialle, Carles was prematurely claiming a postcolonial present and consequently ignoring the institutional racism still present in the French Union and which made her law necessary: "Toutefois, je regrette de ne pas être tout à fait de l'avis de M. CARLES, parce que si, à cette tribune, nous prenons de belles résolutions, et si l'Union Française se fait ici, en France, on constate que, dans les territoires d'Outre-Mer, les pouvoirs publics n'ont pas toujours cette même compréhension, et n'appliquent pas forcement à la lettre les lois qui sont votées ici" ("Nevertheless, I am regretfully not of the same opinion as Mr. Carles, because if in this Senate we undertake beautiful resolutions, and if the French Union is made here in France, we remark that in the overseas territories those in power do not always have the same understanding we do and therefore do not necessarily apply to the letter the laws we adopt here").[107] Vialle highlights here the tensions that persisted between republican promises and colonial reality, between "ici," the metropolitan seat of power, and the implicit "là-bas" where these promises were not yet a reality but hopefully would become so.

Both Éboué-Tell and Vialle left their mark on the political destiny of overseas France through their proposed laws and voting record in the Senate. They sought to make citizenship a meaningful status that would guarantee political enfranchisement and recourse to the justice system for inhabitants of the French Union. Their writings and speeches allow us to piece together the multiple and sometimes shifting positions that characterized their understanding of what it meant to be African, Antillean, Guyanese, a woman, a citizen of France. Both women emphasized a harmonious fusion of multiple political and cultural institutions and communities, even when their engagement in transnational conversations showed the frayed seams of this composite citizenship. Éboué-Tell's vision of a culturally hybrid France and Vialle's demands for the legal recognition of métis children provide an entry point into the complex and often fraught politics of métissage in the colonial period.

Andrée Blouin intervenes even more forcefully in the conversation on racial and cultural hybridity and embodies the complexity of navigating multiple

belongings both in the colonial context and in the African nationalist discourse that was amplified by the approach of independence. In the years that Éboué-Tell and Vialle spent in the Senate speaking as elected representatives of overseas France, Blouin lived firsthand the conflict and contradictions that came with being French, African, métisse, and a woman in colonial Central Africa. Her narrative *My Country, Africa: Autobiography of the Black Pasionaria* highlights the stakes of French-African citizenship for those whose affiliations troubled the supposedly clear-cut racial binary in the colonial context. It also reveals the strategies for anticolonial resistance that women employed when it became abundantly clear that French citizenship would not bring with it the political agency that Vialle and Éboué-Tell had so dearly hoped it would.

4. Andrée Blouin

Métissage and African Liberation in *My Country, Africa: Autobiography of the Black Pasionaria*

My story, which I have often pondered, is, I see, inextricably entwined with Africa's fate as a land of black people colonized by whites. The contradictions within my life are those from which Africa has suffered.

—Andrée Blouin, *My Country, Africa: Autobiography of the Black Pasionaria*

Andrée truly began to contemplate freedom for the first time the night she stood atop the wall of the Catholic orphanage that had been her home for the last fourteen years, and prepared to jump into the darkness below. The high walls that surrounded the orphanage were studded with bottle shards, supposedly to keep intruders out. As she tried to avoid being cut by the sharp pieces of glass, seventeen-year-old Andrée realized that they were to keep fleeing girls like herself in. Her accomplices, Louisa and Madeleine, began to sob, terrified that they would be badly hurt when they hit the ground. Afraid that her companions would turn back, Andrée steeled herself, pushed each girl into the void and then jumped. She recalls that night as the moment of her self-determination: "After all these years with the nuns I was convinced that they were the last to know or care where my real happiness lay. I had no idea what the future of a métisse like myself should be. . . . I was determined to forge my own future, however good or bad that might turn out to be."[1] And so, "limping and leaving bloody traces behind," she took her "first steps toward freedom at last."[2] Andrée's story of flight is not simply the dramatic retelling of a rebellious teenager running away from adult authority. It is, as the epigraph to this chapter shows, the entangled stories of Blouin's political

prise de conscience in colonial Central Africa and the liberation struggles of Central African colonies in the mid-twentieth century.

Andrée's escape from the Catholic orphanage for métisse girls in Brazzaville was, in crucial ways, an act of anticolonial resistance. Orphanages for métis children in the French colonies were instituted by the colonial administration and run by nuns and priests. Behind the administration's supposed justification of providing education and socioeconomic mobility for the abandoned offspring of French men lay their primary objective: to sequester métis children from public view, a strategy aimed at preserving a colonial racial hierarchy by denying the existence of sexual relations between white men and black women. These orphanages were sites of psychic and physical violence inflicted on métis children by taking them away from their African mothers, erasing their African families by designating them as orphans, and brutalizing the children through starvation, unhygienic living conditions, and corporal punishment.[3] Métis children received a vocational education designed to make them productive subjects of the colony in the long term and to produce goods that were sold to fund the orphanages' activities in the short term. The colonial obsessions of codifying racial difference and extracting goods and services came together in brutalizing ways in these orphanages.

In outlining his vision for a more progressive politics for French Equatorial Africa (AEF), the Guyanese colonial administrator, Félix Éboué, denounced the orphanages' colonial project of bartering one form of community for another by making French citizenship for métis children contingent on their isolation from their families. As Éboué writes, "I am further of the opinion that the acquisition of the status of citizen is a rather sad gift in exchange for all that the métis has lost: life with a family and security."[4] Andrée's escape from the orphanage therefore signaled her rejection of a colonial project that sought to disavow métissage and perpetuate the myth that life in the colonies was black and white, governed always by an impenetrable divide between African and European, colonized and colonizer. Her narrative brings important nuance to ideas of citizenship in the lead-up to independence, because her claims to French and Pan-African citizenship as a woman who identified as "mixed race" in a racially stratified society disrupted the colonial racial hierarchy upheld by institutions such as métis orphanages.

Andrée was born in Oubangui-Chari in 1921 to Josephine Wouassimba, a fourteen-year-old Banziri girl from the Kwango region, and Pierre Gerbillat, a French businessman. Family lore has it that Gerbillat's and Wouassimba's union was made possible by the French man's offer to double the bride price that Félix Éboué had already paid for the young village beauty.[5] Andrée grew up in an orphanage for métis children in Brazzaville and did

not have a surname for the first sixteen years of her life, because the colonial administration prohibited her use of her father's name and identified her in its records only by the number 22. As a teenager, she fought to obtain the right to use what she describes as a "mutilated" version of her father's name and became Andrée Gerbilla.[6] Only much later in her adult years would her father concede to her use of Gerbillat. After she ran away from the orphanage, her life seemed to follow the colonial script for métisses as she struggled to negotiate recognition from her father and solidarity with her mother. In her text, she describes intimate relationships with white men that were as much about individual choices as they were about navigating the racial hierarchy in colonial Central Africa.

For example, in 1939 Andrée met Roger Serruys and moved with him to the Belgian Congo. Serruys was the director of the Kasai Company, a concession company involved in the exploitation of rubber in the Kasai River basin. It was also the de facto government of the area. A year later, Serruys abandoned her while she was pregnant with his child, preferring a socially acceptable and politically advantageous marriage to a governor's daughter. Andrée returned to the French colony of Oubangui-Chari and lived with her father in the capital, Bangui. There she met Charles Greutz, an Alsatian businessman. They bought a coffee plantation eight hundred kilometers away "in the middle of the jungle."[7] In that isolated setting, surrounded by her immediate family and Charles's black workers, Andrée experienced her husband's racism firsthand. He frequently used racial slurs against her mother and was cruel to his black workers, one of whom he brutally attacked with a metal hook, leaving the hook embedded in the man's skull. It was also during her marriage to Charles that her two-year-old son, René, died from malaria after the colonial administration denied him the medication that was reserved for whites only. In 1948 Andrée met André Blouin, an engineer for the French Bureau of Mines. She obtained a divorce from Charles, married André, and moved with him to Guinea in the early 1950s.

Blouin continued to negotiate racial politics in her marriage with André. Yet she also departed from the colonial script for métisses as she crisscrossed multiple colonial borders through her political activism. In Guinea she joined the Rassemblement Démocratique Africain (RDA), an anticolonial political party that spanned French West and Equatorial Africa. Blouin went on to work closely with leaders of African liberation movements, including Ghana's Kwame Nkrumah and Guinea's Sékou Touré. She began her grassroots mobilization of women in the Belgian Congo on the eve of independence in 1960 as an organizer for the Feminine Movement for African Solidarity. The organization's charter outlined projects for women's health, literacy, and their

recognition as citizens of the emerging postcolonial nation-state. Her work was informed by the conviction that "if she so chose, the woman could be the foremost instrument of independence."[8] That year, Patrice Lumumba appointed her to the position of chief of protocol in his cabinet. Blouin was one of three members of Lumumba's inner circle, working so closely with the Congolese prime minister that the press nicknamed them "team Lumum-Blouin."[9] At a time when the world's attention was riveted on the Belgian Congo and its place in Cold War politics, international news media focused not only on Patrice Lumumba but also on "the woman behind Lumumba."[10]

The production history of her narrative *My Country, Africa: Autobiography of the Black Pasionaria* is as charged and complex as Blouin's own life story. Like Blouin herself, the text slips between and sometimes stands outside of several categories. Despite its title, the text is not an autobiography in the conventional sense. Blouin did not write the book, a fact that is made even clearer by its publication in English even though Blouin spoke French. *My Country, Africa* was born out of a series of interviews that Jean MacKellar conducted with Blouin during her later years living in exile in Paris. The paratext provides little biographical information about MacKellar, stating only that she graduated from Stanford University and "lived in Paris for 12 years, where she was closely associated with Andrée Blouin and many other personalities in the African independence movements."[11] The text, though constructed as a seamless narrative written in the first person, bears many marks of MacKellar's presence in her role as translator and transcriber. Sources suggest that Blouin later tried to sue MacKellar in order to prevent the manuscript's publication.[12] As Carole Boyce Davies has shown, collaborative authorship of a life story raises important questions about authority. She asserts that "writing another person's life story can become an act of power and control."[13] Blouin's lawsuit against MacKellar would signify her attempt to take back control of her narrative. It is therefore worthwhile to consider the turbulent origins of this book, because the tensions within and surrounding the text provide insight into the politics of textual production for black and métisse women as political protagonists.

Blouin's contestation of power and control over the text mirrors in key ways her contestation for the same within the book's pages. Sidonie Smith argues that "domination has different meanings and implications for the 'wife,' 'daughter,' and 'independent woman' of the colonizer and for the 'wife,' 'daughter,' and 'independent woman' of the colonized."[14] Throughout her life, the structure of colonial racial and gendered hierarchies kept Blouin outside of these categories. The colonial administration's designation of Blouin as an orphan kept her outside the category of daughter of the colonizer and the

colonized. She stood outside of "wife" when Roger chose to marry a white woman, and in causing the death of her son René, the colonial administration sought to push her outside of motherhood. In *My Country, Africa*, Blouin claims but also redefines these different social relations and categories. Analyzing the multiple and intertwined forms of exclusion and domination she faced allows me to further nuance this study's claims that women in the French colonies imagined more expansive forms of belonging in response to the interlocking oppressions they faced under colonialism. What do belonging and community look like for Blouin as a métisse in colonial Africa? What do space and place in public life look like for her in the early years of African independence? Blouin's narrative remains an important historical archive that provides an insider's account of anticolonial struggle at the height of independence movements in the francophone world. Yet, despite her significant contributions to African politics and the attention she received on the world stage in the 1960s, her experiences and analyses of the events of this period, like those of all the other women discussed thus far, have been overshadowed by the voices of more illustrious "founding fathers" of political movements.

Existing scholarship on *My Country, Africa* provides an important foundation for situating Blouin as a political protagonist. Irène d'Almeida and Renée Larrier take up related questions about what it means to read Blouin as a speaking subject and the role that orality plays in her text respectively.[15] Building on these studies of voice, authority, and authorship, I emphasize the political context of colonialism in Central Africa as a crucial frame for examining what it means to define, claim, and practice decolonial citizenship on the eve of independence. In other words, I want to read *My Country, Africa* not solely as Blouin's autobiography, given how fraught this categorization is, but also as a narrative about the politics of decolonization. Indeed, there is strong evidence that Blouin's narrative was motivated by a desire to preserve the legacy of her political work. Karen Bouwer claims that Blouin's major objection to MacKellar's manuscript was that it presented her story "in social-psychological terms, while Blouin wanted to leave a political testament."[16] Blouin herself, boarding a flight into exile in Paris after the coup d'état led by Mobutu in 1960, announced that "she would publish in France her memoirs 'containing sensational revelations'."[17] She clearly intended her autobiography to counter not just the general silencing of women in the archives, but the specific silencing imposed on her by political opponents. Rendering her account apolitical reenacts the very silencing she sought to oppose.

This chapter therefore examines *My Country, Africa* as primarily a political narrative that sheds crucial light on race, gender, and belonging in France's Central African colonies. I aim to tease out the connections between Blouin's

most intimate experiences of racial discrimination and privilege and her work as an anticolonial activist. These experiences shaped her articulation of a Pan-African citizenship that envisioned African political unification in response to European colonialism. In the crucial moment when African nationalist movements sought "to minimize divisions of class or ethnic origin by emphasizing the importance of concerted action by the mass of common people against foreign rulers or domestic oligarchies," what definition of citizenship and belonging emerges in the testimony of a métisse African woman?[18] Because Blouin was vocal about her multiple racial, cultural, and political affiliations, she went against the grain of the prevailing discourse of her time on race and decolonization. She did not gloss over difference in the service of a black nationalist struggle as some of her contemporaries sought to do. Rather, she productively engaged different identities as crucial for a more capacious vision of Pan-African belonging. Blouin's notion of citizenship in sovereign African nation-states at the moment of their formation was premised on recognizing plural spaces of belonging within communities that were defined by their members' shared commitment to the overthrow of colonialism. Her narrative also envisions a clear place for those Africans whose claims to multiple racialized belongings were often read as a disavowal of blackness in a Manichean struggle between black and white. As this chapter shows, Blouin's unstable, ever-shifting racial identifications certainly betray her lingering attachment to the very racial hierarchies that her activist work sought to dismantle. But they also engage in the kind of borderlands thinking that, as Gloria Anzaldúa indicates, disrupts discourses that equate citizenship with racial nationalism.[19] Where Nardal, Éboué-Tell, and Vialle framed French citizenship as a right that one simply had to claim from France at the ballot box and in Senate debates, Blouin's narrative illuminates a central challenge on which the other women preferred not to dwell: what happens when, despite constitutions ratified and laws passed, France continues to reject the citizenship claims of the colonized?

In order to better understand Blouin's claims to Frenchness, her navigation of race and racism in the colonial context, and her definition of Pan-African citizenship from the borderlands, I turn not only to the rich content of *My Country, Africa* but also to the text's narrative form. Because Blouin takes up racial and cultural hybridity rather than a singular black African nationalism as the focal point of her anticolonial activism, reading hybridity necessitates understanding how it functions both within her narrative and in her political work. Consequently, I juxtapose *My Country, Africa* with a novel that is loosely based on Blouin's life, Henri Lopes's *Le lys et le flamboyant*, in order to analyze the textual métissage at work in Blouin's contested autobiography.

By taking creative liberties with Blouin's narrative in his fictional account of her life, Lopes encourages readers to explore the frayed seams of *My Country, Africa*, the moments of slippage between Blouin's voice and MacKellar's. A close reading of both works therefore allows us to examine ideas about authenticity and the stakes of literary representation, particularly in the context of anticolonial struggle. Ultimately, Blouin's narrative shows that her anticolonial activism was motivated in part by her engagement with her multiple and shifting positions vis-à-vis African and European communities in the colonial context. Throughout her political work, she advocated for a more expansive idea of Pan-African identity that was not predicated on limited notions of color consciousness but instead embraced all Africans who shared her investment in decolonization.

Textual Hybridity in Narratives of Belonging

My Country, Africa is a hybrid text in several ways. Generically speaking, it encompasses autobiography, biography, and oral history. Blouin's autobiographical "I" that narrates much of the story gives way to MacKellar's intervention as biographer, translator, and transcriber in the epilogue. This shift exposes the fiction of a unified identity of author and subject that underlies traditional autobiographies.[20] It also highlights the contest between representation and self-representation that is at the heart of both the book's production and Blouin's anticolonial activism. As Boyce Davies asks, "What are the implications of editorial intervention and ordering processes in the textual production of a life story?"[21] Accounting for the implications of the unseen biographer/transcriber/translator's hand illuminates the central idea of autobiography as the construction of the subject. Blouin's story of anticolonial resistance in *My Country, Africa* is constructed (this does not mean fabricated) through her collaboration with MacKellar. But beyond that, if, as Philippe Lejeune argues, "the autobiographical form is undoubtedly not the instrument of expression of a subject that preexists it, nor even a 'role,' but rather that which determines the very existence of 'subjects,'"[22] then *My Country, Africa* is not just the construction of Blouin's life story but also of Blouin herself as the subject of this story.

Because the genre of fiction allows the author to highlight with more transparency the different voices and texts present in collaborative life writing, the intertextuality between *My Country, Africa* and *Le lys et le flamboyant* is crucial for examining this process of constructing the subject. Henri Lopes is himself a political protagonist who stands at the point of overlap between public politics and literary production. Born in Leopoldville in 1937, Lopes,

like Blouin, moved between Oubangui-Chari and the French and Belgian Congos throughout much of his early life. From the late 1960s onward, he occupied several ministerial positions in the Republic of Congo, including a brief tenure as prime minister. Lopes served as the country's ambassador to France from 1998 to 2016. As a writer, his novels have largely focused on métis communities in Central Africa. He received the Grand prix littéraire de l'Afrique noire in 1972, joining the ranks of such distinguished African writers as Léopold Senghor, Aoua Kéita, and Ahmadou Kourouma. He was also awarded the Grand prix de la francophonie in 1993.

Henri Lopes frames his novel *Le lys et le flamboyant* as a corrective to the Blouin/MacKellar production.[23] Through the paratext, Lopes crafts an alternative history of the production of *My Country, Africa* that moves away from the singular "I" that stakes its claim in Blouin's narrative and instead takes a polyvocal approach to life writing. The blurb on the back cover, rather than provide biographical information on the author Lopes, introduces three fictional characters. Simone Fragonard, alias Kolélé, is the protagonist whom the reader cannot help but identify as Blouin, given the remarkable similarities in their biographies. Victor-Augagneur Houang is the narrator, who speaks in the first person. "Un certain Henri Lopes" is the obscure author who once wrote Kolélé's/Blouin's story before the fictional Houang decided to intervene with *Le lys et le flamboyant* as his corrective version. Lopes's choice of fictional narrator is significant because he shares his name with the historical figure Victor Augagneur, a French socialist politician who was governor of Madagascar and then AEF in the first two decades of the twentieth century.[24] Like his fictional namesake, the historical Augagneur was also an author. His account of the 1904–1905 revolt in southeast Madagascar reveals a view of history that is ultimately subverted by Lopes's novel. In his preface to *Erreurs et brutalités coloniales*, Augagneur eschews oral testimony and argues that it is his reliance on verified written documents that renders his account an exemplary and impartial historical narrative. It is these very claims to an impartial and definitive version of history that Lopes's paratext counters. Like *My Country, Africa*, *Le lys et le flamboyant* is also a hybrid text, at once a book with no author and a book with multiple authors.

Lopes tries to lay bare the behind-the-scenes mechanisms at work in constructing Blouin as the subject of her life story. He does this in a prologue that is as atypical as the blurb. Here we learn from the narrator, Houang, that the fictional Henri Lopes's biography of Kolélé was produced by a publishing house in Kinshasa that soon went out of business. Years later, an American edition appeared "that saved the text from obsolescence, thanks to the remarkable work of revision done by the translator, Marcia Wilkinson."[25] In a

clear gesture to *My Country, Africa,* Houang states that the American version included a subtitle that hailed Kolélé as an African *pasionaria.* Lopes gestures here to the hegemonic power of the English language, which increases chances of publicity and circulation for English-language texts as compared to French works.

Houang also takes up the construction of Kolélé as a heroine to appeal to a feminist readership. He informs his reader about the book's reception: "In those years when feminism was all the rage, Kolélé's biography responded to the demands of the American market. The fact that the heroine was a black woman added to the text's appeal and made it 'politically correct' merchandise that was easy to market."[26] He argues that the subtitle was a calculated and successful marketing gimmick that allowed Marcia Wilkinson to sell more copies than Lopes's original French version ever could. The book's cover image for Houang is another shrewd calculation. Kolélé appears on the cover of the fictional American version wearing a madras head scarf and flanked by the silhouettes of Kwame Nkrumah, Sékou Touré, and Patrice Lumumba, as though to suggest that her story is worth reading only when framed by a larger narrative about the so-called founding fathers of African independence. Houang's critique of the subtitle and cover imagery plunges the reader into what is usually unseen territory—that is, the packaging and marketing decisions that significantly influence how a published work is disseminated and received. The subject of the text herself remains on the margins of this decision-making process. In Houang's paratextual interventions, we hear the same irreverent tone that characterizes the rest of the novel as he interrogates the deliberate construction of Kolélé/Blouin as a heroine. His tongue-in-cheek description of the subtitle and cover image as simply packaging for an American feminist audience highlights the impulse to refashion Kolélé/Blouin into a heroine who is recognizable by European and American readers.

This project of repackaging for international consumption was very much the case outside Lopes's novel, in media representations of Blouin at the height of her political career. Pierre Davister, a journalist writing for the Belgian newspaper *Pourqoui Pas?* first referred to Blouin as "The Black Pasionaria" in his coverage of her expulsion from the Belgian Congo.[27] With this moniker, Davister equated Blouin with Spanish communist activist and orator Dolores Ibárruri, whose political work during the Spanish Civil War earned her the nickname La Pasionaria. Following Davister's lead, American publications such as *Time* chose to style Blouin "the Madame de Staël of [Sékou Touré's] revolutionary movement" and, later, of Lumumba's Congo.[28] The *Baltimore Afro-American* described her as the "Red Mata Hari," fashioning Blouin after

the Dutch exotic dancer who was executed in France on suspicion of being a spy for Germany during World War I.[29] Perhaps most imaginative was the *Washington Post*'s mention of Blouin as "the Eartha Kittenish Clara Petacci of the Congo's brief strongarm regime."[30] The *Post*'s reimagining of Blouin as Eartha Kitt is particularly interesting, given some of the similarities in the two women's backgrounds. Kitt was born in the cotton fields of South Carolina to a black mother. Although her father's identity remains unknown, there is some speculation that he was a white man. She trained under Katherine Dunham and went on to become a cabaret dancer, singer and actress.[31] The *Post* also likens Blouin to Mussolini's mistress Clara Petacci, who was executed alongside the Italian dictator. In each of these titles we find the desire to recast Blouin as a Congolese version of a well-known European or American figure in order to render her more digestible to the reader. This impulse, Houang would argue, reveals the terms on which Blouin was made visible for consumption by audiences in Europe and the United States. Consumption here takes on multiple figurative meanings, particularly because many of the descriptions also represent her as highly sexualized: a courtesan, a cabaret dancer, and a politician's mistress. The alternating push-and-pull factors of exoticism and familiarity at work in the global circulation of sexualized images of Blouin portray her as an exoticized version of a recognizable Self and feed into stereotypes of métisse women as exotic objects of desire.[32]

In Lopes's novel, Houang undertakes his own project of conscious refashioning of the protagonist even as he criticizes this practice. He rejects the fictional collaborator, Marcia Wilkinson's representation of Kolélé/Blouin, as a singular figure, "a 'positive heroine' in accordance with the aesthetic canon of socialist realism that was then in vogue in certain literary milieus."[33] He presents an alternative image of Kolélé/Blouin as a protagonist whose identity is shaped by the multiple voices and influences of her community: "At that time, all the métisses on both banks of the river were my aunts."[34] Kolélé is but one of the numerous métisse aunts who form part of the large, multiethnic community of Poto-Poto in Brazzaville. Like them, she negotiates life, love, and family in the racially stratified society of colonial French Congo. Kolélé/Blouin is a woman like the numerous other African women who made important contributions to the anticolonial movement. She is set apart only by the fact that as part of an educated, elite minority, she could leave behind a written testimony. Lopes has argued elsewhere that Poto-Poto as the métis quarter of Brazzaville—not coincidentally where the real-life Blouin sought refuge from the colonial administration the night she escaped from the orphanage—is a space charged with political significance. He gives the example of "the declaration of one of our prime ministers who, immediately after his

nomination, announced that he was 'a child of Poto-Poto.' In Brazza, when someone proclaims himself a child of Poto-Poto, he proclaims himself above the ethnic cleavages that continue to poison the political and social life of our country."[35] To be métis in this context symbolizes the ability to transcend racial, cultural, and political divides by embracing a composite identity. As we will see, Blouin articulates a similar project of going beyond singularity and embracing multiplicity.

Houang further counters the representation of Blouin as heroine by employing a tone he describes as "the lightheartedness and humor suited for serious subjects."[36] In a notable example, both *My Country, Africa* and *Le lys et le flamboyant* recount the singular moment of Blouin's political awakening. Juxtaposing the two renderings of this event reveals the marked difference in tone:

> I had no idea that he [Sékou Touré] would become the catalyst of my political commitment. This took place at a moment so clear, so overwhelming that it was like a mystical conversion. I was in a humble African shop in Siguiri. . . . As I waited for my change I raised my eyes to the poster photograph that was on the wall behind the shopkeeper. . . . A spirit, a light, a recognition—I hardly know what to call it—came over me. The eyes that looked into mine challenged me. I felt sure I heard words spoken. "Why are you on the other side, in this struggle? Why are you against us?"[37]

> —Un jour j'ai rencontré des frères . . .
> —Et tu as eu la révélation, comme saint Paul, ricana Josépha.
> —C'est ça même, agréa Kolélé avec un sourire malicieux. Et pour bien montrer qu'elle savait rire d'elle-même, elle tendait la paume de sa main pour que Josépha y topât. Les deux femmes s'esclaffèrent.

> —One day I met some brothers . . .
> —And you had a revelation like Saint Paul, Josepha snickered.
> —Exactly, Kolélé agreed with a malicious smile. And to show that she could laugh at herself, she held her palm out to Josepha, who slapped it. The two women guffawed.[38]

Lopes is deliberate in his use of a *champ lexical* of "rire," particularly evoked by verbs like "ricaner," "s'esclaffer," and "sourire malicieux," to emphasize mockery. The irreverence of his retelling directly opposes Blouin's use of religious imagery in raising her eyes to encounter this "mystical conversion" from an apolitical person to a central figure in the anticolonial movement. It may be that Lopes's mocking tone conveys his skepticism that this event did in fact occur. However, read in the context of Houang's insistence that Kolélé/Blouin "was not a heroine of her times," this mockery is more likely

directed not at the episode's veracity but rather at its use in the text to set Blouin apart from other anticolonial activists by representing her as a prophetic or messianic figure.[39]

MacKellar's epilogue ultimately reveals the potential pitfalls of fashioning an idealized heroine as a singular character apart from all others. She asserts that "in a society where most women were consigned, with a swat, to their cooking pots, and where even today many thousands are still excised and sewn in one of the cruelest denigrations of the feminine sex in the world, this brilliant woman appeared, to provide an unparalleled example of courage and gifts realized. *Andrée Blouin emerges from the shadows of her continent as its first authentic heroine.*"[40] Certainly, MacKellar's work in producing *My Country, Africa* is useful because it highlights Blouin's otherwise ignored role in African politics and preserves the story of her work for posterity. However, by casting Blouin as an exceptional woman, MacKellar also confines African women within the role of passive immobility on a continent whose figuration very much resembles the setting of Joseph Conrad's *Heart of Darkness*. Anupama Rao and Steven Pierce identify the impulse behind such declarations of exceptionalism as a form of imperialist feminism that operates on the assumption "that the only relevant part of other women's identity [is] their victimization by traditional practices such as veiling, footbinding, genital operations or sati. Gendered susceptibility to violence and violation [come] to stand in for the other woman's subjectivity, and pain and suffering [are] its unique expression."[41]

MacKellar's framing of Blouin in these terms breaks the trust that Boyce Davies identifies as central to the process of collaborative life storytelling. For Boyce Davies, this trust is often facilitated by a shared identity between collaborators: "Affiliations or disjunctions of gender, class, nationality, language, and shared politics seem to be the primary facilitators of, or interferences in, the collaborative life story telling process. The extent to which the editor shares common identity locations with the narrator determines the extent of full articulation of an autobiographical 'we' rather than the 'I'."[42] The trust between Blouin and MacKellar is broken by the disjunction between narrator and writer/transcriber/biographer, which exists not merely because MacKellar is white and Blouin is not but because MacKellar inscribes Blouin in an imperialist power dynamic that casts African women as a homogenous, victimized Other. Blouin herself would most likely reject MacKellar's fashioning of a singular African heroine who emerges from a continent otherwise populated by women who are memorable only for the mutilation of their genitals. In an interview, she once responded to the title Red Mata Hari with a forceful denunciation: "I couldn't care less. Let small

fools call me what they like. I am an African nationalist."[43] Blouin refuses the singularity of the title ascribed to her and rather establishes herself as *an* African nationalist—that is, one of many.

Through its rewriting of the Blouin/MacKellar production, *Le lys et le flamboyant* ultimately questions the claims to truth and reliability implied in the framing of *My Country, Africa* as an autobiography. Both texts reveal that disentangling the voices of author, narrator, and translator in the story of decolonization in Africa is a messy affair. Yet that messiness is productive because, as we will see shortly, it nudges readers toward a reading of citizenship, in the context of decolonization, as grounded in plurality rather than in singularity. Houang performs this questioning of truth and reliability in two steps. First, he unravels the assumption of authenticity and objectivity that underlies the genre of autobiography: "Do you know Kolélé? . . . A certain Henri Lopes has already told her story. But I, Victor-Augagneur Houang, narrator of *Le lys et le flamboyant*, I reject that testimony and restore for you the events in their authenticity."[44] Yet for all his claims to providing an authentic and definitive version of events, Houang is oddly ambiguous. Whose testimony does he repudiate in the above statement? Is it that of Lopes as author or Kolélé as narrator? Further, if Blouin's and MacKellar's voices are inextricably intertwined in *My Country, Africa*, then whose voice does *Le lys et le flamboyant* ultimately subvert? This ambiguity characterizes much of the novel, such that the opening question "Do you know Kolélé?" appears to really be asking whether we can ever truly know Kolélé/Blouin, given the multiple degrees of mediation in her narrative. As Houang tries to peel back the many layers of Kolélé's identity, and as her unexplained absences and numerous pseudonyms in Lopes's novel (Simone Fragonard, Monette, Kolélé, Célimène, Malembé wa Lomata) veil more than they reveal, the answer to his question is a resounding no.

Once the claim to an objective account of Kolélé/Blouin's life has been thus unraveled, Houang proposes Louis Aragon's concept of *mentir-vrai* as an alternative frame for producing and reading his version of the Kolélé/Blouin narrative. Aragon's short story "Le mentir-vrai" takes a fictional-autobiographical look at childhood. Through changing perspectives and questioning the narrator's own reliability, Aragon's text challenges the "je" of the narrator and the "jeu" of the author in producing fiction. Lopes cites Aragon as a key influence and argues that he too grapples with the interplay of truth and lies, fact and fiction in his literary production. He argues that "to write is to wrestle with the complexity of life. The novelist's 'mentir-vrai' is a work of art."[45] Wrestling with representation, as Lopes describes it here, becomes even more difficult in a novel framed as a biography and presented as a corrective

to an autobiography that is itself located in the hyphen between mentir-vrai. Houang explains to his reader, "Forgive me for wanting to 'mentir-vrai' too; it is simply to remind you that at the end of it all, the real remains ungraspable and slips through our fingers when we think we have a hold of it."[46] Lopes employs concrete, corporeal imagery that throws into relief the elusive nature of any kind of objective, unmediated reality.

Throughout his novel, Kolélé remains recognizable as Blouin despite the fact that some of her key biographical information—the most verifiable aspects of her otherwise contested text—does not correspond to the reality of Blouin's life. Notably, the date and location of her birth and death are not factual. What Lopes intends his reader to take away, then, is not so much the events of Blouin's life and political work but rather a more nuanced understanding of the mechanics of the production of her narrative: "How to engrave these moments? How to do so with the accent of the country? How to say all that this woman was?"[47] Throughout the novel, Houang is particularly conscious of the "how," the narrative strategies and cinematic techniques he hopes to employ in preserving, through film, the story of Kolélé and the métis community of Poto-Poto.[48] His self-conscious narrative reminds the reader to take nothing for granted in Blouin's autobiography. Houang questions everything from the illusion of a linear, chronological narrative to his/MacKellar's roles as supposedly invisible "collaborators" in the production of the Kolélé/Blouin story. Le lys et le flamboyant unravels My Country, Africa not to discredit it but to show its seams in order to make the reader aware of the politics that hold Blouin's narrative together.

It is significant that much of my reading of the intertextuality between My Country, Africa and Le lys et le flamboyant has centered on the latter's paratext. Richard Watts persuasively argues that "this manipulation by Lopes of the sites of authority around the text—prefaces, back covers, prologues, epilogues—simultaneously elides that authority while forcing us to think about the traces."[49] Questions of authorship and identity are, as Lejeune reminds us, questions of power relations: "One is not an author in the absolute. . . . One becomes an author only when one takes, or finds oneself attributed, the responsibility for the emission of a message (emission that *implies* its production) in a given circuit of communication."[50] Despite its transparency about its project, Le lys et le flamboyant's framing as a corrective to My Country, Africa and its tongue-in-cheek rewriting of Blouin's life perpetuates the conflictual relationship among author, narrator, and subject. Given Blouin's assertion as she went into exile that she intended to publish a revelatory narrative, Lopes's novel joins My Country, Africa as another text that claims authority and displaces Blouin as the author of her own life story.[51] The paratext as the site of this

contestation of power is also significant because its location, neither within the pages of the novel nor separate from the text, highlights the importance of border spaces and nudges us to be attentive to the framing gestures that occur at the edges of Blouin's life story.

Lopes's and Blouin's texts therefore operate within multiple liminal spaces and perform what Lopes calls *écriture métisse*. Watts argues that the hybridizing function of both works' paratexts is doubled by the narrators, who also inhabit the hybrid space of métissage.[52] Lopes's narrator Victor-Augagneur Houang, for example, is an Afro-Asian Congolese man whose geographies crisscross Central Africa, France, the United States, and China. He shares his name with the historical figure Victor Augagneur, who, in his capacity as a colonial administrator, was a particularly outspoken opponent of métissage in the French colonies, describing métis children as "a curse" and "a disruptive element."[53] In his écriture métisse, Lopes cannibalizes—à la Suzanne Césaire—the historical Victor Augagneur. He absorbs the political debates on métissage in the colonies that so preoccupied the French politician and regurgitates them in modified form. The fictional narrator Victor-Augagneur, like his namesake, is particularly concerned with métissage, but his concerns are informed by his own experiences as a Congolese métis.

My Country, Africa too may be characterized as écriture métisse, because it is a bilingual text, the product of a collaboration between a Congolese métisse and a white American woman. The text's métissage has important implications for reading African women's roles in shaping and defining new forms of political identity through anticolonial activism. For Blouin, positioning oneself vis-à-vis black and white, African and European, took on a different shade in the starkly Manichean social and political divides that often characterized anticolonial movements. Voice and agency are virtually impossible to pin down in Blouin's narrative, in much the same way as Blouin's own racial and national identifications constitute a constantly shifting terrain of engagement with colonial power. Through her multiple identifications, Blouin highlights the obstacles to claiming French citizenship and articulates the possibility of a Pan-African citizenship that privileges flexibility and multiplicity over the imagined singularity of a black African identity.

Resistance at the Crossroads: Toward a Métisse Politics of Decolonization

As the daughter of a French father and an African mother, Blouin's navigation of multiple communities and allegiances in colonized space began long before the short-lived project of citizenship in the French Union. Like Nardal,

who imagined a composite Antilles-France, and Éboué-Tell and Vialle, who argued for intertwined French, African, and Antillean cultural and political communities as the best chance for survival in the modern world, Blouin sought to weave her multiple strands of belonging into a hybridized political identity. Yet unlike Nardal, Éboué-Tell, and Vialle, her narrative suggests that there was no neat reconciliation of the multiple and sometimes opposing racial, cultural, and political influences to which she lay claim. Throughout *My Country, Africa*, Blouin's French-African citizenship constantly unravels as she tries to situate herself vis-à-vis black and métisse women as allies, white women as employers and rivals, black men as colleagues in the Pan-Africanist movement, and white men as husbands, lovers, and fathers.

Blouin navigated conflicting racial affiliations in both her interpersonal relationships and political associations. Throughout her narrative, her black mother and white father stand in at various moments for her allegiance to Africa and France. For example, in describing her mother's legacy, Blouin asserts:

> I want everyone to know what kind of person she was and to know the tenderness I feel for the fragility of a being like her. I think that this love that I experience in my awareness of her derives from my role as her protector. She was so unequipped for life, so unconscious of many of its realities. They escaped her. As they do many Africans. Whatever was painful she lived only for a moment. Then she forgot it, thrust it aside in some riotous new joy, usually associated with her family. . . . She was constantly surrounded by troops of children; there was usually a little one on her back. Although she had only one child, in her love of the young and of family, she was a real *maman*, the embodiment of the true mother spirit. Each morning I call my fragile, child-hearted mother, in whom I see Africa itself, and each evening.[54]

Josephine stands in for the entirety of the African continent in this declaration of love that shows the porous boundary between intimate familial relationships and colonial racial politics. There is much in Blouin's description of her mother that troublingly hearkens back to colonial stereotypes of insouciant, childlike Africans, a view that in turn influences how she understands the political instability and economic uncertainty that many newly independent African countries faced: "I see now how ill prepared, morally, we were for our new responsibilities. Like greedy children freed from unjust restraints. . . . We have not yet learned the long term, day-to-day faith and application needed in the slow task of building a responsible citizenry."[55] Blouin's depiction of the challenges of citizenship after independence recycles essentialist colonial tropes. Interestingly, within this colonial discourse is also interwoven the im-

age of Africa as nurturing mother—notably in the slippage between Josephine as both child and mother—a maternal image that, as Anne McClintock, Amina Mama, and others have shown, was integral to African nationalist discourse in the early years of independence.[56] Through her descriptions of Africa as both the hapless child of the colonizer's imagination and the nurturing mother who would be central to postcolonial visions of liberation, Blouin reveals much about her own self-positioning as she defines herself as both the child and protector of the African continent.

If Blouin's understanding of citizenship in Africa is filtered through the language of motherhood, her reclamation of French citizenship is rooted in her negotiation of paternal recognition. She asserts, "In spite of the manner in which I had been brought up by the nuns, I still had feelings for France, and especially my father's sacrifices had been a lesson to me in the love of country."[57] Pierre Gerbillat's "unconfined patriotism" was manifested in his enlistment in the Free French Forces during World War II.[58] It instilled in his daughter notions of citizenship premised on reciprocated love between the individual and the state. For Blouin, claiming recognition from France required, first and foremost, legitimacy and recognition as Gerbillat's daughter: "Perhaps I will never be able to fully integrate the meaning of Pierre Gerbillat in my life. But once in a while I find myself saying or doing something in which I recognize myself as Gerbillat's daughter. And then, perhaps, I move a little closer to the truth."[59] Blouin confers the denied paternal recognition on herself, a recognition that then becomes the conduit for her reclamation of French citizenship.

Blouin's raced and gendered notions of French and African identities as two ostensibly separate citizenships, reinforce colonial stereotypes. She does, however, circumvent the trope of the "tragic mulatta." Hers is not the story of an impossible duality whereby the métisse is unable to find acceptance at either pole of a black/white binary and ultimately meets a tragic end. Instead, as Blouin's daughter Eve asserts, "Son statut de métisse la posait à un carrefour et fut le joug qu'elle porta toute sa vie" ("Her status as a métisse placed her at a crossroads and this was the yoke she carried all her life").[60] The image of the "carrefour" is particularly productive because it moves us away from the discourse of duality that often characterizes reflections on métissage, including Henri Lopes's own notions of *double appartenance*.[61] The crossroads represent Blouin's awareness of the multiple lineages that lead back to her composite métisse identity. That Eve characterizes this as a "yoke" ("joug") suggests that these multiple belongings were never easy to negotiate, particularly given the language of stark binary divisions that framed anticolonial movements. As Suzanne Césaire's writing shows, the crossroads, that Césairean meeting point

of creativity, resistance, and multiple cultural influences, provides a more nuanced framework for understanding the complexity of citizenship that is untethered from the nation-state and that is shaped by alternate geographies.

The crossroads, a spatial metaphor that evokes simultaneously a terrain to be navigated and a choice to be made, resonates with Anzaldúa's theorizing of a *mestiza* "consciousness of the Borderlands."[62] Anzaldúa's argument that the mestiza copes with contradictory signals about her place in a supposedly binary social order by "developing a tolerance for contradictions" illustrates Blouin's simultaneous navigation of the multiple paths that lead to and away from the crossroads of her racial and political identity. [63] She travels all of these paths at once when she recounts the moment of her political *prise de conscience*:

> The death of my son politicized me as nothing else could. In the revolt that overwhelmed me after the first pain had passed, in the wonder and bitterness of my grief, I came to integrate in an entirely new way the meaning of the colonialists' terms in Africa. I understood at last that it was no longer a matter of my own maligned fate but a system of evil whose tentacles reached into every phase of African life. I experienced this evil in the grief particular to a female—in an orphanage for girls, as a repudiated mistress, and most of all, as the mother of a dying child. For men there were other kinds of torment and degradation. The difference between my new attitude and the old one was a matter of clarity of vision. I had suffered intensely for the blacks who were whipped with the *chicotte*, and I had been outraged by the forced marriages of my friends. These injustices I had related to my own. Still, it had been all a little removed from the understanding that is at the source of one's energy and will. When I lost my bronzed little boy I saw finally the pattern connecting my own pain with that of my countrymen and knew that I must act.[64]

Blouin moves systematically through the process of her political awakening. She begins by recognizing the interlocking oppressions she faces as a métisse woman. In the colonial economy, she occupies the multiply devalued social positions of orphan and sexual object. In causing the death of her son, the quinine law that made malaria treatment available to whites only negates her motherhood. René's death is the moment when Blouin begins to understand these interconnected marginalized positions to be a manifestation of colonial power. The language of maternal grief gives way to that of awareness of institutionalized racism. Her shift in consciousness results in her realization that whiteness by proxy would not offer her the imagined protections from the colonial system. Her language here becomes increasingly politicized as her personal "grief," "pain," and "bitterness" give way to "revolt," "outrage,"

and a will to "act." Blouin attempts then to articulate solidarity with different groups of marginalized people, "the blacks who were whipped with the *chicotte*," métisse friends forced into marriages with other métis, and her "countrymen." She moves beyond the idea of a fractured métisse consciousness to imagine resistance beyond a racial binary, as articulated in Eve's image of the crossroads.

Throughout *My Country, Africa*, Blouin identifies her multiple racial affiliations as a reflection of AEF's larger negotiation of citizenship and belonging in the French empire. Thus, although she views colonial oppressions and humiliations as personal hardships at the time that she suffers them, the hindsight afforded by reflecting on and retelling these experiences leads her to draw parallels between her personal trauma and systemic colonial violence on a wider scale. The injustices that she suffers become manifestations of the institutionalized racism that was necessary for imperial rule to function. For example, in recounting her traumatic childhood in the Brazzaville orphanage, she describes the intertwined nature of gendered repression as perpetrated by French nuns and colonial oppression as perpetrated by European administrators. The opening sentences of her autobiography express this connection in powerful terms:

> As punishment for the crime of being born of a white father and a black mother I spent my early years in a prison for children. This prison was the orphanage for girls of mixed blood at Brazzaville in the French Congo. The time was the dark years of colonialism in Africa. . . . It was while I was still in the orphanage-prison that I first identified with the struggle for freedom of my black countrymen. Like them I was beaten with the *chicotte*, a whip made of ox sinews. Like them I was the victim of injustices of which I hardly knew the name but against which my blood never ceased to rebel. For many years, however, I did not participate in the African struggle for self determination. I could not overcome the resignation taught me by the nuns. I bowed my head, I held my tongue, I shut myself up in the dreary passiveness of the other women of my race.[65]

In this description of Blouin's early encounters with colonial oppression, individual tools and sites of torture come to stand in for the larger system of violence that was colonialism. The métis orphanage is coded as a prison, a space of surveillance and sequestration. The chicotte, or what one historian describes as "a potentially lethal whip of dried hippopotamus hide,"[66] is wielded both by Catholic nuns against children and by colonial overseers against workers on rubber plantations,[67] thus blurring the putative line between Christianity's civilizing mission and the murderous colonial enterprise

of extracting profit for the mother country. Blouin experiences the feelings of resignation, powerlessness, and simmering rebellion that Frantz Fanon shows to be manifestations of the effects of colonialism on the psyche of the colonized.[68] This brief passage also shows Blouin's multiple and sometimes rapidly shifting identifications throughout her autobiography. As she is beaten with the chicotte, her body stands in for those of her "black countrymen," the naked chained men she sees through the orphanage gates being whipped as they are dragged to prison.[69] Next she identifies "the African struggle for self determination" in which she would take active part, but not before passively accepting the social roles imposed on "women of [her] race," the roles played by the girls and young women in the orphanage for métis children who are taught that they are "made for nothing better than to be a servant to the whites."[70] In each of these moments, Blouin is at once insider and outsider, weaving a hybrid identity that would later allow her, in Lumumba's Congo, to articulate a Pan-African citizenship that sought to unify all of the different groups of colonized people evoked in this passage in a common, anticolonial cause.

Like Blouin, few of the influential thinkers writing about métissage and anticolonial politics in French West and Equatorial Africa in this period grappled with the fictions of race as a socially constructed identity. For some of these thinkers writing at the time of Blouin's political awakening, the shifting nature of her social positioning suggested a disavowal of what they saw in sometimes essentialist terms as a specifically black African identity. Léopold Senghor argued in a 1947 article for *Réveil*, a newspaper with connections to the RDA, that métissage and racial identity were explicitly about political power in the soon-to-be post-colony.[71] He boldly titled his article "Il n'y a pas de problème du métis" (There Is No Métis Problem) and published it in the middle of an almost yearlong raging debate in the pages of *Réveil* about métissage in Africa. This debate took place amid the constitutional changes that would birth the French Union. Senghor was categorical about his position on métissage in the new political configuration. Despite "the kind efforts of some well-meaning métis to define their place in the Negro-African community, I do not believe there is a métis problem."[72] For Senghor, the francophone African federations needed now more than ever to present a unified bloc that would advocate for their best interests within the French Union. Consequently, his article argues that there is no separate "métis problem," because all Africans are métis, each ethnic group a mixture of several others. He suggests further that all the major challenges identified as unique to the métis community are shared by other sectors of the African population. For example, Senghor writes, métis Africans are not the only group who have

to navigate double belonging. *Évolués*—that is, Africans who have assimilated French cultural values through education, religion, and language—also have to grapple with a disjunction between their racial and class identities. Abandoned métis children in mixed-race orphanages share their plight with other abandoned children. The temptation for the métis to pass as white in order to gain increased social and economic mobility is shared by educated, middle-class black Africans who are also perceived by their communities as oscillating between the poles of "toubab-bougnoul,"[73] derogatory terms for white and black, respectively.

If Senghor's reading strangely conflates race and class in equating these different experiences of colonial subjugation and humiliation, it is not because he seeks to deny the presence of the significant métis population in France's African colonies. Rather, his perhaps equally troubling goal is to subsume them within what is, for him, the larger and more pressing issue of an African bloc coded as black and unified both within the French Union and on the world stage. For Senghor, the stakes are high: "What are we waiting for, we Negro-Africans, to also become an important factor in building the French Union and humanism in the twentieth century?"[74] The urgency of this political end goal, Senghor argues, necessitates that both évolués and métis "transcend the apparent contradictions and to transform them into a 'conciliatory agreement'" in order to contribute to the unified African front that would make France's former colonies a force to be reckoned with globally.[75] In another strange conflation of how blackness signifies and is constituted differently in the United States and overseas France, Senghor cites the NAACP's executive secretary, Walter White, as an exemplary model of his proposal to transcend contradictions. He describes White as "blond with blue eyes, as ardent a defender of his people as he is an excellent negro writer."[76]

One of the direct responses to Senghor's opinion piece on the colonial politics of métissage came from Jane Vialle, who read Senghor's views as a disavowal of the particular realities faced by those Africans who identified or were classified by the colonial government as métis. A few months after its publication, she referenced Senghor's article in a Senate debate on her proposed paternity law: "There are some African friends—who are not present here today—who claim that the métis problem does not exist. Alas when you travel through Africa, as I have just done multiple times, you see everywhere, in French West Africa and in French Equatorial Africa, that the métis problem does exist."[77] Vialle resists the erasure inevitably enacted by Senghor's attempts to subsume métis political identity within a discussion of black African political identity in a French federation. For Vialle, métis Africans inhabited a particular social position within the colonial hierarchy

that required a different set of strategies to resist colonial oppression. Her argument suggests, then, that for Senghor to assert that the political claims of métis Africans were always a subset of the larger black population's claims was to deny their agency and erase their existence.

Vialle's rejection of Senghor's thesis formed part of her larger argument to extend French paternity laws to the colonies, in which she contended that the problem of abandonment in orphanages was a problem faced uniquely by métis children. Where Nardal's Parisian writings in the interwar years showed the isolation and alienation that resulted from public misrecognition of black women and their labor, Vialle's law showed that withholding state recognition of métis children resulted in isolation and alienation and hindered their ability to access the legal rights and protections accorded to French citizens. In a colony where racist administrators wielded great power, the stakes of state recognition were extremely high and, as the story of Blouin's young son René shows, sometimes a matter of life and death.

Senghor's black-and-white notions of anticolonial politics, while problematic, as Vialle shows, also accurately reflected the views that informed anticolonial movements in Africa. Vialle experienced the marginalizing effects of this dualism firsthand. When she ran for Senate reelection in 1948, other candidates from Oubangui-Chari challenged her ability to represent her constituents on racial grounds: "It was no longer possible to vote for Madame Vialle, because she is not 100% Oubanguienne (she is métisse of a French man and a Congolese woman) and she was too comfortable with the whites."[78] By wielding a percentage as proof of Vialle's illegitimacy in representing her constituents, this declaration uses the marginalizing language of contested authenticity that would come to characterize nationalist movements throughout Africa in the early days of independence.

There is much in Blouin's narrative to suggest that her thinking departed from Senghor's oversimplification of race in Africa and his need to reduce the complexities of identity and political affiliation in the colonies to a binary understanding of black versus white. Blouin explains:

> Only when I had been married—ironically, twice to white men—did I find the equilibrium and courage to become active in the cause of my people. Only then was I able to transcend my black and white inheritance and become more than the stereotype of each. To become, simply, a woman, a human being. It was then I opted to give my life to the struggle of the blacks. In this I was privileged to take part in the movement toward freedom of several African countries. I was to know some of the great leaders of Africa, and because of my passion for our cause, I was to be associated in their work.[79]

Her analysis of the political implications of métis identity resonates with Senghor's to a point. She too emphasizes the need to "transcend" the apparent contradictions of multiple racial affiliations in the service of a humanistic project. Where Senghor is silent on how one concretely goes about this transcending of contradictions, Blouin suggests that the answer lies not in becoming black or "négro-africain," as Senghor argues, but in claiming one's human right to exist, to be "simply, a woman, a human being." Yet even in this seemingly categorical declaration of her humanity as going beyond the fictions of race, Blouin continues to locate herself in multiple categories at once, situating herself as both an insider to "the cause of my people" and an outsider to "the struggle of the blacks." In doing so, she resists equating racial identity with national identity or continental affiliation.

Blouin's account of life as a métisse in colonial Africa, and her work as an African woman at the crossroads of multiple racial, cultural, and political influences, expands notions of African nationalism beyond oppositional blackness. Her brand of Pan-African citizenship, informed by the intersecting oppressions that she faced, was made more inclusive by its insistence on flexibility and hybridity and its refusal to collapse citizenship and race into a singular and exclusionary model of community. Blouin urged all Africans to claim a unified identity that recognized rather than suppressed difference. The road to this Pan-African citizenship was treacherous, as her account of Lumumba's assassination and her own exile show. Yet she also identified moments of success in the arduous journey toward decolonization. Notably, the September 1957 RDA congress in Bamako marked one of these successes for Blouin.

The Bamako gathering was only the RDA's second congress, because for five years the colonial administration in the French Sudan had thwarted any attempts at a meeting that would unite anticolonial activists from all the territories that made up the French West and Equatorial African federations. In 1952 the administration had banned the second RDA congress at the last minute, and delegates en route to the meeting had to return home.[80] The 1957 congress was therefore a highly anticipated and charged event. Foremost on the agenda were the various independence movements that were gaining momentum throughout the continent. Among the territories represented, Guinea would gain its independence a year later, and nearly all the other French colonies would follow suit by 1960. The congress marked a turning point in Blouin's political work, an occasion to imagine herself "not as a woman of one country, but above all, as African. After the 1957 congress in Bamako when I made the acquaintance of the RDA's great family in many countries, I was known to all as 'our sister'."[81] For Blouin, this historic gathering was evidence of successful Pan-African unification.

Present too at the congress was another woman whose recollections of the RDA meeting differ significantly from those of Blouin. Aoua Kéita arrived in Bamako as a delegate of the Union Soudanaise du Rassemblement Démocratique Africain (USRDA). For Kéita, the congress revealed the deep cleavages in political ideology among the leaders of the different French territories.[82] The Africa that she saw moving toward independence was not a unified one but one divided along the lines of economic disparity and varying degrees of allegiance to France. Although Kéita's political vision was very different from Blouin's, she, like all the other women studied thus far, was unwavering in her belief that women would be the catalysts of democratic change. Her autobiography weaves a crucial thread into the larger tapestry of black women's anticolonial resistance in the francophone context because it moves us away from the narratives of elite, educated women in urban centers and emphasizes the long-ignored voices of rural women who were just as vocal and active in working toward a decolonized future.

5. Aoua Kéita

Rural Women and the Anticolonial Movement in *Femme d'Afrique: La vie d'Aoua Kéita racontée par elle-même*

I have had it up to here with this colonial domination that
I have been shaking with such difficulty and that I am
nevertheless unable to rid myself of.
—Aoua Kéita, *Femme d'Afrique: La vie d'Aoua Kéita
racontée par elle-même*

The orphanage for métis children, that "prison for children" that so traumatized a young Andrée Blouin, was, in contrast, a site of upward mobility for Aoua Kéita.[1] As young girls, both were educated in "mixed race" orphanage schools. Yet where Blouin suffered ill treatment and alienation, Kéita thrived. She was routinely at the top of her class at the school for métisses in Bamako. After two years she took the medical school entrance exam, earning the highest grades in French Sudan and the fourth highest in the entire French West African region, a feat that secured her a spot in the midwifery program at the medical school in Dakar. Kéita's and Blouin's educational experiences were so vastly different because they were determined in large part by race-based colonial policies. Kéita acknowledges in her autobiography that attending school as a black girl in the colonial social and racial hierarchy—a school reserved for métisses at that—was a rare privilege afforded few others in her position. Unlike Blouin, who was cut off from her community because the colonial administration designated métis children as orphans in order to hide them from view, Kéita was not resident at the orphanage and so remained connected to her family. This grounding was crucial for her successful navigation of the oppressive colonial education system.

Kéita recounts, for example, the verbal and physical abuse she received from the older girls in her class when she first enrolled in school. The métisse girls threatened to break her ribs if she continued to earn the highest grades in the class.[2] When Kéita informed her family of the situation, her father and brother arrived at the school with alacrity, even before the principal had opened his office for the day, and left only after the older girls had been summoned and made to agree to more amicable relations with their perceived rival. The same setting that represented colonial marginalization and isolation for Blouin thus became the site of one of Kéita's earliest experiences of community-based solidarity and resistance rooted first and foremost in the family unit. In the coming years, Kéita's notions of community would extend to include her fellow activists in the Union Soudanaise du Rassemblement Démocratique Africain (USRDA) party as a surrogate family.

Kéita's feminist, anticolonial, community activism began at the age of nineteen when she was posted to the region of Gao as a Colonial Health Services worker in 1932.[3] As the first midwife assigned to the area, she set about building a much-needed maternity ward and established a women's branch of the USRDA party. A seemingly tireless advocate for women's political enfranchisement, Kéita delivered babies by day and held meetings in the maternity ward by night to educate rural women on their rights to vote, to assemble, and to be heard. She registered voters in areas where misinformation had kept women from the polls, and she had heated exchanges with both French administrators and local chiefs who continued to sideline women from public life. As punishment for her grassroots organizing, the colonial administration continuously transferred Kéita to different posts in French Sudan. She remained undeterred. The administration finally exiled her to the Casamance region of Senegal between 1951 and 1953. On her return to Bamako, Kéita continued her work and founded the Intersyndicat des femmes salariées, a women's trade union. In the coming years, she would represent French Sudanese women's labor interests in international meetings from Bamako to Dakar, Paris to Leipzig. She became a recognizable political figure and was appointed to the committee charged with drafting the constitution of the Sudanese Republic, soon-to-be independent Mali. Kéita subsequently ran for elections and became the first woman deputy in the Malian National Assembly, a position she used to push through marriage reform laws that gave women increased rights. With the overthrow of the first president, Modibo Kéita (no relation), she went into exile in Brazzaville, where she wrote and published her autobiography.

Femme d'Afrique: La vie d'Aoua Kéita racontée par elle-même very tightly interweaves literature and politics. It draws readers' attention not only to the crafting of a political narrative in a literary text but also to the politics

of literary production for African women in the twentieth century. Unlike *My Country, Africa*, which recounts intimate details about Andrée Blouin's personal life in a colonial setting, *Femme d'Afrique* is an explicitly political text that is noticeably reticent about Kéita's life outside of her activism. Kéita devotes no more than thirty-odd pages in her impressive four-hundred-page tome to an account of her childhood, coming of age, and short-lived marriage to her colleague Dr. Daouda Diawara. She is categorical about maintaining her silence on personal matters in her writing and informs her reader, "For certain reasons, I would prefer not to talk about my love life."[4] *Femme d'Afrique* is also the first autobiography published in French by an African woman.[5] Published by Présence Africaine, the text pulls out all the literary stops. Kéita inscribes herself in the griot tradition by recording the stories, songs, and heroic actions of French Sudanese women and the USRDA at the height of the anticolonial movement. A year after its publication, her autobiography won the Grand prix littéraire d'Afrique noire, a prestigious literary award whose recipients include Léopold Senghor, Amadou Kourouma, Alain Mabanckou, and Henri Lopes. Kéita was the first woman to win the award, opening the way for Aminata Sow Fall, Mariama Bâ, Ken Bugul, and Véronique Tadjo, among others. Despite this critical acclaim, *Femme d'Afrique* went out of print in a few years, a fate shared with Blouin's *My Country, Africa*. The early stages of the present study were only made possible by used books retailers selling discarded library copies of both books.[6]

Several factors explain the muting of Kéita's voice in narratives of African liberation and independence. The general marginalization of women's voices in discourses of anticolonial politics is only one element of the story. After all, texts by Sow Fall, Bâ, Ama Ata Aidoo, and Tsitsi Dangarembga often feature in the postcolonial African literary canon. Kéita's absence from the canon is more likely explained by the key ways in which her autobiography departs from expectations of African women's writings. Her disproportionate emphasis on her work in the public sphere and her relative silence on her marriage and familial relationships disrupt expectations of African women's texts as focused primarily on a female protagonist's interiority or conflict in domestic spaces. In the rare instances where Kéita's text invokes the domestic sphere, it does so to turn it inside out. It is no longer uniquely a space from which to explore family life and interpersonal relationships but also a site of communal strategizing and political resistance. Much of the story unfolds in spaces that trouble the public/private binary: state-owned maternity hospitals where women give birth and hold clandestine political meetings, and voting booths where the private act of casting one's ballot is also a public declaration of citizenship. Consequently, although commentators praise Kéita's autobiography as a rich

source of historical information, some have also bemoaned her relative silence on elements of Malian women's private lives, including midwifery practices, female genital mutilation, and mother-daughter relationships.[7] Other scholars have characterized her work as a "masculine autobiography" that precludes "any empathetic bond between narrator and narratee," resists the supposedly more feminine and feminist confessional form of life writing, and pushes feminist readers to disengage from the text.[8]

Even though Kéita's silences on her private life demand a refocusing of the lens through which her work may be read, in scholarship her autobiography remains largely filtered through the terms of domesticity and motherhood that have often been employed to analyze African women's texts. For example, in addition to the focus on her work as a midwife, scholars have also described Kéita as the "mother of the nation."[9] The title is indeed tempting, given her occupation as a midwife and the fact that she delivered, by her own count, over nine thousand of Mali's children.[10] Michael Syrotinski asks, "Given Kéita's inability to become a mother herself, does she, as some have suggested, sublimate her infertility into the symbolic role, as a famous midwife, or 'mother of the people'?"[11] Kéita's work as a midwife is certainly a central node in her narrative on women's anticolonial resistance. The birthing centers in her text are also spaces in which to educate women on maternal health and their rights as voters. Yet to read Kéita primarily through the lens "mother of the people" is to rely on a trope that is in some ways defined by the very patriarchal narratives of African liberation and nationalism that Kéita sought to counter in and through her text. Amina Mama argues that many of the "founding fathers of African nationalism were unable to view women beyond their reproductive and nurturing roles."[12] Mama's observation highlights how the category "mother of the people" upholds patriarchy in the nationalist narratives of newly independent African countries. The colonial family romance between France as mère-patrie and her colonies as eternally indebted children is refigured here in the postcolonial family, where founding fathers and mothers of the nation are confined within predetermined, essentialist, and hierarchical roles of maternity and paternity. The result is a view of citizenship that is filtered through this restrictive gendered lens. Reading Kéita's autobiography on these terms therefore excludes a broad section of her activism.

These reasons for Kéita's limited presence in scholarship are precisely the reasons why she is so important for this study. Because Femme d'Afrique is not easily reducible to or recognizable as belonging to the category of "women's writings," as it is often narrowly defined, the text challenges readers to question the limits of this category. What does it mean to write as an African woman?[13]

How does Kéita's role as a political protagonist in the story of African liberation complicate our views on both literary conventions and anticolonial movements in Africa? *Femme d'Afrique* presents us with new possibilities for reading African women's political writings, because it is both a literary text and historical archive that chronicles the self-representation and political participation of nonliterate women in the years preceding independence. If Kéita's and Blouin's autobiographies differ significantly in tone and scope, they nonetheless converge in their reminder to readers to be attentive to voice, authority, and authorship in the crafting of African women's political narratives. Even while converging with Blouin's on this very crucial point, Kéita's autobiography also makes a unique contribution to the conversation on citizenship in the French empire because it departs in important ways from the narratives studied thus far. Unlike Césaire, Nardal, Éboué-Tell, and Vialle, whose writings give voice to an educated urban elite in Fort-de-France, Paris, and French Equatorial Africa's urban centers, Kéita focuses on the significant yet ignored political contributions of rural women in seemingly far-flung colonial outposts. Further, the definition of citizenship that emerges from *Femme d'Afrique* decenters French citizenship far more than we have seen thus far. Kéita's decolonial politics were instead grounded in her local setting of French Sudan and emphasized a set of concrete practices by which African women would challenge their exclusion from public life and assert the importance of adopting a feminist lens in defining citizenship on the eve of independence.

In the preceding chapters, I have shown that Nardal, Vialle, and others present woman-centered visions for liberation from colonialism. My primary contention in this chapter is that Kéita undertakes an explicitly feminist rewriting of the history of decolonization in *Femme d'Afrique* by identifying rural women's political interests as central to the decolonization enterprise and by situating them at the forefront of a direct contestation of the intertwined oppressions of colonialism and patriarchy. The women who come together as *Femme d'Afrique*'s collective protagonist occupied male-dominated spaces and made their voices heard at the ballot box. Kéita's autobiography therefore highlights the link between the entwined feminist concerns of women's self-expression and political representation. The textual space of *Femme d'Afrique* and the voting booths in French Sudan form the interlinked grounds of African women's engagement with colonial suppression of both their authorial voice and their demands for recognition as autonomous citizens. Kéita's emphasis on electoral politics underscores her understanding of citizenship as a relationship between women and the state. There are also moments when

her grassroots work subverts the state's power and imagines alternative political communities for the women of Mali. *Femme d'Afrique* thus presents a productive tension between state recognition and circumvention of the state that opens up alternative spaces for belonging.

To support this feminist anticolonial reading of Kéita's work, I show first that the narrative form of her autobiography reflects the interweaving of the literary and the political as intertwined sites of contestation. The formal features of the text—notably, the ways in which her autobiography addresses its imagined audience—point to Kéita's project of approximating a collectively authored text. Identifying this multivoiced quality of *Femme d'Afrique* highlights the forms of resistance available to women who were neither the journal editors nor elected representatives whose stories I have examined in this book thus far. Collective speech acts through song, storytelling, and communal strategizing become contestatory practices, particularly when deployed in public places and spaces typically reserved for male representatives of the colonial administration. Women's mobility and their utterances as they move through these masculine-marked spaces challenge colonialism and patriarchy on the ground and in the text.

Although I engage primarily with Kéita's autobiography, I also draw on works by Ousmane Sembène, who fictionalizes the mass political action led by women in colonial French West Africa. Sembène's creative works enlarge the field of possibility for imagining and representing women's resistance of colonial labor practices. Both Kéita and Sembène are invested in a similar project of recuperating narratives of women's resistance as central to African political history. Sembène's novel *Les bouts de bois de Dieu* (*God's Bits of Wood*) is one of the few accounts of the rail workers' strike that swept across French West Africa from October 1947 to March 1948. The workers' main demand was for the *cadre unique*, "a single, nonracial job hierarchy, with the same benefits package for all members, including the complicated supplements for local cost of living and family obligations."[14] As Frederick Cooper shows, the protracted strike ultimately became about the possibility for and extent to which local workers and trade unions could make their voices heard and reshape the colonial administration's labor practices. Consequently, its outcome went beyond guaranteeing equal pay for equal work regardless of race. It also reconfigured the balance of power between the French administration and African workers in the context of labor relations. This reconfiguration is at the heart of Sembène's novel. *Les bouts de bois de Dieu* foregrounds women and their crucial contributions by showing that the strike lasted as long as it did because of the economic support provided by the local community as women worked and performed nonwage activities to sustain the strikers.[15]

Sembène's film *Emitaï* is also a fictional rendering of a historical event that, like *Les bouts de bois de Dieu*, situates women as central actors in contesting colonial exploitation. On its release in 1971, the film was immediately banned throughout much of Africa and in France. Set in the Diola village of Effok during World War II, *Emitaï* dramatizes the French practice of forced conscription in the colonies and the rice tax levied to feed the soldiers who were set to depart from Dakar to fight the war in Europe. The film thus presents a significantly less romanticized account of African participation in World War II than that evoked in Éboué-Tell's narratives about colonies willingly sacrificing lives and resources to save the metropole. In Sembène's retelling, the Diola women resist French colonial exploitation by hiding the rice that is their primary form of subsistence. They refuse to hand it over to the authorities even when they are held hostage by the French colonel and his armed *tirailleurs*. Based on the true story of Diola resistance under the leadership of Aline Sitoé Diatta, *Emitaï* captures women's resistance to colonial oppression on screen. The film's production and subsequent reception also show the opposing elements of commemoration and disavowal at play in the process of rewriting historical narratives and engaging competing memories.

Both *Les bouts de bois de Dieu* and *Emitaï* flesh out the relatively scant historical records on African women's anticolonial activism. Reading these fictional accounts alongside Kéita's autobiography requires that we be attentive to narrative form and the ways Sembène uses creative license not only to commemorate the past but also to raise important questions about the place of women in Africa and the possibilities for a more sovereign future. While the forms of the novel and film imply a clearly demarcated beginning and end to the stories being told, Sembène also uses rhetorical and cinematographic strategies to great effect to trouble this temporalizing of an uninterrupted forward march of time, history, and progress. As my close reading shows, the narrative structure of both works emphasizes circular movement and reflects the seemingly endless cycle of colonial violence inflicted on women. The present analysis privileges Kéita's narrative because of the relative dearth of scholarship on her life and work. Sembène's work, in contrast, has attracted extensive commentary from scholars and film enthusiasts around the globe. I therefore engage with it only to the extent that Sembène's representation of women in moments of political upheaval can be put in productive conversation with *Femme d'Afrique*. Sembène's use of fiction, juxtaposed with Kéita's disruption of the conventions of autobiography, highlights the ways that power and representation are contested across generic boundaries in feminist rewritings of history.

Contesting Voice, Contesting Citizenship

Unlike Blouin's contested life story, Kéita's narrative is a much more straight-forward autobiography. Yet it is no less complex than Blouin's for the light it sheds on the genre of autobiography and its production of citizenship. Leigh Gilmore defines autobiography as "an assembly of theories of the self and self-representation; of personal identity and one's relation to a family, a region, a nation . . . of how selves and milieus ought to be understood *in relation to each other*."[16] As Kéita draws on some of the generic conventions of autobiography and discards others, she crafts her own definition of citizenship in each of these spheres of community. Her engagement with the conventions of the autobiographical genre therefore provides a useful frame within which to read the political project of *Femme d'Afrique*. Renée Larrier encourages Kéita's readers to consider how narrative voice is constructed in her autobiography and to what ends.[17] Her observations on orality in *Femme d'Afrique*, manifested in Kéita's chronicling of orally transmitted stories in the early pages of her text, serve as a crucial point of departure for my reading of form in Kéita's autobiography and the political implications of representing women's voices through this medium.

Indeed, Kéita bends many of the generic conventions that define the auto-biography as the single-voiced narrative of an individual protagonist. Instead, her text gestures to the possibility of a multivoiced narrative whose protagonist is not an individual but a community. She employs rhetorical strategies that signal her desire to recuperate a collective history of African women's activism. Her opening lines challenge the typical declaration "I was born on . . ." as the starting point of the conventional autobiography and propose an alternative notion of origins. Kéita begins, "At the time of my coming to consciousness, around the age of six or seven, Bamako was a small town of barely eight thousand inhabitants."[18] She expresses her coming to consciousness as spatial awareness, an understanding of place and the community within which her coming of age will occur. Kéita's geographic rootedness begins with this depiction of Bamako that quickly gives way to descriptions of her extended family home and finally to her memories of stories told in her mother's hut. In each of these spaces, her consciousness is shaped by the community that surrounds her. Kéita therefore quickly decenters the singular "je" that Philippe Lejeune identifies in *Le pacte autobiographique* as the mark of the classic autobiography.[19] For Lejeune, while the authorial voice in autobiographies may vary, these variations are limited to "je," "tu," and "il" (I, you, and he).[20] His schema makes no provision for "elle" (her), a female-voiced narrator, or for "nous" (we), a collective identification that allows the narrator to remain

present while articulating her development as inseparable from that of her community.

Kéita challenges this convention of the so-called classic autobiography by situating her earliest recollections in her mother's hut at storytelling time, a moment of socialization for the children gathered to hear stories of disobedient girls who suffer terrible fates after rejecting their families' choice of spouse and making important life decisions on their own. Kéita would spend her life challenging patriarchal and colonial structures in seeming disregard of her mother's lessons on conformity and deference to figures of authority. Yet by emphasizing the importance of women's collective input in her political work, Kéita also draws on her mother's lessons of communal decision making. Her autobiography, like Nardal's journal in Martinique and Vialle's in France, provides a textual space in which women speak collectively of strategies for resisting colonial oppression. This emphasis on the collective does not displace the "je" from the narrative but instead decenters it. Kéita remains an individual, and her autobiography remains the story of her life. Yet the singular "je" is often expressed either as an integral part of a collective "nous" or defined in opposition to that collectivity but never independently of it. The title *Femme d'Afrique: La vie d'Aoua Kéita racontée par elle-même* aptly illustrates the delicate balance between individual and collective identity present throughout the text. In the first part of the title, Kéita establishes her continent-wide affiliation. In the second part, she emphasizes the authenticity of her singular narrative and asserts herself as both author and storyteller. In writing *Femme d'Afrique*, Kéita engages in the very political act of self-representation.

In analyzing Kéita's place as a political protagonist in the story of women's anticolonial organizing in French Sudan, it is worth also reflecting on the implications of her role as autobiographer and chronicler of this story. Notably, at her own insistence, she often served as secretary rather than as president of the USRDA chapters that she founded. She explains to her reader that in the Bambara language, "secrétaire" (secretary) is synonymous with "écrivain" (writer) and is defined as a "person who reads and writes the papers of our organization."[21] The secretary establishes and maintains a written archive that will ensure the group's posterity.[22] Kéita performs this secretarial role not only in the USRDA women's groups but also through her autobiography. When she recounts tense electoral battles, her narrative reads like the minutes of a meeting. She gives an hour-by-hour breakdown of actions and events. Her short, quick sentences convey the urgency of both the situation being described and the task of recording it all for posterity. By positioning herself as a scribe, Kéita remains present in the text but privileges the voices of the

many nonliterate rural women who contributed to the anticolonial struggle in French Sudan. She does not speak for these women but instead allows them to speak through her by employing extensive quotes and direct speech throughout her text.

By emphasizing multiple voices in a genre that is primarily defined by the singularity of the protagonist, Kéita presents new possibilities for hearing multiplicity in a definition of citizenship that goes beyond notions of belonging to a supposedly homogenous nation. In redefining the terms of French citizenship for African women, Kéita initially proposed a hyphenated French-African political identity, akin to Nardal's Antilles-France, that sought to encompass both the ideals of revolutionary France and the anticolonial politics of the regional RDA party. This composite citizenship was symbolized by the flag that Kéita made for her local chapter of the RDA. She made a provocative statement by embroidering the letters "RDA" on the French tricolor.[23] By creating this composite flag for a political party that represented, for many, a Pan-African independence movement, Kéita melds African liberatory politics and French republican ideals. She troubles notions of the flag as that quintessential symbol of territorial claims and national identity by crafting one whose statement of belonging reaches across the Atlantic, all the while remaining firmly rooted in francophone Africa. Her alteration of the tricolor suggests that she saw citizenship as a continually evolving political identity.

Kéita's insistence on this malleability allowed her to challenge the specific elements of citizenship that marginalized African women. Where Éboué-Tell and Vialle invoked French law as that great equalizer of metropolitan and overseas France, Kéita found these laws to be rigid, ill-adapted to the realities of women's lives in French Sudan's rural areas, and therefore ultimately exclusionary. She believed, therefore, that African women's remaking of the category of citizen would require a fundamental redefining of citizenship by circumventing the state where necessary in order to activate new forms of civic engagement that took women's lived experiences into account. She explains in her text, for example, that while working to register women voters for the approaching elections for local representatives of the Gao district in 1951, she rejected the French-imposed minimum age of twenty-one. Instead, she also registered women who were seventeen and eighteen years old, choosing to redefine women's eligibility not by age but by their status in the community as wives and mothers who had established their maturity by caring and providing for their families.[24]

Ultimately, however, Kéita's faith in French citizenship was short-lived, because she found it to be far more of an obstacle to anticolonial action than a tool with which to work toward equality. She was especially frustrated by

the fact that her acquisition of French citizenship by marriage gave her the legal right to vote for deputies to the National Assembly in hexagonal France but also barred her from participating in elections to select representatives for local governing bodies in French Sudan.[25] For many middle-class Africans who had acquired French citizenship through their classification as évolués, this interdiction effectively severed them from local politics while giving them limited voice and representation in the metropole. The limitations of the évolué status illustrate the pernicious and misleading promises of French citizenship in the colonies. It was a status that often took away more than it gave, in much the same way that the status of orphan, as Blouin's narrative shows, violently uprooted métis children from African communities while extending promises of limited upward social mobility offered by the orphanages' colonial education.

Kéita therefore officially renounced her French citizenship in 1951, an act that adds yet another layer to her notions of malleable political affiliations by raising the possibility of disavowal. Her renunciation of French citizenship is significant for many reasons. It disrupts the ontological claims of citizenship as a state of being—that is, that one *is* French—and proposes in its place a vision of citizenship as an identification that is in constant negotiation through conscious practices that claim, redefine, and disavow those belongings. It also sets Kéita apart from Césaire, Nardal, Vialle, and others who wielded their unwavering belief in French republican rhetoric in their fight against imperialism. Kéita, in contrast, believed that another community was possible. Yet, as Blouin's narrative showed in the previous chapter, claiming and rejecting different affiliations was not a simple task. It was not a matter of simply taking up a tricolor embroidered with the letters RDA or casting it aside at will. As we will see in Kéita's subsequent negotiation of what it meant to be at once an African woman, a citizen in the federation of the French Union, and a subject in a colony on the path to independence, citizenship in this fraught period was expressed through acts of resistance that sought to end imperialism and create new, more equitable forms of belonging for African women.

Decolonizing Space

In *Femme d'Afrique*, Kéita chronicles the different forms of resistance by which African women created a space for themselves as audible and visible actors in the political domain and in public life. This resistance sometimes took a form as simple, fundamental, and powerful as how women moved through the colony, entering spaces from which they had previously been excluded. Their transgressive embodied movement places the women of French Sudan

in a long history of movement as resistance in the African diaspora. In *Race, Space, and the Poetics of Moving*, M. NourbeSe Philip describes carnival in Toronto as an occasion for black revelers to remember and reenact the history of both displacement in slavery and black resistance to oppression. They do this through their disorderly movement in the streets, movement that was and continues to be viewed as a threat to imperial power and notions of order. Colonial conquest manifested itself in the appropriation of the land and its resources to be extracted for the benefit of the metropole. Demarcating that land and controlling movement within the colonial space were therefore essential for maintaining imperial power. Kéita's and Sembène's works emphasize the importance of understanding women's ability to move through space, and the terms on which that movement occurs, as a strategy of anticolonial resistance. They portray women in motion, using images that counter traditional notions of African women as passive or immobile, to show the centrality of their contributions to African liberation.

Kéita's autobiography chronicles her experiences in this anti/colonial contest over space. Throughout her career, the colonial administration sought to control her mobility as punishment for founding and consolidating USRDA women's movements wherever she was posted as a midwife. As a civil servant whose livelihood depended on her compliance with government rules, her grassroots organizing became a point of contention. The administration consequently transferred her to increasingly remote reaches of French West Africa, disciplinary uprootings aimed at separating her from her family and systems of community support. Kéita's description of one of these uprootings, her posting to Gao in 1950, highlights another dimension of the imagined colonial family that Éboué-Tell and Vialle invoked in their work:

> Il faut retenir en passant que cette ville était considérée comme un poste disciplinaire, où étaient envoyés tous les enfants turbulents de la grande famille des fonctionnaires du Soudan français. Les militants de notre Parti, quoique de loin les meilleurs de tous les salariés, étaient considérés par le gouvernement comme des mauvais garnements, les enfants terribles de la famille. Voilà la raison pour laquelle je fus mutée à Gao à l'instar de nombreux militants du RDA.[26]

> One must note in passing that this city was considered a disciplinary post where all the rowdy children of the great family of civil servants in French Sudan were sent. Our party activists, although by far the best employees, were considered by the government to be the rascals, the *enfants terribles* of the family. This is the reason why I was transferred to Gao like many other activists of the RDA.

Kéita's language is telling of the uneven terms of power on which this colonial family was constructed. Her descriptions of RDA activists as "enfants turbulents" "mauvais garnements," and "enfants terribles" highlight the colonizer's infantilizing of the colonized. The spatial dimensions of this uneven power are emphasized in the administration's use of transfers as a disciplinary tool to punish its so-called wayward children. After her successful mobilization of women voters in Gao, the administration once again transferred her, noting on her dossier that she was a "famous communist, undesirable civil servant."[27] This time she was exiled from French Sudan to Senegal, where she did not speak the local languages. For the colonial administration, removing a community activist from her home base was an effective way to end her activities. The strategy was initially successful, as Kéita's experience of alienation and isolation in Senegal shows. Yet exile also expanded the scope of her activism by giving her a broader view of the continent-wide scale of colonial oppression: "I resolved then to put everything in motion for the smooth running of my party by increasing my participation in all the political and trade union activities, not only in my country but also throughout Africa."[28] With this resolution, Kéita attempts to take back some measure of control by using these arbitrary colonial postings to broaden the scope of her political activism on a continental scale.

Contesting space in *Femme d'Afrique* went beyond Kéita's individual conflict with the colonial administration. French Sudanese women in rural communities collectively reclaimed space as a feminist practice of anticolonial resistance. They transformed sites that were traditionally marked as feminine and apolitical into spaces for political discussions and strategizing. Thus, in the late 1940s, as debates raged in Paris about the modalities of French citizenship in the colonies, Kéita and her patients in the maternity ward in Niono cradled newborns and discussed upcoming elections. When her then-husband and colleague, Diawara, happened on one of these meetings on his way to the dispensary, the women immediately fell silent. They perceived his appearance as an intrusion and a threat to their ability to speak freely, and Kéita agreed, describing the encounter as "a clandestine meeting," as much for her as for her husband.[29] Although Diawara was a doctor at the hospital, his presence in the maternity ward was met with tense silence, because the women had reclaimed that space as a privileged site of feminist political strategizing.[30]

Throughout *Femme d'Afrique* women disrupt assumptions of which spaces may be considered political. In Gao they habitually congregated in Kéita's home to discuss their planned contributions to the USRDA's electoral campaign. There they assigned a variety of tasks to different women based on their

role and status in the community. These tasks included distributing voter cards, facilitating travel to the polling stations, and providing refreshments to voters. When Kéita was posted to Nara, women once again faithfully made their way to her home every day in the early afternoon. As they thumbed through glossy copies of *Marie Claire* and *Femmes du monde entier*, those who could not read pointed out the photographs they found most striking and asked Kéita to read the accompanying stories about clashes between protesters and police in apartheid South Africa and African American women's experiences of poverty in inner cities in the United States.[31] The domestic space, in these moments, became a site of women's political education administered through magazines that provided a broader international perspective on imperialism.

In addition to speaking from feminine-marked spaces, women also resisted colonial power by occupying masculine-marked spaces. African women were often excluded from the public administrative spaces that were reserved for white male representatives of the colonial government. Taking up space at these sites of exclusion was a crucial way to challenge hierarchies and to allow women to participate meaningfully in political decisions. The women of Gao, for example, were adamant about arriving en masse at the polling station where they were to participate in the 1951 legislative elections, many of them as first-time voters. In ordinary times the polling station was the office of a French colonial administrator described simply as the *commandant*. Election day therefore presented an opportunity for the people of Gao to enact an important reversal, transforming this seat of colonial power into a site for the people's enfranchisement as citizens and not subjects.

In her text Kéita paints a vivid picture of the commandant, who, in full military attire, conspicuously cast his ballot for his chosen candidate and then attempted to influence his subordinates to vote for the same candidate by remaining in the voting booth as each came in to vote. In her capacity as a registered electoral observer, Kéita challenged him directly, citing his violation of electoral laws. He responded, "I laugh in the face of your mandates, I am in my office and I intend to stay here as long as I like. Are you the one in command of Gao or am I?"[32] The spatial dimensions of his response are noteworthy. The commandant asserts that his authority radiates from the immediate space of his office and out onto all of Gao. Even as the people of French Sudan exercise their voting rights as citizens of France, the power relations between colonizer and colonized, in his view, remain virtually unchanged.

In her response to the commandant, Kéita reverses the terms of power and access by reclaiming the office not only for herself but for all the people of Gao district: "Ordinarily you command the entire Gao region. But on this day of elections . . . they are the ones who govern this room. Today this room

belongs to the people for whom you have no consideration. Therefore, sir, either you get out or I stop the proceedings."[33] Here Kéita reveals her knowledge of electoral law and uses it as leverage against the colonial administrator, who is ultimately exiled from his own office for the day. Further, her success in contesting his intimidation depends on the support of the crowd of women voters. By the time the commandant walks out, we see that he has been silenced not by the other military personnel who remained intimidated by his presence but by a large crowd of ululating women. Reclaiming space in this moment was a crucial strategy used by the rural women of Gao to counter colonial repression and ensure their right to participate meaningfully in the electoral process.

Similarly, in Sembène's representations on the page and on the screen of African women's practices of resistance, the protagonists are neither passive nor immobile. They move through space as a collective body and constitute a threat to colonial power through this purposeful movement. The plot of *Les bouts de bois de Dieu* is a fictional rendering of the historic strike that shut down public services throughout French West Africa between 1947 and 1948. The massive strike was organized by the Fédération des travailleurs indigènes des chemins de fer de l'AOF, a rail workers' union that counted branches throughout the region, including in Senegal, Guinea, and Ivory Coast. It lasted over three months and involved twenty thousand workers whose central demand was a nonracial pay scale that would apply to African and French rail workers alike.[34] Sembène's novel centers the action on the railway junction of Thiès, where male workers on strike plan to travel to Dakar to present their demands to the colonial administration. The women of Thiès also resolve to be present, marching in unison as they undertake the over forty-kilometer journey on foot. Thus, they reclaim the space of the colony by marching along the railway line, a political act that opens the way for them to assert their presence in the male-dominated space of labor union negotiations when they finally arrive in Dakar.

The women's march is of utmost importance in the novel, particularly because it becomes a central part of the social practices and collective memory of the Thiès community after the strikes. In the epilogue the narrator describes post-strike Thiès as a ghost town. Only the women occupy the streets in their daily commute to a nearby lake to do their washing, cooking, and sewing. They shift the site of domestic work from the house to this communal public space. As the narrator notes, "Since their triumphal return from Dakar, the women had organized their lives in a manner which made them almost a separate community. Distances no longer inspired any fear in them."[35] Through their political action, the women of Thiès develop a new relationship to the

space they inhabit. Moving through the streets and transforming the shores of the lake into a site for communal engagement becomes both a means of reclaiming the territory still under colonial rule and of commemorating their contributions to the labor movement by reenacting their march. In the aftermath of the social upheaval in which colonized workers effectively challenged the colonizer's exploitation of their labor, women's resistance through mobility brings about fundamental changes in their relationship to public space and power.

Sembène's portrayal of the ways that his female characters' participation in the strike precipitated their leadership in anticolonial organizing reflects the testimonies of the women who took part in the historical event. Guinean activist Jeanne-Martin Cissé recalls this watershed moment for women, using language that echoes the opening lines of *Femme d'Afrique*. She describes it as "a coming to consciousness for us or rather my own coming to consciousness."[36] She highlights the galvanizing rhetoric of Adja Mafori Bangoura, a leader of the labor movement in Guinea who exhorted her compatriots to make financial sacrifices to sustain the strike: "I still remember her words: 'It is necessary for all women to sell their *pagnes* and their jewelry in order to feed their families so that their husbands can continue the strike."[37] For Cissé, as for the women in Sembène's novel, their crucial roles in sustaining a protracted strike solidified their visibility in labor and other political movements.

In *Emitaï*, Sembène again uses space and movement to great effect in dramatizing women's resistance of colonial exploitation. In this film, colonial power provokes disorder in the social, political, and religious systems of the Diola people. Sembène portrays this disorder through the chaotic movement of bodies on the screen. Women run in all directions when the commandant invades the village with his army of tirailleurs in order to seize the rice that will be used to feed colonial conscripts. Their motions are again disorderly when the tirailleurs shoot a young boy, causing the women to scatter from their position under the tree where they were held hostage. Colonial brutality destabilizes social and political order, and the Diola women embody this destabilization through their frantic, disorderly movements. Yet Sembène also captures moments of order, when women move with a purpose through the village. In a particularly striking scene, the women march through the village on their way to hide the rice. Here their bodies move in unison in the dark. They stride purposefully in two lines to the beat of drums. This scene parallels two others—one in which the new conscripts are marched off and another in which a group of tirailleurs marches through the village. On both occasions, the viewer sees neither the origin nor destination of this marching, just mechanical movements of men seemingly marching nowhere because

they have been conscripted into a war of which they have little knowledge. The women's purposeful march to hide the rice therefore stands in direct opposition to the colonial war machine.

The commandant's decision to immobilize the women takes on an added layer of meaning given the politics of women's mobility in the colonial context. If the Diola women's movement—physically and metaphorically—constituted a significant threat to colonialism, then restraining that movement was an act designed to restore the colonial balance of power. Sembène powerfully portrays the colonial violence enacted through torture and restraint of women's bodies when the commandant and his tirailleurs hold the women hostage under a tree in the blazing heat of high noon in order to compel them to reveal where they have hidden the rice. As the hours pass, the camera zooms in on one woman's neck as she angles it to avoid the scorching sun, or on another woman's leg as she moves it slightly to loosen a cramp. These small, restricted movements of seemingly disembodied limbs symbolize the commandant's dismembering of the women's movement.

In another powerful scene that Sembène notes was unscripted, a small girl breaks away from the women under the tree and totters toward one of the tirailleurs.[38] The camera zooms in on his rifle leaning against his leg. The little girl playfully reaches for the rifle, taking five or six steps forward as she holds on to it. The tirailleur in turn takes the same number of steps back, as though made to retreat by the little girl's strength. In this shot, the rifle and khaki-clad leg stand in for the tirailleur—for all the tirailleurs—suggesting that if the older women have been immobilized, then a new generation will spring forward to precipitate the retreat of colonial agents. The Diola women's imprisonment eventually prevents them from circulating freely in the village. The songs they sing while immobilized beneath the tree, in tandem with the Diola men who move through the village, symbolize their use of their voices to reclaim a space that is theirs, much as the women of Gao do as they ululate on the commandant's departure and as Kéita does as her voice reverberates throughout her autobiography.

Feminist Rewritings of History

As Kéita and Sembène represent women's roles in the contestation of power in colonial spaces, their works raise important questions about the implications of this representation for how we understand the history of anticolonial movements and women's citizenship in the postcolonial moment. Specifically, what would decolonization look like if we took into account, even centered, women's visions for a decolonial future? Both Kéita and Sembène make a

case for a feminist rewriting of the history of anticolonial activism in French West Africa by emphasizing how this rewriting is ultimately also a project of imagining a decolonial future informed by a feminist praxis. Their political protagonists belong to the group of people that Carole Boyce Davies aptly describes as having been "dispossessed in the documenting of nationalist struggles and/or in the shaping and reconstruction of new societies."[39] Boyce Davies's terminology of dispossession highlights a deliberate exclusion of black women's experiences, perspectives, and contributions from the nationalist discourses that undergird anticolonial struggle. Black women's narratives are cast as secondary to the supposedly larger goal of national liberation in terms akin to those employed by Senghor in his dismissal of métis narratives as a distraction from a larger, nobler goal of black solidarity. As Anne McClintock notes, the result is a nation-state that inevitably denies women full access to the rights and resources that the state accords to its male citizens.[40] At the heart of Kéita's and Sembène's feminist rewriting of history, therefore, is the goal to redress this dispossession by foregrounding women's contributions to and disruptions of these national narratives.

In writing *Femme d'Afrique*, Kéita already anticipates the subsequent marginalization of women's voices from historical accounts of anticolonial movements in francophone Africa. She thus positions the text as a valuable archive that preserves not only the story of the individual as many autobiographies do but also of a community of women that extends from Bamako to Gao to Dakar. Kéita herself emphasizes the need for a more comprehensive archive of African political history:

> Les travailleurs, même dans la vieillesse, peuvent continuer à apporter une contribution effective à la construction du pays. En effet, ces hommes, surtout ceux ayant un certain niveau intellectuel, débarrassés de toutes préoccupations matérielles, peuvent réfléchir, concevoir et écrire leurs expériences multiples et riches en événements. *Ces documents mis en forme par nos enfants plus lettrés, peuvent constituer un trésor historique pour les générations futures.*[41]

> The workers, even in their old age, can continue to contribute effectively to nation building. Indeed, these men, especially those who have a certain intellectual level, free from all material concerns, can reflect, develop, and write their multiple and rich experiences. *These documents, formatted by our more literate children, can constitute a historical treasure for future generations.*

Aside from titles of publications and words in African languages, this is the only italicized passage in Kéita's text, an emphasis that signals the importance of this proposed archival project. Kéita moves us away from the grand narratives of the political elite and calls for the contributions of retired workers

whose actions both on the continent and abroad would play an important role in the conception of and struggle for decolonization. She describes this deliberate construction of an archive as a multigenerational task. Rather than a collection of individual stories, Kéita imagines collective narratives quilted by children writing the stories of their fathers. When she refers to "these men" whose writings would constitute an act of nation building, Kéita makes explicit reference to male workers. Yet even as she describes this writing as a uniquely masculine act, her own autobiography disrupts this claim by chronicling women's collective contributions to the emerging Mali.

Like Kéita, Sembène would argue that this project of constructing the independent nation is as much a discursive act as it is a political, economic, and social one. He writes, "If we do not praise and dignify our women's heroism, which I see as preeminent, Africa is not going to be liberated. Let's be clear about this: If we do not accord women their rightful place, there will be no liberation."[42] Sembène is emphatic that the fact of women's participation in public life alone does not bring about their emancipation, particularly if these contributions fall out of public memory and historical narratives. He argues that women's emancipation hinges on public, collective recognition of their contributions. As a self-described Marxist filmmaker, his definition of women's emancipation from existing patriarchal narratives and systems of labor involves recognition and just compensation for women's work, as well as cultural production that centers women's stories.

He writes this recognition in the epilogue to *Les bouts de bois de Dieu*, where he asserts that the men and women who took part in the 1947–1948 rail workers' strike throughout French West Africa "owe nothing to anyone: neither to any 'civilizing mission,' nor to any parliament or parliamentarian."[43] Sembène, like Kéita, anticipates that the voices of the workers and their families will be excluded from historical accounts. He foreshadows the official narrative of the strike as a struggle between colonial administrators and union leaders. Through his novel, Sembène privileges the voices of a variety of nonliterate workers, their families, and members of their communities and shows the internal workings of the movement to which they were indispensable. He also undertakes a feminist rewriting of history by foregrounding women's resistance to colonial racialization and discriminatory labor practices. In short, his novel privileges women actors where the archive says there were none.[44]

In *Emitaï*, Sembène's rewriting of history on screen highlights the processes of exclusion that are also present in the project of recuperating silenced voices.[45] Historical sources name a Diola woman, Aline Sitoé Diatta, as a religious leader who led the resistance against the rice tax that is dramatized in the film. Diatta has been described as a Senegalese/Diola Joan of Arc,

because she derived her authority from claims that she heard the voice of Emitaï, the Diola deity, instructing her to resist colonial agricultural and taxation practices.[46] In portraying Diola resistance on screen, Sembène replaces Sitoé as an individual religious leader with the village women as a collective secular heroine. He explains his decision as follows: "And then the mysticism of An Sitoe made me sick, me who am an Atheist and Marxist. So I decided to remove An Sitoe from her role as main character."[47] Whether we read *Emitaï* as the making of a Diola national myth or a Senegalese one, Sembène's selective rendering is especially troubling for its silencing and erasure of Diatta in favor of a more suitably Marxist collective heroine. He ultimately closes off avenues for a crucial discussion on the role of religion in women's resistance against imperialism, a phenomenon that resonates throughout the African diaspora.

Substituting Diatta in this narrative reveals the processes of inscription and erasure at work in the creation of national myths. McClintock notes the stakes of this dual process when she states that "history is a series of social fabulations that we cannot do without. It is an inventive practice, but not just any invention will do. For it is the future, not the past, that is at stake in the contest over which memories survive."[48] In Suzanne Césaire's temporalizing of the stakes of collective self-definition, the urgency of undertaking such a project in the present lies precisely in the ability to imagine the future, a Caribbean civilization in the making. For McClintock, history is an invention that, though speaking from the present, looks simultaneously to the past and to the future. Feminist rewritings of history, such as those undertaken by Kéita and Sembène, are ultimately about the possibility to imagine and call into being a future that recognizes women as both creators of and participants in social and political transformation.

Sembène's revelation of the inner workings of his production sheds light on these temporal stakes of rewriting history for Africa's political past, present, and future. Sembène asserts on multiple occasions that *Emitaï* is as much about the present failures of the governing African bourgeoisie as it is about addressing the silences in historical accounts of anticolonial resistance.[49] By capturing past revolts, the film imagines a future in which popular acts of resistance undertaken by marginalized populations—in this case women and members of the minority Diola ethnic group—become incorporated into the larger story of nation formation. In considering how Sembène's work calls the past into being in the present, the concept of "rememory" is particularly useful because it captures the temporalizing at work in Sembène's project. In Toni Morrison's novel *Beloved*, Sethe describes rememory as an image of the past that inhabits the present: "If a house burns down, it's gone, but

the place—the picture of it—stays, and not just in my rememory, but out there, in the world. What I remember is a picture floating around out there outside my head. I mean, even if I don't think it, even if I die, the picture of what I did, or knew, or saw is still out there. Right in the place where it happened."[50] Rememory encapsulates key components in the past-present relationship. It exists outside of the one who rememories (Sethe also uses it as a verb) and is located in a specific place, usually the site of trauma. A third party to the event may consciously or inadvertently encounter the rememory at this site, suggesting that it is both an intensely personal and a potentially collective act. Ultimately, rememory argues for understanding the past as a concrete, ongoing presence that is larger than individual recollections. In making *Emitaï*, Sembène encounters the rememory of the Diola massacre at the site and in the people of Effok. His film functions as that picture "floating around out there." As he dramatizes the past and provides a commentary on Senegal's political future, Sembène also makes this forgotten massacre a very real contemporary presence.

Sembène's and Kéita's emphasis on female protagonists does not in and of itself make their historical rewritings feminist in nature. Here too Boyce Davies provides a useful framework for identifying the feminist questions that motivate these texts. As she argues, "Feminism questions and seeks to transform what it is to be a woman in society, to understand how the categories woman and the feminine are defined, structured and produced."[51] We might, then, ask of Kéita's and Sembène's works, how did women transform notions of womanhood through their collective acts of anticolonial resistance? Both Sembène and Kéita show how women changed the meanings and expectations attached to gender categories by blurring lines between socially constructed notions of masculinity and femininity. It is this fundamental exploration of social identities and transformation of their meanings that most qualifies Kéita's and Sembène's works as feminist rewritings of history. The social transformations they chronicle occur both in individual women and in a collective women's consciousness shaped by political action.

Social transformation is a violent process in Sembène's novel. In describing the fight between a group of women in Dakar and policemen over a goat that the women stole from a wealthy merchant in order to feed their families during the strike, the narrator employs the language of military operations to show the violence of such confrontations. After successfully fighting off the police, the women patrol the compound and interrogate anyone they think might be a plainclothes policeman. As they compare their wounds, they weave a narrative that names each of the women as heroines in a battle for survival against the agents of the colonial administration. They also pass

around a *chéchia* taken from one of the policemen. The red cap functions as the quintessential symbol of African patriarchal complicity with colonial violence and repression. One woman tells the story of the chéchia's capture: "When one of them fell down, she [Bineta] grabbed him by his . . . you know what I mean . . . you could hear him yelling even with all the other noise. Then Mame Sofi said to me 'Piss in this pig's mouth!' I tried, too, but I was too embarrassed."[52] The fallen policeman represents a weakened form of French colonialism. As Cooper argues, the West Africa–wide labor strikes that took place in the 1940s dealt a significant blow to French imperial power by repurposing the language of republicanism and France's modernization project—the very language that had been used to justify exploitative labor practices—against the colonial administration.[53] Similarly, the women of Dakar use the policeman's own body as the instrument of his pain, torture, and ultimate defeat. The speaker's attempt to urinate in his mouth signifies a desire among the women to liberate themselves from social codes of "proper" behavior. Sembène crafts this scene, therefore, as the simultaneous liberation of women and the colony. Yet just as independence is imminent but not yet a reality, the women's liberation also remains in a suspended state. The speaker is not able to complete her act, because shame is still a very real social force that exerts its pressure on her. The ellipses referring to the policeman's genitals also reveal more than they obscure, particularly the fact that women's liberation in this moment remains an unspeakable act.

Likewise in *Femme d'Afrique*, Kéita negotiates notions of supposed feminine propriety and decorum as she struggles to decide how to respond to the colonial violence that targeted women activists. She cites, for example, her confrontation with the elderly chief of Singné during her visit to the village's polling station on election day. Kéita arrived in Singné to observe the electoral process in her capacity as a candidate for the 1959 parliamentary elections that would select deputies to the French Sudanese National Assembly. She soon found herself surrounded by a group of angry women led by an irate chief whose tirade is worth quoting extensively here because it shows the struggle to imagine the place that women would occupy in the soon-to-be-independent Mali:

> Sors de mon village, femme audacieuse. Il faut que tu sois non seulement audacieuse, mais surtout effrontée pour essayer de te mesurer aux hommes en acceptant une place d'homme. Mais tu n'as rien fait. C'est la faute des fous dirigeants du RDA qui bafouent les hommes de notre pays en faisant de toi leur égale. . . . Koutiala, un pays de vaillants guerriers, de grands chasseurs, de courageux anciens combattants de l'Armée française, avoir une petite femme de rien du tout à sa tête ? Non, pas possible. . . . Moi, sergent-chef

de l'Armée française, ayant combattu les Allemands, accepter d'être coiffé par une femme? Jamais. . . . J'ai trois femmes comme toi qui me grattent le dos tous les soirs à tour de rôle. Retiens ta langue. Si tu continues à me parler, je te ferai bastonner par les femmes.[54]

Get out of my village, brazen woman. You must be not just brazen but especially shameless to try to measure up to men by accepting a man's position. But you have done nothing. It is the fault of the crazy RDA leaders who ridicule the men of our country by making you their equal. . . . Koutiala, a land of brave warriors, great hunters, and courageous veterans of the French army, have a little nothing of a woman at its head? No, not possible. . . . I, sergeant of the French army, having fought the Germans, accept to be led by a woman? Never. . . . I have three women like you who take turns to scratch my back every evening. Hold your tongue. If you continue to speak to me, I will have you flogged by the women.

The chief's final command, "retiens ta langue," delivered in the overly familiar "tu" form of the imperative, seeks to silence Kéita by reducing her to a subaltern, one of the mute, unnamed women in his harem whose only role was to scratch his back. Throughout the chief's tirade, there is significant tension between his views of Kéita as object and subject. On one hand, he sees her as a political pawn, an object in the hands of RDA men who want to make a mockery of local chiefs by foisting upon them a woman as their political representative. By insisting "tu n'as rien fait," he therefore negates Kéita's autonomy and political action.

The chief's speech reveals too the ongoing struggle between old and new political orders. His legitimacy and authority stem from his service in the French army. Yet on the eve of independence—this incident takes place a year before Mali's independence—this power is rapidly waning. The days of local chiefs arbitrarily installed by the colonial administration for such reasons as their service in the French army are giving way to a new political order. In the new era, the people will confer power and legitimacy on their leaders through their participation in democratic elections, at least in theory. In the new era, Kéita will make history by becoming the first woman deputy in French Sudan and one of the first in francophone Africa. Fittingly, the old chief, symbolic of the dying embers of colonial chieftaincy, disappears rapidly from the text. In a few short lines, Kéita recounts her two subsequent visits to Singné after winning the election. On the first occasion, the chief refuses to see her and chooses instead to hide in the forest on the pretext of a hunting expedition. On her second visit, she learns that he has since died. A few pages later, in the penultimate paragraph of her autobiography, Kéita announces Mali's independence.

Despite his dwindling power, the chief of Singné posed a real and immediate danger to Kéita. To fully grasp the magnitude of this threat and Kéita's visceral fear during this encounter that she would remember for the rest of her life, it is important to place this exchange in the larger context of violent reprisals against women activists in West Africa by men who had a stake in preserving the colonial status quo. Four years before Singné, a violent confrontation in Tondon in Guinea left thirty-seven villagers wounded and M'Ballia Camara, a leader of the Parti Démocratique de Guinée (PDG), dead at the hands of another furious village chief. Much of Camara's trajectory paralleled Kéita's. Like Kéita, she was a prominent activist in the PDG, Guinea's local branch of the RDA. Unlike Kéita, however, only a small written trace of her life, work, and death remains.[55] Her husband, Thierno Camara, a World War II veteran, presided over the Tondon chapter of the party while M'Ballia headed the women's section. Their clash with the village chief, David Sylla, came over the issue of taxes, which were usually collected by chiefs and handed over to the colonial administrators who had installed said chiefs and often propped up their reign.

In Tondon, Camara and his party had set up a shadow government that bypassed Sylla by collecting taxes directly from the villagers. When on February 8, 1955, Sylla demanded that the villagers produce their taxes, they informed him that they had already paid to Camara's PDG. To his furious demands that they pay again or be beaten, a group of angry women surrounded Sylla, stripped him of his insignia, and, hurling insults at him, took him to the Camaras' home. The humiliated chief slunk away and returned the next day with policemen from Conakry to arrest the PDG leaders. A crowd of villagers showered the officers with rocks. The officers responded with tear gas. Of the thirty-seven people wounded, over half were women.[56] After the clash, Sylla returned to the Camara house, the site of his humiliation the day before. Forcing his way in, he found a heavily pregnant M'Ballia. Sylla enacted his rage on mother and unborn baby. In an act of extreme violence and brutality, he slashed M'Ballia's stomach open with his saber. M'Ballia, in critical condition, gave birth to a stillborn child and then died a week later. Her death catalyzed the increasing militancy of Guinea's RDA. Her life and work were enshrined in political songs, and her example was held up for women as the ultimate sacrifice in the service of anticolonial struggle. Three years later Kéita would attend an RDA congress in Guinea held at the M'Ballia Camara market, a space for women's economic exchange that also served as a site for political assembly and commemoration of "one of the greatest figures of the feminine African movement."[57]

In *Femme d'Afrique*, Kéita counters the violence of the chief of Singné's response to this emerging new order symbolized by her potential election, as well as Camara's activism and subsequent veneration in the anticolonial political imaginary, by refusing to be docile and accepting of patriarchal oppression. She describes this era as "this pre-independence period in which the African, more and more conscious of his exploited condition, no longer docilely tolerated certain behaviors."[58] However, in this particularly heated moment of conflict, as the chief and his crowd of angry women inched closer to Kéita with their threats of violence, M'Ballia Camara's deadly encounter with another member of the colonial chieftaincy was no doubt foremost in Kéita's mind. She weighed her belief in resistance against the immediate, practical need to save her life and fled to her Land Rover. Her chauffeur, instead of speeding off as instructed, advised Kéita to defend herself with the revolver in her purse, a surprising request for the reader of *Femme d'Afrique*, who, until now, had only encountered a Kéita who prided herself on being the epitome of respectability and decorum, never so much as raising her voice in an argument.

In a rare outburst, Kéita responded by slapping the chauffeur's hand with such force that her purse fell to the floor of the car. She informed him first of her ideological revulsion to physical violence and then of her belief that the crowd of angry women were simply "under the power of men like their chief."[59] Finally, ever the pragmatic thinker, Kéita argued that once she had fired all twelve bullets from her revolver, the crowd of women would still have time to "tear me to shreds before I am able to reload the chamber."[60] To the chauffeur's muttered challenge of why she would carry a weapon if she did not know how to use one, Kéita retrieved the gun from her purse and expertly fired off a shot. Her chauffeur finally drove away, leaving the large crowd of women chasing after the speeding Land Rover. This was one of the last conversations the two were to have. By the end of that eventful day, as Kéita celebrated the RDA's electoral victory with other party members, she received news that an unknown arsonist had set fire to her Land Rover. Her chauffeur begged leave to relieve himself, ran into the bush, and was never seen again. Kéita suspected that he had either fled for fear of being accused of burning the car or had committed suicide.

Throughout the exchange with her driver in Singné, it is evident that Kéita struggles with ethical considerations about violence, particularly when women are both the instruments and targets of that violence. Surrounded by acts of brutality, Kéita weighs the costs of political activism in settings that were hostile to women's presence in the public sphere against the price of remaining

marginalized, docile, and compliant. That she chose to discreetly arm herself attests to her belief that women's exclusion from politics was the less desirable option. Although Kéita appears to emerge unscathed from the near-attack in Singné and the charred remains of her Land Rover, she also does not diminish the toll of such attacks on women. She asserts in her autobiography that the chief's words remain indelibly imprinted on her memory, and even at the time of writing, nearly two decades later, she still vividly remembered the splash of cola-stained saliva on her white dress where he spat on her in rage.

Physical, verbal, and psychological attacks such as those described here were frequent obstacles that women faced in their political work. This kind of violence sought to silence women and to prevent them from upsetting the existing power balance. However, as Kéita's rise through the ranks of the USRDA and her persistence in enfranchising women as political actors show, to argue that intersecting racial and gendered oppression effectively excluded women from political participation would be to erase the significant roles that African women did indeed play in anticolonial movements, despite these attacks that sought to silence them, render them invisible, and even take their lives.

Kéita's accounts of colonial violence resonate with Eslanda Robeson's observations of the ravages of colonialism in Central Africa and the rumblings of nascent independence movements she heard during her visit there in 1946. Robeson brought to these observations her own experiences of segregation in the United States and her firsthand knowledge of racism in the many countries she visited during her travels. She insisted that the global reach of colonial power necessitated global solidarity to overthrow it. The Pan-African, Pan-Caribbean, and Afro-diasporic notions of belonging articulated by all the women whose interwoven stories have made up this study therefore come together in Robeson's work to inform her articulation of Global South solidarity and resistance.

6. Eslanda Robeson

Transnational Black Feminism in the Global South

> All through the years since 1944 I have been active in the fight for freedom and for first-class citizenship for my own people, the American people of African descent here in the United States. And all through the years I have been working also for increased understanding, co-operation and friendship between all our citizens here at home, and all the peoples of the world. This means, of course, that I have been working for peace at home and peace in the world.
> —Eslanda Robeson, "Postscript to African Journey,"
> Eslanda G. Robeson Papers

For many in overseas France, 1946 was a pivotal year. It was the year that French politicians drafted the constitution that would usher in the Fourth Republic. Outre-mer representatives converged on Paris to ensure that the recognition of their constituents as citizens would be enshrined in the constitution. In response, the metropole waffled between upholding its rhetoric of liberty, equality, fraternity and conceding little to nothing in its grip on the resource-rich territories that comprised its empire. It was also the year that Jane Vialle and Eslanda Robeson found themselves at the post office in two different Central African territories, navigating strikingly similar instances of racial discrimination that highlighted for both women the stakes of these citizenship claims on the ground and the different forms of solidarity on which they would base their anti-imperialist politics. Each of their encounters is worth citing in full as Vialle and Robeson alternately situate themselves in relation to those who wield colonial power and those who are subjugated by it.

Vialle recounts:

Je me trouvais, tout de suite après la promulgation de la Constitution, à la poste de Bangui. Un mendiant était là, comme il y en a un peu partout, et une femme européenne se trouvait au guichet de la poste avec moi. Elle m'avait reconnue et en termes peu amènes et peu académiques, elle renvoya vertement le mendiant en lui disant: "Fous le camp, citoyen!" En même temps, elle me regardait naturellement, le terme citoyen étant à mon adresse, elle avait l'air de dire: "Peut-on donner le droit de citoyenneté à 'un type comme ça'?" Il semble que ce "type comme ça" était aussi respectable que le mendiant du pont de l'Alma ou de la gare de l'Est.[1]

I was at the post office in Bangui soon after the ratification of the constitution. There was a beggar there, as there are nearly everywhere, and a European woman was at the counter with me. She had recognized me, and in less than charitable and polite terms she harshly dismissed the beggar, saying, "Get lost, citizen!" Naturally, she looked at me as she said it, since the term citizen was addressed to me. She seemed to say: "Can citizenship be given to such a person?" It seems to me that "such a person" is as respectable as the beggar on the Alma bridge or at the gare de l'Est.

Vialle's short anecdote contains many twists that are telling of the fraught terrain of imperial citizenship. She prefaces the story by noting that the constitution had just been ratified and thus situates French citizenship as the dividing line between a before of colonial racism and an after of egalitarian civil rights. Yet, because the modes of address are slippery, it remains unclear who the European woman in the story understands to be a citizen and who she excludes from this collective belonging. She recognizes Vialle as a public figure but withholds recognition of citizenship from both Vialle and the beggar by wielding her contemptuous "citoyen!" as a challenge to the legitimacy of their presence. The elusiveness of "on," translatable as the plural form of the first-person "we" or the impersonal third-person "one," simultaneously includes Vialle as an arbiter of who deserves French citizenship ("Can *we* give citizenship to such a person?") and excludes her by placing her on the same side of illegitimate belonging as the beggar ("Can *one* give citizenship to such a person?"). In response Vialle invokes the principles of republican France to counter the European woman's disavowal of the beggar's belonging to a French polity. By insisting that there are beggars everywhere and implying that the most indigent citizens of Paris are still recognized as French, she demands that citizenship be predicated on a universal recognition of all those covered by the constitution and not on racial discrimination that is thinly veiled by specious arguments about class and propriety—such as those implied in the European woman's dismissal of "un type comme ça."

Robeson's brush with the perils of running even the most mundane of post office errands as a black person in colonial space occurred in Leopoldville and echoed key elements of Vialle's experience:

Over at the Post Office where I went to send a cable home, I was interested in the Belgian attitude. There was a sort of hurdle of wood blocking off a kind of aisle—very short—leading up to the telegraph window. The Africans went outside the hurdle, and the whites inside the hurdle, in the aisle. As I took my place in the line of the white people, I noticed an African standing at the window, outside the hurdle. The clerk who took the telegrams, a nasty cheap white trash type, took all the white people first, then I stood back so the African could get his in before mine (since he had been before me); but the clerk looked up and reached all the way out of the window for mine first. I handed it to him, smiling apologetically at the African. He smiled back and shrugged his shoulders angrily as if to say: "These So-and So's!!" . . . Later, I mentioned the incident to Mr. Lutete in the car and he said, "Oh yes, always the white man first. No matter when he arrives, no matter how many Africans, always all white men first!" I told him we have that kind of thing in the USA, especially in the South. . . . Had an interview with a Mr. Tirrell, the British Baptist missionary who has been here in Leo for 6 months. . . . When I spoke to him about the African waiting at the post office this morning, he said they wait in cues [*sic*] for half a day sometimes. He said "I never send a boy for stamps, for instance, it would take him ½ a day waiting around. So I go along, right up to the window, past the Africans, and buy them. I couldn't afford the time to wait in cues" [*sic*], he said . . . (No? He will, some day, I hope).[2]

The turns of Robeson's narrative mirror Vialle's in many ways. Here, the colonial administration quite literally places a hurdle in the path of Africans who seek to access public services. The built environment therefore reflects the colonial obsession with a racially stratified order whose notions of place are predicated on relegating the colonized to the literal margins of the space. The separate lines coded as "whites" and "Africans" conflate race and geography in their division of the post office space such that there is no place for a black American woman. Robeson therefore finds herself at a crossroads where, like Vialle, she negotiates solidarity with a marginalized African and her own fraught belonging. Her summary dismissal of the clerk as a "cheap white trash type" and her evocation of similar experiences of Jim Crow in the U.S. South signal the American lens through which she views segregation in Leopoldville. The choice she makes at the crossroads is therefore significant. When she declares, "I took my place in the line of the white people,"

Robeson claims a whites-only line as *her* place. This assertion, combined with her gesture of hanging back and recognizing the African man as an equal, a customer who must be served in a timely manner, disrupts business as usual and forces a change in the automated gestures of the clerk, who must now go to extra lengths to attempt to restore the racial spatial order. Finally, like Vialle, who attempts to decode the European woman's "citoyen!," Robeson seeks to interpret the African man's shrug and ascribes meaning to his gesture.

Like Paulette Nardal, Frantz Fanon, and Aimé Césaire, who explore forms of public transportation such as the bus and tram as key sites of contestation over race and belonging, Vialle and Robeson both find the post office to be a similar public site of simmering racial tension and conflict. However, despite the resonances in their experiences, Robeson's encounter differed from Vialle's in crucial ways because it was shaped by the American lens through which she viewed racism and by the specific contours of Belgian colonialism. Notably, the discourse on citizenship that reached its apogee in the French colonies at the time of Vialle's post office confrontation was largely absent from the Belgian context. Although the colony that came to be known as the Belgian Congo was governed by the Belgian state, its roots in King Leopold II's murderous administration of the Congo Free State as his personal possession determined the outlook and practices of the colonial administration. Political repression and economic exploitation went hand in hand such that "the traditional ruling class, formerly the chief beneficiary of rural surplus labour, was incorporated into the authority structure of the colonial state to facilitate its extractive and repressive tasks, including tax collection, labour recruitment, conscription and order maintenance."[3] While this colonial violence also characterized France's imperial presence in the region, Belgium distinguished itself by its suppression of movement between the metropole and the colony, thus limiting the multidirectional exchanges that characterized the experiences of the black women in the French colonies whose stories have been highlighted here.[4]

Consequently, where Vialle sought to counter racism by appealing to the constitutionally enshrined right to French citizenship, Robeson, as a black American woman in a colony where not even lip service was paid to citizenship, negotiated the terms of her solidarity with the colonized differently. In acknowledging the shared experience of racial segregation in the Belgian Congo and the United States, Robeson gestures to imperialism's global scope and will continue to make these connections over the course of her nearly five-month stay in French and Belgian Central Africa. In subsequent years, her articles for the journal *New World Review* would take these connections even further by advocating for indigenous people's reclamation of land, natu-

ral resources, and methods of production across spaces that have now come to be called the Global South. For now, as evidenced by her response to the British missionary about the post office episode, that anti-imperialist future remains a hope cautiously held within parentheses. Robeson's articulations of citizenship during her travels, including in this encounter at the post office in Leopoldville, were premised on transnational black solidarity that acknowledged shared experiences under imperialism and, above all, highlighted a collective vision of liberation to come.

Robeson's firsthand knowledge of imperialism was not limited to the United States and Central Africa. She was a bona fide globetrotter who visited more than forty countries in her lifetime. During her travels she met many of the women whose stories have been at the heart of this book, including Nardal, Éboué-Tell, and Vialle. However, her presence as a political protagonist in the story of black women's citizenship in the francophone world is not simply occasioned by her connections to Antillean and African thinkers and political figures. In her writings, she contributed to defining black women's citizenship in a global context. Her engagement with ideas of rights and belonging as she traveled through the French empire challenges the notion of Paris as the central location for the negotiation of anticolonial and diasporic solidarity. Her work therefore demands a shift from the emphasis on European capitals as privileged sites to which colonized populations gravitated in building networks of anticolonial resistance. Ultimately, Robeson's expansive geography allows us to read decolonial citizenship as both acts of resistance and notions of belonging that troubled the metropole/colony binary by mapping a new Global South identity.

The term "Global South" delineates at once a geography, theoretical framework, and field of study. Its origins lie in the rise of global movements against colonialism in Africa, Asia, and Latin America. The 1928 gathering in Brussels of the transnational group of anticolonial leaders who made up the League Against Imperialism and the 1955 Bandung conference of newly and soon-to-be independent African and Asian states were early articulations of the Global South project. Defining this seemingly catch-all term remains the stuff of many debates. For some scholars, it denotes the "interconnected pockets of poverty, gender inequality, and racism throughout the world—including the so-called 'wealthy nations'—by attending to the importance of both local context and global interdependence."[5] Understanding the Global South thus in spatial terms demands that we also recognize its presence in places traditionally marked as the Global North. Yet to define the Global South as simply a conglomeration of poor, underdeveloped spaces is to run the risk of reinforcing a Global South identity that is marked primarily by its oppression.

Vijay Prashad proposes a definition that shifts the emphasis from the spatial to the temporal dimensions of the Global South and thereby grounds the concept in a shared history of anti-imperial resistance. Prashad argues that the Global South is not a place but rather a project that is recognizable in a

> concatenation of protests against the theft of the commons, against the theft of human dignity and rights, against the undermining of democratic institutions and the promises of modernity. The global South is this: a world of protest, a whirlwind of creative activity. These protests have produced an opening that has no easily definable political direction. Some of them turn backwards, taking refuge in imagined unities of the past or in the divine realm. Others are merely defensive, seeking to survive in the present. And yet others find the present intolerable, and nudge us into the future.[6]

Several elements of Prashad's definition are crucial for understanding Robeson's praxis of black transnational feminism and Global South citizenship avant la lettre. His repeated assertion of "protests against" the different manifestations of imperialism highlights the work of dismantling colonial systems of inequality as the primary goal of transnational solidarity. What Prashad describes as theft, Robeson formulated as exploitation in her critiques of colonialism and capitalism as intertwined systems of oppression. In her writings she connected anticolonial movements across several continents in order to envision a more inclusive global citizenship for the world's marginalized. For Robeson, decolonial citizenship was a commitment to the overthrow of imperialism in order to bring about a decolonized future characterized by political independence and economic autonomy throughout the Global South.

Creating Black Transnational Circuits through Travel

Robeson's articulation of a Global South project premised on anticolonial resistance was honed through her early expressions of black transnational identity as a student in London and a traveler through Southern Africa. In her travel writing, Robeson explored what it meant to be black, American, and mobile in the face of global white supremacy. As her biographer, Barbara Ransby, notes, "Essie often had to defend her dual roles as an American citizen and an American dissident," a careful balancing act between claiming her rights as an American and distancing herself from the United States' record of racism at home and imperialism abroad.[7] In navigating this dual role, Robeson proposed an expanded definition of citizenship for African Americans that recognized both their place within the Global North and their solidarity with, or even belonging to, the Global South.

Robeson's travelogue, *African Journey*, functions as one of her earlier articulations of black transnational identity by exploring African Americans' relationship to Africa.[8] The book is a collection of daily journal entries interspersed with Robeson's photography of the people, landscape, and cultural artifacts she encountered on her travels through Southern Africa in 1936. As scholars of American travel writing note, texts by African American travelers often problematize the construction of American identity through their adoption and disavowal of core elements of American myths of origin.[9] This problematizing occurs in the opening lines of the introduction to *African Journey*, where Robeson inscribes her travels in the genre of the homecoming narrative of African diaspora discourse: "I wanted to go to Africa. It began when I was quite small. Africa was the place we Negroes came from originally. Lots of Americans, when they could afford it, went back to see their 'old country.' I remember wanting very much to see my 'old country,' and wondering what it would be like."[10] In these opening lines, Robeson locates her desire to see Africa first in the intimately personal sphere of her earliest childhood longing, then in the larger sphere of African diasporic homecoming, and finally in the context of American immigration. Thus in a few deft rhetorical moves, she suggests that her pilgrimage is both the story of African American displacement through the slave trade and a quintessentially American story of migration to which her white compatriots can relate. Imagining the African diaspora in this desire to see the "old country," a term that evokes Irish and Italian immigration to the United States, is also a project of redefining the United States by staking a place for African Americans in the foundational myth of America as a nation of immigrants, each with their own "old country."

In addition to the personal, spiritual element of her journey, traveling to Africa was also very much about producing a counter-narrative to the dominant discourse on black inferiority that Robeson encountered in the United States and in London. Her journey was motivated by the desire to define what it meant to be black and African and American and to buttress her anti-imperialist arguments with empirical knowledge. She writes, "I'd just have to go out to Africa and see and meet and study and talk with my people on their home ground. Then I would be able to say truly: I have been there too and I *know*."[11] Here, she places herself as both an insider and an external observer seeking the empirical evidence that would allow her to articulate a more nuanced, quilted image of black diasporic identity that goes beyond the homecoming narrative.

The need for counter-narratives that Robeson expresses in the early pages of *African Journey* stemmed from the racist discourse on "the primitive [African] mind" that she heard in her courses at the London School of Economics and

the white American discourse on "the primitiveness, ignorance, laziness and smell of Negroes" that she heard in the United States. In the initial counter-arguments that she put forward as the "obstreperous" student in her seminars, she attributed the economic deprivation in black communities to Western imperialism: "I'm educated because I went to school, because I was taught. . . . I'm cultured because my people had the education and the means to achieve a good standard of living. . . . Poor whites have neither education nor culture. Africans would have both if they had the schools and the money. Going to school and having money doesn't make me European. Having no schools and no money doesn't make the African primitive."[12] In this argument, Robeson recognizes the discourse on black inferiority as a flimsy justification for colonial exploitation. Her self-positioning also challenges colonial categories and shows the depth of her reflection on what it means to be black and American in a global context. She refuses to be identified as European despite her education and social status. Nor can she accept the label "primitive African" as some of the Negritude founders did at the time in their efforts to reverse its negative connotations. In these sometimes inelegantly expressed reflections on education, culture, and economic advancement that Robeson put forward in her graduate seminars, we find the beginnings of the more incisive, scathing attacks on "colonial white supremacy" that would come to characterize her op-eds in American newspapers on her return from Africa.[13] But before her departure, she was already grappling with ideas about modernity and challenging European-defined notions of culture and education.

From these early moments of exploring shared identities in the African diaspora, Robeson went on to imagine transnational belonging on a global scale by situating black Americans as world travelers in her writings. In a 1955 essay for the *Baltimore Afro-American* titled "How to Behave Abroad," she provided a "Code of Behavior" for African Americans who had to field questions abroad about racism at home. She rejected the idea that America's black citizens needed to portray a patriotic "unified front" by staying silent on the realities of racism in the United States.[14] Robeson published her article during the Cold War, when the stakes were high for the United States in portraying abroad a positive image of race relations at home. Her essay sought to challenge the official government narrative that highlighted token appointments of black people in the army or public office as proof of racial equality. She aptly described these gestures as "partial down payments on democracy," insufficient attempts by the U.S. government to "whitewash a very dirty wall" in its desire to win the competition for allies among the newly and nearly independent African and Asian nations.[15] Robeson's counter-narrative denounces segregation and discrimination as "a festering sore, an abscess in

the body of American life," and encourages her black readers to articulate their belonging to the American body as citizens, all the while remaining critical of the injustices that afflicted this imagined body.[16]

Robeson envisioned black transnationalism as an engagement in a shared project of anti-imperialist politics buttressed by economic autonomy. In a speech that she delivered at a fund-raising concert for the Movement for Colonial Freedom in the United Kingdom, Robeson described the organization as "a BRIDGE between the Old Dream-World of Colonial Subjection and the New Real World of Freedom and Independence and Equality for all."[17] The old dream world was made up of European colonial powers and the apartheid government in South Africa. The new real world brought together those involved in "the real Revolution that is going on in Africa, in Asia, in North and South America, in the Caribbean."[18] Robeson also pointed to the presence of representatives of African and Asian embassies at the fund-raiser, as well as those of "the youngest of all the Independent Countries in Africa, ALGERIA," thereby widening her transnational geography beyond the African diaspora and framing this emerging Global South identity in the context of interconnected anti-imperialist struggles.[19] Ever the inspirational speaker and fund-raiser, she exhorted her audience, "SO NOW MONEY MONEY MONEY PLEASE-AND-THANK-YOU," and included a hand-written note in her speech reminding herself to hold up a bill of money to drive home her point.[20]

For Robeson, the ideology of shared resistance that was shaping the Global South necessitated an economic commitment to supporting this collective struggle in the short term and a restructuring of the global economy in the long term by those who were marginalized and exploited by Western imperialism. She advocated for a global citizenship premised on economic autonomy for African Americans as well as the colonized in Africa, Asia, and Latin America. Communism, she believed, would be the most viable economic model for enfranchising the world's marginalized. In her article "What Is Communism?" she sought to define the features of this economic system that most "affect [her] as a woman, as a colored person and as a human being."[21] Her self-positioning in this statement recognizes black women as active participants in structuring the global economy and building new political communities free from colonial imposition.

Race and Surveillance in the Global South

Thus in 1946 Eslanda Robeson was thinking about global identities and collective resistance as she trekked up the Congo River and bumped along

un-tarred roads in Chad. Whereas her journey through Southern Africa in 1936 had been motivated by a desire to learn as much as she could about the diversity of cultural practices and political structures among different communities in the region, her travel to Central Africa, in contrast, was fueled in part by her fascination with one figure: Félix Éboué. She interviewed colonial administrators, African deputies to the French National Assembly, and disenfranchised laborers whose testimonies of their working and living conditions echoed the stories of debt peonage suffered by black people in the American South under the sharecropping system.[22] She asked dangerous questions that ruffled feathers because they constantly challenged the racial hierarchy that the colonial administration struggled to keep intact. She also spent a great portion of her time recording the testimonies of people who had known and worked with Éboué during his tenure as governor general of French Equatorial Africa.

Éboué's life and work intrigued Robeson because she believed that his position as governor general of AEF challenged the colonial discourse on black inferiority that was used to disenfranchise black people and bar their access to political power: "White supremacy was an all-important part of colonial philosophy, law and economy. Therefore, when Félix Éboué, Negro from French Guiana, and very dark indeed, was appointed Chief of a Department, then Governor of a Province, and finally Governor-General of F.E.A., a revolution took place in colonial thinking. It could no longer be said that the Negro was not able nor [sic] 'ready' to govern himself. Was not Éboué governing the African people?"[23] Robeson's emphasis on Éboué's "very dark" skin is a response to the historical process that Fanon terms the "epidermalization" of black racial inferiority. Fanon argues that the white gaze refracts the black person into an inferior subject position by assimilating skin color with imagined markers of inferiority.[24] Robeson echoed Fanon's analysis in many of her writings and here holds Éboué up as a symbolic figure that deflects this negative racialization of black skin. Unlike Fanon, however, she held fast to the ideal that publicly highlighting the achievements of black figures such as Éboué would create a counter-narrative powerful enough to destabilize colonial discourses on race.[25]

The Guyanese administrator's public support of Charles de Gaulle at a time when much of France had capitulated to the Nazi-collaborationist Vichy regime made Central Africa the birthplace of France's liberation during World War II. Robeson argues as much when she notes that through his war efforts and economic reforms, Éboué was far more loyal to French republican ideals than other colonial administrators: "*Éboué believed that the resources of Africa should be developed for the African people, not for the handful of exploiters who*

took everything, gave nothing, and in the war emergency proved to be cowards and traitors to France."[26] This remapping of the geography of the French Resistance resonates with Éboué-Tell's highlighting of the black transnational actors whose efforts contributed to French liberation and who, she argued in the Senate, were as much citizens of France as their white co-combatants. Robeson, however, goes further than Éboué-Tell by establishing a connection between this commitment to France's freedom and the struggle for African liberation:

> It has often been said by colonial "experts" that the darker peoples of the earth are not yet "ready" nor [*sic*] able to govern themselves. This is said despite the records of history which show that the darker peoples not only governed themselves efficiently, but also developed superior civilizations, while white men still lived in caves, almost on a level with the animals. Well the magnificent and shining example of Felix [*sic*] Éboué is a direct contradiction to all this.[27]

This statement takes on multiple elements of colonial discourse at once. Robeson's emphasis on "darker peoples" takes aim again at epidermalization. She also rejects the idea of Africa as an ahistorical continent and points not only to its long history but also more specifically to its history of self-government before colonization. Éboué symbolizes, for Robeson, yet another reversal of the discourse on black inferiority that was used to justify colonial conquest. She is not critical here of Éboué's complicity with the perpetuation of that conquest in his capacity as a colonial administrator. On a purely symbolic level, she will argue, his presence as a black man in a position of power traditionally reserved for white men already destabilizes the foundations of colonialism's racial hierarchy. Even more significantly, Robeson situates Éboué in the category of people she describes as "the darker peoples of the earth" and thus articulates a Global South consciousness that unifies different communities of people marginalized along racial lines.[28]

As Robeson engaged in public conversations about Éboué's legacy and its implications for imagining economic autonomy and political sovereignty, colonial administrators grew increasingly nervous. That her presence in AEF set off a flurry of policing and surveillance activities shows the perceived danger that black women's visibility and mobility posed to the colonial order. In July 1946, Sir Percy Sillitoe, head of MI5, the United Kingdom's internal security service, sent a memo to police commissioners in the British West African colonies of Gold Coast, Gambia, Sierra Leone, and Nigeria informing them that Robeson was visiting AEF, where she had made "indiscreet" comments about colonialism.[29] He warned them to keep an eye out for her possible arrival in the

British colonies. Sillitoe was right to be concerned about Robeson's presence. A confidential report he received from the Royal Canadian Mounted Police headquarters months after Robeson had completed her Central African circuit confirmed his suspicions that she was a radical anticolonial activist. Canadian police informed Sillitoe that in January 1947, Robeson had addressed an audience of 250 people at the Canadian–West Indian Progressive Student Centre, where she "harshly castigated the backward social conditions of colonization and interpreted [it] as 'taking over and keeping by force.'"[30] In addition to questioning the legitimacy of colonial occupation, Robeson said she was "glad to belong to the numerically superior 'black' race," because decolonization was inevitable and would possibly be violent: "'Freedom has never been won without a struggle.' . . . The fight for freedom seems to be a universal fight and the oppressed peoples will continue fighting until they achieve their freedom and colonization will be completely eradicated."[31] Here too Robeson locates herself as an African American woman in multiple and ever-widening spheres of political engagement. Her racial identity is inextricably intertwined with her identification as a citizen of the Global South engaged in a struggle against imperialism. Three years later, in what the *Baltimore Afro-American* would describe as "a slashing 90-minute oration,"[32] Robeson would again define black transnationalism as a political alliance within the Global South in order to imagine the possibility for a global citizenship forged through the overthrow of imperialism. She locates "the colored peoples of the world," yet another precursor to the term "Global South," "in Russia, Eastern Europe, and China" and argues that their wariness of U.S. imperialism stemmed directly from their awareness of the treatment of America's own "colored people."[33] Her own mobility as an African American woman was central in shaping this vision of anti-imperialism as a global struggle.

As an outspoken activist with an international platform, Robeson's presence in Central Africa posed a threat to colonial authority, because her demands for African self-government put even more pressure on colonial administrations facing increasing labor strikes and protests after World War II. It is no surprise, then, that in another secret memo to MI5, the British consul general in Leopoldville described Robeson as "a dangerous customer," whose remarks in AEF "leave no doubt about her *very advanced* Leftist opinions and her determination to champion the negro cause at all costs. Her indiscretions have been numerous; her crowning one was the suggestion that the native in the Congo would only get a square deal when he was governed by one of his own kin."[34]

Robeson would not have been surprised to discover that she was the subject of police surveillance in the French and British territories. She experienced

colonial surveillance and border policing tactics firsthand in 1936 when the apartheid government refused to issue her a visa to visit South Africa. Robeson argued that the objective of these tactics was to prevent Global South solidarity. Her analysis of her experience with the apartheid regime offers an astute reading of border policing and surveillance as technologies of imperial control:

The visas were the real problem. It seems if you are Negro, you can't make up your mind to go to Africa, and just go. Oh, no. Not unless you are a missionary. The white people in Africa do not want educated Negroes traveling around seeing how their brothers live; nor do they want those brothers seeing Negroes from other parts of the world, hearing how they live. It would upset them, make them restless and dissatisfied; it would make them examine and re-examine the conditions under which they, as "natives" live; and that would never do at all. In fact it would be extremely dangerous. Something must be done to prevent this "contact." But what to do? It's simple: just keep all other Negroes out of Africa, except maybe a few who will come to preach the Gospel. The Gospel always helps to keep people quiet and resigned. And how to keep them out? That's simple, too: just don't grant them visas. So they don't grant them visas. Voilà.[35]

Robeson steps out of the first-person narrative voice that she uses throughout the rest of *African Journey* to draw the reader into a collective "you" that is denied access to Africa through colonial gatekeeping tactics. She speaks the rhetorical question "But what to do?" from the colonial administration's point of view as she attempts to inhabit the colonizer's mind and explain his deep-seated fears of black mobility and transnational resistance to colonialism. Speaking through an imagined colonizer's voice, Robeson describes black people in Africa and the diaspora as "them," an anonymous mass that must be kept out or contained within manageable spaces to maintain the colonial racial order. Ultimately, the goal in reducing mobility is to prevent the formation of a transnational anticolonial movement that is formed through colonized people's shared "dissatisfaction" with the status quo. As Robeson argues here, and again in a later essay titled "Passports and Agents," border-control practices such as issuing or denying visas become a key strategy for imperial powers to prevent transnational "contact" among marginalized groups.[36] For those already within the borders, either by birth or because they have entered the territory by subverting border controls, as Robeson did by ultimately traveling to South Africa without a visa, surveillance keeps black people visible to the colonizer's eye at all times. Thus, border policing and internal surveillance are complementary strategies that allow colonial powers to keep the colonized in and lock others out.

Mobility, then, was an important strategy for subverting colonial surveillance and remained a recurring theme in Robeson's continued engagement with colonialism long after her Central African journey. Notably, on her return from her travels, she became a contributor to the left publication *New World Review*. Her official title in her early years in this role was "Editorial consultant on negro colonial questions." She wrote her *New World Review* articles from the United States, unable to travel because the government had seized her passport on suspicion of her adherence to the Communist Party. When her passport was returned in 1958, Robeson's title quickly changed to "Roving correspondent, editorial consultant on negro colonial questions," a testament not only to her mobility but also to the importance of that movement in creating a Global South network of political action.

Robeson's examinations of mobility as resistance to imperialist surveillance and policing extended beyond her engagement with colonialism in Africa. As she continued to develop a language to articulate collective acts of resistance to global imperialism, she saw mobility as a crucial strategy for marginalized people everywhere. Thus, in a 1954 address delivered at the Manhattan Center to commemorate the eleventh anniversary of the Warsaw Ghetto Uprising, Robeson built on her earlier reflections on colonial policing in *African Journey* to outline a Global South resistance that employed mobility as a key strategy.[37] She began her address with an expanded definition of a ghetto: "Many people used to think that a Ghetto was the place where the Jewish people lived. Nowadays most people know that a Ghetto is the place where people, any people, are forced to live so that they can be isolated, segregated, separated from the rest of the population, and be discriminated against, neglected, exploited, persecuted and even killed, all in a separate, and if possible, distant place, where the rest of the population may not see, hear and know."[38] Robeson outlines here what scholars will later come to articulate as the existence of the Global South in the Global North.[39] She also adds the dimension of physical and psychic violence to which Global South populations are subjected. The ghetto as both a segregated space and a lived reality of oppression and discrimination, Robeson argues, can be translated across spaces and across times: "The Ghetto may be called by another name. But it is a Ghetto none the less—whether it is called the Bottom, Across the Tracks, or Negro Town in the Deep South; The Reservation for the American Indian in the South West; The Location in Africa, near the towns; or The Reserve in the African countryside; The Native Quarter in other areas—they are all Ghettoes."[40] The proliferation of segregated spaces across both the Global North and South, Robeson contends, points to surveillance and policing as a tool to control oppressed populations and to consolidate and maintain imperial control.

Yet, ever focused on the Global South as a project of collective resistance, Robeson also moves beyond this framework of shared oppression to emphasize the translatability of anti-imperial resistance across the world's ghettos. Mobility is at the heart of this global resistance: "Now all of us know that we can no longer remain as sitting ducks in our Ghettoes, targets for whoever wants to go shooting some fine day. . . . The spirit of the Warsaw Ghetto rising has spread around the world to the most remote places. It is no longer so easy to stage a riot or a pogrom or a lynching. The would-be victims don't just sit there and wait in terror: they come out fighting."[41] From physical movement through marches, protests, and armed struggle in Kenya to antiapartheid movements in South Africa, mobility is central to Robeson's vision of the fight against dispossession, violence, and segregation. Her refusal to be a "sitting duck" and her use of language that evokes movement—"rising," "come out fighting," and "our marching steps will thunder"—work together to paint the picture of people subversively surging through and ultimately beyond the spaces to which the policing apparatus of imperial powers seeks to contain them.

Robeson articulated her vision for a Global South citizenship not only in spatial terms but in temporal terms as well. Even as she described the present realities of exploitation across the different countries and territories she visited and connected these realities to a larger history of global imperialism, she also presented a forward-looking narrative that would situate the emergence of the Global South in a decolonized future. A month after her laudatory essay about Éboué, she turned her attention to decolonization on a global scale. She argued in an essay for *New World Review* that imperialist fears of "the Yellow Peril" and "the Black Menace" were being realized in the form of a "Rising Tide of Color" across Latin America, Africa, Asia, Europe, and the United States.[42] She noted that the world was on an inevitable path toward decolonization in the form of the restoration of land and economies to the colonized. Robeson's essay repurposed the metaphor put forth by the eugenicist Lothrop Stoddard in his book *The Rising Tide of Color against White World-Supremacy*.[43] Stoddard's white supremacist treatise argued that the white race was superior to all others and that it was constantly in danger of extinction due to high birth rates among other races and the death toll of World War I, which he described as an internecine conflict. For Stoddard, the war had not only decreased the "white world" population but had also made it clear to other races that white supremacy was neither inevitable nor impervious to overthrow. Without directly referencing Stoddard, Robeson's essay jubilantly announces decolonization as a certainty, the realization of white supremacy's deepest fears. In her trademark tongue-in-cheek style, she informs imperial powers that their only choice, in the face of the long-feared

"rising tide of colored peoples," is to "jump in and learn to swim."[44] For Robeson, this rapidly approaching decolonial future would bring political and economic sovereignty to the Global South and would allow African and Asian peoples to "control their own land and the fruits thereof, their own lives, their own destinies."[45]

Global South Feminisms

Over the course of her travels, Robeson became increasingly interested in recognizing women as a significant presence and political force in the Global South. In 1946 she and Vialle interviewed each other over two days in Oubangui-Chari, talking about African politics and women's rights.[46] Robeson was particularly interested in Vialle's work with African women in her capacity as founder of the Association des femmes de l'Union française. She asked Vialle about "the position of African women," to which Vialle responded:

> They have none, but we work now so they will have. If women of the world will become interested in them and help them, it will be a good thing because we must struggle against indigene [*sic*] custom here, against Musselmen [*sic*] religion and custom, and against the white man—all are against liberty for African women. The wife of an African man works very hard, and the man does not want to lose her labor. . . . Many white women and wives in the colonies are traditional and reactionary and are only interested in advancing themselves and their husbands to higher positions and to more business.[47]

Vialle articulates the intersections of oppression along the lines of race, gender, and class that continued to marginalize working-class African women, who were often left out of the ongoing debates on French citizenship and rights in the colonies. She outlines here the colonial hierarchy that disenfranchises women of all races, positioning them as labor for their husbands. Yet while white women remain complicit in a system that affords them economic benefits in business and politics, African women, for Vialle, continue to struggle within and against this hierarchy that denies them their liberty. Robeson, however, was skeptical about the efficacy of Vialle's methods in demanding women's inclusion within the framework of French politics rather than their enfranchisement in the context of independence.

Despite their ideological differences, both women firmly believed in the value of global feminist networks, as evidenced by Vialle's appeal to "women of the world" to take an interest in the advancement of their African counterparts. On the second day of their meeting in Bangui, Vialle and Robeson went shopping and exchanged gifts: "Mme Vialle gave me a long sleeved blouse for

Tchad, with the most marvellous ivory buttons. I gave in exchange a Revlon lip stick [sic] and a pair of nylon stockings, both of which she adores."[48] In this simple and seemingly frivolous exchange, the two women added not only to their wardrobe and makeup collections but also to their quickly growing transnational network of black feminist leaders and activists. Among Robeson's letters is one she received from Vialle nearly five years after this exchange. Vialle, writing from the Henry Hudson Hotel in downtown New York City, had just been appointed to the United Nations Ad Hoc Committee on Slavery, where she would advocate for the rights and safety of African women and girls, and sought out Robeson as a resource.[49]

As her ideological disagreement with Vialle shows, Robeson was not one to shy away from presenting radical and dissenting views, even as she sought to establish meaningful transnational connections with other black women. In 1945 she interviewed Éboué-Tell at a press conference in New York about her role in drafting the new French constitution. Notably, she asked Éboué-Tell "whether she thought it likely that the new Constitution might grant the French Equatorial Africans the right of secession if they desired to secede."[50] The question of independence was a tricky one for black deputies in the French National Assembly, who favored varied degrees of autonomy and citizenship within a French polity rather than outright independence and insisted that their vision of composite citizenship was not an assimilationist acquiescence to continued colonial domination. Éboué-Tell toed the French line and said in response that "she believed that the colonial population was not interested in secession."[51] Yet asking thorny questions did not jeopardize the strength of Robeson's feminist network. She remained friends with Éboué-Tell for many years. Letters in the archives today attest to their bilingual epistolary exchanges. In one of her missives to Éboué-Tell, Robeson outlines her plan to write the script for a biopic on Félix Éboué and to cast her husband, Paul Robeson, in the lead role.[52] She articulates here a desire to preserve, through film, Éboué's contributions to global politics through his role in World War II. Her choice to cast Paul as Félix also signaled her desire to extend her participation in the ongoing black transnational movement beyond politics and into the arts.

Robeson continued to work toward forging a global feminist network even when the United States government curtailed her international travel. In July 1954 and March 1958, she published two articles, titled "Women in the UN," in the *New World Review*, in which she profiled some of the delegates present at the annual meeting of the Commission on the Status of Women at the UN headquarters in New York. What is most interesting about Robeson's reflections on women's political participation is her articulation of the rela-

tionship between women's work in the private sphere and public domain. In the 1958 installment of "Women in the UN," she argues that women's experience with domestic work made them uniquely qualified to manage national and international affairs: "The United Nations is still predominantly a man's organization, and this may be one of the reasons why some of its important discussions continue to be unrealistic, impractical and futile. Women, with the day-to-day direct working responsibility for the children, the family, the home, and the budget are inclined to be, often forced to be, much more down-to-earth and common-sensical than men. Generally speaking of course."[53] For Robeson, private and public are not diametrically opposed; rather, the home functions as a microcosm of the nation and even of an international community. Consequently, tasks such as raising children and managing the household budget prepare women to take up public office. She imagines a complementary relationship between women's roles in the home and their contributions to the nation. Her call for a United Nations that more accurately reflects "not only the nations but the *people* of the world" reveals her hopes for a more inclusive future of international politics.[54]

The years from the 1940s through the 1960s were some of the most crucial years of black women's transnational activism because of the important advancements made toward citizenship rights in Africa and the diaspora. Robeson's efforts in forging a black transnational feminist network on a global scale continue to resonate in the articulations of a Global South project today. Her writings allow us to reimagine the geography of citizenship in the francophone world by decentering France as the only site of political organizing and showing Central Africa to be crucial to the discourse of anti-imperial resistance. Her extensive travels and critical engagement with imperial domination at home and abroad prompt us to account for black women's work in imagining the Global South as a project of collective anti-imperial resistance.

Epilogue

Of all the women whose paths have crossed throughout this study, the two least likely to have encountered each other were Aoua Kéita and Paulette Nardal. Despite their international travels, their orbits never quite overlapped. Kéita undertook her activist work in rural Mali. Nardal spent her post-Paris years working toward women's political enfranchisement in Martinique. The United Nations headquarters in New York City was a potential point of convergence, and I have sometimes tried to imagine the two women chatting in a coffee shop after a day of UN meetings, comparing notes on their strategies to get Malian and Martinican women to the polls. They would both turn their keen powers of observation onto New York City as a site to examine the role of black women in public life. The reality, however, is that although Kéita did take advantage of her attendance at the UN General Assembly to visit American women's organizations, she did so not in New York but rather by traveling through Chicago, Albuquerque, San Francisco, and Portland, nearly twenty years after Nardal's time in the United States as an area specialist at the UN.

Kéita and Nardal may never have met in person, but their voices did coincide in the pages of the magazine *AWA: La revue de la femme noire*. *AWA* was founded in Dakar by the poet and journalist Annette Mbaye d'Erneville and was headed by an all-female editorial team. It appeared from 1964 to 1966 and, after a hiatus, returned between 1973 and 1974. *AWA*'s contributors and readers spanned West, Central, and North Africa; the Caribbean; the United States; and much of Europe, including the former Soviet Union. Aware of its international readership, the editors published English translations of some of the contributions. The articles themselves covered a broad range of subjects.

Reviews of Aimé Césaire's play *La tragédie du Roi Christophe*, original short stories by Joseph Zobel and Negritude writer Birago Diop, mythical tales transcribed from griots, and features about women in liberation struggles in Guinea Bissau appeared alongside cake recipes and centerfolds featuring the latest in wig styles. A short informative piece on the "arsenal brassiere"—the newest development in gendered technologies of state violence deployed by the apartheid regime in South Africa—was published on the same page as entries for a baby photo contest.[1] Past, present, and future came together in an eclectic collection of articles and images that expressed the complexity of black womanhood. Indeed, as wide-ranging as the topics were, *AWA* was uncompromising in its singular focus on black women as mothers, workers, consumers, political actors, educators, cultural producers, and citizens.

Nardal's and Kéita's contributions to *AWA*, a letter of support and an interview, respectively, were published in 1964.[2] By then, much had changed since the early days of both women's activist work. Antillean politicians were becoming increasingly disillusioned with and critical of departmentalization; French Sudan was now the Republic of Mali; the French Union was no more, and the wave of independence sweeping the African continent effectively halted any further plans for French-African citizenship. Although much had changed, there was also much that remained the same. Contributors shared countless experiences of the obstacles that continued to render women's political empowerment and economic mobility a daily struggle. As though to prove right the magazine's founding statement that gender equality remained an unattained ideal, male readers sent letters to the editor challenging the legitimacy of *AWA*'s project to recognize women's concerns as critical to the development of newly independent African states.

One such reader was so disconcerted by African women's heightened visibility in the magazine's pages that he complained in the most bombastic terms about "the eternal puerility—I do not want to say childishness—of African negresses . . . that congenital flaw, so to speak, that pushes them to put the most insignificant things next to more serious ones: in their propensity to exhibit themselves singularly by an ill-timed photographic narcissism."[3] Nardal's warning in *La femme dans la cité* that women would need to fortify themselves mentally if they were not to be undone by the rampant sexism in public life remained true two decades later for *AWA*'s editors.

I turn to *AWA* because periodicals have been a crucial archive for this study. *Tropiques, La revue du monde noir, La femme dans la cité*, and the AFUF journal, among others, were important texts whose local reception and international circulation testify to the spaces for public expression that black women created and to the politics of sustaining those spaces in the face

of opposition, as Suzanne Césaire did in response to Vichy censorship. It is fitting, therefore, to conclude this study of black women's visions of decolonial citizenship, by considering a publication that took up the mantle left by these journals. In this reflection on the subsequent generation of writers and activists whose work took place after the formal dissolution of the French empire, I want to focus on what changed and what remained the same.

It has been my contention in this book that black women made crucial contributions to anticolonial movements and therefore that scholarship that limits the intellectual history of the French-speaking world to the texts of a select few so-called founding fathers is insufficient for understanding the range of decolonial visions and hopes for liberation that were operative at a critical moment in the history of the French empire. Examining the ruptures and continuities in the history of black women's activism in the pages of *AWA* highlights the continued centrality of this work to evolving ideas of citizenship, this time in the age of African independence.[4] The conversations about rights and duties, identities and belonging that took place in *AWA* in the 1960s and '70s testify to the longevity of black women's critical engagement with citizenship in the francophone world. The under-studied nature of *AWA* as an archive of transnational black feminism also underscores the need for continued scholarship that attends to black women's global voices as central rather than peripheral to decolonial thought.

In many ways *AWA* was an intellectual successor to the myriad journals that circulated in the African diaspora in the early twentieth century. It has been described as "the first francophone African women's magazine," a technically accurate depiction that is supported by the publication's chosen moniker.[5] Awa is a popular name for girls and women in West Africa, with variations including Aoua, Haoua, and Hawa found throughout the region. Aoua Kéita's interview in the November 1964 issue carried the headline "Who Are You Awa Kéita?" ("Qui êtes-vous Awa Kéita?"). This slippage in orthography from the Malian to the Senegalese rendering of the name signals the magazine's vision of itself as the African everywoman, characterized by an ability to cross national and linguistic borders. Indeed, the question that it addressed to Kéita was one that *AWA* would try to answer of itself throughout its lifespan.

The magazine's subtitle also invites readers to broaden their understanding of what this initial description of an African women's magazine entails. *AWA*'s project was not solely one of continental unification, as the geographic emphasis of the descriptor "African women's magazine" suggests. It was also very much invested in presenting an intertwined raced and gendered identity that was as diasporic as it was continental. Readers remarked on the deliberate choice of *La revue de la femme noire* (The Black Woman's Journal) over *La*

revue de la femme africaine (The African Woman's Journal), and the editors declared that "*AWA* is not only African but quite simply black, from America, from Haiti or from the Antilles: from mother Africa or the diaspora!"[6] Within each issue the editorial team expressed its vision of black womanhood under the pen name "Awa-la-noire" ("Awa-the-black-woman"), a fictional figure who wrote pithy and incisive missives published in response to letters to the editor. This image of black womanhood was a composite of the different black women who graced the journal's pages. From Kéita and Nardal to Coretta Scott King, Josephine Baker, Miriam Makeba, and the biblical and Quranic figure of Makeda, Queen of Sheba, *AWA* wove together narratives by and about black women across a variety of geographies and historical traditions.

This enduring commitment to transnational black feminism presents a clear line of continuity from Nardal, Vialle, Robeson, and others, to d'Erneville's editorial vision. *AWA*'s reach beyond borders even when the debate had moved from French-African citizenship to the emergence of sovereign nation-states echoes the Global South politics that I examine in Robeson's work in chapter 6. The publication's continuation of the legacy of black transnational feminism is particularly important because, unlike the previous generation of women, whose activism came at a time when the options for anticolonial outcomes ranged from departmentalization to federation to independence, the magazine's transnational practice occurred at a historical moment when nationalism was the order of the day.

AWA therefore had to grapple with what it meant to pursue a project of global black feminism at the height of African nationalist movements. Because the magazine was based in Dakar and Senegalese contributors featured prominently in some issues, readers occasionally leveled charges of a myopic nationalism at the editors. One such charge came from a reader whose letter to the editor was published under the headline "AWA est-elle nationaliste?" (Is AWA nationalist?). Mireille Bastard, a French woman whose extensive list of critiques in her letter included comments about the magazine's font, wrote that she considered some of the articles "of a 'nationalist' or even a 'patriotic' persuasion."[7] She argued that this nationalism could reproduce in Africa rivalries similar to those that had once pitted European states against one another. She admonished, "Il faut que l'expérience des peuples 'vieux' serve aux jeunes" ("The experience of the older peoples must be a lesson to the younger peoples").[8] Bastard's temporalizing reproduces colonialism's infantilizing discourse on Africa as an ahistorical continent that would be ushered into history with a benevolent Europe leading the way. *AWA*'s response is instructive, and I replicate it at length here because it underscores what is really at stake, what has been at stake throughout this study, in the

transnational reach of black women's political praxis: that intellectual, cultural, linguistic, and physical border crossings are not in themselves liberatory but become so when they are undertaken in the service of dismantling structures of oppression and building a more equitable future.

Awa-la-noire est contre le nationalisme irréfléchi et borné qui ressemble plus au racisme qu'à tout autre idéologie, mais il est indispensable, à l'heure actuelle, que les femmes, plus que quiconque, prennent conscience (ce mot a été tellement employé! . . .) non seulement de la forme de leur Continent, qu'elles portent en bijoux sur leur poitrine ou à leurs oreilles, mais aussi et surtout de son devenir. AWA comme le dit le Poète est "poreuse à tous les souffles du Monde" mais doit s'imprégner de la chaude haleine de son Afrique au labeur. Vous êtes Française, MIREILLE, et avez eu derrière vous, depuis "nos communs ancêtres Gaulois" des générations de Français pour chanter la beauté et la grandeur de la France et maintenant celles de l'Europe. Permettez nous amie, à nous qui réapprenons notre Histoire, d'être exaltées parce que [*sic*] nous sommes et de nous enthousiasmer pour ce que devons [*sic*] être à force de travail, de discipline. Vous dites qu' "il faut encourager au travail pour quelque chose de plus grave que le Pays"? Je ne vois pas pour l'instant, ce qui est, pour nous, "plus grave que le Pays" et n'est-ce point lutter pour le bonheur de l'humanité que faire en sorte qu'une partie de cette humanité—si minime soit-elle—soit informée de ses devoirs?[9]

Awa-the-black-woman is against thoughtless, narrow-minded nationalism that looks more like racism than like any other ideology. But it is essential at this moment that women, more than anyone else, become conscious (this word has been used so much!) of not just the shape of their continent, which they wear as jewelry on their chests or in their ears, but also of its becoming. AWA, as the Poet says, is "porous to all the breath of the world" but must be steeped in the hot breath of her laboring Africa. You are French, Mireille, and you have behind you, since "our common ancestors the Gauls," generations of French to sing the beauty and grandeur of France and now of Europe. Allow us too, friend, those of us who are relearning our History, to be exalted for who we are and to praise ourselves for what we must be through our hard work and discipline. You say that we must "encourage work for a greater cause than Country." I do not see, for now, what is greater for us than Country. And is it not to struggle for the happiness of humanity that we work so that a part of that humanity—small as that part may be—is informed of its duties?

AWA's call for awareness of Africa's becoming ("son devenir") articulates the vision of more democratic futures that motivated Éboué-Tell's and Vialle's work in the postwar French Republic in chapter 3. The opening and closing sentences of this letter simultaneously support a reading of the magazine as

nationalist and proffer a definition of nationalism that departs from the racial and gendered exclusions traditionally enacted by nationalist movements. Awa-la-noire describes her nationalism as located on the African continent and rippling out to the rest of the world. Perhaps because this definition is articulated in response to a French reader who herself evokes imperialist notions of history, it is acutely aware of coloniality in the independence period. Thus, the nationalism that the editors imagine seeks to dismantle this colonial legacy by rejecting racism and countering narratives of erasure. If *AWA* publishes transcriptions of griot's tales and myths, it is also in response to the imperial mandate to replace the history of the colonized with that of the colonizer, a mandate heard in the ubiquitous refrain throughout the French empire paying homage to "nos ancêtres les Gaulois" ("our ancestors the Gauls").

AWA's nationalism in this response to Bastard is not performative, operating primarily through symbolic gestures such as Africa-shaped jewelry. Instead it is a coming to consciousness through concrete practices such as reclaiming African history from colonial distortion and upholding rather than delegitimizing black women's celebration of themselves and their work as political protagonists. The magazine's rhetoric here does not indicate a divestment from the nation-state. There is no stake higher than country ("le Pays"), Awa-la-noire declares. Yet everything about her response points to an awareness of the limits of the nation-state as the only, or primary, sphere within which to work toward decolonization. The traditional nationalist rhetoric of working for country is repurposed here as a humanistic project that decenters the state and instead reaches beyond national boundaries in its invocation of Aimé Césaire's ("the Poet's") articulation of a global black identity in *Cahier*.

This commitment to transnational exchange highlights one strand of the thread of decolonial citizenship that runs through this book, a strand that emphasizes the recognition of diverse epistemologies that chapter 1 shows to be at the center of Suzanne Césaire's decolonial thought. Throughout its lifespan, *AWA* valorized different sources of knowledge, including Negritude poetry, as shown in the example above. The magazine's equivalent of a horoscope section, a recurring column titled "Les cauris de Mam'Awa" ("Madam Awa's Cowries"), created a place for West African divination practices within the printed text. To define black womanhood, to paint a picture of Awa-la-noire, was to put Martinique in conversation with Senegal, Tunisia, the United States, Trinidad, and a host of other places that came together in *AWA*'s broad geography. It was to imagine, as Suzanne did aboard a Pan American Airways clipper soaring over the Caribbean Sea, liberation through the interconnection of spaces.

The importance of diverse epistemologies recurs in the work of the women examined in this book. Their writings ask us to consider whose freedom

dreams underlie our contemporary understandings of what decolonization could look like. Can rural African women be heard alongside Aimé and Senghor as also articulating prescient visions of liberation in the twentieth century? Can M'Ballia Camara's death at the hands of a canton chief, her pregnant body slashed open by his saber in a dispute over local taxes for the colonial administration, speak across time and archival silences? Can it speak into a historical canon that is only now beginning to acknowledge black women as midwives who help to birth anticolonial movements and bear witness also to their *leadership* in these movements? As I have shown in chapters 4 and 5, Kéita's and Blouin's autobiographies respond to these questions with a resounding *yes* that is nonetheless inflected by their awareness of the obstacles involved in shifting the terms on which we hear black women's voices in public discourse.

The range of political visions put forth by the women in this study attests to the heterogeneity of these voices and reminds us of the varied strategies that black women adopted to contest colonialism and to claim a plurality of national, cultural, linguistic, and intellectual attachments. If challenging colonial domination has been a continuous line running through this work, it is a line with many breaks. Nardal and Kéita were equally invested in the electoral process as a means of enfranchisement for women. But where Nardal viewed the ballot as a way for Martinican women to speak back to the Hexagon, Kéita saw in it a path toward independence from France. Similarly, Éboué-Tell's and Vialle's unshakable faith in the French Republican model would not have resonated with Blouin, a self-proclaimed African nationalist. It certainly did not sit well with Robeson, who favored national sovereignty as part of her Global South politics. In the line of ideas from these women to *AWA* too, we find several breaks, such as the magazine's negotiation of the porous boundary between public and private. The discussion of Ginette Éboué's marriage to Senghor in this book's introduction identifies this boundary as a site at which intimate relationships come to stand in for national politics. Although both the Éboués and *AWA*'s editors had to negotiate their place within discourses of private and public, we may read that navigation as a form of rupture rather than continuity, because they did so in markedly different ways.

Whereas public commentary on Ginette remained on the order of lamenting a political marriage that supposedly symbolized a discordant relationship between Africa and the Antilles, *AWA* faced readers who expressed their dissatisfaction with the magazine's project in even more personal terms. One such reader, N'Diaga, framed his discovery of the journal's issues as a blow-by-blow account of meetings with *AWA* personified as a black woman, using language

that was strongly suggestive of a romantic encounter. N'Diaga declared himself smitten by her "velvety eyes" and her minimal makeup.[10] However, he was displeased by her choice of undergarments: "You show off your underwear of lace and nylon, frills and brassiere. That is all well and titillating, but do not forget the little white 'bethio' with its black border that our grandmothers used to wear."[11] In this indictment of *AWA* as insufficiently authentic, as not African enough, the writer's recourse to sexual innuendo specifically aims at revealing and laying bare black women's bodies, from Awa-la-noire's to those of her foremothers.

This impulse to uncover and lay bare the body of the black woman who dares to speak publicly recalls the experience of Gerty Archimède, the Gua-deloupean deputy whose political opponents tried to strip her naked in a public meeting. It also echoes the experience of Nardal's protagonist Elisa in "En exil," whose alienation in Paris illustrates the effects of such a gaze in the public sphere that misrecognizes black women as objects to be consumed and negates their claims to citizenship. Nardal's exploration of the meanings ascribed to black women's bodies when they are scrutinized by the imperial white male gaze, ends at Elisa's head scarf. Neither she nor the other women at the center of this study take up the body in any significant way as they discuss black women's presence in public spaces and as they examine the physical and discursive violence that accompanied this public visibility, as well as ways to counter or escape this violence. *AWA*'s exchange with N'Diaga is one of those broken lines between *AWA* and her predecessors. On one hand, it shows the continued public contestation over black women's bodies stretching from the colonial era to the neocolonial period. On the other hand, it throws into sharp relief one of the many dimensions of this public discourse that were not taken up by the women in this book and that remain important categories of analysis for a fuller understanding of the entwined workings of race, gender, and class in systems of oppression.

My goal in *Reimagining Liberation* has been to examine the work of black women who redefined transnational exchange beyond several binaries. They unsettled the colony/metropole paradigm by demanding a more expansive idea of France. They also refigured the notions of diaspora that located Africa as a point of origin or site of homecoming in order to imagine more multidirectional flows of knowledge, cultural production, and solidarity. Beginning with Suzanne Césaire, who developed an archipelagic vision of Caribbean civilization by traveling beyond Martinique and metropolitan France to Haiti, the women in this study cultivated global alliances as a nec-essary component of their decolonial praxis. Their work highlights a simple but sometimes elusive truth: that "a global problem cannot have a national

solution."[12] The coloniality of power was and remains a global problem, and its eradication would have to take seriously global solidarity as a strategy of resistance. Many of the women analyzed here believed that foregrounding black women's experiences, political concerns, and intellectual leadership in transnational liberation movements would offer new ways of dismantling colonial structures of oppression by challenging the interconnected racist, patriarchal, and economically exploitative foundations of those structures. Their writings bear witness to the radical futures they imagined and the pitfalls they did not avoid. They present us today with a road map to this future that is yet to come, for it is the spark of their decolonial citizenship in the French empire that illuminates our way toward a decolonized world.

Notes

Introduction

1. Blouin, *My Country, Africa*, 145.

2. Ibid.

3. I encountered the term "political protagonist" in Keisha-Khan Perry's description of black women's experiences of racialized and gendered forms of state violence in Brazil. My development of the term here emphasizes the literary definition of a protagonist in order to connect political activism, leadership, and textual production. See Perry, "Gendered Racial Frame."

4. De Gaulle, "Appel du 18 juin 1940."

5. Robeson, "Felix Eboué," 47.

6. For further studies on postwar protests and labor movements in the French colonies see Aldrich and Connell, *France's Overseas Frontier*, and Cooper, *Colonialism in Question*.

7. Scott, *Only Paradoxes to Offer*, 162.

8. For an analysis of French women's acquisition of the vote and its political implications, see Duchen, *Women's Rights and Women's Lives in France*, 34, and Ramsay, *French Women in Politics*, 41.

9. See Wynter, "Unsettling the Coloniality of Being/Power/Truth/Freedom."

10. Ibid., 260.

11. Ibid., 263.

12. Balibar, *Citoyen sujet*, 51, emphasis in original. For further discussion on the equation of man with citizen, see also Balibar, *We the People of Europe?* 59.

13. Wynter, "Unsettling the Coloniality," 269.

14. Balibar, *Citizenship*, 16.

15. Ibid.

16. Ibid., emphasis in original.

17. Quijano, "Coloniality of Power, Eurocentrism, and Latin America."

18. A. Césaire, *Discourse on Colonialism*, 33.

19. Theorists of coloniality and decolonization have examined this privileging of Eurocentric sources of knowledge extensively in their works. See, for example, Grosfoguel, *Colonial Subjects*; Lugones, "Coloniality of Gender" and "Toward a Decolonial Feminism"; Maldonado-Torres, "On the Coloniality of Being"; Mignolo, "Citizenship, Knowledge, and the Limits of Humanity"; Mohanty, *Feminism without Borders*; and Quijano, "Coloniality of Power, Eurocentrism, and Latin America."

20. Mignolo, "Citizenship, Knowledge, and the Limits of Humanity," 315.

21. For an examination of diverse concepts of belonging and collective dwelling in the Aztec civilization, see Mignolo, "Citizenship, Knowledge, and the Limits of Humanity."

22. Stephens, "Re-imagining the Shape and Borders of Black Political Space," 177.

23. A. Césaire, *Notebook of a Return to the Native Land*, 91.

24. On decolonizing citizenship, see Mignolo, "Deorientalizing/Dewesternizing/Decolonizing Citizenship."

25. Grosfoguel, *Colonial Subjects*, 195.

26. For an overview of the evolution of Césaire's text from "L'Impossible contact" to *Discours*, see A. Césaire, Eshelman, and Smith, *Aimé Césaire*, and "Aimé Césaire et le colonialisme," Portail de la Banque Numérique des Patrimoines Martiniquais (PBNPM).

27. Berge, "Editorial," 9. All translations are mine unless otherwise indicated.

28. Césaire signs his essay with his name and his position as deputy from Martinique. See A. Césaire, "L'Impossible contact," May 1948. Fonds Aimé Césaire (hereafter FAC). The FAC in the Archives Départementales de la Martinique contain Césaire's correspondence and documents related to his political work in Martinique and Haiti.

29. Mignolo, "Citizenship, Knowledge, and the Limits of Humanity," 313.

30. Archimède remains a grossly under-studied figure. For further sources on her life and work, see Archimède and Farrugia, *Gerty Archimède*; Joseph-Gabriel, "Gerty Archimède and the Struggle for Decolonial Citizenship," in Germain and Larcher, *Black French Women*; Monpierre, *Gerty Archimède: La candidate du peuple*; Semley, *To Be Free and French*; and Base de données des députés français, "Gerty, Marie, Bernadette Archimède."

31. Melas, *All the Difference in the World*, 36.

32. Pauline Debionne, personal communication.

33. Michelet, *Introduction à l'histoire universelle*, 79.

34. In her study on African American women's thought, Brittney Cooper outlines a dual framework of black women's intellectual genealogy and intellectual geography. I am indebted to that framework here. See Cooper, *Beyond Respectability*.

35. Umoren, *Race Women Internationalists*, 14.

36. Stephens, "Re-imagining the Shape and Borders of Black Political Space," 172.

37. Ibid.

38. See Chancy, "African Diasporic Autochthonomies," 269.

39. Stephens, "Disarticulating Black Internationalisms," 109. See also Sharpley-Whiting, "Erasures and the Practice of Diaspora Feminism," and Edwards, "Pebbles of Consonance."

40. See also Ransby, *Eslanda*, and Lewis, *Race, Culture, and Identity*.

41. Andrade, *Nation Writ Small*, 5. See also Rodríguez, *House, Garden, Nation*.

42. "Union dans 'l'Union'" and "Accordailles à la Constituante," in Coupures de presse sur les fiançailles de Ginette Éboué avec Léopold Senghor, Sept. 1946. These press releases are collected in Eugénie Éboué-Tell's papers in the collection Papiers personnels d'Eugénie Éboué (hereafter PPEE) in the Fondation Charles de Gaulle in Paris.

43. "Untitled," Coupures de presse, PPEE.

44. Vaillant, *Black, French, and African*, 99–100, 211.

45. Delas and Mongo-Mboussa, "Ne prenons pas Senghor pour ce qu'il n'est pas."

46. Vaillant, *Black, French, and African*, 280.

47. Fanon, "Antillais et Africains."

48. Eve Blouin, personal correspondence.

Chapter 1. Suzanne Césaire

1. See, for example, Ponton to Secrétaire Générale, Apr. 14, 1944, FAC; Ponton to Algiers, Apr. 19, 1944, FAC; Prizac to Ponton, May 2, 1944, FAC; and Prizac to Ponton, Oct. 3, 1944, FAC.

2. Seyrig to Ponton, Dec. 15, 1943, 2, FAC.

3. Ponton to Algiers, Mar. 17, 1944, FAC.

4. S. Césaire, "Rapport sur les cours de français donnés à la faculté de droit de Port-au-Prince aux élèves professeurs de lettres de la République d'Haïti," 1944, FAC 3 (hereafter "Rapport").

5. Aimé Césaire to Ponton, July 17, 1944, FAC.

6. S. Césaire, "Rapport." Among the differences in the Césaires' accounts is the discrepancy between Aimé's description of teaching courses at the Faculté des Lettres and Suzanne's assertion that they taught at the Faculté de Droit. According to Suzanne's report, the former school did not exist at the time, and its foundations were laid in part as a result of the Césaires' work in Haiti.

7. See Rabbitt, "In Search of the Missing Mother"; Sharpley-Whiting, *Negritude Women*; and Wilks, *Race, Gender, and Comparative Black Modernism*. Nicole Aas-Rouxparis describes Antillean women's writings as oscillating between the extremes of presence and absence in literary history. See Aas-Rouxparis, "Espace antillais au féminin."

8. See "Certificat de marriage," FAC. For examples of texts that present these varying biographical accounts, see Fonkoua, *Aimé Césaire: 1913–2008*; Sharpley-Whiting, *Negritude Women*; Toumson and Henry-Valmore, *Aimé Césaire*; and Wilks, *Race, Gender, and Comparative Black Modernism*.

9. Leiris, *Contacts de civilisations*, 31.

10. Ibid., 159.

11. Ibid.

12. See *Les Cahiers d'Estienne*, n.p.

13. Sharpley-Whiting, *Negritude Women*, 97, 102.

14. Condé, "Unheard Voice."

15. Aimé Césaire to Seyrig, July 16, 1944, Fonds Henri Seyrig. The Henri Seyrig collection in the Bibliothèque nationale de France contains correspondence between the Césaires and Seyrig.

16. Ibid.

17. While I draw my analysis from Suzanne's letters, I do not quote directly from them due to the financial conditions for their reproduction outlined by the Césaire family and their team of Paris-based lawyers.

18. Jennings, *Vichy in the Tropics*, 89.

19. Gauclère was a teacher in France in the 1930s and '40s and taught at Hamilton College in New York in 1943. She was married to the French writer and intellectual René Etiemble and worked closely with him, coauthoring a book on Rimbaud. During the war, she joined the French Ministry of Information and was stationed first in Algiers and then Paris.

20. Suzanne Césaire to Gauclère, July 25, 1944, Fonds Yassu Gauclère. The René Etiemble collection in the Bibliothèque nationale de France includes a small dossier of correspondence and press clippings related to the Césaires and Martinique.

21. An estimated five thousand dissidents left Guadeloupe and Martinique to join the Resistance in Dominica and Saint Lucia. See Childers, *Seeking Imperialism's Embrace*.

22. S. Césaire, "The Malaise of a Civilization," 31, emphasis in original. All quotes from Césaire's *Tropiques* essays are taken from S. Césaire, *Le grand camouflage*, ed. Daniel Maximin, and S. Césaire, *The Great Camouflage*, trans. Keith Walker.

23. S. Césaire, "Malaise of a Civilization," 32.

24. Césaire to Gauclère.

25. S. Césaire, "Malaise d'une civilisation"/"Malaise of a Civilization," 70/29. "Inaltérablement" is better translated as "inalterably" rather than "unilaterally."

26. S. Césaire, "Malaise of a Civilization," 29.

27. S. Césaire, "Malaise d'une civilisation"/"Malaise of a Civilization," 70/29.

28. Marie-Agnès Sourieau and Jennifer Wilks point out that Césaire's overreliance on Frobenius's ethnography in her early works results in some of the conceptual limitations of essentialism. See Sourieau, "Suzanne Césaire et Tropiques," and Wilks, *Race, Gender, and Comparative Black Modernism*, 119–21.

29. See Curtius, "Cannibalizing Doudouisme."

30. S. Césaire, "Leo Frobenius et le problème des civilisations,"/ "Leo Frobenius and the Problem of Civilizations," 40/9–10.

31. "Le Maréchal de France," 1.

32. Aimé and Suzanne Césaire to M and Mme Breton, Oct. 21, 1941, Fonds André Breton (hereafter FAB). The Fonds André Breton are located at the Bibliothèque littéraire Jacques-Doucet.

33. S. Césaire, "1943: Surrealism and Us," 23.

34. In *What Is Surrealism?* Breton cites the surrealists' protest of the Moroccan war in 1925 as a deciding moment in the cohesion of surrealism as an artistic, social, and political movement. See Breton, *What Is Surrealism?*

35. Wilks, *Race, Gender, and Comparative Black Modernism*, 124.

36. *VVV*, 3.

37. Breton, "Situation du surréalisme," 49.

38. Rimbaud, *Poésies*, 95.

39. Césaire to Gauclère.

40. Ibid.

41. In *L'Isolé soleil*, Daniel Maximin's protagonist Siméa criticizes Césaire for her overreliance on European theorists. See Maximin, *L'Isolé soleil/Lone Sun*, 192–93/191.

42. Sourieau, "Suzanne Césaire et Tropiques," 71.

43. Césaire, "Leo Frobenius et le problème des civilisations"/"Leo Frobenius and the Problem of Civilizations, 36/7.

44. Conklin, *Mission to Civilize*, 1.

45. S. Césaire, "Great Camouflage," 40.

46. Césaire, "Leo Frobenius et le problème des civilisations"/"Leo Frobenius and the Problem of Civilizations," 34/6.

47. S. Césaire, "Le grand camouflage"/"Great Camouflage," 91/43.

48. Ponton to Trujillo, May 19, 1944, FAC.

49. S. Césaire, "Great Camouflage," 40.

50. "La dernière conférence de Aimé Césaire," FAC.

51. "La conférence de M. Césaire," FAC.

52. "Une fête de l'Esprit," Le Soir, May 1944, FAC.

53. Depestre, "André Breton à Port-au-Prince," in Bloncourt and Löwy, *Messagers de la tempête*, 50. For firsthand testimonies on the student-led movement to overthrow Elie Lescot, see Bloncourt and Löwy, *Messagers de la tempête*. For further analysis on the surrealist inspiration for this movement see Joseph-Gabriel, "Beyond the Great Camouflage."

54. S. Césaire, "Rapport."

55. Césaire to Bayle, May 12, 1943, qtd. in S. Césaire, *Le grand camouflage*, 13–14.

56. S. Césaire, "1943: Le surréalisme et nous,"/"1943: Surrealism and Us," 82/38.

57. S. Césaire, "1943: Surrealism and Us."

58. Wilder, *Freedom Time*, 33.

59. See "Une elégante réception au Palais National," *Le Soir*, May 1944, FAC; and "La réception au Port-au-Prince en l'honneur des Professeurs Etrangers," June 1944, FAC.

60. S. Césaire, "Rapport."

61. Fanon, *Wretched of the Earth*, 97.

62. Seyrig to Ponton, Dec. 15, 1943, FAC.

63. Césaire, "Rapport."

64. Césaire to Gauclère.

65. See Joseph-Gabriel, "Beyond the Great Camouflage."

66. Wilks, *Race, Gender, and Comparative Black Modernism*, 129.

67. Stephens, "What Is an Island?" 11.

68. S. Césaire, "Le grand camouflage"/"Great Camouflage," 94/46.

69. S. Césaire, *Great Camouflage*, ix.

70. Boyce Davies, *Caribbean Spaces*, 35, emphasis in original.

71. S. Césaire, "Le grand camouflage"/"Great Camouflage," 84/39.

72. Ibid., 87/41.

73. Ibid., 94/46.

74. Césaire to Gauclère.

75. Césaire, "1943: Surrealism and Us," 38.

76. Price-Mars, *Ainsi parla l'oncle*, 10.

77. Ibid.

78. Césaire to Gauclère.

79. S. Césaire, "Great Camouflage," 41.

80. Ibid., 39.

81. Boyce Davies, *Caribbean Spaces*, 1.

82. Césaire to Gauclère.

83. Ménil, "Mythologies Antillaises," in *Tracées*, 56.

84. See Olmos and Paravisini-Gebert, *Creole Religions of the Caribbean*.

85. Césaire to Jahn, Feb. 25, 1962, Nachlass von Janheinz Jahn (hereafter NJJ).

86. S. Césaire, *Great Camouflage/Le grand camouflage*, xxxv/22.

87. Scharfman, "De grands poètes noirs," 239.

88. S. Césaire, "Leo Frobenius," 10.

89. See Maximin, *L'Isolé soleil*, and Scharfman, "De grands poètes noirs."

90. Suzanne and Jahn worked simultaneously from the 1956 and 1960 editions of *Cahier*, both published by Présence Africaine.

91. Jahn to Césaire, Feb. 19, 1962, NJJ. It is unclear whether Jahn's decision to render "lunes rousses" as "lunes rouges" was his own or was made at the suggestion of one of the Césaires. The subtle switch from "rousses" to "rouges" is very much in line with Suzanne's own shift in emphasizing the manmade stoplight over the organic imagery of moons, fires, and fevers.

92. Kesteloot, *Histoire de la littérature négro-africaine*, 135.

93. Césaire to Jahn.

94. Ibid.

95. Ibid.

96. A. Césaire, *Zuruck ins Land der Geburt*, 43.

97. A. Césaire and Irele, *Cahier d'un retour au pays natal*, ix–x.

98. Ibid., 89.

99. "Aimé Césaire, l'adhésion au Parti communiste," Archives départementales, Martinique

100. Aimé Césaire to Louis Adrassé, May 19, 1945, Fonds Louis Adrassé (hereafter FLA).

101. "Aimé Césaire en campagne électorale," Archives départementales, Martinique.

102. Suzanne Césaire to Louis Adrassé, FLA.

103. Ibid.

104. Unsigned letter, FLA.

105. In "Revolutionary Genealogies," Wilks analyzes Césaire's *Tropiques* essays and situates her as a precursor to the French Guyanese politician Christiane Taubira.

106. A photograph of the closing banquet at the 1944 International Congress of Philosophy in Port-au-Prince shows Suzanne Césaire and Marie Vieux-Chauvet to be the only women at a table of male intellectuals and dignitaries. See "Au banquet de clôture," FAC.

Chapter 2. Paulette Nardal

1. The Césaires' return to Martinique in 1939 aboard the SS *Bretagne* is reported in several biographies of Aimé. See Davis, *Aimé Césaire*, 13, and Toumson and Henry-Valmore, *Aimé Césaire: Le Nègre inconsolé*, 71. Romuald-Blaise Fonkoua reads scholars' assertions that the Césaires traveled on the *Bretagne* as a myth whose purpose is to mobilize the sinking of the ocean liner as a symbol of the definitive end to one phase of Aimé's life. See Fonkoua, *Aimé Césaire*, 65.

2. For a full account of Nardal's escape and recovery from the German attack, see the dossier "Mademoiselle Paulette NARDAL, Victime civile de guerre," 1M861/D. Archives Départementales de la Martinique, Schœlcher, Martinique.

3. See P. W., "Paulette Nardal est morte," 1.

4. See Nardal and Grollemund, *Fiertés De Femme Noire*, 79, and "Mademoiselle Paulette NARDAL."

5. "Mademoiselle Paulette NARDAL," 5.

6. Parisot, "Urgent," Sept. 6, 1945, 1, in "Mademoiselle Paulette NARDAL."

7. The decision from Algiers is the last entry in Nardal's "Victime civile de guerre" folder. It is not clear whether the governor, who appeared sympathetic to Nardal's request, was able to assist further or "faire quelque chose pour Mlle. Nardal," as he wrote in the margins of her dossier.

8. Grosfoguel, *Colonial Subjects*, 9.

9. For a more extensive biography of the Nardal family, see Church, "In Search of Seven Sisters," and Servant, *Paulette Nardal*.

10. Sharpley-Whiting, *Black Venus*, 17.

11. Nardal, "In Exile," 116. All references to "In Exile," the English translation of "En exil," are taken from Sharpley-Whiting, *Negritude Women*.

12. Fanon, *Black Skin, White Masks*, 91–92.

13. A. Césaire, *Notebook*, 109.

14. Harris-Perry, *Sister Citizen*, 39.

15. Ibid.

16. See Boittin's tabulation on the distribution of jobs for Africans and Antilleans in Paris in the 1930s in *Colonial Metropolis*, 45.

17. Nardal, "In Exile," 116.

18. Said, "Reflections on Exile," 176.

19. David Powers identifies the laguia as the Martinican equivalent of the *calenda*, a dance form believed to have originated from Guinea. See Powers, *From Plantation to Paradise?* 208. Nardal, "In Exile," 118.

20. Nardal, "In Exile," 117.

21. Couti, "Am I My Sister's Keeper? The Politics of Propriety and the Fight for Equality in the Works of French Antillean Women Writers, 1920s–40s," in *Black French Women*, ed. Germain and Larcher, 136.

22. See Garcia, "Remapping the Metropolis: Theorizing Black Women's Subjectivities in Interwar Paris," in *Black French Women*, ed. Germain and Larcher, 230.

23. Edwards, *Practice of Diaspora*, 144.

24. Said, *Reflections on Exile*, 185.

25. Hall, "Negotiating Caribbean Identities," 6.

26. Nardal, "In Exile," 118.

27. See Hearn, *Two Years in the French West Indies*, 216.

28. Nardal, "L'Antillaise: Marchandes des rues."

29. Charles, "Reflections on Being Machann ak Machandiz," 119.

30. Nardal, "L'Antillaise: Marchandes des rues."

31. See "Mademoiselle Paulette NARDAL," 1.

32. Nardal, "Martinique," 5.

33. Hall, "Negotiating Caribbean Identities," 6.

34. See Palmiste, "Le vote féminin," 4.

35. Nardal, "Facing History," 69. Unless otherwise indicated, Nardal's *La femme dans la cité* editorials and their English translations are taken from Sharpley-Whiting, *Beyond Negritude*.

36. Nardal, "Martinican Women and Politics," 65.

37. Nardal, "From an Electoral Point of View," 35.

38. Ibid.

39. E. D., "Pensée," *La femme dans la cité*, May 1948, 4.

40. Nardal, "Editorial," 97.

41. Archimède, "Débats parlementaires, assemblée nationale," Mar. 16, 1948, 1731.

42. A. Césaire, "Débats parlementaires assemblée nationale," Mar. 15, 1950, 2077.

43. During World War II, Vichy replaced France's tripartite republican motto,

liberté, égalité, fraternité, with one of its own: *travail, famille, patrie*. To invoke the republican motto in the postwar period, then, was to declare one's renewed adherence to the French Republic, which was associated with resistance rather than collaboration during the war.

44. Taillandier, "Avec nos élus nous travaillerons à façonner notre securité sociale," *La femme dans la cité*, July 1951, 11.

45. Archimède, "Le Rassemblement féminin," 4.

46. Monpierre, *Gerty Archimède: La candidate du peuple*.

47. Nardal, "Discrimination raciale?" *La femme dans la cité*, July 1951, 5.

48. Ibid.

49. H. D., "Racisme," *La femme dans la cité*, July 1951, 5.

50. Georges Parisot to M. l'Inspecteur des Affaires Administratives et Communales, Féminisme colonial, Dec. 28, 1945.

51. R. Hennebault to Georges Parisot, Dec. 28, 1945, Féminisme colonial.

52. Sharpley-Whiting, *Negritude Women*, 21–22.

53. Umoren, *Race Women Internationalists*, 78.

54. Emily Musil Church's useful one-paragraph examination of the report remains to date the most extensive treatment of this crucial text. See Church, "In Search of Seven Sisters."

55. Nardal, "Féminisme colonial: Action sociale et politique," Féminisme colonial.

56. Ibid., 6.

57. Ibid., 4.

58. Ibid., 7.

59. Ibid., 8.

60. Nardal, "Aux Antilles: Les communistes profitent," 6.

61. This was not the first time Nardal used her publication as a platform from which to engage in a public debate about high-profile cases of racism in Martinique. In the December 1931 issue of *La revue du monde noir*, Nardal solicited readers' responses to the question "How should Negroes living in Europe dress?" Her question was motivated by a controversial essay assignment given by a white teacher to her students at the Lycée Schœlcher in Fort-de-France on the topic "Why does the Negro make Whites laugh when he dresses like a European?" In response to the assignment and the subsequent protest it sparked, Nardal provided a textual space for black students and intellectuals in Paris to engage in a transatlantic conversation about race, place, and culture in the African diaspora. See Nardal, *La revue du monde noir*, 129, 182–86; and Weinstein, *Éboué*, 134.

62. In *Les 16 de Basse-Pointe*, filmmaker Camille Mauduech reconstructs the circumstances of Fabrique's death and the ensuing trial in Bordeaux through a combination of interviews and archival documents.

63. Testimony by Paul Prompt, a member of the defense team interviewed in Mauduech, *Les 16 de Basse-Pointe*.

64. A. Césaire, "Débats parlementaires, assemblée nationale," Mar. 16, 1948, 1732.

65. Ibid.

66. See Mauduech, *Les 16 de Basse-Pointe.*

67. Freundschuh, "Marchal Case in Franco-Moroccan History."

68. Nardal, "About a Crime," 85.

69. Ibid.

70. See Agard-Jones, "Bodies in the System."

71. In a 1958 report delivered to the Parti Progressiste Martiniquais, Aimé Césaire outlined the negative effects of departmentalization on Martinique's cultural development and its ability to form meaningful alliances in Africa and the diaspora. Césaire, *Pour la transformation de la Martinique*, 3.

72. "Martinique Girl Given High Post with UN Body," 13.

73. Ibid.

74. Nardal, "Martinican Women and Social Action," 32.

75. Nardal, "Editorial," 82.

76. Nardal, "Martinican Women and Social Action," 32.

Chapter 3. Eugénie Éboué-Tell and Jane Vialle

1. Levasseur, "Les femmes-soldats."

2. The name appears in archival documents as either Henri or Henry. See Papiers personnels d'Eugénie Éboué (hereafter PPEE) located in the Félix Éboué archives at the Fondation Charles de Gaulle. In his biography of Éboué, Brian Weinstein identifies Henri's mother as Éboué's unnamed housekeeper and Robert's mother as Éboué's common-law wife, a Banziri woman named Bada Marcelline. See Weinstein, *Éboué*, 43, 48, 63.

3. Véronique Hélénon's study of French Caribbean colonial administrators in Africa presents a useful analysis of the political implications of Éboué's appointments as well as those of other black French Antilleans, such as René Maran, and the possibility of troubling the boundaries between subjects and citizens in French African colonies. See Hélénon, *French Caribbeans in Africa.*

4. Office of War Information, "Advance Release for Sunday Papers," 1. Papers of the NAACP (hereafter PNAACP).

5. Éboué, "Note au sujet de Henri Eboue-31 ans Robert Eboue-24 ans," PPEE 1.

6. Weinstein, *Éboué*, 282.

7. Office of War Information, "Advance Release."

8. Robeson, "Félix Éboué: The End of an Era," 48.

9. Weinstein, *Éboué*, 127.

10. Éboué-Tell, "Débats parlementaires, assemblée nationale," Sept. 20, 1946, 3909.

11. Éboué-Tell, "Les Rôles des femmes." *La Raison*, Feb. 2, 1952, PPEE.

12. See Vialle interrogation transcripts, 8W3 and 8W53, Conseil départemental 13, Archives départementales, tous droits réservés (hereafter ADBRA). These transcripts are located in the Archives départementales des Bouches-du-Rhône, Aix-en-Provence.

13. Bradshaw and Fandos-Rius, *Historical Dictionary*, 627; Serre, *Hommes et destins*, 759.

14. Marriage certificate of Jane Vialle and Marcel Beauvais, Dossier Jane Vialle (hereafter DJV).

15. Robeson, "Congo Diary," EGRP, 90.

16. Bradshaw and Fandos-Rius, *Historical Dictionary*, 629; Weinstein, *Éboué*, 97.

17. Serre, *Hommes et destins*, 761.

18. Vialle interrogation transcripts, ADBRA.

19. Ambassade de France, Service de presse et d'information, DJV 2.

20. Strangely, there is no consensus among historians on the name of the journal. Serre identifies it as "Femmes de l'Union Française" (*Hommes et destins*, 764), which is perhaps not coincidentally the name of the women's organization that Éboué-Tell is believed to have founded. Bradshaw and Fandos-Ruis render the title as "Les Femmes de l'union française d'outre-mer et metropole" (*Historical Dictionary*, 629), and Penel simply refers to it as the "Journal de l'AFUF" (*B. Boganda*, 1).

21. Recent scholarship by Lorelle D. Semley has begun to uncover both women's significance to discourses on race, gender, and citizenship in the French empire. See Semley, *To Be Free and French* and "Women Citizens of the French Union Unite!"

22. McCray, "Negro Who Defeated Hitler," 18.

23. Éboué-Tell, "Débats parlementaires, assemblée nationale," Dec. 29, 1945, 545.

24. Ibid.

25. "Madame Eugenie Eboue Elated over Courtesies in States," 11.

26. Dunbar to White, PNAACP.

27. C. T. to White, PNAACP.

28. Éboué-Tell to White, Jan. 2, 1952, PNAACP.

29. "Mme E. Eboue Arrives from Paris," 14.

30. "Editor's Note," *Pittsburgh Courier*, Mar. 23, 1946, 1.

31. See Pénel, *B. Boganda*, 154 and Vialle, "Débats parlementaires, conseil de la république," Mar. 19, 1948, 890.

32. Garrett, "Gadabouting in the U.S.A," 10; "Hunter College Students Hear Senator Vialle of Africa," 18.

33. "Negro History Week Kit," 3.

34. See, for example, Childers, *Seeking Imperialism's Embrace*; Jennings, *Free French Africa*; Mourre, *Thiaroye 1944;* and Onana, *1940–1945: Noirs, blancs, beurs*.

35. See, for example, Echenberg, *Colonial Conscripts*; Fargettas, *Les tirailleurs Sénégalais*; Ginio, *French Army and Its African Soldiers*; Lawler, *Soldiers of Misfortune*; and Mouragues, *Soldats de la république*.

36. See Orr, *Women and the French Army*.

37. I take this quote from the title of the historic and pioneering collection of black feminist scholarship that featured essays by Alice Walker, Barbara Smith, and the Combahee River Collective among others. See Hull et al., *All the Women Are White*.

38. Éboué-Tell, "Citoyens, Citoyennes," PPEE.

39. Ibid., 7.

40. Ibid., 8.

41. Ibid., 7–8.

42. Éboué-Tell notes that members of the Socialist Party in Guadeloupe asked her to run for elections as a form of political homage to her husband. Although she had their support, she still faced stiff competition from other candidates, particularly Gerty Archimède, and needed a sound campaign strategy to win the needed votes.

43. Éboué-Tell, "Débats parlementaires, assemblée nationale," Oct. 5, 1946, 4714.

44. Ibid.

45. Ibid.

46. Éboué-Tell, "Citoyens, Citoyennes," PPEE.

47. Monnerville, "Débats parlementaires, conseil de la république," May 29, 1947, 661.

48. Éboué-Tell, "Débats parlementaires, assemblée nationale," Oct. 5, 1946, 4714.

49. Kaskeline, "Visiting French Assembly Deputy."

50. Capdepuy, "Quelle place pour Madame Éboué?" 1–13.

51. Mann, Nolan, and Wellman, "Sousveillance," 332.

52. Ibid., 333.

53. In *Dark Matters: On the Surveillance of Blackness*, Simone Browne examines the *longue durée* of racialized surveillance as well as the tactics of sousveillance by which black people resisted oppressive surveillance apparatuses.

54. Vialle interrogation transcript, ADBRA.

55. Ibid.

56. Ibid.

57. Unless otherwise indicated, all quotations of Vialle are taken from J. D. Pénel's compilation of Vialle's Senate speeches and AFUF editorials. Pénel, *B. Boganda*, 135.

58. Ibid.

59. "Assembly Member," *Baltimore Afro-American*, Nov. 10, 1945, 1. See also "Going to Paris meeting," PNAACP.

60. Éboué-Tell, "Mes chers amis," PPEE.

61. Ibid., 6.

62. Ibid.

63. Éboué-Tell, "Impressions sur mon voyage en A.E.F.," Dossier Eugénie Éboué-Tell.

64. "Mme Eboué à la Conférence caraïbe," *La femme dans la cité*, 5.

65. Ransby, *Eslanda*, 170.

66. Pénel, *B. Boganda*, 135, 160.

67. Ibid., 157.

68. Ibid., 160.

69. Ibid., 196.

70. Ibid., 199.

71. See, for example, Confiant, *Aimé Césaire*. In a special issue of the journal *Esprit*, intellectuals including Edouard Glissant and Paul Niger present strident criticisms of the Antilles' departmental status as a pernicious form of colonial assimilation. See *Les Antilles avant qu'il ne soit trop tard*.

72. Conrad, "Eboue Widow, Elected," 12.

73. Ibid.

74. Ibid.

75. Spraggs, "Eboue Widow Opposes," 1.

76. Conrad, "Eboue Widow, Elected," 12.

77. Spraggs, "Eboue Widow Opposes," 4.

78. Ibid., 4.

79. Edwards, *Practice of Diaspora*, 7.

80. Éboué-Tell, "French End Colonial Era," 1.

81. Rodney, *How Europe Underdeveloped Africa*, 3.

82. Éboué-Tell, "French End Colonial Era," 18.

83. Ibid.

84. Ibid.

85. Éboué, "Note au sujet de Henri Eboue," PPEE.

86. "Conférence de la Caraïbe," qtd. in Palmiste, "Le vote féminin," 12.

87. See C. Jones, "American Imperialism and the British West Indies."

88. Pénel, *B. Boganda*, 157.

89. Césaire, *Discours*, 10.

90. Pénel, *B. Boganda*, 157.

91. In his essay for *L'étudiant noir*, "L'humanisme et nous: René Maran," Senghor identifies the Martinican colonial administrator as the embodiment of this productive encounter. He argues that in his writing, Maran draws on his observations of African landscape and culture and his knowledge of French and Greek literary traditions and considers each of these influences to be equally important to his work.

92. Pénel, *B. Boganda*, 157.

93. Ibid., 164.

94. Ibid.

95. Ibid., 166.

96. Vergès, *Monsters and Revolutionaries*, 6.

97. Derrida, "Laws of Reflection," 66.

98. In 2015 the newly elected mayor of Frémainville, a small village in the Val d'Oise region of France, decided to remove the bust of the black Marianne that had held a place of honor in the town hall since 1999. The new mayor, Marcel Allegre, described the black Marianne as commissioned to commemorate the abolition of slavery and argued, in a selective reading of the French Revolution, that "this black sculpture was a Marianne of liberty, not a Marianne of the Republic. It represented something, certainly, but not the Republic." See Triay, "A Frémainville, la première Marianne noire."

99. Monnerville, "Débats parlementaires, assemblée nationale," Dec. 29, 1945, 547.

100. Saada, *Empire's Children*; White, *Children of the French Empire*.

101. Pénel, *B. Boganda*, 147.

102. Ibid.

103. Ibid.

104. Ibid., 140.

105. Ibid.

106. Ibid., 146.

107. Ibid.

Chapter 4. Andrée Blouin

1. Blouin, *My Country, Africa*, 60, emphasis in original.

2. Ibid., 62.

3. White, *Children of the French Empire*, 50.

4. Éboué, *La nouvelle politique indigène pour l'Afrique Équatoriale Française*, 29.

5. Blouin notes further that Éboué was already married to one of Josephine's aunts, an assertion that may be supported by Weinstein's descriptions of Robert Éboué's mother, Bada Marcelline, as a Banziri woman from Kwango. However, where Blouin states that Josephine's aunt was the mother of both Henri and Robert, Weinstein's biography notes that Henri's mother was a Mandjia woman, Éboué's housekeeper. See Blouin, *My Country, Africa*, 6–7, and Weinstein, *Éboué*, 43, 48, and 63.

6. Blouin, *My Country, Africa*, 15.

7. Ibid., 128.

8. Ibid., 205.

9. Ibid., 258.

10. "The Woman behind Lumumba," A5. For a discussion of Blouin's role in Lumumba's government, see Bouwer, *Gender and Decolonization in the Congo*.

11. Blouin, *My Country, Africa*, inside jacket.

12. In personal correspondence, Blouin's daughter Eve could not confirm the reasons for her mother's lawsuit. However, she also did not deny that Blouin did indeed try to sue MacKellar. See also Bouwer, *Gender and Decolonization in the Congo*, 72.

13. Boyce Davies, "Collaboration and the Ordering Imperative," 13.

14. Smith and Watson, "Introduction," xv.

15. See D'Almeida, *Francophone African Women Writers*, and Larrier, *Francophone Women Writers* and "Discourses of the Self."

16. Bouwer, *Gender and Decolonization in the Congo*, 72.

17. "Congo Begins Rounding Up Undesirables," 16.

18. Hargreaves, *Decolonization in Africa*, xviii. I refer to Blouin as an African woman because she identifies herself in her narrative and in interviews with journalists as such. My goal is not to reduce all of Africa to the four West and Central African countries through which Blouin circulated. Rather, I aim to engage with

her construction of an African identity through claims to a content-wide affiliation, all the while navigating the politics of métissage in the colonial context.

19. See Anzaldúa, *Borderlands*. See also Stephens, "Re-imagining the Shape and Borders of Black Political Space."

20. See Lejeune, *On Autobiography*.

21. Boyce Davies, "Collaboration," 3.

22. Lejeune, *On Autobiography*, 192.

23. For a discussion of paratexts across Lopes's œuvre, see Watts, *Packaging Post/Coloniality*, 119–38.

24. See Augagneur, *Erreurs et brutalités coloniales*.

25. Lopes, *Le lys et le flamboyant*, 7.

26. Ibid.

27. Blouin, *My Country, Africa*, 236.

28. "Female Touch," 22; "Congo: The Edge of Anarchy," 20.

29. "Red Mata Hari?" 5.

30. Howe, "Communists Banished in Congo," A1.

31. See Kitt, *Thursday's Child*. For more on Kitt's social and political work, see Janet Mezzack, "'Without Manners You Are Nothing.'"

32. In "The Mulatto Millennium," in the edited volume *"Mixed Race" Studies*, Danzy Senna describes the increasing consumption of images of "mixed race" people in popular media as a twenty-first-century phenomenon. As several of the other contributions to the volume show, the stereotyping of multiracial people as objects of sexual desire is a historical phenomenon rooted in the sexual politics of slavery and colonization. Senna, "Mulatto Millennium," in *"Mixed Race" Studies*, ed. Jayne O. Ifekwunigwe.

33. Lopes, *Le lys et le flamboyant*, 290.

34. Ibid., 27.

35. Lopes and Tirthankar, "Henri Lopes: Le 'mentir-vrai' du romancier relève du grand art."

36. Lopes, *Le lys et le flamboyant*, back cover.

37. Blouin, *My Country, Africa*, 183–84.

38. Lopes, *Le lys et le flamboyant*, 361.

39. Ibid., 430–31.

40. MacKellar, epilogue, in Blouin, *My Country, Africa*, 292, emphasis mine.

41. Pierce and Rao, *Discipline and the Other Body*, 14.

42. Boyce Davies, "Collaboration," 12.

43. "Red Mata Hari?" 5.

44. Lopes, *Le lys et le flamboyant*, back cover.

45. Lopes and Tirthankar, "Henri Lopes: Le 'mentir-vrai' du romancier relève du grand art."

46. Lopes, *Le lys et le flamboyant*, back cover.

47. Ibid., 18.

48. Ibid., 223, 225.

49. Watts, *Packaging Post/Coloniality*, 130.

50. Lejeune, *On Autobiography*, 192–93.

51. For an analysis of the ways the written text displaces the oral text in collaborative life writing that is based on interviews, see Boyce Davies, "Collaboration," 3.

52. Watts, *Packaging Post/Coloniality*, 130.

53. White, *Children of the French Empire*, 34.

54. Blouin, *My Country, Africa*, 179.

55. Ibid., 280.

56. See McClintock, *Imperial Leather*, and Mama, "Sheroes and Villains." In *Mother Africa, Father Marx*, Hilary Owen examines the imagery of Africa as mother in poetry by mixed-race women in Mozambique. Owen argues that mestiça women in some cases positioned themselves as speaking for silenced black women in their writings.

57. Blouin, *My Country, Africa*, 136.

58. Ibid.

59. Ibid., 171.

60. Eve Blouin, personal communication. As a writer and filmmaker, Eve is particularly deliberate in her choice of words. Her film *In the Eye of the Spiral* (with Raynald Leconte) retraces Haitian poet Franketienne's spiralist movement.

61. See Lopes and Chanda, "Henri Lopes: Le 'mentir-vrai,'" and Lopes and Mudileno, "Henri Lopes—'La critique n'est pas une agression.'"

62. Anzaldúa, *Borderlands*, 139.

63. Ibid., 141.

64. Blouin, *My Country, Africa*, 153.

65. Ibid., 3–4.

66. Ewans, "Belgium and the Colonial Experience," 169.

67. Ibid.

68. See Fanon, "On Violence," in *Wretched of the Earth*.

69. Blouin, *My Country, Africa*, 17.

70. Ibid., 184.

71. Senghor, "Il n'y a pas de problème du métis," 3–4.

72. Ibid., 3.

73. Ibid.

74. Ibid.

75. Ibid.

76. Ibid.

77. Pénel, *B. Boganda*, 146.

78. Serre, *Hommes et destins*, 765.

79. Blouin, *My Country, Africa*, 4.

80. Kéita, *Femme d'Afrique*, 346–47.

81. Blouin, *My Country, Africa*, 204.

82. Kéita argues that RDA leaders were unified on the goal of independence but

had irreconcilable differences concerning the path to independence and the kind of nation-state to be formed.

Chapter 5. Aoua Kéita

1. Blouin, *My Country, Africa*, 3.
2. Kéita, *Femme d'Afrique*, 25.
3. See also Akyeampong and Gates, *Dictionary of African Biography*, 3:322–24; Turrittin, "Aoua Kéita."
4. Kéita, *Femme d'Afrique*, 45.
5. See Ormerod and Volet, "Ecrits autobiographiques et engagement."
6. Présence Africaine issued a second edition of Kéita's autobiography in 2014.
7. See, for example, Mouralis, "Une parole autre," and Mazauric, "Review of *Femme d'Afrique*."
8. Hitchcott, "African 'Herstory,'" 25.
9. Mortimer, *Writing from the Hearth*, 36.
10. Kéita, *Femme d'Afrique*, 236.
11. Syrotinski, *Singular Performances*, 61.
12. Mama, "Sheroes and Villains," 55.
13. With Kéita, as with Blouin, my goal is not to collapse all of Africa into a mass of indistinguishable countries. Rather, in asking what it means to write as an African woman, I aim to interrogate the very terms on which Blouin and Kéita identify as African, particularly in the context of other complementary or competing citizenships.
14. F. Cooper, *Colonialism in Question*, 218.
15. Ibid., 221.
16. Gilmore, *Limits of Autobiography*, 12. Although Gilmore's analysis of autobiography and citizenship contains useful elements, she pursues a line of thinking toward an end that does not resonate with Kéita's experience. For Gilmore, the autobiography ultimately becomes a nationalist artifact by defining its subject as representative of the nation and memorializing the subject much as a national monument would. For Kéita, the nation is not a given, a fixed identity that one performs through writing. It is unstable, in formation. Her text is therefore not a space within which to reify dominant constructions of national belonging and its attendant exclusions but rather to reimagine belonging beyond exclusion.
17. Larrier, *Francophone Women Writers*, 107.
18. Kéita, *Femme d'Afrique*, 15.
19. Lejeune, *Le Pacte autobiographique*, 19.
20. Ibid., 18.
21. Kéita, *Femme d'Afrique*, 383.
22. Ibid., 385.
23. Ibid., 132.
24. Ibid., 102.

25. Ibid., 105.

26. Ibid., 83.

27. Ibid., 139.

28. Ibid., 161.

29. Ibid., 65.

30. Kéita discusses Diawara in rather ambiguous terms. Her description of his interdiction of her political activities conflicts somewhat with her assertion that he introduced her to the RDA and party politics. We may attribute Kéita's relative silence and ambiguous representation of her husband to the trauma of her early divorce and to the fact that Diawara was still living at the time of *Femme d'Afrique*'s publication. However, the fact that Kéita glosses over much of her personal life signals clearly to the reader that her autobiography is intended first and foremost as a historical record of French Sudanese women's participation in the anticolonial movement rather than an account of her personal life.

31. Kéita, *Femme d'Afrique*, 322.

32. Ibid., 122.

33. Ibid.

34. See F. Cooper, *Decolonization and African Society*.

35. Sembène, *God's Bits of Wood*, 242.

36. "Jeanne-Martin Cissé," interview between D'Erneville and Cissé, in D'Erneville, *Femmes Africaines*, 138.

37. Ibid., 139.

38. Sembène, *Ousmane Sembène: Interviews*, 68.

39. Boyce Davies, *Black Women, Writing, and Identity*, 37.

40. McClintock, *Imperial Leather*, 353.

41. Kéita, *Femme d'Afrique*, 239, emphasis in original.

42. Sembène, *Ousmane Sembène: Interviews*, 188.

43. Sembène, *God's Bits of Wood*, "Author's Note."

44. See Cooper, *Colonialism in Question*, and Jones, "Fact and Fiction in *God's Bits of Wood*," 124.

45. In its dramatization of women's anticolonial resistance, *Emitaï* presents an interesting counterpoint to Sembène's film *Camp de Thiaroye*, which highlights the conflict between African veterans of World War II and representatives of the French government over their pensions. The protagonist, Diatta, briefly refers to the Diola massacre, which would seem to foreshadow the massacre at Thiaroye.

46. See Baum, "Prophetess: Aline Sitoé Diatta."

47. Sembène, *Ousmane Sembène: Interviews*, 20.

48. McClintock, *Imperial Leather*, 382.

49. Sembène, *Ousmane Sembène: Interviews*, 19, 26.

50. Morrison, *Beloved*, 36.

51. Boyce Davies, *Black Women, Writing, and Identity*, 20.

52. Sembène, *God's Bits of Wood*, 110.

53. F. Cooper, *Colonialism in Question*, 205.

54. Kéita, *Femme d'Afrique*, 390. Kéita explains that the term "coiffer" was synonymous with "diriger," meaning to be led or directed.

55. My account of Camara's death here relies heavily on Elizabeth Schmidt's *Cold War and Decolonization in Guinea, 1946–1958*. Schmidt herself, as well as other scholars who have tried to excavate the narratives of politically active women in Guinea, turns to Idiatou Camara's undergraduate thesis "La Contribution de la femme de Guinée à la lutte de libération nationale (1945–1958)," currently available only in Guinea's national archives. See, for example, Allman et al., *Women in African Colonial Histories*.

56. Schmidt, *Cold War and Decolonization*, 86.

57. Kéita, *Femme d'Afrique*, 362.

58. Ibid., 346.

59. Ibid., 390.

60. Ibid.

Chapter 6. Eslanda Robeson

1. Vialle, "Débats parlementaires. Conseil de la république," June 25, 1948, 1667.

2. Robeson, "Congo Diary," 9–11, EGRP.

3. Nzongola-Ntalaja, *Congo from Leopold to Kabila*, 34.

4. See Stanard, "Belgium, the Congo, and Imperial Mobility."

5. Trefzer et al., "Introduction: The Global South," 4.

6. Prashad, *Poorer Nations*, 9.

7. Ransby, *Eslanda*, 187.

8. *African Journey* was one of three African American works selected by the American Library Association for its list of fifty best books of 1945. The other two were *Black Boy* by Richard Wright and *Color and Democracy* by Du Bois. See "Books by DuBois," *Baltimore Afro-American*.

9. See, for example, Bendixen and Hamera, *Cambridge Companion to American Travel Writing*, and Totten, *African American Travel Narratives from Abroad*.

10. Robeson, *African Journey*, 13.

11. Ibid., 14, emphasis in original.

12. Ibid., 14, 15, 16.

13. Robeson, "Africa—No Longer the Dark Continent."

14. Robeson, "How to Behave Abroad."

15. Ibid.

16. Ibid.

17. There are two versions of this typed speech, each with Robeson's corrections and handwritten notes to herself. See Eslanda Robeson, "Untitled Speech, Version 1," EGRP 2, emphasis in original.

18. Ibid., 4.

19. Ibid., emphasis in original.

20. Ibid., emphasis in original.

21. Robeson, "What Is Communism?"

22. Ransby, *Eslanda*, 163.

23. Robeson, "Felix Eboué," 44.

24. See Fanon, *Black Skin, White Masks*.

25. Robeson, *African Journey*, 16.

26. Robeson, "Felix Eboué," 46, emphasis in original.

27. Ibid., 44.

28. Ibid.

29. Declassified MI5 surveillance files are available from the United Kingdom's National Archives in Kew. See Paul Robeson, Essie Robeson, KV/2/1829.

30. Ibid.

31. Ibid.

32. Travis, "Racism in U.S.," 12.

33. Ibid.

34. See Paul Robeson, Essie Robeson, KV/2/1829, emphasis in original.

35. Robeson, *African Journey*, 18.

36. See Robeson, "Passports and Agents," Oct. 1951, EGRP.

37. This speech was later printed in the monthly publication *The Jewish Life*. See Robeson, "What Is a Ghetto?"

38. Ibid., 25.

39. See, for example, Trefzer et al., "Introduction."

40. Robeson, "What Is a Ghetto?" 25.

41. Ibid.

42. Robeson, "Rising Tide," 10.

43. Stoddard, *Rising Tide of Color*.

44. Robeson, "Rising Tide," 10.

45. Robeson, "Which Way for Africa?"

46. Ransby, *Eslanda*, 170.

47. Robeson, "Congo Diary," 123–24.

48. Ibid., 125.

49. Vialle to Robeson, Feb. 17, 1950, EGRP.

50. E. Conrad, "Éboué Widow," 12.

51. Ibid.

52. Éboué-Tell to Paul and Eslanda Robeson, Dec. 24, 1945, EGRP.

53. Robeson, "Women in the UN," 33.

54. Ibid.

Epilogue

1. *AWA* 11, Jan.–Feb. 1965, 55.

2. *AWA* 6, June 1964, 37; and *AWA* 9, Nov. 1964, 10.

3. Dia, "En toute sincerité," *AWA* 6, 34.

4. For this framework of ruptures and continuities I am indebted to Erik McDuffie's study of black women's organizing against what they identified as triple op-

pressions along the lines of race, gender, and class. See McDuffie, *Sojourning for Freedom*, 193–220.

5. See the editorial description in the online archive of *AWA*, https://www.awa magazine.org. Accessed Jan. 20, 2017.

6. *AWA*, New Series 2, Nov. 1972, 29.

7. Bastard, "AWA est-elle nationaliste?" *AWA* 8, Oct. 1964, 34.

8. Ibid.

9. *AWA* 8, 35.

10. N'Diaga, "À la belle aux yeux de velours," *AWA* 5, May 1964, 34.

11. Ibid. A *bethio* is an undergarment traditionally worn by Senegalese women.

12. Grosfoguel, *Colonial Subjects*, 17.

Bibliography

Aas-Rouxparis, Nicole. "Espace antillais au feminin: presence, absence." *French Review* 70, no. 6 (1997): 854–64.

Adrassé, Louis. Fonds Louis Adrassé. 36J. Archives Départementales de la Martinique. Schœlcher, Martinique.

Agard-Jones, Vanessa. "Bodies in the System." *Small Axe: A Journal of Criticism.* (2013): 182–92.

"Aimé Césaire et le colonialisme." Portail de la Banque Numérique des Patrimoines Martiniquais. http://www.patrimoines-martinique.org/ark:/35569/a011421768655922 MRSd. Accessed Dec. 12, 2017.

"Aimé Césaire, l'adhésion au parti communiste." Portail de la Banque Numérique des Patrimoines Martiniquais. http://www.patrimoines-martinique.org/ark:/35569 /a011421691316iSvJ3S. Accessed Oct. 1, 2018.

Akyeampong, Emmanuel K., and Henry L. Gates. *Dictionary of African Biography.* Vol. 3. Oxford: Oxford University Press, 2012.

Aldrich, Robert, and John Connell. *France's Overseas Frontier.* Cambridge: Cambridge University Press, 2006.

Allman, Jean M., Susan Geiger, and Nakanyike Musisi. *Women in African Colonial Histories.* Bloomington: Indiana University Press, 2002.

Andrade, Susan Z. *The Nation Writ Small: African Fictions and Feminisms, 1958–1988.* Durham, NC: Duke University Press, 2011.

Anzaldúa, Gloria. *Borderlands: La Frontera = the New Mestiza.* San Francisco: Aunt Lute Books, 1987.

Archimède, Gerty. "Débats parlementaires, assemblée nationale." Mar. 16, 1948, 1731. http://4e.republique.jo-an.fr. Accessed Mar. 3, 2014.

———. "Le Rassemblement féminin vu de la Guadeloupe." *La femme dans la cité.* Feb. 1, 1945, 4.

————, and Laurent Farrugia. *Gerty Archimède: Entretien*. Basse-Terre: Jeunes Antilles, 1976.

"Assembly Member," *Baltimore Afro-American*, Nov. 10, 1945.

Augagneur, Victor. *Erreurs et brutalités coloniales*. Paris: Éditions Montaigne, 1927.

AWA: La revue de la femme noire. https://www.awamagazine.org. Accessed Jan. 20, 2017.

Balibar, Étienne. *Citizenship*. Cambridge: Polity Press, 2015.

————. *Citoyen sujet et autres essais d'anthropologie philosophique*. Paris: Presses universitaires de France, 2011.

————. *We, the People of Europe? Reflections on Transnational Citizenship*. Princeton, NJ: Princeton University Press, 2010.

Baum, Robert M. "Prophetess: Aline Sitoé Diatta as a Contested Icon in Contemporary Senegal." In *Facts, Fiction, and African Creative Imaginations*, edited by Toyin Falola and Fallou Ngom, 48–59. New York: Routledge, 2010.

Bendixen, Alfred, and Judith Hamera. *The Cambridge Companion to American Travel Writing*. Cambridge: Cambridge University Press, 2009.

Berge, François. "Editorial." *Fin de l'ère coloniale?: Peuples et évolution*. Special issue of *Chemins du monde* 5/6 (1948): 5–15.

Bloncourt, Gérald, and Michael Löwy. *Messagers de la tempête: André Breton et la révolution de janvier 1946 en Haïti*. Pantin, France: Temps des cerises, 2007.

Blouin, Andrée, with Jean Scott MacKellar. *My Country, Africa: Autobiography of the Black Pasionaria*. New York: Praeger, 1983.

Blouin, Eve, and Raynald Leconte. *In the Eye of the Spiral*. Arcady Bay Entertainment, 2014. Film.

Boittin, Jennifer A. *Colonial Metropolis the Urban Grounds of Anti-imperialism and Feminism in Interwar Paris*. Lincoln: University of Nebraska Press, 2010.

"Books by DuBois, Wright, Mrs. Robeson among 50 Best in '45." *Baltimore Afro-American*. Feb. 9, 1946, 1.

Boutrin, Louis, and Confiant, Raphael. *Chronique d'un empoisonnement annoncé: Le scandale du Chlordécone aux Antilles françaises, 1972–2002*. Paris: L'Harmattan, 2007.

Bouwer, Karen. *Gender and Decolonization in the Congo: The Legacy of Patrice Lumumba*. Basingstoke, UK: Palgrave Macmillan, 2013.

Boyce Davies, Carole. *Black Women, Writing, and Identity: Migrations of the Subject*. London: Routledge, 1994.

————. *Caribbean Spaces: Escapes from Twilight Zones*. Urbana: University of Illinois Press, 2013.

————. "Collaboration and the Ordering Imperative in Life Story Production." In *De/Colonizing the Subject: The Politics of Gender in Women's Autobiography*, edited by Sidonie Smith and Julia Watson, 3–19. Minneapolis: University of Minnesota Press, 1988.

————. *Left of Karl Marx: The Political Life of Black Communist Claudia Jones*. Durham, NC: Duke University Press, 2008.

Bradshaw, Richard, and Juan Fandos-Rius. *Historical Dictionary of the Central African Republic*. Lanham, MD: Rowman and Littlefield, 2016.

Breton, André. Fonds André Breton. BRT. Bibliothèque littéraire Jacques Doucet, Paris.

———. *Situation du surréalisme entre les deux guerres*. Paris: Éditions de la revue Fontaine, 1945.

———. *What Is Surrealism?* London: Faber and Faber, 1936.

Browne, Simone. *Dark Matters: On the Surveillance of Blackness*. Durham, NC: Duke University Press, 2015.

Capdepuy, Arlette. "Quelle place pour Madame Éboué dans le Gaullisme de la Ve République?" *Histoire@ Politique* 2 (2012): 37–50.

Césaire, Aimé. "Débats parlementaires de la 4eme république et constituantes. Assemblée nationale." Journal Officiel de la République Française. Mar. 15, 1950, 2077. http://4e.republique.jo-an.fr. Accessed Mar. 3, 2014.

———. *Discours sur le colonialism suivi de Discours sur la Négritude*. Paris: Présence Africaine, 2004.

———. *Discourse on Colonialism*. New York: Monthly Review Press, 1972.

———. Fonds Aimé Césaire. Archives Départementales de la Martinique. Schœlcher, Martinique.

———. "L'Impossible contact. *Fin de l'ère coloniale?: Peuples et évolution*." Special issue of *Chemins du monde* 5/6 (1948): 105–111.

———. *Notebook of a Return to the Native Land*. England: Bloodaxe Books, 1995.

———. *Pour la transformation de la Martinique en "région" dans le cadre d'une Union Française Fédérée*. Fort-de-France: Imprimérie Bezaudin, 1958.

———. *Zuruck ins Land der Geburt*. Frankfurt: Suhrkamp Verlag, 1967.

———, Clayton Eshleman, and Annette Smith. *Aimé Césaire: The Collected Poetry*. Berkeley: University of California Press, 1984.

———, and Abiola Irele. *Aime Césaire: Cahier d'un retour au pays natal*. Columbus: Ohio State University Press, 1993.

Césaire, Suzanne. *Le grand camouflage: Écrits de dissidence, 1941–1945*. Ed. Daniel Maximin. Paris: Éditions du Seuil, 2009.

———. *The Great Camouflage: Writings of Dissent (1941–1945)*. Ed. Daniel Maximin. Trans. Keith Walker. Middletown, CT: Wesleyan University Press, 2012.

Chancy, Myriam J. A. "African Diasporic Autochthonomies: A Syncretic Methodology for Liberatory Indigeneities." In *Post/colonialism and the Pursuit of Freedom in the Black Atlantic*, edited by Jerome C. Branche, 259–74. London: Routledge, 2018.

Charles, Carolle. "Reflections on Being Machann ak Machandiz." *Meridians: Feminism, Race, Transnationalism* 11, no. 1 (2011): 118–23.

Childers, Kristen S. *Seeking Imperialism's Embrace: National Identity, Decolonization, and Assimilation in the French Caribbean*. Oxford: Oxford University Press, 2016.

Church, Emily M. "In Search of Seven Sisters: A Biography of the Nardal Sisters of Martinique." *Callaloo* 36, no. 2 (2013): 375–90.

Clapson, Mark, and Peter J. Larkham, eds. *The Blitz and Its Legacy: Wartime Destruction to Post-War Reconstruction*. Abingdon, UK: Routledge, 2016.

Condé, Maryse. "Unheard Voice: Suzanne Césaire and the Construct of a Caribbean Identity." In *Winds of Change: The Transforming Voices of Caribbean Women Writers and Scholars*, edited by Adele S. Newson Horst and Linda Strong-Leek, 61–66. New York: Peter Lang, 1998.

Confiant, Raphaël. *Aimé Césaire: Une traversée paradoxale du siècle*. Montréal: Ecriture, 2006.

"Congo Begins Rounding Up Undesirables: Crowd Sees Abduction of Beaten African." *Chicago Daily Tribune*. Oct. 16, 1960, 16. ProQuest Historical Newspapers.

"Congo: The Edge of Anarchy." *Time*. Aug. 29, 1960, 20.

Conklin, Alice L. *A Mission to Civilize: The Republican Idea of Empire in France and West Africa, 1895–1930*. Stanford, CA: Stanford University Press, 2003.

Conrad, Earl. "Éboué Widow, Elected to French Assembly, Tells Views on Colonies." *Chicago Defender*. Nov. 10, 1945, 12. ProQuest Historical Newspapers.

Conrad, Joseph. *Heart of Darkness and Other Tales*. Ed. Cedric Watts. Oxford: Oxford University Press, 2008.

Cooper, Brittney C. *Beyond Respectability: The Intellectual Thought of Race Women*. Urbana: University of Illinois Press, 2018.

Cooper, Frederick. *Colonialism in Question: Theory, Knowledge, History*. Berkeley: University of California Press, 2009.

———. *Decolonization and African Society: The Labor Question in French and British Africa*. Cambridge: Cambridge University Press, 2005.

Curtius, Anny D. "Cannibalizing Doudouisme, Conceptualizing the Morne: Suzanne Césaire's Caribbean Ecopoetics." *South Atlantic Quarterly* 115, no. 3 (2016): 513–34.

D'Almeida, Irène A. *Francophone African Women Writers: Destroying the Emptiness of Silence*. Gainesville: University Press of Florida, 1994.

D'Erneville, Annette M. *Femmes africaines: Propos recueillis par Annette Mbaye D'Erneville suivi de Une si longue lettre*. Romorantin, France: Martinsart, 1981.

Davis, Gregson. *Aimé Césaire*. Cambridge: Cambridge University Press, 2008.

De Gaulle, Charles. "Appel du 18 juin 1940." Musée de l'ordre de la libération. https://www.ordredelaliberation.fr/fr/ordre-de-la-liberation/le-grand-maitre/l-appel-du-18-juin-1940. Accessed Oct. 1, 2017.

Delas, Daniel, and Boniface Mongo-Mboussa. "Ne prenons pas Senghor pour ce qu'il n'est pas: Entretien de avec Daniel Delas." Sept. 2014. http://www.africultures.com/php/?nav=article&no=5900#sthash.NWmW5iLd.dpuf. Accessed May 12, 2015.

Derrida, Jacques. "The Laws of Reflection: Nelson Mandela, in Admiration." In *Psyche: Inventions of the Other*, Vol. 2, edited by Peggy Kamuf and Elizabeth Rottenberg, 63–86. Stanford, CA: Stanford University Press, 2008.

Dubois, Laurent. *Haiti: The Aftershocks of History*. New York: Metropolitan Books, 2012.

Duchen, Claire. *Women's Rights and Women's Lives in France, 1944–1968.* London: Routledge, 2004.

Éboué, Félix. *La nouvelle politique indigène pour l'afrique équatoriale française.* Rufisque, Senegal: Imprimerie du Gouvernement général de L'A.O.F, 1948.

Éboué-Tell, Eugénie. "Débats parlementaires. Conseil de la république." *Journal Officiel de la République Française.* http://www.senat.fr/seances/comptes-rendus.html#archives. Accessed Nov. 5, 2014.

———. "Débats parlementaires de la 4eme république et constituantes. Assemblée nationale." *Journal Officiel de la République Française.* Sept. 20, 1946, 3909. http://4e.republique.jo-an.fr. Accessed Nov. 3, 2014.

———. Dossier Eugénie Éboué-Tell. Archives du Sénat. Paris.

———. "French End Colonial Era, Grant West Indies Citizenship. *Pittsburgh Courier.* Mar. 23, 1946. ProQuest Historical Newspapers.

———. Papiers personnels d'Eugénie Éboué (PPEE). F22/26. Fonds Félix Éboué. F22. Fondation Charles de Gaulle, Paris.

Echenberg, Myron. *Colonial Conscripts: The Tirailleurs Senegalais in French West Africa, 1857–1960.* London: James Currey, 1991.

"Editor's Note." *Pittsburgh Courier.* Mar. 23, 1946, 1.

Edwards, Brent H. "Pebbles of Consonance: A Reply to Critics." *Small Axe: A Caribbean Journal of Criticism* 9, no. 1 (2005): 134–49.

———. *The Practice of Diaspora: Literature, Translation, and the Rise of Black Internationalism.* Cambridge: Harvard University Press, 2003.

Ewans, Martin. "Belgium and the Colonial Experience." *Journal of Contemporary European Studies* 11, no. 2 (2003): 167–80.

Fanon, Frantz. "Antillais et Africains." *Esprit* 233, no. 2 (1955): 261–69.

———. *Black Skin, White Masks.* Trans. Richard Philcox. New York: Grove Press, 2008.

———. *Peau noire, masques blancs.* Paris: Editions du Seuil, 1952.

———. *The Wretched of the Earth.* Trans. Richard Philcox. New York: Grove Press, 2007.

Fargettas, Julien. *Les Tirailleurs Sénégalais.* Paris: Tallandier, 2012.

"The Female Touch." *Time.* Aug. 15, 1960, 22.

"Féminisme colonial." 1M1097/D. Archives Départementales de la Martinique. Schœlcher, Martinique.

Flaubert, Gustave. *Madame Bovary.* Paris: Rasmussen, 1946.

Fonkoua, Romuald-Blaise. *Aimé Césaire: 1913–2008.* Paris: Perrin, 2010.

Freundschuh, Aaron. "The Marchal Case in Franco-Moroccan History." French Colonial Historical Society Conference, May 31, 2018, Seattle, Washington.

Frobenius, Leo. *Histoire de la civilisation africaine.* Paris: Gallimard, 1933.

Garrett, Lula. "Gadabouting in the U.S.A." *Baltimore Afro-American.* May 5, 1951. ProQuest Historical Newspapers.

Gauclère, Yassu. Fonds Yassu Gauclère. NAF 28584. Bibliothèque nationale de France.

Germain, Félix F., and Silyane Larcher, eds. *Black French Women and the Struggle for Equality, 1848–2016*. Lincoln: University of Nebraska Press, 2018.

"Gerty, Marie, Bernadette Archimède." Base de données des députés français depuis 1789. http://www2.assemblee-nationale.fr/sycomore/fiche/(num_dept)/186. Accessed June 29, 2016.

Gilmore, Leigh. *The Limits of Autobiography: Trauma and Testimony*. Ithaca, NY: Cornell University Press, 2001.

Ginio, Ruth. *The French Army and Its African Soldiers: The Years of Decolonization*. Lincoln: University of Nebraska Press, 2017.

Grosfoguel, Ramón. *Colonial Subjects: Puerto Ricans in a Global Perspective*. Berkeley: University of California Press, 2003.

Hall, Stuart. "Negotiating Caribbean Identities." *New Left Review* 209 (1995): 3–14.

Hargreaves, John D. *Decolonization in Africa*. London: Routledge, 2016.

Harris-Perry, Melissa V. *Sister Citizen: Shame, Stereotypes, and Black Women in America*. New Haven, CT: Yale University Press, 2011.

Hearn, Lafcadio. *Two Years in the French West Indies*. New York: Harper and Brothers Publishers, 1903.

Hélénon, Véronique. *French Caribbeans in Africa*. New York: Palgrave Macmillan, 2011.

Hitchcott, Nicki. "African 'Herstory': The Feminist Reader and the African Autobiographical Voice." *Research in African Literatures* (1997): 16–33.

Howe, Russel. "Communists Banished in Congo." *Washington Post*. Sept. 18, 1960, A1.

Hull, Gloria T., Patricia Bell Scott, and Barbara Smith, eds. *All the Women Are White, All the Black Are Men, but Some of Us Are Brave: Black Women's Studies*. New York: Feminist Press at the City University of New York, 1992.

"Hunter College Students Hear Senator Vialle of Africa." *New York Amsterdam News*. May 5, 1951, 18. ProQuest Historical Newspapers.

Ifekwunigwe, Jayne O. *"Mixed Race" Studies: A Reader*. London: Routledge, 2004.

Jahn, Janheinz. Nachlass von Janheinz Jahn (NJJ). Korrespondenz Ausland K-O. Institut für Asien- und Afrikawissenschaften, Berlin.

Jennings, Eric T. *Free French Africa in World War II: The African Resistance*. New York: Cambridge University Press, 2015.

———. *Vichy in the Tropics: Pétain's National Revolution in Madagascar, Guadeloupe, and Indochina, 1940–1944*. Stanford, CA: Stanford University Press, 2001.

Jones, Claudia. "American Imperialism and the British West Indies." *Political Affairs* 37, Apr. 1958, 9–18.

Jones, Jim. "Fact and Fiction in *God's Bits of Wood*." *Research in African Literatures* 31, no. 2 (2000): 117–31.

Joseph-Gabriel, Annette K. "Beyond the Great Camouflage: Haiti in Suzanne Césaire's Politics and Poetics of Liberation." *Small Axe: A Caribbean Journal of Criticism* 20, no. 2 (2016): 1–13.

Kaskeline, Egon. "Visiting French-Assembly Deputy Committed to Women's and

Children's Aid: Madame Eboue Watchful, Too, of Negro Need." *Christian Science Monitor*. Apr. 23, 1946, 14. ProQuest Historical Newspapers.

Kéita, Aoua. *Femme d'Afrique: La vie d'Aoua Kéita racontée par elle-même.* Paris: Présence africaine, 1975.

Kesteloot, Lilyan. *Histoire de la littérature négro-africaine.* Paris: Éditions Karthala, 2001.

Kitt, Eartha. *Thursday's Child.* New York: Duell, Sloan, and Pearce, 1978.

Larrier, Renee. "Discourses of the Self: Gender and Identity in Francophone African Women's Autobiographies." In *Mapping Intersections: African Literature and Africa's Development,* edited by Anne V. Adams and Janis Alene Mayes, 123–35. Trenton, NJ: Africa World Press, 1998.

———. *Francophone Women Writers of Africa and the Caribbean.* Gainesville: University Press of Florida, 2000.

Lawler, Nancy E. *Soldiers of Misfortune: The Tirailleurs Sénégalais of the Cote D'Ivoire in World War 2.* Ann Arbor: University of Michigan Press, 1991.

"Le Maréchal de France chef de l'Etat s'est adressé aux Français." *Le petit Marseillais.* Nov. 20, 1942, 1. Archives Départementales des Bouches-du-Rhône, Marseille.

Leiris, Michel. *Contacts de civilisations en Martinique et en Guadeloupe.* Quebec: Les classiques des sciences sociales. http://classiques.uqac.ca/contemporains /leiris_michel/contacts_civilisations_martinique/contacts_civilisations.html. Accessed Oct. 1, 2018.

Lejeune, Philippe. *Le pacte autobiographique.* Paris: Éditions du Seuil, 2008.

———. *On Autobiography.* Trans. Katherine Leary. Minneapolis: University of Minnesota Press, 1989.

Les Antilles avant qu'il soit trop tard. Special issue of *Esprit.* Apr. 1962.

Les Cahiers d'Estienne 15 (1949). 4-V-15010 (1949). Bibliothèque nationale de France.

Levasseur. "Les Femmes soldats existent depuis longtemps." *Horizons.* Dec. 1944. Archives Départementales des Bouches-du-Rhône, Marseille.

Lewis, Shireen, K. *Race, Culture, and Identity: Francophone West African and Caribbean Literature and Theory from Négritude to Créolité.* Lanham, MD: Lexington Books, 2006.

Lopes, Henri. *Le lys et le flamboyant: Roman.* Paris: Éditions du Seuil, 1997.

———, and Tirthankar Chanda. "Henri Lopes: Le 'mentir-vrai' du romancier relève du grand art." *Radio France Internationale.* http://www.rfi.fr/afrique/20120522 -henri-lopes-le-mentir-vrai-romancier-releve-grand-art. Accessed Mar. 9, 2013.

———, and Lydie Moudileno. "Henri Lopes—'La critique n'est pas une aggression.'" *Genesis* (2011): 93–100.

Lugones, María. "The Coloniality of Gender." *Worlds and Knowledges Otherwise* (Spring 2008): 1–17.

———. "Toward a Decolonial Feminism." *Hypatia* 25, no. 4 (2010): 742–59.

"Madam Eugenie Eboue Elated over Courtesies in States." *Baltimore Afro-American.* Apr. 12, 1958. ProQuest Historical Newspapers.

"Mademoiselle Paulette NARDAL, Victime civile de guerre." 1M861/D. Archives Départementales de la Martinique, Schœlcher, Martinique.

Maldonado-Torres, Nelson. "On the Coloniality of Being: Contributions to the Development of a Concept." *Cultural Studies* 21 (2007): 240–70.

Mama, Amina. "Sheroes and Villains: Conceptualizing Colonial and Contemporary Violence against Women in Africa." In *Feminist Genealogies, Colonial Legacies, Democratic Futures*, edited by M. Jacqui Alexander and Chandra T. Mohanty, 46–62. New York: Routledge, 1997.

Mann, Steve, Jason Nolan, and Barry Wellman. "Sousveillance: Inventing and Using Wearable Computing Devices for Data Collection in Surveillance Environments." *Surveillance and Society* 1, no. 3 (2002): 331–55.

"Martinique Girl Given High Post with UN Body." *Chicago Defender*. Dec. 12, 1946, 13.

Mauduech, Camille. *Les 16 de Basse-Pointe*. Gros Morne: Les Films du Marigot, 2009.

Maximin, Daniel. *L'Isolé soleil*. Paris: Éditions du Seuil, 1981.

———. *Lone Sun*. Charlottesville: University of Virginia Press, 1989.

Mazauric, Catherine. "Review of *Femme d'Afrique: La vie d'Aoua Kéita racontée par elle-même* by Aoua Kéita." *Notre librairie* 75/76 (1984): 184–86.

McClintock, Anne. *Imperial Leather: Race, Gender, and Sexuality in the Colonial Contest*. London: Routledge, 1995.

McCray, George F. "The Negro Who Defeated Hitler." *Chicago Defender*. Apr. 30, 1949, 18. ProQuest Historical Newspapers.

McDuffie, Erik S. *Sojourning for Freedom: Black Women, American Communism, and the Making of Black Left Feminism*. Durham, NC: Duke University Press, 2011.

Melas, Natalie. *All the Difference in the World: Postcoloniality and the Ends of Comparison*. Stanford, CA: Stanford University Press, 2007.

Ménil, René. *Tracées: Identité, négritude, esthétique aux Antilles*. Paris: R. Laffont, 1981.

Mezzack, Janet. "'Without Manners You Are Nothing': Lady Bird Johnson, Eartha Kitt, and the Women Doers' Luncheon of January 18, 1968." *Presidential Studies Quarterly* 20, no. 4 (1990): 745–60.

Michelet, Jules. *Introduction à l'histoire universelle, suivie du Discours d'ouverture prononcé en 1834 à la Faculté des lettres et d'un Fragment sur l'éducation des femmes au moyen-âge*. Paris: L. Hachette, 1843.

Mignolo, Walter D. "Citizenship, Knowledge, and the Limits of Humanity." *American Literary History* 18, no. 2 (2006): 312–31.

———. "Deorientalizing/Dewesternizing/Decolonizing Citizenship: Citizenship, Knowledge, and the Limits of Humanity II." London, November 12–13, 2012. https://m.youtube.com/watch?v=guRtl-tRydA. Accessed Nov. 1, 2017.

"Mme Eboué à la Conférence caraïbe." *La femme dans la cité*. April 1, 1946, 5.

"Mme E. Eboue Arrives from Paris." *New York Amsterdam News*. May 4, 1946, 14. ProQuest Historical Newspapers.

Mohanty, Chandra T. *Feminism without Borders: Decolonizing Theory, Practicing Solidarity*. Longueuil, Québec: Point Par Point, 2007.

Monnerville, Gaston. "Débats parlementaires. Conseil de la république." *Journal Officiel de la République Française.* May 29, 1947, 661. http://www.senat.fr/seances/comptes-rendus.html#archives. Accessed Nov. 5, 2014.

Monpierre, Mariette. *Gerty Archimède: La candidate du peuple.* Paris: La Lanterne, 2005.

Morrison, Toni. *Beloved.* London: Vintage, 2007.

Mortimer, Mildred P. *Writing from the Hearth: Public, Domestic, and Imaginative Space in Francophone Women's Fiction of Africa and the Caribbean.* Lanham, MD: Lexington Books, 2007.

Mouragues, Jean-François. *Soldats de la république: Les tirailleurs sénégalais dans la tourmente; France, Mai–Juin 1940.* Paris: L'Harmattan, 2011.

Mouralis, Bernard. "Une parole autre: Aoua Kéita, Mariama Bâ et Awa Thiam." *Notre libraire.* 117 (1994): 21–30.

Mourre, Martin. *Thiaroye 1944: Histoire et mémoire d'un massacre colonial.* Rennes, France: Presses universitaires de Rennes, 2017.

NAACP. Collection: Race Relations in the International Arena, 1940–1955. Papers of the NAACP. Library of Congress, Washington, DC.

Nardal, Paulette. "Aux Antilles: Les communistes profitent de la crise pour provoquer des troubles dans nos plus anciennes colonies." *Je suis partout,* July 16, 1937.

———. "En exil." *La Dépêche africaine.* Dec. 15, 1929.

———. "In Exile." Translation of "En exil," in Sharpley-Whiting, *Negritude Women.*

———. "L'Antillaise: Marchandes des rues." *Le Soir.* 1930. Archives Nationales d'outre-mer. Aix-en-Provence, France.

———. "Guignol Ouolof." *L'Etudiant noir.* Mar. 1935.

———. *La femme dans la cité: Revue mensuelle du Rassemblement féminin.* 1948–1951. FOL-JO-6350. Bibliothèque nationale de France.

———. *La revue du monde noir: The Review of the Black World, 1931–1932: Collection Complete, 1 à 6.* Paris: Jean-Michael Place, 1992.

———. "Martinique." *Guides des colonies françaises: Martinique, Guadeloupe, Guyane, St. Pierre-Miquelon.* Paris: Société d'Editions géographiques, Maritimes et Coloniales, 1931.

———, and Philippe Grollemund. *Fiertés De Femme Noire: Entretiens-mémoires De Paulette Nardal.* Paris: L'Harmattan, 2019.

———, and T. Denean Sharpley-Whiting. *Beyond Negritude: Essays from Woman in the City.* Albany: State University of New York Press, 2009.

"Negro History Week Kit." *Baltimore Afro-American.* Jan. 13, 1951, 3. ProQuest Historical Newspapers.

Nesbitt, Nick. *Caribbean Critique: Antillean Critical Theory from Toussaint to Glissant.* Liverpool: Liverpool University Press, 2017.

Nzongola-Ntalaja, Georges. *The Congo from Leopold to Kabila: A People History.* London: Zed Books, 2002.

Olmos, Margarite F., and Lizabeth Paravisini-Gebert. *Creole Religions of the Carib-*

bean: An Introduction from Vodou and Santeria to Obeah and Espiritismo. New York: NYU Press, 2011.

Onana, Charles. *1940–1945: Noirs, blancs, beurs: Libérateurs de la France.* Paris: Duboiris, 2006.

Ormerod, Beverly, and Jean-Marie Volet. "Ecrits autobiographiques et engagement: Le cas des africaines d'expression française." *French Review* 69, no. 3 (1996): 426–44.

Orr, Andrew. *Women and the French Army during the World Wars, 1914–1940.* Bloomington: Indiana University Press, 2017.

Owen, Hilary. *Mother Africa, Father Marx: Women's Writing of Mozambique, 1948–2002.* Lewisburg, PA: Bucknell University Press, 2007.

Palmiste, Clara. "Le vote féminin et la transformation des colonies françaises d'Amérique en départements en 1946." *Nuevo mundo, mundos nuevos* (June 2014): n.p.

Paul Robeson, Essie Robeson: American. KV/2/1829. National Archives. Kew, United Kingdom.

Pénel, J. D. *B. Boganda, A. Darlan, J. Vialle: Trois representants oubanguiens du deuxieme college, 1946–1952.* Bangui, Central African Republic: Université de Bangui, 1985.

Perry, Keisha-Khan. "The Gendered Racial Frame of Land and Housing Rights as Human Rights Issues." Human Rights, Borders and Barriers Symposium. University of Arizona, Jan. 22, 2016.

Philip, M. NourbeSe. *Race, Space and the Poetics of Moving.* Toronto: Poui Publications, 1996.

Pierce, Steven, and Anupama Rao. *Discipline and the Other Body: Correction, Corporeality, Colonialism.* Durham, NC: Duke University Press, 2006.

Powers, David. *From Plantation to Paradise?: Cultural Politics and Musical Theatre in French Slave Colonies, 1764–1789.* East Lansing: Michigan State University Press, 2014.

Prashad, Vijay. *The Poorer Nations: A Possible History of the Global South.* New York: Verso, 2012.

Price-Mars, Jean. *Ainsi parla l'oncle.* New York: Parapsychology Foundation, 1954.

P. W. "Paulette Nardal est morte." *France Antilles,* Feb. 22, 1985. Archives Départementales de la Martinique. Schœlcher, Martinique.

Quijano, Anibal. "Coloniality of Power, Eurocentrism, and Latin America." *Nepantla: Views from South* 1, no. 3 (2000): 533–80.

Rabbitt, Kara. "In Search of the Missing Mother: Suzanne Césaire, Martiniquaise." *Research in African Literatures* 44, no. 1 (2013): 36–54.

Ramsay, Raylene L. *French Women in Politics: Writing Power, Paternal Legitimization, and Maternal Legacies.* New York: Berghahn Books, 2003.

Ransby, Barbara. *Eslanda: The Large and Unconventional Life of Mrs. Paul Robeson.* New Haven, CT: Yale University Press, 2014.

"The Red Mata Hari? Woman of Mystery." *Baltimore Afro-American.* Dec. 5, 1961, 5.

Rimbaud, Arthur. *Poesies.* S.L: MERCURE DE FRANCE, 1922.

Robeson, Eslanda, G. "Africa—No Longer the Dark Continent." *New World Review* (1952): 3–6.

———. *African Journey.* Westport, CT: Greenwood Press, 1972.

———. Eslanda G. Robeson Papers (EGRP). Paul and Eslanda Robeson Collection. Moorland-Spingarn Research Center, Howard University, Washington, DC.

———. "Felix Eboué: The End of an Era." *New World Review* 44 (Oct. 1952): 44–48.

———. "How to Behave Abroad." *Baltimore Afro-American.* Aug. 27, 1955, 22.

———. "The Rising Tide." *New World Review.* Nov. 1952, 10.

———. "What Is a Ghetto?" *Jewish Life.* Aug. 1954, 25–26.

———. "What Is Communism?" *Baltimore Afro-American.* July 8, 1950, 13.

———. "Which Way for Africa?" *New World Review.* Dec. 1952, 24–29.

———. "Women in the UN." *New World Review.* Mar. 1958, 33–35.

Rodney, Walter. *How Europe Underdeveloped Africa.* Baltimore: Black Classic Press, 2011.

Rodríguez, Ileana. *House, Garden, Nation: Space, Gender, and Ethnicity in Post-Colonial Latin American Literatures by Women.* Durham, NC: Duke University Press, 1994.

Roumain, Jacques. *Gouverneurs de la rosée.* Coconut Creek: Educa Vision, 1999.

Saada, Emmanuelle. *Empire's Children: Race, Filiation, and Citizenship in the French Colonies.* Trans. Arthur Goldhammer. Chicago: University of Chicago Press, 2012.

Said, Edward. *Reflections on Exile and Other Essays.* Cambridge: Harvard University Press, 2001.

Scharfman, Ronnie. "De grands poètes noirs: Breton rencontre les Césaire." In *Nouveau Monde, Autres Mondes: Surréalisme and Amériques,* edited by Daniel Lefort, Pierre Rivas, and Jacqueline Chénieux-Gendron, 231–39. Paris: Lachenal and Ritter, 1995.

Schmidt, Elizabeth. *Cold War and Decolonization in Guinea, 1946–1958.* Athens: Ohio University Press, 2007.

Scott, Joan W. *Only Paradoxes to Offer: French Feminists and the Rights of Man.* Cambridge: Harvard University Press, 2004.

Sembene, Ousmane. *Camp de Thiaroye.* Paris: Organisation internationale de la francophonie, 2012.

———. *Emitaï.* Paris: La Médiathèque des Trois Mondes, 1971. Film.

———. *God's Bits of Wood.* London: Heinemann, 1995.

———. *Les bouts de bois de Dieu: Banty mam yall.* Paris: Livre Contemporain, 2008.

———. *Ousmane Sembène: Interviews.* Ed. Annett Busch, and Max Annas. Jackson: University Press of Mississippi, 2008.

Semley, Lorelle D. *To Be Free and French: Citizenship in France's Atlantic Empire.* Cambridge: Cambridge University Press, 2017.

————. "Women Citizens of the French Union Unite!: Jane Vialle's Postwar Crusade." In *Gender and Citizenship in Historical and Transitional Perspective*, edited by Anne R. Epstein and Rachel G. Fuchs, 186–210. London: Palgrave Macmillan, 2016.

Senghor, Léopold S. "Il n'y pas de problème du métis." *Reveil*. June 2, 1947, 1–2.

————. "L'humanisme et nous: René Maran." *L'étudiant noir*. Mar. 1935.

Serre, Jacques. *Hommes et destins. Tome XI: Afrique Noire*. Paris: L'Harmattan, 2011.

Servant, Jil. *Paulette Nardal: La fierté d'être négresse*. Paris: Les productions de la lanterne, 2005.

Seyrig, Henri. Fonds Henri Seyrig. NAF 19792. Bibliothèque nationale de France.

Sharpley-Whiting, T. D. *Black Venus: Sexualized Savages, Primal Fears, and Primitive Narratives in French*. Durham, NC: Duke University Press, 1999.

————. "Erasures and the Practice of Diaspora Feminism." *Small Axe: A Caribbean Journal of Criticism* 9, no. 1 (2005): 129–33.

————. *Negritude Women*. Minneapolis: University of Minnesota Press, 2003.

Smith, Sidonie, and Julia Watson. "Introduction: De/Colonization and the Politics of Discourse in Women's Autobiographical Practices." *De/Colonizing the Subject: The Politics of Gender in Women's Autobiography*. Ed. Sidonie Smith and Julia Watson, xii-xxxi. Minneapolis: University of Minnesota Press, 1988.

Sourieau, Marie-Agnès. "Suzanne Césaire et *Tropiques*: De la poésie cannibale à une poétique créole." *French Review* 68, no. 1 (1994): 69–78.

Spraggs, Venice, T. "Eboue Widow Opposes French Colonial Freedom." *Chicago Defender*. Nov. 17, 1945. ProQuest Historical Newspapers.

Stanard, Matthew, G. "Belgium, the Congo, and Imperial Immobility: A Singular Empire and the Historiography of the Single Analytic Field." *French Colonial History* 15 (2014): 87–110.

Stephens, Michelle. "Disarticulating Black Internationalisms: West Indian Radicals and the Practice of Diaspora." *Small Axe: A Caribbean Journal of Criticism* 9, no. 1 (2005): 100–111.

————. "Re-imagining the Shape and Borders of Black Political Space." *Radical History Review* 2003, no. 87 (2003): 169–82.

————. "What Is an Island? Caribbean Studies and the Contemporary Visual Artist." *Small Axe: A Caribbean Journal of Criticism* 17, no. 2 (2013): 8–26.

Stoddard, Lothrop. *The Rising Tide of Color against White World-Supremacy*. Memphis: General Books, 2010.

Syrotinski, Michael. *Singular Performance: Reinscribing the Subject in Francophone African Writing*. Charlottesville: University of Virginia Press, 2002.

Totten, Gary. *African American Travel Narratives from Abroad: Mobility and Cultural Work in the Age of Jim Crow*. Amherst: University of Massachusetts Press, 2015.

Toumson, Roger, and Simonne Henry-Valmore. *Aimé Césaire: Le Nègre inconsolé: Biographie*. Châteauneuf-le-Rouge, France: Vents d'ailleurs, 2002

Travis, Dan. "Racism in U.S. Rocks World—Mrs. Robeson." *Baltimore Afro-American*. Apr. 22, 1950, 12.

Trefzer, Annette, Jeffrey T. Jackson, Kathryn McKee, and Kirsten Dellinger. "Introduction: The Global South and/in the Global North: Interdisciplinary Investigations." *Global South* 8, no. 2 (2014): 1–15.

Triay, Philippe. "A Frémainville, la première Marianne noire de France mise au rancart." *Outre-mer première.* Jan. 26, 2015. https://laıere.francetvinfo.fr/2015/01/26/fremainville-la-premiere-marianne-noire-de-france-mise-au-rancart-224271.html. Accessed Jan. 30, 2016.

Turrittin, Jane. "Aoua Kéita and the Nascent Women's Movement in the French Soudan." *African Studies Review: The Journal of the African Studies Association* 36, no. 1 (1993): 59–89.

Umoren, Imaobong, D. *Race Women Internationalists: Activist Intellectuals and Global Freedom Struggles.* Oakland: University of California Press, 2018.

"Untitled." Coupures de presse sur les fiançailles de Ginette Éboué avec Léopold Senghor. Sept. 1946. Papiers personnels d'Eugénie Éboué, Fondation Charles de Gaulle, F22/26.

Vaillant, Janet G. *Black, French, and African: A Life of Léopold Sédar Senghor.* Cambridge: Harvard University Press, 1990.

Vergès, Françoise. *Monsters and Revolutionaries: Colonial Family Romance and Métissage.* Durham, NC: Duke University Press, 1999.

Vialle, Jeanne. "Débats parlementaires. Conseil de la république." *Journal Officiel de la République Française.* Mar. 19, 1948. http://www.senat.fr/seances/comptes-rendus.html#archives. Accessed Nov. 5, 2014.

———. "Débats parlementaires. Conseil de la république." *Journal Officiel de la République Française.* June 25, 1948. http://www.senat.fr/seances/comptes-rendus.html#archives. Accessed Nov. 5, 2014.

———. Dossier Jane Vialle. Archives du Sénat. Paris.

———. Interrogation Transcripts. 8W3 and 8W53. Archives Départementales des Bouches-du-Rhône, Aix-en-Provence.

"Victime civile de guerre." 1M861/D. Archives Départementales de la Martinique. Schœlcher, Martinique.

VVV: Poetry, Plastic Arts, Anthropology, Sociology, Psychology 1 (June 1942).

Watts, Richard. *Packaging Post/Coloniality: The Manufacture of Literary Identity in the Francophone World.* Lanham, MD: Lexington Books, 2005.

Weinstein, Brian. *Éboué.* New York: Oxford University Press, 1972.

West, Michael O., William G. Martin, and Fanon Che Wilkins. *Toussaint to Tupac: The Black International since the Age of Revolution.* Chapel Hill: University of North Carolina Press, 2009.

White, Owen. *Children of the French Empire: Miscegenation and Colonial Society in French West Africa, 1895–1960.* Oxford: Clarendon Press, 2010.

Wilder, Gary. *Freedom Time: Negritude, Decolonization, and the Future of the World.* Durham, NC: Duke University Press, 2015.

Wilks, Jennifer, M. *Race, Gender, and Comparative Black Modernism: Suzanne Lac-*

ascade, Marita Bonner, Suzanne Césaire, Dorothy West. Baton Rouge: Louisiana State University Press, 2008.

———. "Revolutionary Genealogies: Suzanne Césaire's and Christiane Taubira's Writings of Dissent." *Small Axe: A Caribbean Journal of Criticism* 19, no. 3 (2015): 91–101.

"The Woman behind Lumumba." *Baltimore Afro-American*. Oct. 15, 1960, A5.

Wynter, Sylvia. "Unsettling the Coloniality of Being/Power/Truth/Freedom: Towards the Human, After Man, Its Overrepresentation—An Argument." *CR: The New Centennial Review* 3, no. 3 (2004): 257–337.

Index

Page numbers in *italics* indicate illustrations. Titles of authored works are under the author's name.

gagement of, 20, 81, 84, 90–91, 99–108; Vialle and, 88, 96, 97

Éboué-Tell, Eugénie, writings: electoral campaign speech (1945), 93–95; "French End Colonial Era," 82, 103–4; Guadeloupean constituents, addresses to, 99; parliamentary speeches, 90, 94–95, 113; "Les rôles des femmes," 88

écriture métisse, 133

Edwards, Brent, 17, 65, 103; *The Practice of Diaspora,* 19

Emitaï (film), 27, 149, 158–59, 161–63, 214n35

epidermalization of race/racism, 178, 179

Esprit (journal), 209n71

état civil (statut civil), 87–88

Etiemble, René, 37, 200nn19–20

évolués, 107–8, 139, 153

Fabrique, Gaston de, 78

Fabrique, Guy de, 78, 79, 205n62

Fanon, Frantz, 18, 138, 172, 178; "Antillais et Africains," 22; *Peaux noire, masques blancs,* 63; *The Wretched of the Earth,* 19, 43

Fédération des travailleurs indigènes des chemins de fer de l'AOF, 157

Feminine Movement for African Solidarity, 121–22

feminism/sexism/women's liberation: African women under colonialism and, 116; Gerty Archimède, attacks on, 74, 96; AWA and, 190–94; bodies of black women, treatment of, 116, 194; colonial elites, Vialle on women's role in formation of, 108; "colonial feminism," 75; domestic/gendered racism experienced by Blouin, 121, 136–38; Éboué-Tell and Vialle, feminist anticolonialism of, 84–85, 91–92, 95, 99–101; *La femme dans la cité* and, 24, 56, 57, 60–62, 65, 68, 70–78, 80, 96, 188; history, rewriting, 149, 159–68; imperialist feminism, 130–31; Kéita, feminist activism of, 144, 147–48, 152, 154–57, 163, 164–68; Man-as-citizen, 9–15; myth of colonial family, disrupting, 108–17, 146; Paulette Nardal's "Féminisme colonial," 75–77; paternity law in France and, 88, 114–17, 121, 139–40, 146; resistance to black women in power, overcoming, 96; Robeson, Global South feminism of, 174, 177, 184–86; in Sembène's work, 157–59, 161, 163; transnational feminist alliances, 80–81, 99–101; violence, women, and political activism, 163–68, 194; women's suffrage

in metropole, 8–9, 71, 95; WWII, French women's involvement in, 82–84, *83,* 92–99

La femme dans la cité (journal), 24, 56, 57, 60–62, 65, 68, 70–78, 80, 96, 99, 188

Les Femmes de l'Union française, 99, 207n20

Flaubert, Gustave: *Madame Bovary,* 47

Fonkoua, Romuald-Blaise, 203n1

Franketienne, 212n60

Free French Forces, 34, 85, 86, 93, 95, 135

French-Antillean citizenship, Nardal's concept of, 60, 61, 65, 71, 133–34

French Antilles. *See specific colonies/countries*

French citizenship: author's citizenship papers, 1–3; granted to all colonial subjects (1946), 84, 94, 169–70; Kéita on ultimate untenability of, 103, 152–53; Man-as-citizen, 9–15; as means of anti-colonial resistance, 80; secession rights of French Equatorial Africans, 185; *statut civil (état civil),* 87–88; in transnational context, 101–8

French Congo, 26, 126, 128, 137

French Equatorial Africa (AEF), 25; Blouin and, 120, 121, 126, 137–39, 141; Éboué-Tell/Vialle and, 84, 93, 94, 100, 110; Robeson and, 178–80, 185

French Guyana, 6, 8, 13, 17, 22, 25; Blouin and, 120; Suzanne Césaire compared to Christiane Taubira of, 203n105; Éboué-Tell/Vialle and, 84, 85, 89, 94, 95, 105, 113, 117; Nardal and, 68, 81; Robeson and, 178

French Resistance, 25, 34, 59, 84, 85–87, 88, 92–99, 115, 200n21

French Revolution, 1, 9, 105, 109, 110, 114, 209n98

French Sudan: Éboué-Tell in, 85; Kéita and, 26–27, 141–45, 147, 151–56, 164, 165, 214n30; Robeson and, 188

French Union: Blouin and, 133, 138–39; decolonial citizenship and, 14, 109, 114; dissolution of, 21, 28, 188; Éboué-Tell/Vialle and, 85, 88, 95, 99, 100, 101, 103, 107, 115, 117; formation of, 8, 21, 25; Kéita and, 153; marriage/divorce of Léopold Senghor/Ginette Éboué and, 21, 85; *métissage* "problem" and, 138–39; paternity law and, 115; Semley, Lorelle, on, 19; WWII and, 6, 8

French West Africa, 27; Blouin and, 121, 138, 139, 141; Éboué-Tell/Vialle and, 94, 100; Kéita and, 143, 148, 154, 157, 160–61

Freundschuh, Aaron, 78

Frobenius, Leo: *Histoire de la civilisation africaine,* 34, 35, 37–38, 44–45

Republic of the Congo, 5, 88, 122, 126, 127–28, 133, 138
Réunion, 90
Réveil (newspaper), 138
La revue du monde noir (journal), 58, 60, 188, 205n61
rice tax, 149, 161
Rimbaud, Arthur, 39, 40, 200n19; *Lettres du voyant*, 37
Robert, Georges, 33, 35
Robeson, Eslanda, 27–28, 169–86; African diaspora and, 175, 176, 177, 181, 186; AFUF manifesto and, 100; archives of, 51; Central Africa, surveilled in, 177–82; decolonial citizenship of, 6, 174, 183–84; Éboué-Tell and, 27, 173, 185; feminism of, 174, 177, 184–86; Global South politics of, 27–28, 68, 173–74, 177–86, 193; Kéita and, 168; on mobility as resistance to surveillance and policing, 181–83; Nardal and, 27, 172, 173; passport and visa issues, 7, 182, 185; as political protagonist, 173; post office experiences of Vialle and, 169–73; private/public life, negotiation of, 23; solidarity with colonized/racially segregated, negotiating, 171–74; South Africa, refused visa for, 181; transnational black identity and, 20, 174–77; Vialle and, 27, 88, 169–73; WWII, on colonial support of Free France in, 8
Robeson, Eslanda, writings: *African Journey*, 175–76, 181, 182, 215n8; Canadian-West Indian Progressive Student Centre, address at, 180; "How to Behave Abroad," 176–77; Manhattan Center address, 182; *New World Review*, articles for, 172–73, 182, 183, 185; planned biopic on Félix Éboué, 185; "Postscript to African Journey," 169; speech at Movement for Colonial Freedom in the United Kingdom, 177; "What Is Communism?," 177; "Women in the UN," 185–86
Robeson, Paul (husband of Eslanda), 185
Roumain, Jacques: *Les gouverneurs de la rosée*, 50

Saada, Emmanuelle, 114
Said, Edward, 64
Saint-Domingue, 105
Saint Lucia, 200n21
Sajous, Léo, 60, 70
Scharfman, Ronnie, 52
Schmidt, Elizabeth, 215n55
Schwarz-Bart, Simone, 20

Sembène, Ousmane, 154, 159–60; *Les bouts de bois de Dieu* (novel), 27, 148–49, 157–58, 161, 163–64; *Camp de Thiaroye* (film), 214n35; *Emitaï* (film), 27, 149, 158–59, 161–63, 214n35
Semley, Lorelle D.: *To Be Free and French*, 19, 207n21
Senegal, 14, 89, 144, 155, 157, 192
Senghor, Léopold, 18, 21–22, 26, 85, 126, 145, 160, 193, 209n91; "Il n'y a pas de problème du métis," 138–40
Senna, Danzy, 211n32
Serruys, Roger, 121, 123
Sévère, Victor, 55
sexism. *See* feminism/sexism/women's liberation
Seyrig, Henri, 29–30, 32, 33, 44, 200n15
Sharpley-Whiting, T. Denean, 32, 75; *Negritude Women*, 19
Sillitoe, Sir Percy, 179–80
Smith, Sidonie, 122
Le Soir (newspaper), 40, 66–68
Sourieau, Marie-Agnès, 37, 38, 200n28
sousveillance (undersight), 97–98
South Africa, 62, 156, 177, 181, 183, 188
Sow Fall, Aminata, 20, 145
Spanish Civil War, 127
spiralist movement, 212n60
statut civil (*état civil*), 87–88
Stephens, Michelle: "Re-imagining the Shape and Borders of Black Political Space," 17–18
Stoddard, Lothrop: *The Rising Tide of Color against White World-Supremacy*, 183
Sudanese Republic, 144
surrealism and Suzanne Césaire, 36–37, 40
Sylla, David, 166
Syrotinski, Michael, 146

Tadjo, Véronique, 26, 145
Taubira, Christiane, 203n105
Tell, Joséphine and Herménégilde, 85
Thésée, Lucie, 32
Thiam, Aoua: *La Parole aux négresses*, 20
Touré, Sékou, 5, 121, 127, 129
Toussaint Louverture, François-Dominique, 18, 40, 49
Toussaint to Tupac, 18
transnational engagement: AWA and black transnational feminism, 190–92; concept of, 7, 9, 17–18, 20, 25–26, 194–95; of Eugénie Éboué-Tell, 81, 84, 90–91, 99–108;

Woodson, Carter G., 91

World War II: SS *Bretagne,* 7, 57–58, 203n1; Suzanne Césaire in Martinique during, 7, 32, 33–38; colonial relations and, 5–9, 25, 33; concentration camp, Vialle's internment in, 17, 25, 84, 89, 98; *Emitaï* (film) on rice tax and forced conscription, 27, 149; Free French Forces, 34, 85, 86, 93, 95, 135; French Resistance, 25, 34, 59, 84, 85–87, 88, 92–99, 115, 200n21; French women's involvement in, 82–84, *83,* 92–99; Paulette Nardal's quest for disability benefits as war victim, 58–59, 72, 75; Warsaw Ghetto Uprising, 182. *See also* Vichy regime

Wouassimba, Josephine, 120, 134–35, 210n5

Wright, Richard: *Black Boy,* 215n8

Wynter, Sylvia, 9, 10, 11

Zobel, Joseph, 188

Annette K. Joseph-Gabriel is an assistant professor
of French at the University of Michigan.

The New Black Studies Series

The University of Illinois Press
is a founding member of the
Association of University Presses.

———————————————————

Composed in 10.75/13 Adobe Garamond
with Univers display
by Jim Proefrock
at the University of Illinois Press

University of Illinois Press
1325 South Oak Street
Champaign, IL 61820-6903
www.press.uillinois.edu